P9-DOC-182

REAL WORLD
CAMERA RAW
WITH ADOBE PHOTOSHOP CS4

BRUCE FRASER
AND JEFF SCHEWE

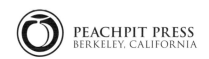

PEACHPIT PRESS
BERKELEY, CALIFORNIA

REAL WORLD CAMERA RAW WITH ADOBE PHOTOSHOP CS4

Bruce Fraser and Jeff Schewe

Peachpit Press
1249 Eighth Street
Berkeley, CA 94710
510/524-2178
510/524-2221 (fax)

Peachpit Press is a division of Pearson Education.
Find us on the Web at: www.peachpit.com
To report errors, please send a note to: errata@peachpit.com
Published in association with Adobe Press
For the latest on Adobe Press books, go to www.adobepress.com
Copyright © 2009 by Jeff Schewe

Editor: Rebecca Gulick
Copy Editors: Liz Welch and Anne Marie Walker
Production Editor: Lisa Brazieal
Compositor: WolfsonDesign
Indexer: Jack Lewis
Cover Design: Charlene Charles-Will
Cover Illustration: Regina Cleveland
Cover Photos: Jeff Schewe

Notice of Rights
All rights reserved. No part of this book may be reproduced or transmitted in any form by any means, electronic, mechanical, photocopying, recording, or otherwise, without the prior written permission of the publisher. For information on getting permission for reprints and excerpts, contact permissions@peachpit.com.

Notice of Liability
The information in this book is distributed on an "As Is" basis, without warranty. While every precaution has been taken in the preparation of the book, neither the authors nor Peachpit Press shall have any liability to any person or entity with respect to any loss or damage caused or alleged to be caused directly or indirectly by the instructions contained in this book or by the computer software and hardware products described in it.

Trademarks
"Adobe," "Adobe Bridge," "Photoshop Camera Raw," "Lightroom," and "Photoshop" are either registered trademarks or trademarks of Adobe Systems Incorporated in the United States and/or other countries.

Many of the designations used by manufacturers and sellers to distinguish their products are claimed as trademarks. Where those designations appear in this book, and Peachpit was aware of a trademark claim, the designations appear as requested by the owner of the trademark. All other product names and services identified throughout this book are used in editorial fashion only and for the benefit of such companies with no intention of infringement of the trademark. No such use, or the use of any trade name, is intended to convey endorsement or other affiliation with this book.

ISBN-13: 978-0-321-58013-9
ISBN-10: 0-321-58013-3

9 8 7 6 5 4 3 2 1

Printed and bound in the United States of America

This book is dedicated to the significant contributions and the lasting memory of Bruce Fraser.

TABLE OF CONTENTS

PREFACE
Real World Raw

If you're reading this book because you want to be told that digital really is better than film, look elsewhere. The term "digital photography" may still be in current use, but sooner rather than later, it will be replaced by the simple term "photography." If you want to be told that shooting digital raw is better than shooting JPEG, you'll have to read between the lines—what this book does is explain how raw *differs* from JPEG, and how you can exploit those differences.

But if you're looking for solid, tested, proven techniques for dealing with hundreds or thousands of digital captures a day—moving them from the camera to the computer, making initial selects and sorts, optimizing the captures, enriching them with metadata, and processing them into deliverable form—this is the book for you. The entire reason for writing this book was to throw a lifebelt to all those photographers who find themselves drowning in gigabytes of data.

The combination of Photoshop CS4, Bridge CS4, and the Camera Raw 5 plug-in offers a fast, efficient, and extremely powerful workflow for dealing with raw digital captures, but the available information tends to be short on answers to questions such as the following:

- What special considerations should I take into account when shooting digital raw rather than film or JPEG?

- What edits should I make in Camera Raw?

- How and where are my Camera Raw settings saved?

- How can I fine-tune Camera Raw's color performance to better match my camera's behavior?

- How can I set up Bridge to speed up making initial selects from a day's shoot?

- How can I make sure that every image I deliver contains copyright and rights management notices?

- How do I make sure that all the work I do in Bridge, ranking or flagging images, entering keywords and other metadata, and sorting in a custom order, doesn't suddenly disappear?

- How can I decide which image-editing adjustments should I do in Camera Raw versus Photoshop?

- How can I automate the conversion of raw images to deliverable files?

Digital shooters face these questions, and many others, every day. Unfortunately, the answers are hard to find in the gazillion of Photoshop books out there—much less Photoshop's own manuals—and when they're addressed at all they tend to be downplayed in favor of whizzy filter effects. This book answers these questions, and the other daily workflow issues that arise, head-on, and focuses on everything you need to do *before* you get your images open in Photoshop.

TEACH A MAN TO FISH

The old saw goes, "Give a man a fish, and you give him a meal; teach a man to fish, and you give him a living." By that reckoning, our goal is to make you, gentle reader, a marine biologist—teaching you not only how to fish, but also to understand fish, how they think, where they hang out, and how to predict their behavior.

Digital capture is the current state of photography, but if you're on a deadline and suddenly find that all your raw images are mysteriously being processed at camera default settings rather than the carefully optimized ones you've applied, or your images insist on displaying in order of filename rather than the custom sort order you spent an hour constructing, you can easily be forgiven for wishing for a nostalgic return to the days of smelly chemicals and rush processing at your friendly local lab and sorting film on a light table with a grease pencil.

Our hope is that you'll turn to this book instead.

You Are the Lab

One of the best things about shooting raw is the freedom it confers in imposing your preferred interpretation on your images. The concomitant downside is that if you don't impose your preferred interpretation on the images, you'll have to settle for one imposed by some admittedly clever software that is nonetheless a glorified adding machine with no knowledge of tone and color, let alone composition, aesthetics, or emotion.

With raw capture, you have total control, and hence total responsibility. Too many photographers wind up converting all their raw images at default settings and then try to fix everything in Photoshop, because Photoshop is something they know and understand. You'd be hard pressed to find bigger Photoshop fans than Bruce Fraser and Jeff Schewe—we've been living and breathing Photoshop for over 15 years—but the fact is that Camera Raw lets you do things that you simply cannot do in Photoshop. If you don't use Camera Raw to optimize your exposure and color balance, you'll wind up doing a lot more work in Photoshop than you need to, and the quality of the results will almost certainly be less than you'd obtain by starting from an optimized raw conversion rather than a default.

Drowning in Data

If you had to edit every single image by hand, whether in Photoshop or in Camera Raw, you'd quickly find that digital is neither faster nor cheaper than film. A day's shoot may produce six or seven (or more) gigabytes of image data, and it all has to get from the camera to the computer before you can even start making your initial selects. Building an efficient workflow is critical if you want to make the digital revolution survivable, let alone enjoyable. So just about every chapter in this book contains key advice on building a workflow that lets you work smarter rather than harder.

Making Images Smarter

We're already living science fiction, and the future arrived quite a while ago. Some of the most-overlooked aspects of digital imaging are the opportunities offered by metadata. Your camera already embeds a great deal of potentially useful information in the image—the date and time of shooting, the ISO speed, the exposure and aperture settings, the focal length, and so on—but

Bridge makes it easy to enrich your images still further with keywords and other useful metadata and lets you protect your intellectual property by embedding copyright and rights management.

Metadata is a means of adding value to your images. Camera metadata provides unambiguous image provenance, while keywords make it much likelier that your images will be selected by clients you've yet to meet. An image with no metadata is simply a collection of pixels, while an image that has been enriched by metadata is a digital asset that can keep earning for a lifetime.

Starting Out Right

The reason for doing a lot of work in Camera Raw and Bridge is simple. If you do the work correctly right at the start of the workflow, you'll never have to do it again. When you attach your preferred Camera Raw setting to a raw image, those settings will be used every time you open that raw image, with no further work required on your part. Any metadata you apply to the raw image will automatically be embedded in every converted image you create from that raw image unless you take steps to remove it (and yes, we'll show you how to do that too). Not only do you have to do the work only once, you greatly reduce the likelihood that it will be undone later.

BRUCE FRASER'S LEGACY

When Bruce penned the first edition of this book, he claimed to be the world's worst photographer. Jeff, however, knew better. Bruce had a sharp mind and an insatiable desire to understand and control the digital photographic process. He had far more capability than he was willing to admit and the unique capacity to express it.

Bruce also had something that every photographer should be infected with—an incurable desire to shoot. While Bruce did not try to make a profession from his photographic endeavors, he did share a "love of the game" with everybody who picks up a camera.

It's lamentable that Bruce is no longer with us to carry this book forward. However, his spirit lives on in these pages. Bruce had asked his friend Jeff Schewe to take over *Real World Camera Raw*, and Jeff has tried to maintain

Bruce's structure and writing voice. It's proven to be a challenging task because so much of what is in Camera Raw 5 is completely new, but the job was made slightly easier by virtue of the fact that Bruce himself was a major influencer of many aspects of Camera Raw.

This edition of the book contains a lot of Bruce (the best stuff) and careful updates and additions to illuminate just how Camera Raw 5 has been changed.

Bruce is greatly missed, but he is remembered by the legions of people whose lives were touched and enriched by his teachings and writings.

How the Book Is Organized

A significant problem faced in writing this book is that everything in the workflow affects everything else in the workflow, so some circularity is inherent.

The first two chapters look at the technical underpinnings of digital raw capture. Chapter 1, *Digital Camera Raw*, looks at the fundamental nature of raw images—what they are, and the advantages and pitfalls of shooting them. Chapter 2, *How Camera Raw Works*, looks at the specific advantages that Camera Raw offers over other raw converters.

Chapter 3, *Raw System Overview*, provides a road map for the remainder of the book by showing the roles of the three major components in the system: Photoshop, Bridge, and the Camera Raw plug-in.

Chapter 4, *Camera Raw Controls*, describes the many features offered by the Camera Raw plug-in, which has grown to the point where it's almost an application in its own right. Chapter 5, *Hands-On Camera Raw*, explores how to use these features quickly and effectively to evaluate and edit raw captures.

Chapter 6, *Adobe Bridge*, looks at the features in Bridge CS4 that are particularly relevant to a digital photographic workflow—Bridge is a surprisingly deep application that serves the entire Adobe Creative Suite, not just Photoshop. Chapter 7, *It's All About the Workflow*, doesn't evangelize a specific workflow, because our needs may be very different from yours. Instead, it introduces some basic workflow principles, then looks at the various ways in which you can use Bridge to perform common tasks, so that you can build the workflow that works for you.

Chapter 8, *Mastering Metadata*, delves into the various metadata schemes used by Camera Raw and Bridge and shows you how to make them work for you. Finally, Chapter 9, *Exploiting Automation*, shows you how to leverage the work done in Camera Raw and Bridge to produce converted images that require minimal work in Photoshop and contain the metadata you want.

A Word to Windows Users

This book applies to both Windows and Macintosh. But Bruce and Jeff have been using Macs for over 20 years, so all the dialog boxes, menus, and palettes are illustrated using screen shots from the Macintosh version. Similarly, when discussing the many keyboard shortcuts in the program, we normally cite the Macintosh versions. In almost every case, the Command key translates to the Ctrl key and the Option key translates to the Alt key. In the relatively few exceptions to this rule, we've spelled out both the Macintosh and the Windows versions explicitly. We apologize to all you Windows users for the small inconvenience, but because Photoshop is so close to being identical on both platforms, we picked the one we know and ran with it.

The Pace of Innovation

When this edition of the book was started, Camera Raw 5 was pretty much finished even though CS4 had not been released. We struggled with the timing of the release of the book but knew that Thomas and crew were planning a November surprise, so we deferred the release in order to use Camera Raw 5.2 as the base version for the book. The 5.2 features and functionality should remain consistent until the next version of the Creative Suite, so if you are using Camera Raw 5.3, 5.4, or above there shouldn't be any differences. If there are any important changes and updates that impact the features and functionality of Camera Raw 5, Bridge, and Photoshop CS4, they will be outlined on the Real World Camera Raw Web site at www.realworldcameraraw.com.

A Note About Camera Raw Updates

Adobe has stated that Camera Raw will be updated three or four times per year. These updates are to add camera compatibility for new cameras and certain maintenance issues relating to known bugs and compatibility with Adobe Photoshop Lightroom. The Camera Raw 5.2 update was unusual in that it actually added new features and functionality.

You must run Photoshop CS4 in order to use Camera Raw 5.x. Some people may lament that fact that Camera Raw isn't compatible with older versions of Photoshop. Camera Raw 4.6 will only run in Photoshop CS3, 3.7 will only run in Photoshop CS2, and Photoshop CS's last compatible version was Camera Raw 2.4. However, even Photoshop CS with Camera Raw 2.4 can open a DNG made with DNG Converter 5.2 of a raw shot with a camera that was just released.

As far as updating Camera Raw, the easiest method now is to use the Adobe Updater. There have been a lot of tech support issues with users not understanding how and where to install the updates manually. If you feel compelled to update manually, just understand that Camera Raw doesn't go inside the normal Photoshop Plug-ins folder since it needs to be used by both Photoshop and Bridge. These are the operating system–specific installation locations:

Macintosh:

Root/Library/Application Support/Adobe/Plug-Ins/CS4/File Formats/Camera Raw.plugin

Windows XP and Vista 32-bit binaries:

Boot\Program Files\Common Files\Adobe\Plug-ins\CS4\File Formats\Camera Raw.8bi

Photoshop CS4 running as a 64-bit binary in Windows Vista 64 bit requires installations in two locations:

1. The 32-bit version of Camera Raw 5.x in:

 Boot\Program Files (x86)\Common Files\Adobe\Plug-Ins\CS4\File Formats\Camera Raw.8bi

2. The Camera Raw 5.x version found in the folder labeled 64-bit should be placed in the following directory:

 Boot\Program Files\Common Files\Adobe\Plug-Ins\CS4\File Formats\Camera Raw.8bi

If you put it anywhere else, either Bridge or Photoshop may not find it. You should also be sure to decompress the downloaded file so it has the correct extension, and you should never have more than one version in the final folder. Simply renaming the older version isn't sufficient; you have to remove it or put a special character as the leading character of the name.

If you browse a folder and your raw images aren't showing up correctly or you can't call up Camera Raw from either Bridge or Photoshop, the plug-in is probably not properly installed. Also note that the installation locations we just listed are not in your user folder but in the root level of your boot hard drive (unless you've installed Photoshop in an odd or alternative location, which we seriously suggest avoiding). Adobe will be happy to charge you money for tech support to correct your problems—we suggest just using the Adobe Updater to avoid hassles.

Downloads

For those of you who may find such an exercise helpful, we've made some of the raw files of the images that we evaluated and processed in Chapter 5, *Hands-On Camera Raw*, available for download should you wish to go through the steps yourself. You can find them at www.realworldcameraraw.com. The login is **RWCRCS4**, and the password (in a Brucian tribute to Mel Brooks) is **swordfish**.

Camera Raw Credits

Camera Raw was originally designed and written by Thomas Knoll, coauthor of Photoshop itself, along with his brother John Knoll. Thomas remains the founder and primary author of Camera Raw and the DNG format. Additional code was written by Mark Hamburg (gone but not forgotten), Zalman Stern, and Eric Chan. Camera Raw's Engineering Manager is Peter Merrill, the Product Manager is Tom Hogarty, and the Program Manager is Melissa Itamura. Camera Raw QE (Quality Engineering) is done by Heather Dolan and Adriana Ohlmeyer, and the QE Manager is Michelle Qi. Camera Raw's raw processing pipeline has been incorporated into Adobe Photoshop Lightroom, and the Camera Raw plug-in is used in Adobe Photoshop Elements (in a limited form) as well as in Adobe After Effects CS4 Professional.

Thank You!

Bruce and Jeff owe thanks to the many people who made this book possible. First, Thomas Knoll, both for creating Photoshop and Camera Raw, and for taking the time to patiently answer questions while chapters were under construction and for correcting a number of egregious errors. Thanks also to the inimitable Russell Preston Brown, who convinced Peachpit Press that this book was needed and that Bruce was the person to originally write it. Any errors or inadequacies that remain in the book are despite their best efforts and are solely our responsibility.

We couldn't have done this without the Peachpit Press Dream Team. Rebecca Gulick, our editor extraordinaire, somehow just makes things happen when and how they need to while appearing absolutely unflappable; production virtuoso Lisa Brazieal turned our virtual creation into a manufactured reality; WolfsonDesign finessed the text and graphics on the page; Liz Welch and Anne Marie Walker painstakingly groomed the manuscript to make things more clear and consistent; Jack Lewis provided the comprehensive index to make sure that everyone can find the information they need.

Thanks to our partners in PixelGenius LLC—Martin Evening, R. Mac Holbert, Seth Resnick, Andrew Rodney, and the late Mike Skurski—for forging a brotherhood that does business in a way that makes MBAs blanch but keeps our customers happy, and for being the finest bunch of people with whom it has ever been our pleasure and privilege to work. Thanks to Michael Keppel, our engineer, for really good engineering (since we can't) and thanks also to the Pixel Mafia—you know who you are!

Last but by no stretch of the imagination least, Bruce would no doubt have paid homage to his wife Angela, for putting up with the stresses and strains that go with an author's life, for being his best friend and partner, and for making his life such a very happy one. Jeff would also like to thank again, his wife of 35+ years, Rebecca, for being the one and only, forever (or at least a really, really long time) and his daughter Erica, who loses quality time with Dad because of the work.

Jeff Schewe, on behalf of Bruce Fraser

Chicago, November 2008

CHAPTER ONE

Digital Camera Raw

EXPLOITING THE DIGITAL NEGATIVE

Perhaps the greatest challenge that faces photographers who have made—or are in the process of making—the transition to digital is dealing with the massive gigabytes of captured data. You can make some limited judgments about the image from a camera's on-board LCD display, but to separate the hero images from the clutter, you have to copy the images from the camera media to a computer with a decent display, which is a major challenge for those of you who are used to getting rush-processed chromes back from the lab and sorting them on the light table.

Digital raw files present a further bottleneck, since they require processing before you can even see a color image. This book tells you how to deal with raw images quickly and efficiently, so that you can exploit the very real advantages of raw capture over JPEG, yet still have time to have a life. The key is in unlocking the full power of three vital aspects of Adobe Photoshop CS4—the Adobe Photoshop Camera Raw plug-in, the standalone Bridge application, and Photoshop actions. Together, these three features can help you build an efficient workflow based on raw captures, from making the initial selects, through rough editing for client approval, to final processing of selected images.

In this first chapter, though, we'll focus on raw captures themselves, their fundamental nature, their advantages, and their limitations. So the first order of business is to understand just what a raw capture is.

WHAT IS A DIGITAL RAW FILE?

Fundamentally, a digital raw file is a record of the raw sensor data from the camera, accompanied by some camera-generated *metadata* (literally, data about data). We'll discuss metadata in great detail in Chapter 8, *Mastering Metadata*, but for now, all you need to know is that the camera metadata supplies information about the way the image was captured, including the ISO setting, shutter speed and aperture value, white balance setting, and so on.

Different camera vendors may encode the raw data in different ways, apply various compression strategies, and in some cases even apply encryption, so it's important to realize that "digital camera raw" isn't a single file format. Rather, it's a catch-all term that encompasses Canon CRW and CR2, Minolta MRW, Nikon NEF, Olympus ORF, and all the other raw formats on the ever-growing list that's readable by Adobe Camera Raw. But all the various flavors of raw files share the same basic properties and offer the same basic advantages. To understand them all, you need to know a little something about how digital cameras work.

The Camera Sensor

A raw file is a record of the sensor data, so let's look at what the sensor in a digital camera actually captures. A number of different technologies get lumped into the category of "digital camera," but virtually all the cameras supported by the Camera Raw plug-in are of the type known as "mosaic sensor" or "color filter array" cameras (*virtually all* because versions 2.2 and later of Camera Raw also support the Sigma cameras based on Foveon's X3 technology—see the sidebar "The Foveon X3 Difference," later in this chapter). The first key point is that striped-array raw files are grayscale!

Color filter array cameras use a two-dimensional area array to collect the photons that are recorded in the image. The array is made up of rows and columns of photosensitive detectors—typically using either CCD (charge-coupled device) or CMOS (complementary metal oxide semiconductor) technology—to form the image. In a typical setup, each element of the array contributes one pixel to the final image (see Figure 1-1).

But the sensors in the array, whether CCD or CMOS, just count photons —they produce a charge proportional to the amount of light they receive— without recording any color information. The color information is produced

by color filters that are applied over the individual elements in the array in a process known as *striping*—hence the term *striped array*. Most cameras use a Bayer pattern arrangement for the color filter array, alternating green, red, green, and blue filters on each consecutive element, with twice as many green as red and blue filters (because our eyes are most sensitive in the green region). See Figure 1-2.

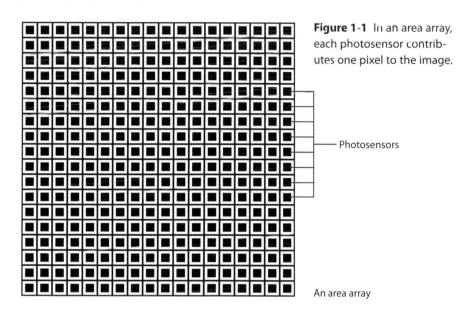

Figure 1-1 In an area array, each photosensor contributes one pixel to the image.

— Photosensors

An area array

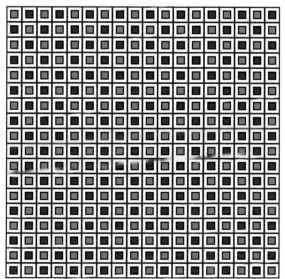

Bayer pattern

Figure 1-2 In a Bayer pattern color filter array, each photosensor is filtered so that it captures only a single color of light: red, green, or blue. Twice as many green filters are used as red or blue because our eyes are most sensitive to green light.

NOTE Planar RGB files. Camera Raw 5 has the ability to process planar RGB raw files, which are images with regular red, green, and blue pixels instead of a Bayer array of green, red, green, and blue pixels. Planar images are produced by tri-linear CCD (scanning back) cameras like the Better Light cameras (www.betterlight.com), which process out captures as DNG files. The only limitation is Camera Raw's 512-megapixel pixel count.

Other color filter array configurations are possible—some cameras use a cyan, magenta, and yellow arrangement instead of the GRGB configuration in the classic Bayer pattern, while still others may use four colors in an attempt to improve color fidelity. But unless you plan on designing your own cameras, you needn't worry about the details of this or that filter setup.

Raw Files Are Grayscale

No matter what the filter arrangement, the raw file simply records the luminance value for each pixel, so the raw file is essentially a grayscale image. It contains color *information*—the characteristics of the color filter array are recorded, so raw converters know whether a given pixel in the raw file represents red, green, or blue luminance (or whatever colors the specific camera's filter array uses)—but it doesn't contain anything humans can interpret as color.

Obtaining a color image from the raw file is the job of a raw converter such as Camera Raw. The raw converter interpolates the missing color information for each pixel from its neighbors, a process called *demosaicing*, but it does much more, too. Besides interpolating the missing color information, raw converters control all of the following:

- **White balance.** The white balance indicates the color of the light under which the image was captured. Our eyes automatically adapt to different lighting situations—to oversimplify slightly, we interpret the brightest thing in the scene as white, and judge all the other colors accordingly. Cameras—whether film or digital—have no such adaptation mechanism, as anyone who has shot tungsten film in daylight has learned the hard way, so digital cameras let us set a white balance to record the color of the light.

 But the on-camera white balance setting has no effect on the raw capture. It's saved as a metadata tag and applied by the raw converter as part of the conversion process.

- **Colorimetric interpretation.** Each pixel in the raw file records a luminance value for red, green, or blue. But *red*, *green*, and *blue* are pretty vague terms. Take a hundred people and ask them to visualize *red*. If you could read their minds, you'd almost certainly see a hundred different shades of red.

 Many different filter sets are in use with digital cameras. So the raw converter has to assign the correct, specific color meanings to the *red*,

green, and *blue* pixels, usually in a colorimetrically defined color space such as CIE XYZ, which is based directly on human color perception and hence represents color unambiguously.

- **Tone mapping.** Digital raw captures have linear gamma (gamma 1.0), a very different tonal response from that of either film or the human eye. The raw converter applies tone mapping to redistribute the tonal information so that it corresponds more closely to the way our eyes see light and shade. I discuss the implications of linear capture on exposure in the upcoming section "Exposure and Linear Capture."

- **Noise reduction, antialiasing, and sharpening.** When the detail in an image gets down to the size of individual pixels, problems can arise. If the detail is only captured on a red-sensing or a blue-sensing pixel, its actual color can be difficult to determine. Simple demosaicing methods also don't do a great job of maintaining edge detail, so raw converters perform some combination of edge detection, antialiasing (to avoid color artifacts), noise reduction, and sharpening.

All raw converters perform each of these tasks, but each one may use different algorithms to do so, which is why the same image can appear quite different when processed through different raw converters.

The Foveon X3 Difference

Foveon X3 technology, embodied in the Sigma SD-9, the SD-10, and the new SD14 SLR cameras, is fundamentally different from striped-array cameras.

The Foveon X3 direct image sensor captures color by exploiting the fact that blue light waves are shorter than green light waves, which in turn are shorter than red ones. It uses three layers of photosensors on the same chip. The front layer captures the short blue waves, the middle layer captures the green waves, while only the longest red waves penetrate all the way to the third layer, which captures red.

The key benefit claimed by the X3 sensor is that it captures full color data, red, green, and blue, for every pixel in the image. As a result, .X3F files—Foveon X3 raws—don't require demosaicing. But they do need all the other operations a raw converter carries out—white balance, colorimetric interpretation, gamma correction, and detail control—so Camera Raw is as applicable to files from Foveon X3-equipped cameras as it is to those from the more common striped-array cameras.

EXPOSURE AND LINEAR CAPTURE

One final topic is key to understanding digital capture in general, not just digital raw. Digital sensors, whether CCD or CMOS, respond to light quite differently than does either the human eye or film. Most human perception, including vision, is nonlinear.

If we place a golf ball in the palm of our hand, then add another one, it doesn't feel twice as heavy. If we put two spoonfuls of sugar in our coffee instead of one, it doesn't taste twice as sweet. If we double the acoustic power going to our stereo speakers, the resulting sound isn't twice as loud. And if we double the number of photons reaching our eyes, we don't see the scene as twice as bright—brighter, yes, but not twice as bright.

This built-in compression lets us function in a wide range of situations without driving our sensory mechanisms into overload—we can go from subdued room lighting to full daylight without our eyeballs catching fire! But the sensors in digital cameras lack the compressive nonlinearity typical of human perception. They simply count photons in a linear fashion. If a camera uses 12 bits to encode the capture, producing 4,096 levels, then level 2,048 represents half the number of photons recorded at level 4,096. This is the meaning of linear capture—the levels correspond exactly to the number of photons captured. So if it takes 4,096 photons to make the camera record level 4,096, it takes 3,248 photons to make the same camera record level 3,248 and 10 photons to make it register level 10.

Linear capture has important implications for exposure. When a camera captures six stops of dynamic range (which is fairly typical of today's digital SLRs), half of the 4,096 levels are devoted to the brightest stop, half of the remainder (1,024 levels) are devoted to the next stop, half of the remainder (512 levels) are devoted to the next stop, and so on. The darkest stop, the extreme shadows, is represented by only 64 levels—see Figure 1-3.

Figure 1-3 Linear capture.

64 128 256 512 1,024 2,048 levels (half of the total)

We see light very differently. Human vision can't be modeled accurately using a gamma curve, but gamma curves are so easy to implement, and come sufficiently close, that the working spaces we use to edit images almost invariably use a gamma encoding of somewhere between 1.8 and 2.2. Figure 1-4 shows approximately how we see the same six stops running from black to white.

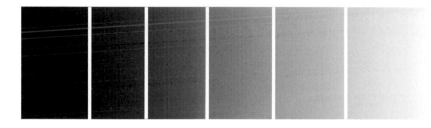

Figure 1-4
Gamma-encoded gradient.

One of the major tasks raw converters perform is to convert the linear capture to a gamma-encoded space to make the captured levels more closely match the way human eyes see them. In practice, though, the tone mapping from linear to gamma-encoded space is considerably more complex than simply applying a gamma correction—when we edit raw images, we typically move the endpoints, adjust the midtone, and tweak the contrast, so the tone-mapping curve from linear to gamma-encoded space is much more complex than can be represented by a simple gamma formula. If we want our images to survive this tone mapping without falling apart, good exposure is critical.

Exposure

Correct exposure is at least as important with digital capture as it is with film, but correct exposure in the digital realm means keeping the highlights as close to blowing out, without actually doing so, as possible. If you fall prey to the temptation to underexpose images to avoid blowing out the highlights, you'll waste a lot of the bits the camera can capture, and you'll run a significant risk of introducing noise in the midtones and shadows. If you overexpose, you *may* blow out the highlights, but one of the great things about the Camera Raw plug-in is its ability to recover highlight detail (see the sidebar, "How Much Highlight Detail Can I Recover?" in Chapter 2, *How Camera Raw Works*), so if you're going to err on one side or the other, it's better to err on the side of *slight* overexposure.

Figure 1-5 shows what happens to the levels in the simple process of conversion from a linear capture to a gamma-corrected space. These illustrations use 8 bits per channel to make the difference very obvious, so the story they tell is somewhat worse than the actual behavior of a 10-bit, 12-bit, or 14-bit per channel capture, but the principle remains the same.

Figure 1-5 Exposure and tone mapping.

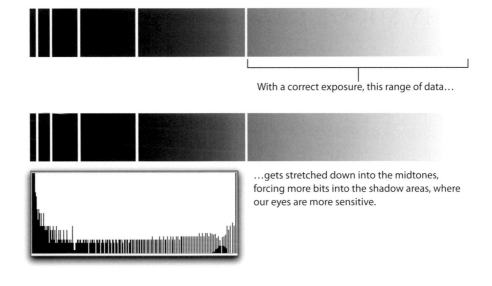

With a correct exposure, this range of data…

…gets stretched down into the midtones, forcing more bits into the shadow areas, where our eyes are more sensitive.

If you underexpose by one stop, you've only captured this much data…

…which must get stretched to cover the entire tonal range before the highlight range is stretched again to darken the midtones.

Note that the on-camera histogram shows the histogram of the conversion to JPEG: a raw histogram would be a strange-looking beast, with all the data clumped at the shadow end, so cameras show the histogram of the image after processing using the camera's default settings. Most cameras apply an S-curve to the raw data to give the JPEGs a more film-like response, so the on-camera histogram often tells you that your highlights are blown when in fact they aren't. Also, the response of a camera set to

ISO 100 may be more like ISO 125 or ISO 150 (or, for that matter, ISO 75). It's worth spending some time determining your camera's real sensitivity at different speeds, then dialing in an appropriate exposure compensation to ensure that you're making the best use of the available bits.

WHY SHOOT RAW?

The answer to the above question is, simply, control over the interpretation of the image. When you shoot JPEG, the camera's on-board software carries out all the tasks listed earlier to produce a color image, and then compresses it using JPEG compression. Some cameras let you set parameters for this conversion—typically, a choice of sRGB or Adobe RGB as color space, a sharpness value, and perhaps a tone curve or contrast setting—but unless your shooting schedule is atypically leisurely, you probably can't adjust these parameters on an image-by-image basis, so you're locked into the camera's interpretation of the scene. JPEGs offer fairly limited editing headroom— large moves to tone and color tend to exaggerate the 8-by-8-pixel blocks that form the foundation of JPEG compression—and while JPEG does a pretty good job of preserving luminance data, it really clobbers the color, leading to problems with skin tones and gentle gradations.

When you shoot raw, however, *you* get to control the scene interpretation through all the aforementioned aspects of the conversion. With raw, the *only* on-camera settings that have an effect on the captured pixels are the ISO speed, shutter speed, and aperture. Everything else is under your control when you convert the raw file. You can reinterpret the white balance, the colorimetric rendering, the tonal response, and the detail rendition (sharpening and noise reduction) with a great deal of freedom, and, within the limits explained in the previous section, "Exposure and Linear Capture," you can even reinterpret the basic exposure itself, resetting the white and black points.

Using All the Bits

Most of today's cameras capture at least 12 bits per channel per pixel, for a possible 4,096 levels in each channel. More bits translates directly into editing headroom, but the JPEG format is limited to 8 bits per channel per pixel. So when you shoot JPEG, you trust the camera's built-in conversions to throw away one-third of your data in a way that does justice to the image.

When you shoot raw, though, you have, by definition, captured everything the camera can deliver, so you have much greater freedom in shaping the overall tone and contrast for the image. You also produce a file that can withstand a great deal more editing in Photoshop than an 8-bit-per-channel JPEG can.

Edits in Photoshop are *destructive*—when you use a tool such as Levels, Curves, Hue/Saturation, or Color Balance, you change the actual pixel values, creating the potential for either or both of two problems:

- **Posterization can occur when you stretch a tonal range.** Where the levels were formerly adjacent, they're now stretched apart, so instead of a gradation from, for example, level 100 through 101, 102, 103, 104, to 105, the new values may look more like 98, 101, 103, 105, and 107. On its own, such an edit is unlikely to produce visible posterization— it usually takes a gap of four or five levels before you see a visible jump instead of a smooth gradation—but subsequent edits can widen the gaps, inducing posterization.

- **Detail loss can occur when you compress a tonal range.** Where the levels were formerly different, they're now compressed into the same value, so the differences, which represent potential detail, are tossed irrevocably into the bit bucket, never to return.

Figure 1-6 shows how the compression and expansion of tonal ranges can affect pixel values. Don't be overly afraid of losing levels—it's a normal and necessary part of image editing, and its effect can be greatly reduced by bringing correctly exposed images into Photoshop as 16-bit/channel files rather than 8-bit/channel ones—but simply be aware of the destructive potential of Photoshop edits.

White Balance Control

I'll go into much more detail on how Camera Raw's white balance controls work in Chapter 2, *How Camera Raw Works.* For now, I'll make the key point that adjusting the white balance on a raw file is fundamentally different from attempting to do so on an already-rendered image in Photoshop.

As Figure 1-6 shows, Photoshop edits are inherently destructive—you wind up with fewer levels than you started out with. But when you change the white balance as part of the raw conversion process, the edit is much less

destructive, because instead of changing pixel values by applying curves, you're gently scaling one or two channels to match the third. There may be very few free lunches in this world, but white balance control in Camera Raw is a great deal cheaper, in terms of losing data, than anything you can do to the processed image in Photoshop.

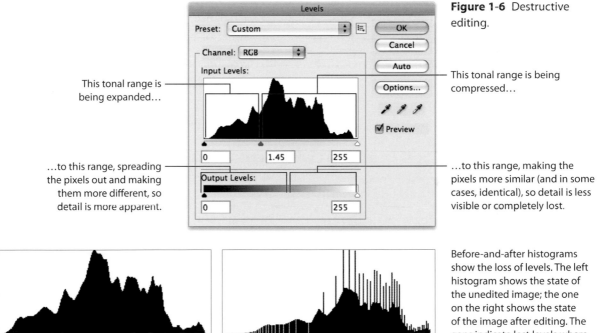

Figure 1-6 Destructive editing.

This tonal range is being expanded…

This tonal range is being compressed…

…to this range, spreading the pixels out and making them more different, so detail is more apparent.

…to this range, making the pixels more similar (and in some cases, identical), so detail is less visible or completely lost.

Before-and-after histograms show the loss of levels. The left histogram shows the state of the unedited image; the one on the right shows the state of the image after editing. The gaps indicate lost levels where the tonal range was stretched, and the spikes indicate lost differences where the tonal range was compressed.

Colorimetric Interpretation

When you shoot JPEG, you typically have a choice between capturing images in either sRGB or Adobe RGB (1998). Yet the vast majority of today's cameras can capture colors that lie outside the gamut of either of these spaces, especially in the case of saturated yellows and cyans, and those colors get clipped when you convert to sRGB or Adobe RGB.

Raw converters vary in their ability to render images into different color spaces, but Adobe Camera Raw offers four possible destinations. One of these, ProPhoto RGB, encompasses all colors we can capture, and the vast majority of colors we can see—if you see serious color clipping on a conversion to ProPhoto RGB, you're capturing something other than visible light!

Figure 1-7 shows a totally innocuous image rendered to ProPhoto RGB, and plotted against the gamuts of sRGB, Adobe RGB, and Pro Photo RGB. Notice just how much of the captured color lies outside the gamut of the first two spaces.

Figure 1-7 Color spaces and clipping.

The gamut plots below, produced using Chromix ColorThink, plot color in Lab space. You're looking at a side elevation of the color space, with the Lightness axis running vertically. The a* axis, from red to green, runs almost straight toward you out of the page; the b* axis, from blue to yellow, runs from left to right.

Even an innocuous image like the one at right can contain colors that lie well outside the range that either Adobe RGB (1998) or sRGB can represent.

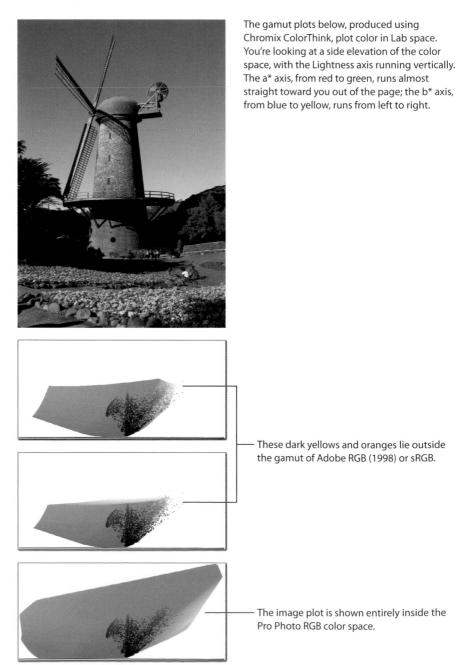

The image above plotted (as squares) against the color gamut of Adobe RGB (1998) (shaded solid)

These dark yellows and oranges lie outside the gamut of Adobe RGB (1998) or sRGB.

The image above plotted (as squares) against the color gamut of sRGB (shaded solid)

The image above plotted (as squares) against the color gamut of Pro Photo RGB (shaded solid)

The image plot is shown entirely inside the Pro Photo RGB color space.

Exposure

As with white balance adjustments, exposure adjustments performed as part of the raw conversion are relatively lossless (unless you clip highlights to white or shadows to black), unlike tonal adjustments made in Photoshop on the rendered image (see Figure 1-3). In practice, however, you have less freedom to adjust exposure than you do white balance.

The main limitation on exposure adjustments is that when you try to open up significantly underexposed images, you'll probably see noise or posterization in the midtones and shadows. It's not that the edit is destructive—you just didn't capture enough shadow information in the first place.

Completely blown highlights are also beyond recovery, but Camera Raw goes a good bit further than other raw converters in rescuing highlight detail even when only one channel contains data. Depending on the camera and the white balance chosen, you may be able to recover one or more stops of highlight detail. Nevertheless, good exposure is still highly desirable—see the section "Exposure and Linear Capture," earlier in this chapter.

Detail and Noise

When you shoot JPEG, the sharpening and noise reduction are set by the on-camera settings (most cameras let you make a setting for sharpness, but few do for noise reduction). When you shoot raw, you have control over both sharpening and noise reduction—Camera Raw even lets you handle luminance noise and color noise separately.

This confers several advantages. You can tailor the noise reduction to different ISO speeds, apply quick global sharpening for rough versions of images, or convert images with no sharpening at all so that you can apply more nuanced localized sharpening to the rendered image in Photoshop.

RAW LIMITATIONS

While raw offers significant advantages over JPEG, it also has some limitations. We believe that, for the majority of work, the advantages outweigh the disadvantages, but we'd be remiss if we didn't point out the downsides. So in the interests of full disclosure, let's look at the limitations of raw.

Processing Time

Perhaps the biggest limitation is also the main strength of raw files—you gain a huge amount of control in the conversion process, but you have to take the time to process the raw file to obtain an image. Camera Raw lets you convert raw images efficiently, particularly once you learn to use it in conjunction with Photoshop's automation features, but each image still takes some time—a few seconds—to process.

If you digest and implement all the techniques, tips, and tricks offered in this book, you'll find that the bulk of the time you spend on raw conversions is computer time—you can set up batch conversions and go do something more interesting while the computer crunches the images. But any way you slice it, raw files aren't as immediately available as JPEGs, and they require one more step in the workflow.

File Size

TIP Two small cards are better than one large one. High-capacity Compact Flash cards command premium prices compared to lower-capacity ones—a 4GB card costs more than double the price of a 2GB one, which in turn costs more than double the price of a 1GB one. But using two smaller cards rather than one bigger one lets you hand off the first card to an assistant, who can then start copying the files to the computer, archiving them, and perhaps even doing rough processing, while you continue to shoot with the second card. Multiple smaller, cheaper cards give you much more flexibility than one big one.

Raw files are larger than JPEGs—typically somewhere between two and four times as large. Storage is cheap and getting cheaper every year, but if you want to fit the maximum number of images on a camera's storage card, or you need to transmit images as quickly as possible over a network or the Web, the larger size of raw files may be an issue.

In most cases, a modicum of planning makes file size a nonissue—just make sure you have enough storage cards, and leave yourself enough time for file transmission.

Longevity

There's one other issue with raw files. Currently, many camera vendors use proprietary formats for raw files, raising a concern about their long-term readability. Hardware manufacturers don't have the best track record when it comes to producing updated software for old hardware—we have cupboards full of ancient orphaned weird junk to prove it—so it's entirely legitimate to raise the question of how someone will be able to read the raw files you capture today in 10 or even 100 years' time.

Adobe's commitment to making Camera Raw a universal converter for raw images is clear. At the same time, it's no secret that some camera vendors

are less than supportive of Adobe's efforts in this regard. If you're concerned about long-term support for your raw files, make your camera vendor aware of that fact. You can also support Adobe's DNG initiative, which offers an open, documented file format for raw captures, and, if necessary, use your wallet to vote against vendors who resist such initiatives. We'll discuss DNG in much more detail in Chapter 7, *It's All About the Workflow*.

ADOBE PHOTOSHOP CAMERA RAW

If you've read this far, we hope we've convinced you of the benefits of shooting raw. In the remainder of this chapter, let's examine the reasons for making Camera Raw the raw converter of choice.

Universal Converter

Unlike the raw converters supplied by the camera vendors, Camera Raw doesn't limit its support to a single brand of camera. Adobe has made a commitment to add support for new cameras on a regular basis, and so far, they seem to be doing a good job. So even if you shoot with multiple cameras from different vendors or add new cameras regularly, you have to learn only one user interface and only one set of controls. This translates directly into savings of that most precious commodity, time.

Industrial-Strength Features

Camera Raw is one of the most full-featured raw converters in existence. It offers fine control over white balance, exposure, noise reduction, and sharpness, but unlike many other raw converters, it also has controls for eliminating chromatic aberration (digital capture is brutal at revealing lens flaws that film masks) and for fine-tuning the color response for individual camera models.

Thanks to the magic of metadata, Camera Raw can identify the specific camera model on which an image was captured. You can create Calibration settings for each camera model, which Camera Raw then applies automatically. Of course, you can also customize all the other Camera Raw settings and save them as Camera Defaults—so each camera model, serial number, and ISO can have its own set of custom settings.

Integration with Photoshop

As soon as you point Adobe Bridge at a folder full of raw images, Camera Raw (depending on your Bridge preferences) goes straight to work, generating thumbnails and previews so that you can make your initial selects quickly.

Bridge's automation features let you apply custom settings on a per-image basis, then call Photoshop to batch-convert images to Web galleries, PDF presentations, or virtual contact sheets. And when it's time to do serious selective manual editing on selected images, Camera Raw delivers them right into Photoshop, where you need them.

THE DIGITAL NEGATIVE

If you've digested this chapter, you'll doubtless have concluded that, like most analogies, the one that equates digital raw with film negative isn't perfect—for one thing, raw capture doesn't quite offer the kind of exposure latitude we expect from film—yet. But in a great many other respects, it holds true.

Both offer a means for capturing an unrendered image, providing a great deal of freedom in how you render that image postcapture. Both allow you to experiment and produce many different renderings of the same image, while leaving the actual capture unchanged.

In the next chapter, *How Camera Raw Works*, we'll look at some of the technological underpinnings of Camera Raw. If you're the impatient type who just wants to jump in with both feet, feel free to skip ahead to Chapter 4, *Camera Raw Controls*, where you'll learn what the various buttons and sliders do, and Chapter 5, *Hands-On Camera Raw*, where you'll learn to use them to interpret your images. But if you want to understand *why* these buttons and sliders work the way they do, and why you should use them rather than try to fix everything in Photoshop, it's worth setting aside part of a rainy afternoon to focus on understanding just what Camera Raw actually does.

CHAPTER TWO

How Camera Raw Works

WHAT LIES UNDER THE HOOD

Despite the title of this chapter, we promise to keep it equation-free and relatively nontechnical. Camera Raw offers functionality that at a casual glance may seem to replicate that of Photoshop. But the important ways in which raw files differ from more conventional Photoshop fare, which we spent the last chapter examining, dictate that just about everything you can do in Camera Raw, you *should* do in Camera Raw.

To understand why this is so, it helps to know a little about how Camera Raw performs its magic. If you're the type who would rather learn by doing, feel free to skip ahead to Chapter 4, *Camera Raw Controls*, where you'll be introduced to the nitty-gritty of using all the controls in Camera Raw. But if you take the time to digest the contents of this chapter, you'll have a much better idea of what the controls do, and hence a better understanding of how and when to use them.

To use Camera Raw effectively, you must first realize that computers and software applications like Photoshop and Camera Raw don't know anything about tone, color, truth, beauty, or art. They're just glorified and incredibly ingenious adding machines that juggle ones and zeroes to order. We won't go into the intricacies of binary math except to note that there are 10 kinds of people in this world: those who understand binary math and those who don't! You don't need to learn to count in binary or hexadecimal, but you do need to understand some basic stuff about how numbers can represent tone and color.

DIGITAL IMAGE ANATOMY

Digital images are made up of numbers. The fundamental particle of a digital image is the pixel—the number of pixels you capture determines the image's size and aspect ratio. It's tempting to use the term *resolution*, but doing so often confuses matters more than it clarifies them. Why?

Pixels and Resolution

Strictly speaking, a digital image in its pure Platonic form doesn't have resolution—it simply has pixel dimensions. It only attains the attribute of resolution when we realize it in some physical form—displaying it on a monitor or making a print. But resolution isn't a *fixed* attribute.

If we take as an example a typical 6-megapixel image, it has the invariant property of pixel dimensions, specifically, 3,072 pixels on the long side of the image, 2,048 pixels on the short one. But we can display and print those pixels at many different sizes. Normally, we want to keep the pixels small enough that they don't become visually obvious, so the pixel dimensions essentially dictate how large a print we can make from the image. As we make larger and larger prints, the pixels become more and more visually obvious until we reach a size at which it just isn't rewarding to print.

Just as it's possible to make a 40-by-60-inch print from a 35mm color negative, it's possible to make a 40-by-60-inch print from a 6-megapixel image, but neither of them is likely to look very good. With the 35mm film, you end up with grain the size of golf balls, and with the digital capture, each pixel winds up being just under $1/50^{th}$ of an inch square—big enough to be obvious.

Different printing processes have different resolution requirements, but in general, you need no fewer than 180 pixels per inch, and rarely more than 480 pixels per inch, to make a decent print. So the effective size range of our 6-megapixel capture is roughly from 11 by 17 inches downward, and 11 by 17 is really pushing the limits. The basic lesson is that you can print the same collection of pixels at many different sizes, and as you do so, the resolution—the number of pixels per inch—changes, but the number of pixels does not. At 180 pixels per inch, our 3072-by-2048-pixel image will yield a 17.07-by-11.38-inch print. At 300 pixels per inch, the same image will make a 10.24-by-6.83-inch print. So resolution is a fungible quality—you can spread the same pixels over a smaller or larger area.

To find out how big an image you can produce at a specific resolution, divide the pixel dimensions by the resolution. Using pixels per inch (ppi) as the resolution unit and inches as the size unit, if you divide 3,072 (the long pixel dimension) by 300, you obtain the answer 10.24 inches for the long dimension. If you divide 2,048 (the short pixel dimension) by the same quantity, you get 6.826 inches for the short dimension. At 240 ppi, you get 12.8 by 8.53 inches. Conversely, to determine the resolution you have available to print at a given size, divide the pixel dimensions by the size, in inches. The result is the resolution in pixels per inch. For example, if you want to make a 10-by-15-inch print from your 6-megapixel, 3,072-by-2,048-pixel image, divide the long pixel dimension by the long dimension in inches, or divide the short pixel dimension by the short dimension in inches. In either case, you'll get the same answer: 204.8 pixels per inch.

Figure 2-1 shows the same pixels printed at 50 pixels per inch, 150 pixels per inch, and 300 pixels per inch.

50 ppi

150 ppi 300 ppi

Figure 2-1 Image size and resolution.

But each pixel is defined by a set of numbers, and these numbers also impose limitations on what you can do with the image, albeit more subtle limitations than those dictated by the pixel dimensions.

Bit Depth, Dynamic Range, and Color

We use numbers to represent a pixel's tonal value—how light or dark it is—and its color—red, green, blue, or any of the myriad gradations of the various rainbow hues we can see.

Bit Depth. In a grayscale image, each pixel is represented by some number of bits. Photoshop's 8-bit/channel mode uses 8 bits to represent each pixel, and its 16-bit/channel mode uses 16 bits to represent each pixel. An 8-bit pixel can have any one of 256 possible tonal values, from 0 (black) to 255 (white), or any of the 254 intermediate shades of gray. A 16-bit pixel can have any one of 32,769 possible tonal values, from 0 (black) to 32,768 (white), or any of the 32,767 intermediate shades of gray. If you're wondering why 16 bits in Photoshop gives you 32,769 shades instead of 65,536, see the sidebar "High-Bit Photoshop," later in this chapter (if you don't care, skip it).

So while pixel dimensions—the number of pixels—describe the two-dimensional height and width of the image, the bits that describe each pixel produce a third dimension that describes how light or dark each pixel is—hence the term *bit depth*.

Dynamic Range. Some vendors try to equate bit depth with dynamic range. This is largely a marketing ploy, because although there *is* a relationship between bit depth and dynamic range, it's an indirect one.

Dynamic range in digital cameras is an analog limitation of the sensor. The brightest scene information the camera can capture is limited by the capacity of the sensor element. At some point the element can no longer accept any more photons—a condition called *saturation*—and any photons arriving after saturation are not counted. The darkest shade a camera can capture is determined by the more subjective point at which the noise inherent in the system overwhelms the very weak signal generated by the small number of photons that hit the sensor—the subjectivity lies in the fact that some people can tolerate a noisier signal than others.

One way to think of the difference between bit depth and dynamic range is to imagine a staircase. The dynamic range is the height of the staircase. The bit depth is the number of steps in the staircase. If we want our staircase to be reasonably easy to climb, or if we want to preserve the illusion of a continuous gradation of tone in our images, we need more steps in a taller staircase than we do in a shorter one, and we need more bits to describe a wider dynamic range than a narrower one. But more bits, or a larger number of smaller steps, doesn't increase the dynamic range, or the height of the staircase.

High-Bit Photoshop

If an 8-bit channel consists of 256 levels, a 10-bit channel consists of 1,024 levels, and a 12-bit channel consists of 4,096 levels, doesn't it follow that a 16-bit channel should consist of 65,536 levels?

Well, that's certainly one way that a 16-bit channel could be constructed, but it's not the way Photoshop does it. Photoshop's implementation of 16 bits per channel uses 32,769 levels, from 0 (black) to 32,768 (white). One advantage of this approach is that it provides an unambiguous midpoint between white and black (useful in imaging operations such as blending modes) that a channel comprising 65,536 levels lacks.

To those who would claim that Photoshop's 16-bit color is really more like 15-bit color, we simply point out that it takes 16 bits to represent, and by the time capture devices that can actually capture more than 32,769 levels are at all common, we'll all have moved on to 32-bit floating point channels rather than 16-bit integer ones.

Color. RGB color images consist of three 8-bit or 16-bit grayscale images, or *channels*, one representing shades of red, the second representing shades of green, and the third representing shades of blue (see Figure 2-2). Red, green, and blue are the primary colors of light, and combining them in different proportions allows us to create any color we can see. So an 8-bit/channel RGB image can contain any of 16.7 million unique color definitions (256 x 256 x 256), while a 16-bit/channel image can contain any of some 35 *trillion* unique color definitions.

Either of these may sound like a heck of a lot of colors—and indeed they are. Estimates of how many unique colors the human eye can distinguish vary widely, but even the most liberal estimates are well shy of 16.7 million and nowhere close to 35 trillion. Why then do we need all this data?

We need it for two quite unrelated reasons. The first one, which isn't particularly significant for the purposes of this book, is that 8-bit/channel RGB contains 16.7 million color *definitions*, not 16.7 million perceivable colors. Many of the color definitions are redundant: even on the very best display, you'd be hard pressed to see the difference between RGB values of 0,0,0, and 0,0,1 or 0,1,0 or 1,0,0, or for that matter between 255,255,255 and 254, 255, 255 or 255, 254, 255 or 255, 255, 254. Depending on the specific flavor

of RGB you choose, you'll find similar redundancies in different parts of the available range of tone and color.

The second reason, which is *extremely* significant for the purposes of this book, is that we need to edit our images—particularly our digital raw images, for reasons that will become apparent later—and every edit we make has the effect of reducing the number of unique colors and tone levels in the image. A good understanding of the impact of different types of edits is the best basis for deciding where and how you apply edits to your images.

Figure 2-2 The top image is an RGB color wheel where the gradients between red, green, and blue combine to create intermediate hues. Yellow is a combination of red and green, while cyan is made of green and blue. Magenta is the final combination of red and blue channels.

Color wheel

Red channel Green channel Blue channel

Gamma and Tone Mapping

To understand the key difference between shooting film and shooting digital, you need to get your head around the concept of *gamma encoding*. As we explained in Chapter 1, digital cameras respond to photons quite differently from either film or our eyes. The sensors in digital cameras simply count photons and assign a tonal value in direct proportion to the number of photons detected—they respond linearly to incoming light.

Human eyes, however, do not respond linearly to light. Our eyes are much more sensitive to small differences in brightness at low levels than at high ones. Film has traditionally been designed to respond to light approximately the way our eyes do, but digital sensors simply don't work that way.

Gamma encoding is a method of relating the numbers in the image to the perceived brightness they represent. The sensitivity of the camera sensor is described by a gamma of 1.0—it has a linear response to the incoming photons. But this means that the captured values don't correspond to the way humans see light. The relationship between the number of photons that hit our retinas and the sensation of lightness we experience in response is approximated by a gamma of somewhere between 2.0 and 3.0, depending on viewing conditions. Figure 2-3 shows the approximate difference between what the camera sees and what we see, and Figure 2-4 is a real-world image showing a linear capture and how the curve must be applied to make it appear "normal."

Figure 2-3 Digital capture and human response.

How the camera sees light

How the human eye sees light

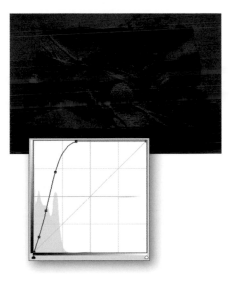

Figure 2-4 The dark image in Figure 2-3 has been processed in Camera Raw at linear settings—Brightness & Contrast are set to zero and the Point Curve options are set to Linear. We remapped the lighter image tone curve by adding a Levels adjustment in Photoshop. The tone curve required a steep curve to simulate the results of gamma remapping.

We promised that we'd keep this chapter equation-free—if you want more information about the equations that define gamma encoding, a Google search on "gamma encoding" will likely turn up more than you ever wanted to know—so we'll simply cut to the chase and point out the practical implications of the linear nature of digital capture.

Digital captures devote a large number of bits to describing differences in highlight intensity to which our eyes are relatively insensitive, and a relatively small number of bits to describing differences in shadow intensity to which our eyes are very sensitive. As you're about to learn, all our image-editing operations have the unfortunate side effect of reducing the number of bits in the image. This is true for all digital images—whether scanned from film, rendered synthetically, or captured with a digital camera—but it has specific implications for digital capture.

With digital captures, darkening is a much safer operation than lightening, since darkening forces more bits into the shadows, where our eyes are sensitive, while lightening takes the relatively small number of captured bits that describe the shadow information and spreads them across a wider tonal range, exaggerating noise and increasing the likelihood of posterization. With digital, you need to turn the old rule upside down—you need to expose for the highlights and develop for the shadows!

IMAGE EDITING AND IMAGE DEGRADATION

Just about anything you do to change the tone or color of pixels results in some kind of data loss. If this sounds scary, rest assured that it's a normal and necessary part of digital imaging. The trick is to make the best use of the available bits you've captured to produce the desired image appearance while preserving as much of the original data as possible. Why keep as much of the original data as possible if you're going to wind up throwing it away later? Very simply, it's all about keeping your options open.

The fact is, you don't need a huge amount of data to represent an image. But if you want the image to be editable, you need a great deal more data than you do to simply display or print it. Figure 2-5 shows two copies of the same image. They appear similar visually, but their histograms are very different. One contains a great deal more data than the other.

The two images shown below appear quite similar, but the histograms shown to the right of each image reveal a significant difference. The lower image contains a great deal less data than the upper one. Careful examination may reveal subtle differences in hue and detail, but the biggest difference is the amount of editing headroom each image offers.

Figure 2-5 Levels and appearance.

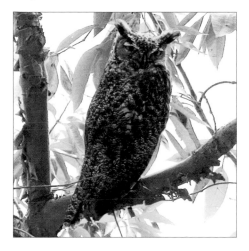

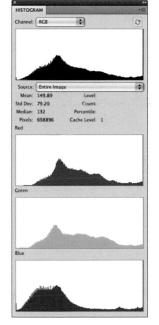

This image was produced by making corrections in Camera Raw, producing a 16-bit-per-channel image in Photoshop.

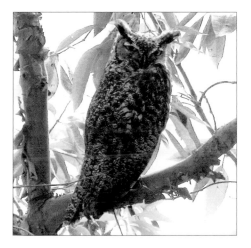

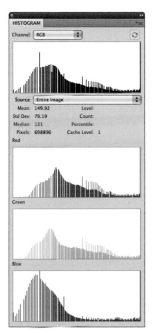

This image was produced by converting at Camera Raw default settings, producing an 8-bit-per-channel image that was further edited in Photoshop.

Despite the vast difference in the amount of data they contain, it's hard to see any significant differences between the two images—you may be able to see that the one with more data shows more details on the chest feathers, but it's a pretty subtle difference. Figure 2-6 shows what happens when a fairly gentle curve edit is applied to the images shown in Figure 2-5. The difference is no longer subtle!

Figure 2-6 Levels and editing headroom.

Here you see the images from Figure 2-5 after application of a fairly gentle S-curve (to increase contrast slightly) to both images. The differences between the data-rich (left) and data-poor (right) versions are now much more obvious. The data-poor version shows much less detail, and displays both exaggerated contrast and unwanted hue shifts.

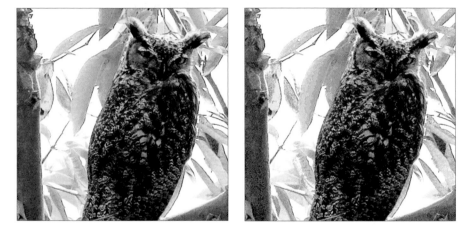

The difference between the two images is in the way they were edited. The one with the larger amount of data made full use of Camera Raw to convert the raw file into a 16-bit/channel image in Photoshop. Additional edits were done in 16-bit/channel mode. The one with the smaller amount of data was converted to an 8-bit/channel image at camera default settings, and the edits were performed in 8-bit/channel mode in Photoshop.

Losing Data and Limiting Options

The sad truth is that every edit you make limits the options that are available to you afterward. You can keep many more options open by making full use of Camera Raw controls and by converting to a 16-bit/channel image rather than an 8-bit one. But no matter what you do, edits degrade the data in an image file in three different ways:

Clipping. The black and white input sliders in Photoshop's Levels command and the Exposure and Shadows sliders in Camera Raw are clipping controls. They let you force pixels to pure white (level 255) or solid black (level 0).

Depending on how you use the sliders, you may clip some levels—in fact, it's often desirable to do so. On the highlight end, you normally want to make sure that specular highlights are represented by level 255, so if the image is underexposed, you usually want to take pixels that are darker than level 255 and force them to pure white. But if you go further than that, you may clip some levels—for example, if you have pixels at levels 252, 253, and 254, and you set the white input slider in Levels to level 252, then all the pixels at levels 252, 253, and 254 are forced to 255. Once you make this edit permanent, the differences between those pixels are gone, permanently.

On the shadow end, you often want to clip some levels, because typically there's a good deal of noise in the shadows. If everything below level 10 is noise, for example, it makes perfect sense to set the black input slider in Levels to 10, to force everything at level 10 and below to solid black. Again, you lose the distinction between the unedited levels 0 through 10 permanently, but it's not necessarily a bad thing. Figure 2-7 shows how clipping works.

However, if you're used to adjusting clipping in Photoshop's Levels, you'll find that the Exposure and Shadow controls in Camera Raw behave a bit differently from Levels' black and white input sliders, partly because the latter works on linear-gamma data rather than the gamma-corrected data that appears in Photoshop, and partly because Camera Raw's Exposure slider can make negative as well as positive moves.

If the camera can capture the entire scene luminance range, as is the case with the image in Figure 2-7, it's usually best to adjust the Exposure and Shadows sliders to near-clipping, leaving a little headroom (unless you actually want to clip to white or black for creative reasons). If the camera can't handle the entire scene luminance range, you'll have to decide whether to hold the highlights or the shadows, and your choice may be dictated by the captured data—if highlights are completely blown, or shadows are completely plugged, there isn't much you can do about it in the raw conversion. See the sidebar "How Much Highlight Detail Can I Recover?" later in this chapter.

Figure 2-7 Black, white, and saturation clipping.

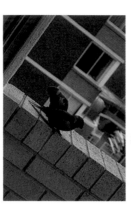

This raw image is underexposed, but it captures the full luminance range of the scene, with no clipping of highlights or shadows.

When you increase the Exposure slider value too far, you clip highlight pixels to solid white.

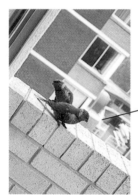

Highlight clipping

Ideally, you want to adjust the Exposure slider to push the data as far to the right end of the histogram as possible without actually forcing clipping.

When you increase the Blacks slider value too far, you clip shadow pixels to solid black.

Shadow clipping

In addition to clipping highlights with Exposure or shadows with the Shadows slider, you can force individual channels to clip by adding too much saturation. In this case, increasing the saturation has clipped the blue channel.

Saturation clipping

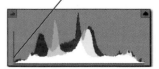

Tonal range compression. When you compress a tonal range, you also lose levels, in a somewhat less obvious way than you do with clipping moves. For example, when you lighten the midtones without moving the white clipping point, the levels between the midtone and the highlight get compressed. As a result, some pixels that were formerly at different levels end up being at the same level, and once you make the edit permanent, you've lost these differences, which may potentially represent detail. See Figure 2-8.

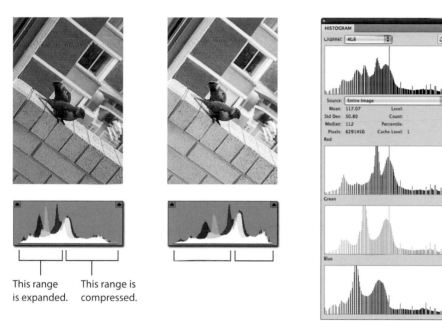

This range This range is
is expanded. compressed.

Figure 2-8 Tonal range compression and expansion.

When you use the Brightness slider in Camera Raw or the gray slider in Levels to brighten the midtones, you compress the highlights and expand the shadows. The images and histograms show Camera Raw's Brightness control, and the histogram shows the results of using the gray input slider in Levels on an 8-bit/channel image. The gaps are from expansion, the spikes from compression.

Tonal range expansion. A different type of image degradation occurs when you expand a tonal range. You don't lose any data, but you stretch the data that's there over a broader tonal range, and hence run the danger of losing the illusion of a continuous gradation. Almost everyone who has used Photoshop for more than a week has encountered the experience of pushing edits just a little too far and ending up with banding in the sky or posterization in the shadows. It's simply caused by stretching the data over too broad a range so that the gaps between the available levels become visibly obvious. See Figure 2-8.

If all this makes you think that editing images is a recipe for disaster, you've missed the point. You need to edit images to make them look good. Sometimes you *want* to throw away some data—shadow noise being a good example—and the inherent data loss is simply something that comes with the territory. It isn't something to fear—just something of which you should be aware. The importance of the preceding information is that some editing methods allow you more flexibility than others.

Color Space Conversions

Another operation that usually entails all three of the aforementioned types of image degradation is color space conversions. When you convert from a larger gamut to a smaller one, colors present in the source space that are outside the gamut of the destination space get clipped (see Figure 1-6 in the previous chapter for an illustration of gamut clipping).

A significant number of levels also get lost in conversions between spaces with different gammas or tone curves. The bigger the difference between the gammas, the more levels get lost. Figure 2-9 shows what happens when you convert a linear-gamma gradient to a gamma 1.8 working space in both 8-bit/channel and 16-bit/channel modes. Even in 16-bit/channel mode, you see some spikes and holes, and in 8-bit/channel mode, about 25 percent of the levels have disappeared.

Figure 2-9 Gamma conversions

A linear (gamma 1.0) gradient

Original data

(Note that since this is a "perfect" gradient, all tones are equally represented, and thus we have a totally solid histogram.)

16-bit conversion to gamma 1.8

(Note that Photoshop's histogram doesn't show the accurate distribution of 16-bit data in its 256-based display, so some spikes show but there is little to no actual data loss).

8-bit conversion to gamma 1.8

The Camera Raw Advantage

The reason all this stuff about data loss and image degradation is relevant is that one of the main tasks Camera Raw performs is to tone-map images from native, linear-gamma camera RGB to a gamma-corrected working space. When you use the controls in Camera Raw, you aren't just editing the pixels you captured; you're also tailoring the conversion. As you saw back in Figures 2-5 and 2-6, it's possible to arrive at the same image appearance with a robust file that contains plenty of data and hence offers plenty of editing headroom, or a very fragile file containing relatively little data that will fall apart under any further editing.

Since the raw conversion is at the beginning of the image-processing pipeline, and the converted images may be subjected to many different color space conversions and many different edits to optimize them for different output processes, you'll save yourself a world of grief if you use Camera Raw's controls to deliver as robust a file as you can muster. The defaults in Camera Raw 5 are a useful starting point, but even though the defaults often work well, it's rare that they can't be substantially improved. It's therefore eminently worthwhile learning to use the Camera Raw controls effectively. If you do, you'll get better images, with much less work in Photoshop.

FROM RAW TO COLOR

At long last, we come to the nitty-gritty of the conversion from Camera Raw to gamma-corrected RGB. In Chapter 5, *Hands-On Camera Raw*, we'll look at the various ways it makes sense to use the controls Camera Raw offers in *real-world* situations. Here, though, we'll look at how they apply to the raw conversion (see Figure 2-10).

Original raw grayscale linear capture

Demosaiced gamma-adjusted processed raw

Undemosaiced raw capture in linear gamma

Undemosaiced raw capture with a gamma correction

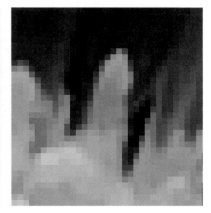

Demosaiced file processed through Camera Raw

Figure 2-10
An undemosaiced grayscale image and the demosaiced RGB gamma-corrected version of the raw.

The three square images show extreme detail of the small flower near the center of the original raw grayscale linear capture above: a gamma-adjusted raw and the final demosaiced RGB image. Note that each pixel represents an actual photo site. In the detail image on the left, in the yellow portions of the flower, you can see the blue photo sites where the pixels are dark. The demosaicing and conversion to color remove the dark pixels and replace them with lighter pixels (middle detail image) to make the color yellow.

Demosaicing and Colorimetric Interpretation

The first stage of the process, demosaicing, introduces the color information, turning the color luminance data into an RGB image. This stage is also where the initial colorimetric interpretation occurs—the "grayscale" is converted to a "native camera space" image, with linear gamma and primaries

(usually, but not always, R, G, and B—some cameras add a fourth color filter) specified by the built-in profiles that define each supported camera's color space. (See the sidebar "Camera Raw and Color" for more details on how Camera Raw handles the tricky task of defining camera color.) The demosaicing and colorimetric interpretation happen automatically to produce the default rendering you see in Bridge and the larger one you see when you open the image in Camera Raw.

Operationally, the first step is the colorimetric interpretation (see Figure 2-10). The demosaicing is then performed in linear-gamma camera space. A little noise reduction, and any chromatic aberration corrections, are also done in the native camera space. (Chromatic aberration corrections could cause unwanted color shifts if they were done later in a non-native space.)

White Balance and Calibrate Adjustments

White Balance (Color Temperature and Tint), in addition to any adjustments made in Camera Raw's Camera Calibration panel, tweak the conversion from native camera space to an intermediate, large-gamut processing space. (This intermediate space uses ProPhoto RGB primaries and white point, but with linear gamma rather than the native ProPhoto RGB gamma 1.8.) Figure 2-11 shows the colors used for white balance.

| 2000°K | 3200°K | 5500°K | 7500°K | 15000°K | ∞K |

White balance color range in degrees Kelvin. Camera Raw uses the Planckian locus. (Note: the range is not accurate to scale.)

Figure 2-11 The colors used for white balance in Camera Raw.

Tint color range between green and magenta. The color scale is not accurate and the colors are plotted perpendicular to the Planckian locus.

These operations work by redefining the colorimetric definition of the camera RGB primaries and white rather than by redistributing the pixel values. It's simply impossible to replicate these corrections in Photoshop, so it's vital that you take advantage of Camera Raw to set the white balance

and, if necessary, to tweak the calibration for a specific camera. (We'll save the detailed description of how to use these controls for Chapter 4, *Camera Raw Controls*.)

Most remaining operations are carried out in the intermediate linear-gamma version of ProPhoto RGB. You may be able to achieve a similar appearance by editing in Photoshop, but the Camera Raw controls still offer some significant advantages. The tone-mapping controls—Exposure (now with Recovery as a separate adjustment), Blacks (called Shadows in previous versions), Fill Light, Brightness, Contrast, and the Curves—present the most obvious case. The Exposure control is paramount—if you don't use it, you simply aren't making the best use of your bits—but the others are super important, too.

Camera Raw and Color

One of the more controversial aspects of Camera Raw is its color handling, specifically the fact that Camera Raw has no facility for applying custom camera profiles. Having tried most camera profiling software, and having experienced varying degrees of disappointment, we've concluded that unless you're shooting in the studio with controlled lighting and a custom white balance for that lighting, camera profiling is an exercise in frustration if not futility, and we've come to view Camera Raw's incompatibility with custom camera profiles as a feature rather than a limitation.

The way Camera Raw handles color is ingenious and, thus far, unique. For each supported camera, Thomas Knoll, Camera Raw's creator, has created not one but two profiles: one built from a target shot under a D65 (daylight) light source, the other built from the same target shot under a Standard Illuminant A (2856°K) light source. The correct profiles for each camera are applied automatically in producing the colorimetric interpretation of the raw image. Camera Raw's White Balance (Color Temperature and Tint) sliders let you interpolate between, or even extrapolate beyond, the two built-in profiles.

For cameras that write a readable white balance tag, that white balance is used as the "As Shot" setting for the image; for those that don't, Camera Raw makes highly educated guesses. Either way, you can override the initial settings to produce the white balance you desire.

It's true that the built-in profiles are "generic" profiles for the camera model. Some cameras exhibit more unit-to-unit variation than others, and if your camera differs substantially from the unit used to create the profiles for the camera model, the default color in Camera Raw may be a little off. So the Calibrate controls let you tweak the conversion from the built-in profiles to optimize the color for your specific camera. This is a much simpler, and arguably more effective, process in most situations than custom camera profile creation (see Chapter 4, *Camera Raw Controls*, for more description of the process).

Tone-Mapping Controls

The tone-mapping controls work together to let you tailor Camera Raw's conversion from linear capture to gamma-encoded output. Collectively, they have a huge influence on the overall tonality of the image. Even if you plan to do significant postconversion editing in Photoshop, it's well worth using Camera Raw's tone-mapping features to get the image as close to the desired end result as possible.

Why? Because doing so produces a gamma-encoded image in Photoshop with the bits already distributed optimally. That means that the image will better withstand subsequent editing (see "Losing Data and Limiting Options," earlier in this chapter) *and* you have less work to do after the conversion in Photoshop.

The adjustments made by Exposure, Blacks, Brightness, Contrast, and the Tone Curve tab are applied as a single operation on the raw conversion, so the order in which you make the adjustments doesn't matter from a quality standpoint. We'll discuss the workflow reasons for making adjustments in a specific order in Chapter 5, *Hands-On Camera Raw.*

Exposure. The Exposure slider is really a white-clipping control, even though it affects the whole tonal range. You can achieve superficially similar results using Exposure or Brightness, but even though Brightness values greater than 100 can produce white clipping, Brightness is at heart a midtone adjustment.

At positive values, the Exposure slider behaves very much like the white input slider in Photoshop's Levels command or the Exposure slider in Photoshop's new Exposure command, clipping levels to white. But since it's operating on linear data, it's gentler on the midtones and shadows than white clipping in Photoshop on a gamma-corrected image, and it offers finer control over the white clipping than do Photoshop's controls.

When you set the Exposure slider to negative values and/or add Recovery, the story is very different, because one of Camera Raw's most remarkable features comes into play. Unlike most raw converters (or Photoshop's Exposure command), Camera Raw offers "highlight recovery." Most raw converters treat all pixels where one channel has clipped highlights as white, since they lack complete color information, but Camera Raw can recover a surprising amount of highlight detail from even a single channel. It does, however, maintain pure white (that is, clipped in all channels) pixels as white (unlike

most converters that turn clipped pixels gray), and darkens the rest of the image using special algorithms to maintain the nonwhite pixels' color. See the sidebar "How Much Highlight Detail Can I Recover?" for more technical details, and see Figure 2-12 for a real-world example.

It's simply impossible to match Camera Raw's highlight detail recovery in Photoshop on a gamma-corrected image. In linear space, half of the captured data describes the brightest f-stop, so you have a large number of bits describing the highlights. Once the image is converted to a gamma-corrected space, you have far fewer highlight bits to play with.

Blacks. The Blacks slider is the black clipping control. It behaves very much like the black input slider in Photoshop's Levels command, but its effect tends to be a little more dramatic, simply because it's operating on linear-gamma data, which devotes very few bits to the deepest shadows. In the first edition of this book, Bruce characterized the Shadows control as "a bit of a blunt instrument," but changes to the logic in Camera Raw 2.3 and later have made it a much more sensitive tool. We now use it fearlessly to set the black point.

Fill Light. After adjusting the Blacks setting, check out the usefulness of Fill Light settings for your image. New to Camera Raw 5, Fill Light is an adaptive shadow adjustment tool that uses a mask-based factor to lighten deep shadows. It's similar to Photoshop's Shadow/Highlight adjustment but arguably better since it's working in linear gamma.

TIP Check clipping at 100% view. At zoomed-out views, you may wind up clipping pixels you didn't intend to. Always check the 100% view before doing the conversion to make sure that you aren't clipping pixels you wanted to preserve.

Brightness and Contrast. The Brightness and Contrast controls let you tweak the conversion of the intermediate tones from the linear capture to the gamma-corrected output space. They work completely differently from the similarly named Photoshop Contrast and Brightness controls. Instead, they behave similarly to Photoshop's Levels and Curves, respectively (Brightness is a midtone adjustment, Contrast is an S-curve) but with one important difference: the Camera Raw controls use an algorithm that preserves the original hue, whereas hard curve adjustments to the composite RGB curve in Photoshop can cause slight hue shifts. While not a pure luminance curve, the saturation is designed to mimic the saturation effects found in film when contrast is increased.

If you make little or no adjustment with the Exposure slider, it's advantageous to use Camera Raw's Brightness and Contrast sliders and Tone Curves rather than using Photoshop's tools. But with bigger Exposure adjustments, it becomes even more essential that you make complementary Brightness and Contrast moves in Camera Raw (see Figure 2-12, earlier in this chapter).

Figure 2-12 Highlight recovery.

We suppose that everybody would consider this image as being overexposed, as indicated by the white spike at the right end of the histogram and the clipping warning shown in red in areas of the image. This is Expose To The Right in the extreme.

Simply selecting Auto in the Basic panel will reduce the Exposure and add highlight recovery. Notice the amount of the red clipping indicators has been greatly reduced. However, the image still looks very light and washed out so additional work is needed.

Here the Blacks setting has been moved to the maximum of +100 and Highlight Recovery to +43. Brightness has been reduced considerably to –113. With the addition of Clarity, Vibrance, and Saturation, the image's tone curve has been optimized. Notice also that the white balance has been cooled down to 5450°K. What you can't see (and will be shown in Chapter 5, *Hands-On Camera Raw*) is the amount of local tone and color correction that is also being used. Clearly this image is severely overexposed, but Camera Raw can still be used to get something out of what might otherwise be presumed as nothing.

How Much Highlight Detail Can I Recover?

The answer, of course, is "it depends." If the captured pixel is completely blown out—clipped to white in all three channels—there is no real highlight detail to recover. If a single channel (or, better, two channels) still contain some information, Camera Raw will do its best to recover the detail and attribute natural-looking color to it.

The first stage of highlight recovery is to use any headroom the camera leaves by default, which varies considerably from vendor to vendor, with some leaving no headroom at all. The next stage uses Camera Raw's highlight recovery logic to build color information from the data in one or two unclipped channels (see Figure 2-12). Next, the amount of highlight compression introduced by the Brightness slider is reduced, stretching the available highlight data over a wider tonal range. The final stage is application of a curve to map the midtones and shadows (see Figure 2-13 for before-and-after examples).

Several factors limit the amount of highlight data you can recover, and these vary from camera model to camera model. The first is the sensor clipping itself—the point at which all three channels clip. You can recover a lot of highlight data when only one channel contains data, but if you stretch the highlights too far, the transition between the totally blown-out highlights and the recovered ones looks unnatural. Also, some cameras run the sensor chip slightly past its linear range, producing hue shifts near the clipping point, and these hue shifts get magnified by the extended highlight recovery process—if you try to stretch the highlight data too far, you'll get strange colors—so in either case the practical limit may be lower than the theoretical one.

Most cameras use analog gain to provide different ISO speeds, but some use digital gain instead—a high-ISO image from these cameras is essentially just an underexposed image with built-in positive exposure compensation applied—so a lot of highlight data can be recovered by undoing the positive exposure compensation.

The white balance also has an effect on highlight recovery, since it scales the clipped channels to match the unclipped one. When you're attempting extreme highlight recovery, it's often a good idea to adjust the Exposure slider before setting white balance, because the white balance is likely to change as you stretch the highlights anyway.

In practice, most cameras will let you recover at least a quarter stop of highlight data if you're willing to compromise a little on the white balance. Many cameras will let you recover at least one stop, possibly more, but the full four-stop range offered by the Exposure slider is beyond the useful range for most cameras. We don't advocate deliberate overexposure, but if you're shooting in changing lighting conditions, the linear nature of digital captures makes

it preferable to err on the side of *slight* overexposure rather than underexposure, because underexposing to hold the highlights will make your shadows noisier than they need be. In these situations, Camera Raw's highlight recovery provides a useful safety net.

Figure 2-13 Detail area before and after image adjustments.

Saturation

Camera Raw 5 now has over 30 controls that directly affect color hue, saturation, and luminance (when you take into account Vibrance, Saturation, the HSL controls, and the Camera Calibration panel). That is because accurately adjusting hue, saturation, and color luminance is so critical at the raw processing stage of conversion. But keeping in mind the old adage "Be careful what you wish for," we'll stick to the main controls on the Basic tab for now.

The main Saturation slider operates similarly to the master saturation slider in Photoshop's Hue/Saturation command, but does a slightly better job of avoiding hue shifts. As with the Exposure and Shadows controls, the Saturation slider can introduce clipping, so exercise caution.

The new Vibrance slider is a nonlinear saturation boost—meaning it increases less saturated colors more than saturated colors, while tapering off adjusting the saturation level of skin tone. Vibrance is much less likely to result in saturation clipping than the Saturation adjustment. But both of these controls act globally on all colors without discrimination. Ideally, for specific color control it's better to use the HSL controls. We'll discuss how to spot saturation clipping in detail as well as how to use the HSL/Grayscale panel in Chapter 4, *Camera Raw Controls*.

Size

Camera Raw allows you to convert images at the camera's native resolution, or at larger or smaller sizes—the specific sizes vary from camera model to camera model, but they generally correspond to 50 percent, 66 percent, 100 percent, 133 percent, 166 percent, and 200 percent of the native size.

For cameras that capture square pixels, there's usually little difference between resizing in Camera Raw and upsizing in Photoshop using Bicubic Smoother or downsizing in Photoshop using Bicubic Sharper. However, if you need a small file, converting to a smaller size in Camera Raw tends to be more convenient than downsampling in Photoshop after the conversion.

For cameras that capture nonsquare pixels, the native size is the one that most closely preserves the original pixel count, meaning that one dimension is upsampled while the other is downsampled. The next size up preserves the pixel count along the higher-resolution dimension, upsampling the lower-resolution dimension to match and create square pixels in the converted image. This size preserves the maximum amount of detail for non-square-pixel cameras, and it typically produces better results than converting to the smaller size and upsampling in Photoshop.

The one size up is also useful for Fuji SuperCCD cameras, which use a 45-degree rotated Bayer pattern. The one size up keeps all the original pixels and fills in the holes caused by the 45-degree rotation. The native pixel count size actually uses the rotation and filling in from the one-size-up processing, and then downsamples to the native pixel count.

Sharpening

The sharpening in Camera Raw 4.1 (as part of Photoshop CS3) underwent a substantial upgrade, in part because of Bruce Fraser. Thomas Knoll and Adobe had contracted with Bruce with the aim of substantially improving Camera Raw's sharpening controls. Although Bruce was unable to finish, Jeff Schewe jumped in and helped bring Bruce's Sharpening Workflow principles into Camera Raw 4.1. Those same principles haven't changed in Camera Raw 5. Using Camera Raw's controls for capture sharpening is covered in depth in Chapter 4, *Camera Raw Controls.* For now, though, keep in mind that Camera Raw's sharpening is designed only as the front end of a sharpening workflow and not intended for applying final sharpening for output. Camera Raw offers the option to apply sharpening to the preview image only, leaving the converted image unsharpened. This option is useful in helping you set the overall image contrast, because a completely unsharpened image generally looks flatter than one that has had some sharpening applied.

Luminance and Color Noise Reduction

While the Sharpening control is convenient, the Luminance Smoothing and Color Noise Reduction controls in Camera Raw are simply indispensable. Luminance noise manifests itself as random variations in tone, usually in the shadows, though if you shoot at high ISO speeds it can spread all the way up into the midtones. Color noise shows up as random variations in color.

Before the advent of Camera Raw, we relied on rather desperate Photoshop techniques that involved converting the image to Lab so that we could address color noise and luminance noise separately, usually by blurring the a and b channels to get rid of color noise, and blurring or despeckling the Lightness channel to get rid of Luminance noise. Compared to the controls offered by Camera Raw, these techniques were very blunt instruments indeed —the round-trip from RGB to Lab and back is fairly destructive due to rounding errors, and working on the individual channels is time consuming.

Thanks to some nifty algorithms, Camera Raw lets you address color noise and luminance noise separately without putting the data through a conversion to Lab—the processing is done in the intermediate large-gamut linear RGB. Camera Raw's noise reduction controls are faster, less destructive, and more effective than anything you can do in Photoshop. So use them!

WATCH THE HISTOGRAM!

The histogram display (see Figure 2-14) is one of Camera Raw's most useful but often most-overlooked features. Throughout this chapter, we've emphasized the usefulness of the histogram as a tool for analyzing the image, and especially for judging clipping. But the histogram in Camera Raw differs from the histograms you see on-camera in an important way.

Figure 2-14 The Camera Raw histogram.

Remember, there is no such thing as a "perfect histogram." The histogram is merely a graphic representation of the data in your image. However, knowing what the histogram is telling you about your image is critical. See Chapter 4, *Camera Raw Controls,* for a full explaination of what the histogram means and how to use it.

Camera Raw's histogram is more trustworthy than the histograms that cameras display—they show the histogram of the JPEG you'd get if you shot JPEG at the current camera settings rather than raw. As a result, they're useful as a rough guide to exposure, but not much more. The same applies to the overexposure warnings offered by most cameras—they're typically quite conservative. Camera vendors tend to apply a fairly strong default tone curve to the default, in-camera raw-to-JPEG conversion, perhaps in an effort to produce a default result that more closely resembles transparency film, so the histogram and exposure warning derived from the JPEG often are not an accurate reflection of the raw capture.

Camera Raw's histogram is a great deal more reliable. It shows you, dynamically, the histogram of the converted image, displaying clipping in its various forms—clipping highlights to white, clipping shadows to black, or clipping one or more channels to totally saturated color. It also lets you see the effect of the various controls on the converted image data. Watching what happens to both the histogram and the preview image as you operate the controls will give you a much better understanding of what's happening to the image than simply looking at the preview alone. In later chapters, we'll look in detail at the many ways you can use the Camera Raw controls to get the best out of your raw captures. But if you're new to digital imaging, or even if you're just new to digital capture, it's well worth spending some time mulling over the contents of this chapter, because digital capture is significantly different from film. Understanding how numbers are used to represent images is key to grasping and, eventually, exploiting that difference.

CHAPTER THREE

Raw System Overview

CAMERA RAW, BRIDGE, PHOTOSHOP, AND DNG

This chapter provides a 30,000-foot overview of the whole digital raw system. We'll discuss the individual components in much more detail in subsequent chapters, but before delving into the minutiae (and there are a *lot* of details), it's helpful to have some idea of what the components do and how they interrelate. Notably, with version 4 Camera Raw was no longer limited to working only with raw files; you could also use it to process JPEG and TIFF files. This was a mixed blessing that was bound to cause confusion, which it did—we'll address this topic in detail in the next chapter, *Hands-On Camera Raw.* Now, with version 5 Camera Raw is capable of doing local tone and color corrections as well. Will Camera Raw replace Photoshop for basic digital imaging? Sometimes, the answer may be yes—again, we'll discuss the relative benefits of working in Camera Raw versus Photoshop in the next chapter.

Camera Raw is an amazing piece of technology, but it's only one component of a powerful system that helps you do everything, from making your initial selects from a shoot, to adding copyright and keywording metadata, to producing final files for delivery (see Figure 3-1). One of the components of this system is, of course, Photoshop itself.

Figure 3.1 Camera Raw + Bridge CS4 + Photoshop CS4 + DNG = Raw Workflow.

Photoshop is truly one of the deepest applications available on any platform, and has probably had more words written about it than just about any other application in existence. It's also seductive and sometimes comfortable if you are a Photoshop maven. But one of the goals in writing this book is to wean photographers from doing everything in Photoshop—if you just treat Camera Raw as a quick way to get raw images into Photoshop for correction, you're missing the boat while making extra work for yourself, and probably not getting everything you can from your raw captures.

For the purposes of this book, Photoshop is simply a tool for making pixel-based edits, hosting automated processes, and writing images to different file formats. Bruce and Jeff had joked that someday, Photoshop would just be a plug-in for Camera Raw; with version 5, that's becoming closer to reality.

One of the biggest challenges the digital raw shooter faces is to avoid drowning in data. Raw captures typically create smaller files than film scans, but we have to deal with so many more raw captures than we did film scans that spending hours correcting an individual image in Photoshop has become the exception rather than the rule if we want to make a living—or even have a life. So in this chapter, we'll lay out the basics of the raw workflow.

ADOBE BRIDGE CS4

Adobe Bridge for CS4 is a third-generation application that comes bundled with every copy of Photoshop CS4 and CS4 Extended. Bridge lies at the center of the entire Adobe Creative Suite—it can manage all sorts of file types besides Camera Raw files and images created by Photoshop, including InDesign and Illustrator files and the ever-ubiquitous PDF format. Bridge can even work with audio and video files, but since this is a book about digital raw capture, we'll focus on its use with digital raw files.

The Virtual Light Table

One of the key roles that Bridge plays is as a virtual light table. As soon as you point Bridge at a new folder of raw images (depending on your Bridge thumbnail options), Camera Raw goes to work behind the scenes, generating thumbnails and large-sized previews using its default settings. As a virtual light table, Bridge lets you view, sort, rank, and make selections from your raw images.

Bridge is highly configurable for different purposes. The thumbnails and previews are resizable, so you can see anything from tiny thumbnails to previews that are large enough to let you decide whether an image is a keeper. As with a physical light table, you can sequence and sort images by dragging them into position. Unlike the physical light table, however, Bridge can find and sort images based on all sorts of metadata criteria, such as the time shot, focal length, shutter speed, aperture setting, or any combination of these factors. You can apply ratings or labels to images to further facilitate sorting and selecting, and you can use Bridge as the source for automated processing into Photoshop by selecting the thumbnails of the images you want to process. Figure 3-2 shows some of the many ways you can configure Bridge for different tasks. We'll discuss Bridge in much greater detail in Chapter 6, *Adobe Bridge*.

Figure 3.2
Bridge configurations.

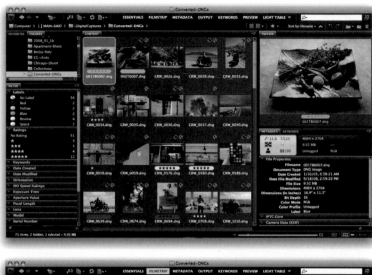

A general-purpose configuration gives access to all of Bridge's tabs—the Folder and Favorites tabs for navigation, the thumbnails and previews for viewing images, the Filter tab for sorting, and the Metadata and Keywords tabs for working with metadata.

You can select multiple images to preview 2-up (or more) with the Loupe view.

You can configure the panels to show detailed metadata views.

Managing Metadata

Metadata literally means "data about data." One of the useful aspects of shooting digital rather than film is that your images contain a wealth of metadata right out of the camera—the shutter speed, aperture, ISO speed, focal length, and other technical metadata are embedded right in the image (see Figure 3-3). But you can and should supplement the camera-generated metadata with custom metadata of your own—copyright and rights-management notices, keywords, and anything else that will make your life easier and add value to your images.

Figure 3.3 Bridge display of image metadata showing file properties, IPTC, EXIF, and Camera Raw metadata.

Moreover, the time and place to add custom metadata is either during or as soon after loading your raw captures into Bridge as possible, for two reasons:

• Metadata added to raw files gets carried through to any image produced from that raw file, so if you enter key metadata such as copyright notices on your raw files, all your converted PSDs, TIFFs, and JPEGs will already have that metadata entered.

• Whereas Photoshop's File Info command lets you edit metadata on one image at a time, Bridge lets you edit metadata for multiple images in a single operation.

If you're new to metadata, consider that as your collection of digital imagery grows, the role of metadata becomes more vital by enabling you and your clients to find your images. Jeff created a single folder of 50,000 images just to show that Bridge could do it; Figure 3-4 shows a single image of those 50,000 selected (although we don't recommend keeping 50,000 images in a single folder!).

Figure 3.4 The need for metadata.

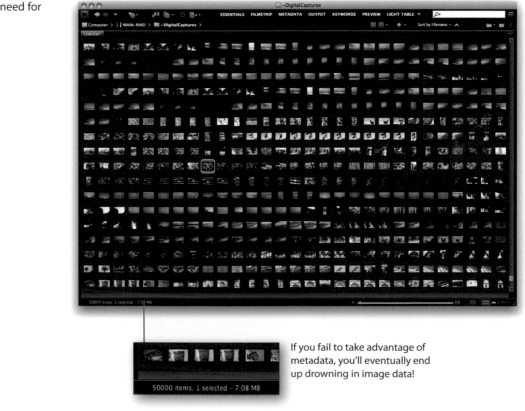

If you fail to take advantage of metadata, you'll eventually end up drowning in image data!

If this seems fanciful, consider the plight of an editorial shooter who shoots 1,000 images a day, just twice a week, and only 25 weeks a year—that's 50,000 images. Now imagine that over a 40-year career; how can you keep track of millions of images?

If you shoot even a tenth of this number of images, you will at some future date have a major challenge on your hands if you don't start taking advantage of the power of metadata to help you manage your image collection. We'll discuss metadata in much greater detail in Chapter 8, *Mastering Metadata*.

Hosting Camera Raw

As a standalone application, Bridge can do things that the old File Browser (back in Photoshop 7) could not, and one of those things is to act as a host for the Camera Raw plug-in. Hence, when you open raw images in Camera Raw, you have the choice of opening them in Camera Raw hosted by Bridge or in Camera Raw hosted by Photoshop (see Figure 3-5).

Figure 3.5 The highlighted button indicates whether Camera Raw is being hosted by Bridge or Photoshop. When Done is highlighted, Camera Raw is being hosted by Bridge; when Open Image is highlighted, it's being hosted by Photoshop.

Camera Raw edits are saved as metadata—the raw files themselves are read-only, so editing in Camera Raw never changes the raw file itself. What you're doing when you edit in Camera Raw is setting the parameters for the conversion from the raw file to an RGB image. This means you can use Camera Raw hosted by Bridge to edit raw images—to set conversion parameters—without actually performing the conversions. This is called *parametric editing* and should not be confused with pixel editing. Then when you open the images in Photoshop, Camera Raw creates an RGB version of the image using the conversion parameters you set in Camera Raw hosted by Bridge. Once the image is opened in Photoshop, you can then do pixel editing. This is an important distinction because parametric editing is essentially nondestructive in that—only the parameters are being altered, not the image data. Photoshop alters the image data when you perform editing.

Of course, if your immediate goal is to open the file in Photoshop, you can host Camera Raw in Photoshop instead, and open raw images directly into Photoshop, bypassing the Camera Raw dialog box (but not Camera Raw itself, which still carries out the conversion), or you can host the Camera Raw dialog box in Photoshop when it makes more sense to do so. We'll discuss these workflow decisions in detail in Chapter 7, *It's All About the Workflow*.

Camera Raw

At its root, Camera Raw is simply a raw file format import plug-in for Photoshop, but it has become so much more. Camera Raw is both the engine that translates your raw captures into color images and the user interface that lets you control that translation. The role that Camera Raw plays when the user interface is exposed is fairly obvious: its role behind the scenes is less so.

Figure 3.6 The Thumbnails settings in Bridge.

In the Thumbnails dropdown menu in Bridge (see Figure 3-6) you have three options; Prefer Embedded (Faster), High Quality on Demand, and Always High Quality. These options dictate when and how Camera Raw generates thumbnails and previews. Choosing Prefer Embedded bypasses Camera Raw and uses whatever internal thumbnails may be available. It's the quickest but least accurate option of the three. Selecting Always High Quality option ensures that Camera Raw is used for all thumbnails and previews. Selecting High Quality on Demand will generate a high-quality thumbnail only when you actually select an image in Bridge to preview. However, this may be disconcerting because those thumbnails that have not been viewed will look different from those that have.

Depending on your these options, one of the key roles that Camera Raw plays is to generate the thumbnails and previews you see in Bridge. When you first point Bridge at a folder full of new raw images, you may see, typically for a few seconds, the camera-generated thumbnails. But Camera Raw will go to work behind the scenes, generating the large, high-quality previews and downsampling them to produce new thumbnails.

Camera Raw also has the interesting property of being able to be shared by Bridge and Photoshop, which opens up some new workflow possibilities. You can, for example, edit images in Camera Raw hosted by Bridge, and hand off the processing of the raw image to a RGB image file saved to Camera Raw running in Photoshop while you continue to edit more images in Camera Raw hosted by Bridge.

Camera Raw Defaults

The role of Camera Raw's default settings in generating Bridge's thumbnails and previews is pretty straightforward. Unless you tell it to do otherwise, Camera Raw uses the default settings for your camera that are hardwired into Camera Raw to build thumbnails and previews for images that Bridge hasn't seen before.

The Default Image Settings (Figure 3-7) found in Camera Raw's preferences allow you to control how the defaults are applied. Camera Raw 5 has the ability to make defaults based on both the serial number of your camera (useful if you have multiple bodies of the same model) and the ISO of the capture. You can also select the option Apply Auto Tone Adjustments or Apply Auto Grayscale Mix When Converting to Grayscale.

Figure 3.7
Camera Raw's
Default Image
Settings.

These defaults aren't sacred, nor "objectively correct," nor "accurate"—they're simply one arbitrary interpretation of the raw image. There's no such thing as an "as shot" interpretation any more than there's a single correct way of printing a negative. One of the most common complaints heard about Camera Raw has been that the images don't look like the in-camera JPEGs or the default conversions from the camera vendors' raw converters. Invariably, those making the complaints haven't bothered to actually *use* Camera Raw's controls—they just use the defaults—and trying to discern any useful information from the default interpretation is impossible. It will only tell you the differences in the default interpretations. However, with the introduction of new DNG Profiles in Camera Raw 5, that debate is now moot. You can have Camera Raw defaults mimic the camera JPEG looks very accurately.

Part of the problem has likely been that Camera Raw gives you access to all the data the camera captured. Many proprietary raw converters bury shadow noise by applying a strong contrast curve that maps much of the noisy shadow data to black. A good many converters also boost the saturation—sometimes

in unexpected ways. Camera Raw's default interpretations tend to be conservative by comparison, with flatter contrast and more open shadows. We use this approach because it makes it easier to see just what usable data the image contains, but that's only our personal preference. More important, Camera Raw offers enough control over the interpretation of the image so that, with very little practice, you can get just about any "look" you want.

Therefore, if you consistently find that Camera Raw's default settings produce images that are too dark, too light, too flat, or too contrasty for your taste, *change them!* It takes only a few minutes and it's easy to change your mind if you need to. We'll discuss Camera Raw's controls, and how to use them—including changing the defaults—in the next chapter, *Camera Raw Controls.*

ADOBE DNG CONVERTER

Adobe DNG Converter is a handy standalone application that converts camera vendors' proprietary raw images to Adobe's documented DNG format (see the next section for an explanation of what we mean by *documented*). It's entirely up to you whether or not you choose to use it—Camera Raw, Bridge, and Photoshop are equally happy with proprietary raw files or DNGs—but the following discussion may help you decide. The advantages of DNG far outweigh any disadvantages, in our opinion, and using DNG sends camera vendors an important message about the future of digital photography, but it *is* a bias. The choice is really up to you.

NOTE The first step when opening a proprietary raw file in Camera Raw is to convert the proprietary raw data to DNG data so that Camera Raw can use it. However, there's no speed advantage (that we can measure) to have already converted the raw to DNG.

To DNG or Not to DNG

Adobe developed the DNG format in response to a very real concern over the longevity of digital raw captures. One of the major problems with camera vendors' proprietary raw formats is that they're undocumented—only the camera vendor knows for sure what they contain. We bear no ill will to any camera vendor, and we hope that they'll all be around for decades to come, stimulating competition and innovation, but it's not beyond the bounds of possibility that one of today's vendors may not be around five, ten, or fifty years from now. The question then becomes, what happens to all the images locked up in a defunct vendor's proprietary raw format?

Archival format. A kindly third-party vendor *may* decide to take on the work of decoding the format to continue support (and let's hear a huge round of applause for Thomas Knoll and the Camera Raw team for the enormous amount of work they've already done in decoding all those proprietary raw formats), but absent that, you'll be stuck with old, non-upgradable software at best, and gigabytes of unreadable data at worst.

The DNG format provides insurance against obsolescence because, unlike proprietary raw formats, it's an open, documented format whose file spec is readily available, so any reasonably talented programmer can build a converter that reads DNG files without any special decoding, even if Adobe should, perish the thought, no longer be in business. So unlike the proprietary raw formats, DNG can fairly lay claim to being an archival format.

The first release of DNG Converter had one potential flaw—it stripped any private metadata that it couldn't understand. While the only things that could possibly use this metadata were the vendors' proprietary raw converters, few of us like the idea of losing something in the translation. Subsequent releases of DNG Converter address this problem by letting you embed a bit-for-bit copy of the proprietary raw file that can be extracted at any time, at the cost of a somewhat larger file size. Additionally, recent versions of DNG Converter will also safely move metadata even if it doesn't actually understand the metadata, so little or nothing is actually lost.

Metadata-friendly. A related issue is that, because proprietary raw files are undocumented, Adobe treats them as read-only files, since writing to them runs the risk of overwriting potentially useful data. So when you add metadata to an image, it gets stored in either a sidecar XMP file or in an application's database.

In contrast, since DNG is a documented file format that's designed to hold metadata, it's safe to write metadata directly into the DNG file, eliminating the need for sidecar files and thus simplifying the workflow. As with proprietary raw formats, the actual image data in the DNG never gets changed. If you work for a client who demands that you submit raw files (as does National Geographic, for example), it's safer to hand off a DNG file with all metadata embedded than it is to submit a proprietary raw along with a sidecar file that may be discarded.

Third-party support. As an open format, DNG is much easier for third parties to support than are the proprietary raw formats. Asset managers and cataloging applications that support DNG automatically gain support for every camera supported by Camera Raw. Thumbnails and previews can be stored directly in the image file so applications don't have to spend time building their own, and there's no possibility of the image losing its metadata because the metadata is right in the image file. Adobe has released a free DNG codec so that Windows Vista (as of the time of this writing, 32 bit only) can treat a raw DNG as a readable image.

More specialized applications are also beginning to support DNG. For example, DxO Labs' DxO Optics Pro, which provides sophisticated corrections for distortions introduced by many common lenses, now offers the ability to write the corrected images as DNG files. That way, you can apply lens corrections, write them to DNG files, and then process the images in Camera Raw.

Since the release of DNG, several camera makers have seen the value of using DNG (although at the time of this writing, some of them *still* need convincing on this point). A number of manufacturers either offer cameras whose native raw file format is DNG or provide DNG as an optional output format.

Ultimately, the proliferation of proprietary raw formats serves no one's interest, not even that of the camera vendors. The DNG spec is flexible enough to let those vendors who insist on doing so put private, secret metadata tags into their images, while ensuring that those images will still be readable by any DNG-compliant converter.

Downsides. The major disadvantage to using DNG is that DNG files will likely not be readable by your camera vendor's proprietary converter. If you typically use Camera Raw on some images and a proprietary converter on others, it's fairly inconvenient to extract the proprietary raws from the DNG file. Therefore, you'll want to either keep versions of the images in both formats or forego the advantages of DNG. If you don't use the camera vendor's software, this disadvantage doesn't apply.

The second disadvantage is that when you choose the "bulletproof" option that embeds the entire proprietary raw file in the DNG, your files will be somewhat larger than the original proprietary raws.

Bruce's solution had been to archive one copy of each image as DNG-with-raw-embedded to long-term storage, while using the smaller, losslessly compressed DNG option for his working files. Jeff uses an equally viable option, which is to archive a copy of the original raws (bearing in mind that they'll only be readable as long as the camera vendor chooses to support them) while using DNG for working files. Either approach is valid while still providing the benefit of using an archival file format.

Using Adobe DNG Converter

Adobe DNG Converter is a simple application. It's not the only way to convert proprietary raws to DNG—you can save DNGs right out of Camera Raw—but it's a convenient way to process large numbers of images into DNG format. See Figure 3-8.

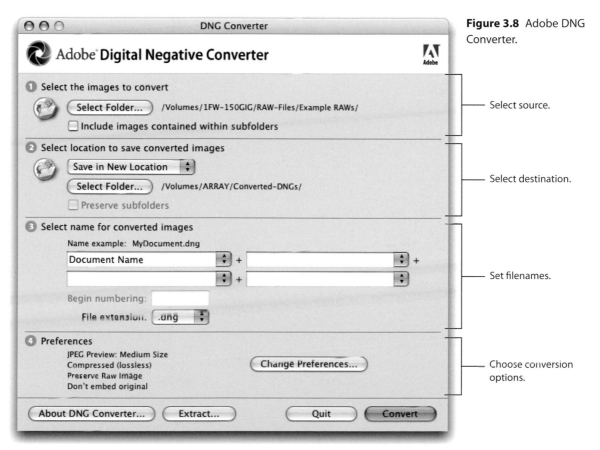

Figure 3.8 Adobe DNG Converter.

Select source.

Select destination.

Set filenames.

Choose conversion options.

The main screen lets you set the following options:

- You can choose a source folder full of raw images for conversion, and optionally include subfolders.

- You can choose a destination, either in the same location as the source raw files or in a new folder, with the option to preserve the subfolder organization.

- You can rename the converted images with the same options as the Batch Rename command in Photoshop and Bridge.

- If you have previously saved DNG files with the original raw file embedded, you can extract the original raw file.

To change the conversion options, click the Preferences button to open the Preferences screen—see Figure 3-9.

Figure 3.9 Adobe DNG Converter Preferences.

The conversion options are likewise very straightforward:

- **Preview** allows you to select the size of the embedded DNG preview or to turn previews off.

- **Compression (lossless)** applies lossless conversion. Unless you own stock in a hard drive vendor, we can't think of a reason to turn this off. And yes, the compression is truly lossless.

- **Preserve Raw Image** preserves the raw pixel data in its original mosaic format. Use this option if you want to be able to use all of Camera Raw's features. You can convert a DNG saved this way to a linear DNG, but not vice versa.

- **Convert to Linear Image** saves a demosaiced version of the image. This option is mostly useful if you want to use a DNG-compliant raw converter other than Camera Raw on images from a camera with a mosaic pattern that isn't supported by the raw converter. Linear DNGs are much larger than mosaic-format ones, so if you're thinking you can save processing time by converting to linear DNG, think again—any savings in processing time are offset by the extra time needed to read the data.

- **Embed Original Raw File** embeds a bit-for-bit copy of the original raw file in the DNG, from which it can be extracted at any time. You can use this option for your archived images just in case you need to retrieve the original raw files at some future date, but we suggest you turn it off for your working files to save space, because embedding the original raw file increases the file size considerably.

When you click Convert, DNG Converter goes to work converting the selected raw files to DNG format using the options specified in Preferences, and displays a status window that shows the progress of the conversions—see Figure 3-10.

To extract the original raw files from DNGs with the original raw embedded, click Extract, which opens the Extract Originals dialog box. Here you can specify source and destination folders for the extraction. When you click Extract, DNG Converter extracts the original raw files from the DNGs. See Figure 3-11.

Figure 3.10
DNG Conversion Status
window.

Figure 3.11 The Extract
Originals dialog box.

At the time of this writing, the main benefit offered by DNG is the elimina-
tion of sidecar files, and it's entirely up to you whether you want to use it,
though it's easy to do so. There's no particular urgency to adopting DNG,
but if you care about the longevity of your images, we do recommend
archiving at least one copy of each image in DNG format, and if you want
to be able to retrieve the original raw files, embed the original raw in the
DNG. That way, you've preserved the raw image in a format that's docu-
mented and hence is likely to be readable as long as humans can still read.

PHOTOSHOP

Photoshop has grown in power and complexity for almost two decades (which is something close to a century in software years). Legions of scribes, Bruce among them, have penned millions of words on its capabilities and quirks. This isn't, however, a book about Photoshop. Instead, it's a book about how to get raw images into Photoshop quickly and efficiently, and in as close to an optimal state as possible.

In short, it's mostly about all the things you do *before* the image lands in Photoshop.

Automation and Actions

The one key area of Photoshop that this book covers in some depth is automation, and especially Photoshop Actions. As a digital photographer, you will routinely be called upon to push amounts of data through your system that only a few years ago would have given NASA nightmares. The hardware you use to do so will doubtless get faster, but one key component in the system, the wetware—the part that occupies the space between the keyboard and the chair—will almost certainly continue to operate at the same speed it has done for the past 20,000 years or so.

Exploiting the power of Photoshop Actions to automate repetitive tasks isn't just good sense—it's a key survival strategy. Writing Actions isn't without its quirks and challenges, so if you're saying to yourself, "But I'm not a programmer," rest assured that writing Actions is, in Bruce's words, "like programming the way driving to the grocery store is like competing in the Dakar Rally."

Any repetitive Photoshop task is a candidate for automation. Our copies of Photoshop spend a lot of time doing their "own thing" while we are free to do other things, and our hope is that by the time you've finished this book, yours will, too. It's rare for us to open an image directly from Camera Raw into Photoshop—we almost invariably apply our raw edits in Bridge, then use batch processes to open the already-edited images into Photoshop.

The batch processes may also include things like sharpening routines, adding adjustment layers, and renaming and saving the files. That way, when we do get them into Photoshop, the layers are there ready for us to go to work on specialized corrections, and the files are already named and saved in the format we need. When we've done our work, we can simply press Command-S! Automating simple things like file renaming, or saving in a specific format with the necessary format options, only saves a small amount of time on any one image. But doing so brings at least four benefits:

- Small savings on one image add up to significant savings on dozens or hundreds or thousands of images.

- Consistency—on Friday you can follow the same steps you did on Monday and get the same results.

- The brain likes being liberated from repetitive drudgery.

- Automated processes don't make mistakes!

We'll talk about the ways we can make the computer do our work for us in detail in Chapter 9, *Exploiting Automation*.

PUTTING IT ALL TOGETHER

Collectively, Bridge, Camera Raw, Photoshop and, optionally, DNG Converter provide a powerful system for managing and converting raw images. As you go through the following chapters, which examine each component in detail, keep this bigger picture in mind, because it provides the context that makes the details relevant.

- Raw images don't change. Instead, they're treated like negatives. You can interpret them in many different ways during the conversion to an RGB image, just as you can make many different prints from the same negative.

- Bridge is the tool for sorting and selecting images, and for adding and editing metadata. The thumbnails and previews you see in Bridge are generated by Camera Raw using the last settings you applied to the image, or (if you haven't edited the image) the Camera Raw default settings for the camera model from which the image came—unless you specifically tell Bridge not to.

- If you don't like Camera Raw's default settings for a particular camera model, you can and should change them to ones that are closer to your taste.

- Editing raw images and converting raw images are logically separate operations, though you can combine them.

- If you have 100 raw images from which you need to produce, for example, a high-res TIFF and a low-res JPEG, the most efficient way to do so is to first edit the images in Camera Raw hosted by Bridge, then run batch operations hosted by Photoshop to open the raw images, using the Camera Raw settings you've applied, and save them in the appropriate formats.

Keeping in mind the bigger picture this chapter presents, it's time to drill down in detail on the Camera Raw plug-in, which is the topic of the next chapter.

CHAPTER FOUR
Camera Raw Controls

DIGITAL DARKROOM TOOLS

In this chapter, we'll look at the Camera Raw controls in excruciating detail. Camera Raw can start working as soon as you point Adobe Bridge at a folder full of raw images, creating thumbnails and previews. But its real power is in the degree of control and flexibility it offers in converting raw images to RGB.

Bear in mind as you go through this chapter that, while Camera Raw lets you make painstaking edits on every image, it doesn't force you to do so! Unless you're being paid by the hour, you'll want to take advantage of Camera Raw's ability to synchronize edits between multiple images and to save settings and subsets of settings that you can apply to multiple images in Bridge without actually launching Photoshop, or even opening them in Camera Raw.

But before you can run, you have to learn to walk, and before you can batch-process images with Camera Raw, you need to learn to deal with them one at a time. If raw files are digital negatives, Camera Raw is the digital darkroom that offers all the tools you need to put your own unique interpretation on those digital negatives.

Like negatives, raw files are simply a starting point. The tools in Camera Raw offer much more control over the interpretation of the raw file than any wet darkroom. Camera Raw is a plug-in the way *War and Peace* is a story and The Beatles were a pop group: At first, the sheer number of options may seem overwhelming, but they're presented in a logical order, and you can master them in a fraction of the time it takes to learn traditional darkroom skills.

Camera Raw, Photoshop, and Bridge

If you're used to the old Camera Raw/File Browser combination in earlier versions of Photoshop, you'll notice that things have changed in several ways, all for the better. If you're new to Camera Raw, this section explains why the screen shots in this chapter may look different from your copy of Camera Raw when you launch it.

As we mentioned in the previous chapter, unlike the old Photoshop File Browser, Adobe Bridge CS4 is a standalone application. One of the many advantages that standalone status confers is that it's capable of hosting Camera Raw when Photoshop is either not running, or more likely, is busy doing something else. You can open Camera Raw in Bridge *or* Photoshop, whichever is more efficient for the task at hand.

If you want to edit the Camera Raw settings for one or more images but don't plan on opening them in Photoshop, you can open Camera Raw in Bridge while Photoshop is, for example, busy running a batch process. Or you can edit images in Camera Raw in Photoshop while Bridge is busy caching a new folder. You can even open one Camera Raw window in Bridge and another in Photoshop, though doing so has the potential to make you a very confused puppy! The subtle clue as to which application is currently hosting Camera Raw is the default button (see Figure 4-1).

A second important workflow enhancement is the "filmstrip" mode of Camera Raw. You can open and edit multiple images in Camera Raw, and transfer settings from one image to another right inside the Camera Raw interface (see Figure 4-2).

These enhancements offer much more flexibility in the workflow. However, in this chapter, we'll first concentrate on the tools Camera Raw offers for editing a single image, because as previously noted, you must learn to walk before you can run. So most of the screen captures of Camera Raw in this chapter will use the single-image mode.

The image controls are the same no matter which application is hosting Camera Raw and no matter how many images you've chosen to edit. We'll discuss workflow and ways to handle multiple images efficiently in Chapter 7, *It's All About the Workflow*. But for the bulk of this chapter, let's take our images one at a time and focus on the actual tools.

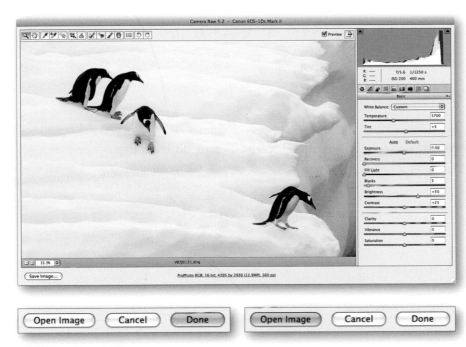

Camera Raw hosted by Bridge Camera Raw hosted by Photoshop

Figure 4-1 Camera Raw in Bridge and in Photoshop.

When Camera Raw is hosted by Bridge (left buttons), the default button is Done. Clicking it closes Camera Raw, applies the settings to the raw file, and returns you to Bridge.

When Camera Raw is hosted by Photoshop (right buttons), the default button is Open Image. Clicking it closes Camera Raw, applies the settings to the raw file, and opens the converted image in Photoshop.

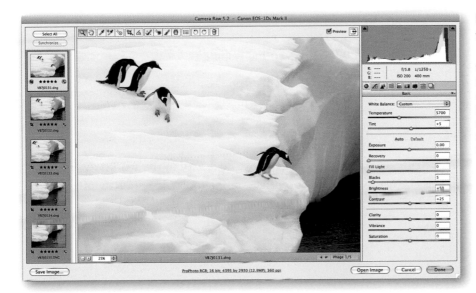

Figure 4-2 Camera Raw in filmstrip mode.

When you open multiple raw images in Camera Raw, they appear in the filmstrip at the left of the Camera Raw window, allowing you to work with multiple images in several useful ways.

CAMERA RAW ANATOMY

Camera Raw opens automatically whenever you open a raw image because neither Bridge nor Photoshop can actually read raw files. In addition to the static elements—the Tool palette, the histogram, the RGB readout, the settings panel—it offers two sets of controls: one static workflow set that is "sticky" (the settings remain unchanged unless and until you change them) and another dynamic image-specific set that changes depending on which panel is currently selected. But to understand all the controls, info readouts, and settings, you need to be familiar with what Camera Raw provides. In this section, we'll take a round-the-world look at the Camera Raw dialog box (see Figure 4-3) and check out all its nooks and crannies.

The static elements include the Toolbar; dialog box title; the Zoom controls; the Preview, Highlight, and Shadow clipping toggles; the Panel settings; the main Save Image, Open Image, Done, and Cancel buttons; the RGB readout; a live histogram that shows the conversion that the current settings will produce; and a Settings menu that lets you load and save settings.

The workflow options govern the kind of output Camera Raw will produce: They let you choose the color space, bit depth, size, and resolution of converted images.

The image controls, which apply to individual images, appear immediately below the Settings menu. In addition to the Presets panel, Camera Raw 5 offers eight separate panels: Basic, Tone Curve, Detail, Curve, HSL/Grayscale, Split Toning, Lens Corrections, and Camera Calibration, each with its own set of controls.

The image preview is based on Photoshop's use of a display profile and will use the same profile to accurately preview the image based on the final output color space. It is colorimetrically accurate and should match the display found in Photoshop.

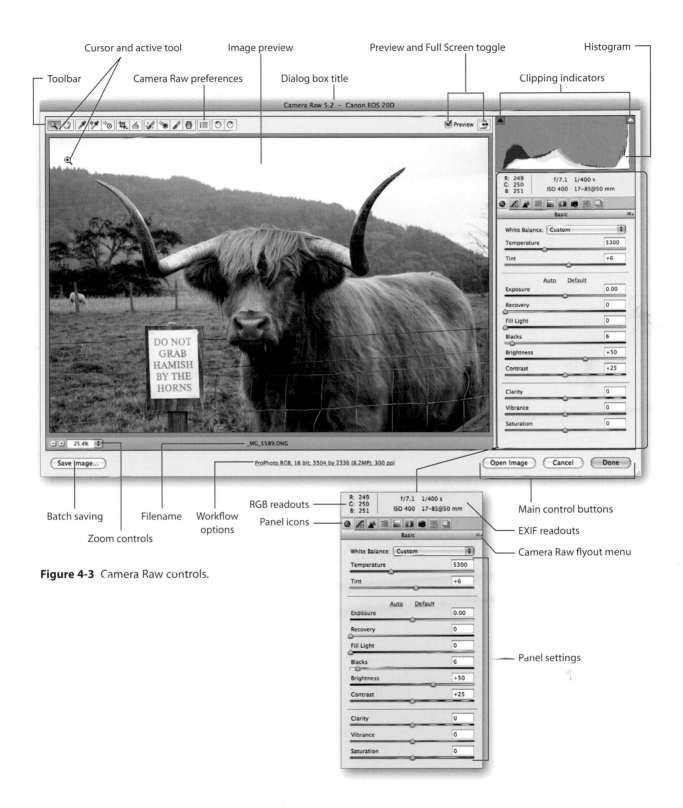

Figure 4-3 Camera Raw controls.

EXAMINING THE CAMERA RAW TOOLS IN DEPTH

With the release of Camera Raw version 4.0, the environment of Camera Raw has become increasingly rich and powerful, and yes, complicated. No longer simply a raw processing plug-in, Camera Raw has moved into new and uncharted waters, giving you the ability to do both global tone and color corrections, and also make edits such as spot healing—tasks that once required a pixel-based image editor. We'll examine, in detail, each of the tools found in Camera Raw. But keep in mind that this chapter is intended to lay a foundation for what the tools do, *not* how you would wish to use them. We'll tackle that topic in Chapter 5, *Hands-On Camera Raw.*

The title provides Camera Raw's version number and the camera model. As you can see in Figure 4-4, the dialog box title displays the current version of Camera Raw being used as well as the camera model used to shoot the image.

Figure 4-4 Dialog box title.

Camera Raw 5.2 – Canon EOS 20D

Figure 4-5 Preview and Full Screen toggle buttons.

The Preview option (see Figure 4-5) allows you to toggle the settings on and off. This enables you to see the changes that have been made during the current editing session. Note that the Preview toggle is panel sensitive, which means that as you move from one panel to another and make changes, you'll see the preview adjustment for that particular panel. To reset the results of multiple panel changes, click on the Camera Raw defaults in the Camera Raw flyout menu.

The Full Screen toggle (also shown in Figure 4-5) allows Camera Raw to expand to the entire screen of the display. By going to Full Screen you'll gain space by hiding the dialog box title. Note that when in full screen mode, the version number and camera model shown in Figure 4-4 is hidden.

Arguably, the histogram is the most important but least understood of all of Camera Raw's information displays. The histogram is merely a graphically represented chart of the data distribution in your image, but it can reveal a lot. It can tell you how well distributed the values are in your image as well as whether values are near or past clipping. As shown in Figure 4-6, you can configure the histogram to show where in your image such clipping can be found.

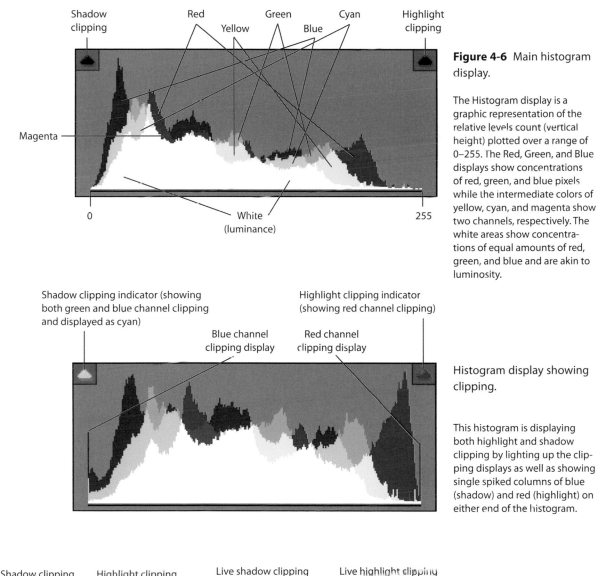

Shadow clipping · Red · Yellow · Green · Blue · Cyan · Highlight clipping

Magenta

0 · White (luminance) · 255

Figure 4-6 Main histogram display.

The Histogram display is a graphic representation of the relative levels count (vertical height) plotted over a range of 0–255. The Red, Green, and Blue displays show concentrations of red, green, and blue pixels while the intermediate colors of yellow, cyan, and magenta show two channels, respectively. The white areas show concentrations of equal amounts of red, green, and blue and are akin to luminosity.

Shadow clipping indicator (showing both green and blue channel clipping and displayed as cyan)

Highlight clipping indicator (showing red channel clipping)

Blue channel clipping display

Red channel clipping display

Histogram display showing clipping.

This histogram is displaying both highlight and shadow clipping by lighting up the clipping displays as well as showing single spiked columns of blue (shadow) and red (highlight) on either end of the histogram.

Shadow clipping preview on · Highlight clipping preview on

Live shadow clipping preview (showing in blue) · Live highlight clipping preview (showing in red)

Histogram display showing clipping previews.

The histogram is plotted based on the Workflow settings and the color space you've chosen. The display is based on 8-bit/channel accuracy in the gamma of your color space. To view a 16-bit/channel histogram would be less useful, since the size would constrain how accurate it could be plotted. The same could be said for viewing a linear gamma histogram. Thus, the final color space and its gamma is the optimal choice for the histogram display.

We'd like to stress that there is no such thing as a "perfect histogram." Nor should you try to adjust an image to arrive at some sort of optimal shape. A histogram whose concentration of data is in the shadows with little or no data in the highlights may indicate underexposure, whereas concentration in the highlights may indicate overexposure. These sorts of shapes can give you hints as to what adjustments you'll need to make to more evenly distribute the levels in your image.

The RGB readout (see Figure 4-7) shows the RGB values that will result from the conversion at the current settings; the readout displays the RGB value for the pixel under the cursor. It always reads 5-by-5 screen pixels at zoom levels of 100% or less, so it may give different values at different zoom levels. When you fit the entire image into Camera Raw's preview, you're sampling an average of a fairly large number of pixels—the exact number depends on the camera's native resolution and the size you've chosen from the Size menu in the Workflow controls. At zoom levels greater than 100%, the sample size is always 5x5 actual image pixels.

Figure 4-7 RGB and EXIF readouts.

The RGB readouts are based on the color space chosen in the Workflow settings and display from the area in the image the cursor is over. The EXIF readouts are read from the EXIF metadata contained in the image.

The EXIF readouts (also shown in Figure 4-7) transcribe the embedded EXIF metadata to provide readings familiar to photographers. The accuracy of the readouts will depend entirely on the way in which cameras store the EXIF metadata. Sometimes that can be ambiguous, particularly when reading lens data. Not all camera makers provide data on all lenses, and some third-party lenses can cause either inaccurate or faulty lens information.

The Adjustment Panel Icons

As shown in Figure 4-8, Camera Raw now has nine separate panels with several containing two or more variations and various dropdown menus. In general, the panels are designed to be used from the top down and from left to right. That's not to say you won't be bouncing back and forth, but generally the optimal approach is to start in Basic, which displays by default. At the top is White Balance. The easy way to navigate to adjustment panels is to use the keyboard commands as shown in Figure 4-8. For Windows, substitute Ctrl-Alt for Command-Option.

Basic
(Command-Option-1)

Detail
(Command-Option-3)

Split Toning
(Command-Option-5)

Camera Calibration
(Command-Option-7)

Tone Curve
(Command-Option-2)

HSL/Grayscale
(Command-Option-4)

Lens Corrections
(Command-Option-6)

Presets
(Command-Option-8)

Snapshots
(Command-Option-9)

Figure 4-8 The Adjustment panel icons.

The order in which you make adjustments has no bearing on the manner in which Camera Raw carries out the processing. That order is fixed in the Camera Raw processing pipeline, where the processing is done in an optimal order. So there's no reason not to make various adjustments in any order that is useful to you, knowing that Camera Raw will do the right thing when it processes. Inevitably, we find ourselves moving back and forth between Basic and Tone Curve often to adjust the image's overall distribution of tones. Color adjustments, even after White Balance is set, are typical, with moves to the HSL/Grayscale and Split Toning panels common. The Camera Calibration panel gets less attention on an image-by-image basis. You'll generally use that panel only a couple of times when zeroing in on your camera's color response. Presets is one area where even advanced users often fail to take maximum advantage.

NOTE On the Macintosh, the system steals the Command-Option-8 keyboard command from Camera Raw. You can correct this by going into System Preferences, Keyboard and Mouse and then the Keyboard Shortcuts. Under Universal Access, uncheck the option to turn zoom on or off. Unless you do this, Camera Raw cannot use this keyboard shortcut.

TIP When working in Camera Raw, you can always reset any control slider to its default settings by double-clicking on the slider knob. Also, you can use Camera Raw's scrubby slider without even grabbing the knob—just hover above the adjustment line indicator and then drag the slider sideways to make adjustments.

Slider knob

Scrubby slider

In this section we'll define what each panel's adjustment sliders do. In the next chapter we'll explain how to combine them to maximum advantage.

The Basic Panel

The Basic panel (which you display by pressing Command-Option-1) is the primary location for general adjustments for tone and color corrections. With 11 sliders, a dropdown menu, and two active buttons, it ranks as the second-most complicated set of adjustments, but it ranks at the top in terms of importance (see Figure 4-9).

Figure 4-9 The Basic panel with the White Balance dropdown menu.

The White Balance Adjustments

White Balance adjustments are so important they are placed at the top of the Basic panel. The White Balance adjusts the following:

White Balance. At the top resides the White Balance setting with its dropdown menu. In general, the most useful setting is As Shot. By enabling this setting you allow Camera Raw to attempt to decode the white balance data stored when you camera-captured the image. Camera Raw may not exactly

match the camera's numbers or its rendering of that white balance, but it does a pretty good job of accessing most cameras' white balance metadata. The Fluorescent dropdown is also helpful because it often gives a more useful starting point than As Shot, if the shot was taken under fluorescent lights.

Keep in mind that the moment you adjust the White Balance slider, the readout in the menu will change to Custom, indicating that you've overridden the As Shot settings.

The White Balance adjustments are split between Temperature and Tint. Camera Raw 5 has interface clues—blue and yellow in the Temperature slider and green and magenta in the Tint slider:

- **Temperature.** The Temperature control lets you specify the color temperature of the lighting in degrees Kelvin, thereby setting the blue-yellow color balance. Lowering the color temperature makes the image bluer to compensate for the more yellow light; raising the color temperature makes the image more yellow to compensate for the bluer light. (If this seems counterintuitive, remember that we think of higher color temperatures as bluer and lower ones as more yellow. The trick is to keep in mind that the Temperature control *compensates* for the color temperature of the light, so if you tell Camera Raw the light is bluer, it makes the image more yellow.)

- **Tint.** The Tint control lets you fine-tune the color balance along the axis that's perpendicular to the one controlled by the Temperature slider—in practice, it's closer to a green-magenta control than anything else. Negative values add green; positive ones add magenta. The up and down arrow keys change the tint in increments of 1. Pressing Shift at the same time changes the tint in increments of 10.

If you are not using the White Balance tool to set the white balance, the sliders give you the ability to adjust either by numbers or by eye.

Auto button. One of the more startling changes for Camera Raw 5 (which was foretold by the Camera Raw 3.7 update) was the removal of per/ adjustment multiple Auto checkboxes. Now we have a single Auto button, which does its work evaluating the statistics of the image's histogram while attempting to produce an optimal distribution of values throughout the image. Can it be wrong? Yes—and it often is in subtle ways. However, this single Auto adjustment is superior to Camera Raw 3's multiple settings and brings with it the needed compatibility with Adobe Photoshop Lightroom.

TIP When the Temperature field is selected, the up and down arrow keys adjust the color temperature in increments of 50 Kelvins. Adding Shift adjusts the temperature in increments of 500 Kelvins.

TIP Camera Raw, just like Photoshop, has multiple undo. There is no setting to change the undo count, but we've gone back a hundred steps (more than we need, since we have very short memories). To access multiple undo, use the keyboard shortcut Command-Option-Z to go back more than one undo. To go forward use Command-Shift-Z.

TIP When the Exposure field is selected, the up and down arrows change the exposure in increments of 0.05 of a stop. Adding Shift changes the exposure in increments of 0.5 of a stop.

When you're first looking at an image that may pose significant adjustment challenges, it's useful to let Auto take a crack at the adjustments. It may not be correct in all its "guesses," but it's often right in at least a couple. And remember, since Camera Raw is a parametric editor (and has multiple undo) you don't risk anything other than a bit of time by trying.

Default button. The Default button (grayed out in Figure 4-9 because all the settings are at their defaults) provides a simple method of returning to the Camera Raw Default settings in the Basic panel based on your current default settings (which can be changed).

The Tone Adjustment Sliders

Once the White Balance adjustments are made, the general rule is to begin adjusting the tones of your image. The Tone adjustments you can make in the Basic panel include the following:

Exposure. The Exposure slider controls the mapping of the highlight tone values in the image to those in your designated working space, but it's first and foremost a white-clipping adjustment. Remember, half of the captured data is in the brightest stop, so Exposure is a highly critical adjustment!

Large increases in exposure value (more than about 0.75 of a stop) will increase shadow noise and may even make some posterization visible in the shadows, simply because large positive exposure values stretch the relatively few bits devoted to describing the shadows farther up the tone scale. If you deliberately underexpose to hold highlight detail, your shadows won't be as good as they could be.

Holding down the Option (Mac) or Alt (Windows) key while adjusting Exposure gives you a live view of the area in the image that is getting clipped. White pixels indicate highlight clipping, and colored pixels indicate clipping in one or two channels.

Recovery. This deceptive slider can have a major impact on the extreme highlights of your image. Unlike most raw converters, Camera Raw offers "highlight recovery." Most raw converters treat as white all pixels where one channel has clipped highlights, since they lack complete color information. But Camera Raw can recover a surprising amount of highlight detail from even a single channel. It does, however, maintain pure white (that is, clipped in all channels) pixels as white (unlike most converters that turn clipped pixels gray) and darkens the rest of the image using special algorithms to

maintain the nonwhite pixels' color. Use of Recovery generally entails inter-active adjustments of Exposure as well as other tone mapping controls. It is one of the adjustments often correctly guessed by the Auto adjustment.

See the sidebar "How Much Highlight Detail Can I Recover?" in Chapter 2 for more technical details and see Figure 2-13 for a real-world example.

Fill Light. Fill Light has been given an almost magical reverence by Camera Raw users for its ability to draw out shadow detail, but it does have its limits. However, it's one of Camera Raw's most processor-intensive algorithms, so on slow machines it can seem to drag when first making an adjustment. This is because under the hood it is producing a blurred mask of the image, on the fly, to adjust the shadows in the image. After the mask is generated (which isn't done until the slider is first moved above 0), slider adjustments should be swifter.

Because of this soft-edge mask, overuse can also lead to visible halos on areas of extreme high-contrast edges. Despite these minor potential short-comings, Fill Light remains an absolutely critical tool for modifying the tone mapping in your image.

Blacks. The Blacks slider is the black clipping control. It works much like the black input slider in Photoshop's Levels, letting you darken the shadows to set the black level. Since the Blacks slider operates on the linear-gamma data, small moves tend to make bigger changes than the black input slider in Levels. In earlier versions of Camera Raw, the former Shadows slider was something of a blunt instrument, but in more recent versions it has a much gentler effect. That said, you may find the default value of 5 a little too aggressive. You can alter the Camera Raw Default to a lower number; we often use 3 as a default instead of 5.

The adjustments between the low numbers of 1–5 can have a tremendous impact at each increment, whereas at higher numbers the changes smooth out. For this reason it's often useful to zoom into the deep shadow areas of your image and hold down the Option (Mac) or Alt (Windows) key to see what effect even small units of adjustments will have on your image. Black pixels indicate shadow clipping, and colored pixels indicate clipping in one or two channels.

When the Blacks field is selected, the up and down arrow keys change the shadows in increments of 1. Adding Shift changes the shadows in incre-ments of 10.

TIP One trick we often use is to combine the Blacks slider with the Fill Light to tune the results of the abruptness often encoun-tered with the Blacks adjust-ment. Increasing the Blacks and then increasing the Fill Light can improve the deep shadows tonality while still punching the Blacks down.

Brightness. Camera Raw's Brightness control is a nonlinear adjustment that works very much like the gray input slider in Levels. It lets you redistribute the midtone values without clipping the highlights or shadows. Note, however, that when you raise Brightness to values greater than 100, you can drive 8-bit highlight values to 255, which looks a lot like highlight clipping. But if you check the 16-bit values after conversion, you'll probably find that they aren't clipped.

The up and down arrow keys change the brightness in increments of 1. Adding Shift changes the brightness in increments of 10.

Contrast. The Contrast slider also differs from the Photoshop adjustment of the same name. While Photoshop's Contrast is a linear shift, Camera Raw's Contrast applies an S-curve to the data, leaving the extreme shadows and highlights alone. Increasing the Contrast value from the default setting of +25 lightens values above the midtones and darkens values below the midtones, whereas reducing the Contrast value from the default does the reverse. Note that the midpoint around which Contrast adds the S-curve is determined by the Brightness value.

The up and down arrow keys change the contrast in increments of 1. Adding Shift changes the contrast in increments of 10.

Both Brightness and Contrast are rough-tuning adjustments that can often be further and better tuned by using the Tone Curve panel adjustments. However, they live on the Basic panel to offer you the ability to do those rough adjustments in combination with the main levels of distribution adjustments of Exposure and Blacks. We'll provide examples of how to work interactively with Exposure and Blacks as well as Brightness and Contrast in the next chapter.

Clarity, Vibrance, and Saturation

In Lightroom, the adjustments named Clarity, Vibrance, and Saturation fall under the heading of "Presence"—and that's a pretty good description of what these adjustments are capable of. Subtle use of these adjustments can add a degree of presence to an image that can't be accomplished easily with other tools or adjustments (unless you count the 24 sliders in HSL/Grayscale). But while the HSL adjustments are scalpels, these tools are more "basic cutting tools," which is why we find them residing in the Basic panel.

Clarity. The word really says it all—Clarity is like a lens-cleaning filter. It works in a mysterious way, using an adaptive image adjustment that is mask based (like the Fill Light adjustment) in that it creates a mask of the image and uses it to add midtone contrast. So why is it in the Basic panel?

Other than the fact it's a "basic" adjustment you'll want to use often, it's more of a tone adjustment for the midtones. Clarity is a distant relative of Photoshop's Unsharp Mask filter. In fact, it uses an algorithm very much like Unsharp Mask set to a small amount but a large radius of sharpening that results in local area contrast increases. The adjustment is very image dependent; it uses the actual image to determine the area over which it will adjust contrast. And the adjustments are tapered off the bright highlights and deep shadows so they concentrate on the midtones.

If you want to roughly duplicate the steps in Photoshop, here's the recipe. Take an image, duplicate the background layer, and apply an Unsharp Mask filter set to an Amount of 15% and a Radius of 100. Then in the layer's Blend If options (double-click the layer icon), select This Layer and split the highlight and shadows sliders to set the blend range so that shadows blend from 0/100 and the highlights blend from 127/255. That will produce a similar result in Photoshop. Then compare that with the effort it takes to merely adjust a slider in Camera Raw. Considering that this adjustment is parametric and done on the fly, it's a remarkable reinvention of an old technique in a new parametric wrapper. We'll provide examples in the next chapter, but for now keep in mind that almost every image can do with at least a small dose of Clarity and sometimes a little negative Clarity does wonders.

Vibrance. While Vibrance is similar to Saturation, it works with a twist: It increases the saturation of unsaturated colors more than it adjusts already saturated colors. An additional twist is that Vibrance will adjust all colors except for skin tones, which means it's safe to use on skin (Saturation would likely result in less-than-desirable saturation boosts to shots of people). For those of you who recall Pixmantec and Raw Shooter Pro (RSP), this control will be familiar. The Vibrance setting in Camera Raw, though inspired by RSP, has been completely rewritten to work in the Camera Raw pipeline.

Saturation. The Saturation slider acts like a gentler version of the Saturation slider in Photoshop's Hue/Saturation adjustment. It offers somewhat finer adjustments than Hue/Saturation. But HSL/Grayscale has saturation controls broken down by not six but eight separate hues. So while Saturation in the Basic panel can be a useful tool for boosting overall saturation, it does run the risk of potentially causing saturation clipping. Please use it sparingly.

TIP If you've often wished that Clarity could go above 100, you can now achieve that result (even though the Basic panel still stops at 100). Simply use the Adjustment Brush using a Clarity parameter to add even more Clarity than you can in the Basic panel. We can almost never have too much Clarity (well, OK, we do confess to sometimes needing some negative Clarity, which is good for people's skin tones).

The Tone Curve Panel

The Tone Curve panel (which you access by pressing Command-Option-2) is the first panel with two faces: the Parametric Curve Editor and the Point Curve Editor (see Figure 4-10). Why two curve editors? Parametric curve editing was introduced in Lightroom, and to maintain cross-compatibility, it was also incorporated into Camera Raw. For some functions, such as relatively simple contrast adjustments, either editor can be used. Their capabilities are similar but their usability is vastly different. In actual use, the Parametric Curve Editor offers a quicker means of achieving a desired tone mapping, whereas the Point Curve Editor can help you obtain a more accurate placement of points on a curve. Your choice should be predicated on the precision your image needs versus the ease of accomplishing what you need. Both require practice.

Parametric. The Parametric Curve Editor uses a simplified user interface to allow quicker adjustments of the Highlights, Lights, Darks, and Shadows. The effectiveness is further enhanced by the range adjustment slider underneath the curve plot, which is used to expand or contract the range over which the curve adjustments are applied. The Highlights control the one-quarter tones and white; the Lights control the one-quarter tones; the Darks control the three-quarter tones; and the Shadows control the three-quarter tones and black. Neither black nor white are affected—those points remain the domain of Exposure and Blacks for setting clipping points. The up and down arrow keys change the units in increments of 1; adding Shift changes the units in increments of 10.

The plot of the luminance image data is in the background, although it's in a different scale than Camera Raw's main color histogram.

Point. While the Parametric Curve Editor can often produce the right tone curves more quickly, there's no denying that the Point Curve Editor can accomplish far finer-tuned controls—particularly in the data rich areas of extreme highlights. The curve behaves like Photoshop CS4's refined curves adjustment. Moving a point will have an impact on the other side of the next point. To place very fine point curves, you can simply click on the curve to add a point; to delete a point, just drag it off the curve plot.

The input/output readout is based on your current working space settings. The up and down arrows and right and left keys change the units in increments of 1. Adding Shift changes the units in increments of 10.

TIP One obscure function of the Point Curve Editor is the ability to see, on the curve, exactly where the cursor is hovering when you hold down the Command (Mac) or Ctrl (Windows) key. If you click on the image holding the key, you can actually place a point on the curve. This is useful when you zoom in to work on delicate highlights that may need special treatment to tease tone values apart to maintain textural detail.

You can choose different hard-coded curve presets from the dropdown menu, but there is no function that lets you save or delete using the menu. You can save a new custom preset for just curves separated by parametric or point curves and apply presets in this manner.

Parametric Curve Editor

Parametric edit showing simple S-curve

Figure 4-10 The two faces of the Tone Curve panel.

Point Curve Editor

Curve dropdown menu

Point edit showing simple S-curve

 NOTE On a personal note, Jeff Schewe says, "I'm absolutely positive that Bruce is smiling now because Camera Raw does what I believe he thought it should be able to do. For that I'll be eternally grateful to Thomas and Mark for their brilliant work as well as their appreciation for Bruce's ideas and concepts. Thanks, guys."

The Detail Panel

It could be said, without much fear of contradiction, that in prior versions of Camera Raw, the series of controls and the functionality provided in the Detail panel (see Figure 4-11) didn't get much "true love." That changed with the release of Camera Raw 4.1 in Photoshop CS3 and now continues with Camera Raw 5 in Photoshop CS4. Not only did the luminance noise reduction receive some much-needed attention, but the image sharpening made a major jump in capability and functionality as well. Adobe had a little special help to accomplish this task.

Bruce Fraser was hired as a special consultant to work with Thomas Knoll and Mark Hamburg (the primary architects for Lightroom, which shares its functionality with Camera Raw). With Bruce's untimely passing, Jeff Schewe had to step in to help fulfill the contract, but the results have Bruce's fingerprints all over them. Bruce's concept of a "sharpening workflow" that originated with a product he worked on for PixelGenius called PhotoKit Sharpener was embodied in Camera Raw's sharpening functionality.

Figure 4-11 The Detail panel.

Changes to the image using the Detail controls will only be visible if you are at 100% zoom or greater. This is supercritical because if you adjust the controls at a lower zoom, you won't be able to see what effect they have on your image. Previous versions attempted to give some indication of the resulting changes but were inaccurate. So, the decision was made to disable preview processing for under 100% zoom previews. Access the Detail Panel by pressing Command-Option-3.

Zoom preview to 100% or larger to see the effects of the controls in this panel.

Zoom preview to 100% or larger to see the effects of the controls in this panel.

The warning given when the image is less than 100% zoom

That's not to say that Mark and Thomas didn't do a lot of the hard work—they wrote the code. Mark was able to take Bruce's ideas as inspiration and direction and incorporate them in a series of parametric edits, which is astonishing when you consider the multitude of steps it takes to run PhotoKit Sharpener's Capture Sharpener inside Photoshop. That's exactly what Thomas wanted to be able to do in Camera Raw—capture sharpening.

As a result, the sharpening process, unchanged in Camera Raw 5, is specifically designed to work optimally as a "capture sharpener." The very process of capturing an image produces softness that must be reconstituted, and Camera Raw now has excellent tools to do just that. However, you shouldn't fall prey to the temptation to overdo it, nor should you try to sharpen "for effect."

The Sharpening Controls

For all the sharpening controls, holding the Option (Mac) or Alt (Windows) key while adjusting the slider will give you a special preview of what the control is doing and how. The ability to see what is being done is incredibly useful for making decisions and evaluating settings. Until you become familiar with the controls and how they interact, we strongly suggest using the Option/Alt method of arriving at optimal settings for your images.

Sharpening. As shown in Figure 4-11, there are four main controls for image sharpening in Camera Raw 5. The defaults are designed to roughly approximate the default results of previous versions of Camera Raw and are intended for general-purpose sharpening. Adjusting the parameters tunes the result, and the adjustments are predicated on capture size and image content. We'll provide examples in the next chapter of various image content and how content impacts the optimized settings. But in this section we'll focus on defining and describing what the controls offer.

Amount. As you might expect, Amount is a volume control that determines the strength of the sharpening being applied. It runs from 0 (zero), meaning no sharpening is being applied (this is the default amount set for non-raw images), all the way to 150. At 150, without adjusting other controls, your image will be pretty much sharpened to death, but you can go to 150 because the other controls will alter how the sharpening is applied.

Radius. Radius defines how many pixels on either side of an "edge" the sharpening will be applied. Camera Raw 5.1's Radius control goes from a minimum of 0.5 pixels to a maximum of 3 pixels.

Detail. During development, the team tried to come up with a better name for this, but the word *Detail* is at least descriptive. Similar in concept to Unsharp Mask's threshold (but totally different in application and function), Detail varies how the sharpening attacks your image. If you run Detail all the way to the right (a setting of 100), Camera Raw's sharpening will be similar to Photoshop's Unsharp Mask—not exactly the same, but very similar. Moving Detail to the left does a halo dampening on the sharpening. Moving it all the way to the left (zero) will almost completely pin the sharpening edge halo.

Masking. Masking reduces the sharpening of nonedge areas while concentrating the sharpening on edges, which is a principle of capture sharpening. The fact that Camera Raw is creating an edge mask on the fly is very impressive. Note, however, that as with Camera Raw's Fill Light, setting the Masking control above 0 will cause a bit of calculation to be done. By default, Masking is set to 0, meaning there's no masking and no mask is being built.

This brings us to the point where you may be asking what constitutes "optimal." In the old days, the general consensus was that you needed to make an image "slightly crunchy" (slightly oversharpened) onscreen at 100% zoom. That slightly crunchy part is a difficult and imprecise description—it's like "salting to taste." It's ambiguous at best and subject to gross oversalting at worst.

While Bruce was not able to see the final iteration of Camera Raw's sharpening, Jeff has worked on determining how best to optimize an image. The current thinking is to aim for "just right" sharpening at 100% zoom. You should sharpen just below the threshold of seeing any undesirable sharpening effects, including any actual appearance of "crunchiness."

Sharpening halos is fine and to be expected, yet halos should remain *invisible* when viewed at 100%. You may see some when viewing at 200% or above but not at 100%. There are no "magic numbers" that will automatically work because you must factor the capture size and the image content into the equation when making adjustments. Chapter 5 provides examples and explains these factors in depth. In the meantime, Figure 4-12 shows the logical process and the previews available while determining the optimal sharpening for this image. (Note that all intermediate figures in grayscale are being displayed while holding down the Option key.) Figure 4-13 compares the results.

The original at default settings

Adjusting the Amount to 70

Figure 4-12
Sharpening tutorial.

The aim of this image's sharpening was to increase the apparent sharpness of the high-frequency textural detail of the sake barrels and recover the sharpness the image lost during the process of being converted to digital pixels. The image was shot by Jeff using a Canon 1Ds camera with a 17-35mm 2.8 lens, one of Canon's sharpest at the time. Yet the image required additional sharpening beyond Camera Raw's default.

The Radius preview at 0.5

The Radius preview at 3

The Detail setting at 10

The Detail setting at 90

The Masking setting at 20 (Note: The preview is showing a preview with very few edges.)

The Masking setting at 90 (Note: The Masking at 90 shows only the edges that will be primarily sharpened.)

The image with Camera Raw defaults

The image with tuned results of:
Amount: 70, Radius: .8, Detail: 50, Masking: 50

Figure 4-13 Comparing results.

The Noise Reduction Controls

Noise reduction in Camera Raw 5 has been improved. Not only has a better demosaicing algorithm been incorporated, but also the Luminance noise reduction has been improved using a wavelet algorithm that seeks to determine extremely high-frequency noise, separate it from high-frequency image texture, and then mitigate the noise. Noise can either come from using a high ISO and the resultant amplification of the signal in the analog-to-digital conversion or be the result of underexposing the image and trying to recover detail from the extreme shadows.

Camera Raw's noise reduction is not a heavy-duty noise obliterator like some third-party Photoshop filters, but it does a really good job of reducing color noise and a suitable job of reducing luminance noise. One big improvement is the ability to find and fix "outlyers"—those random light or dark pixels that may occur as a result of demosaicing flaws that are often seen on high ISO captures. The key to successful use is to "improve" but not "destroy" the nature and look of the image. See Figure 4-14 for an example of luminance and color noise reduction.

Figure 4-14 The processed image of Lupe.

The aim is to reduce the noise without obliterating the actual edges and real textures of the image. The screen shots are done with the image at 300% to show extreme detail of the noise reduction. Notice in particular that with no noise reduction of any kind, there are splotches of green and magenta areas, which is symptomatic of high ISO captures. Also note that the reduced image still has a "grainy" character (you'll never get a high ISO image to look as clean as a low ISO image even using heavy-duty third-party filters). The aim is merely to "improve" the image for further processing without causing any additional problems in the process.

The image with no luminance or color noise reduction

The image with Luminance set to 21 and Color set to its default of 25

NOTE Jeff wants to thank Greg Gorman for permission to use this shot of his dog Lupe (which Jeff shot in his—Lupe's—Hollywood home). While you may not realize it, this dog is very famous and has been shot alongside many of the most famous Hollywood movie stars. However, when Jeff shot him, Lupe was just waiting for Greg to get home—no stars involved.

The HSL/Grayscale Panel

The HSL/Grayscale panel (which you access by pressing Command-Option-4) has three separate subpanels, which can then transform to yet a fourth panel at the click of a button. Depending on which mode you're displaying, Color or Convert to Grayscale, up to 24 separate sliders are in play (see Figure 4-15). With all these controls, you might expect the HSL portion to be a complicated beast to manage, but it's not. It's rather elegantly simple yet incredibly powerful and far more useful than the Basic Saturation control.

Figure 4-15 The HSL/Grayscale panel in color mode showing the Hue tab. When in the color mode, this panel controls a total of 24 sliders separated by three tabs.

The Hue tab

The Saturation tab

The Luminance tab

The HSL Controls

As you can see in Figure 4-15, the colors under control aren't the typical additive and subtractive primaries of red, green, blue, cyan, magenta, and yellow. No, the elves who work on Camera Raw and Lightroom decided to throw in a twist by choosing color controls that are more useful for photographic correction than the primaries. And for good reason—the colors in nature will often fall in between the spectral primaries, a fact that makes control of those colors more difficult using only the primaries.

Hue. The Hue control lets you "tween" a color between two related hues. Thus, red can move toward magenta (cooler) or toward orange (warmer). Each of the hues in the panel can have a useful impact on fine-tuning the exact color rendering the raw processing can deliver. While Hue is conceptually similar to the controls in the Camera Calibration panel, you shouldn't confuse their intended use. The Hue sliders are intended to correct photographic or "memory" colors, whereas Camera Calibration is intended to correct technical rendering of the spectral response of your camera. That said, you are free, of course, to use whichever tool catches your fancy.

Saturation. Saturation controls, well, the saturation of the target's hue. You'll note that on each of the HSL subpanels there is a Default button, which is currently grayed out since there currently are no adjustments. Once you move a slider it is enabled. Since there are three separate panels, the designers decided it would be useful to include a Default button so you could reset all the controls for that subpanel. It's quicker than going through all eight sliders per panel to reset them.

Luminance. The Luminance subpanel is the source of a lot of color and tone adjustment that may augment and improve on the overall tone mapping using Basic and/or Curves. Say, for example, the overall tone mapping is fine except that one particular color is too light or too dark in the resulting tone curve. It's simple to grab the slider for that color and lighten or darken it without affecting the rest of the tone mapping.

The Grayscale Controls

When you click the Convert to Grayscale checkbox (see Figure 4-16), the panel is transformed to the grayscale conversion panel, which offers the ability to choose how certain colors convert to color. Think of this as an infinitely variable "panchromatic response" filter for your images. Unlike the old days when B&W photographers would shoot with color contrast filters over their lenses to alter the color rendering of their B&W film, we can now exercise far more power and control by adjusting sliders.

The same sets of colors are represented here as in the color version of the panel to allow you to fine-tune the tone rendering for various colors.

Auto. Clicking the Auto button performs an automated adjustment of the color settings to optimize the conversion to grayscale while trying to preserve a tonal separation between colors. It's often the case where two colors have considerable color contrast, but upon conversion to grayscale, they end up with almost the exact same grayscale tone. The Auto conversion tries to optimize the separation of colors to tones. In general, it's often close—so close that many times all that is needed is a couple of slider tweaks to finish off what Auto started.

The Split Toning Panel

With only five slider controls, the Split Toning panel (which you access by pressing Command-Option-5) is Camera Raw's simplest set of controls. Some users may think of this panel as a one-trick pony, but its usefulness would prove otherwise. Although many use the options on this panel only for grayscale conversion and to re-create chemical split toning, the adjustments can be used for color images as well. The functionality is pretty simple (see Figure 4-17); you select a color hue and a degree of saturation in Highlights or Shadows or both. Then, depending on the area you want to act as a balance point, you can adjust the Balance to bias the adjustment split lighter or darker.

The original color image

The image with the "default" settings

The image with "Auto" settings

The final adjusted settings

Figure 4-16 The Grayscale subpanel at default.

Figure 4-17
The Split Toning panel.

This example shows the results of applying a warm/cool split tone to grayscale swatches originally photographed on a GretagMacbeth ColorChecker card. This effect is designed to look similar to a traditionally toned silver gelatin print using sepia toning chemicals.

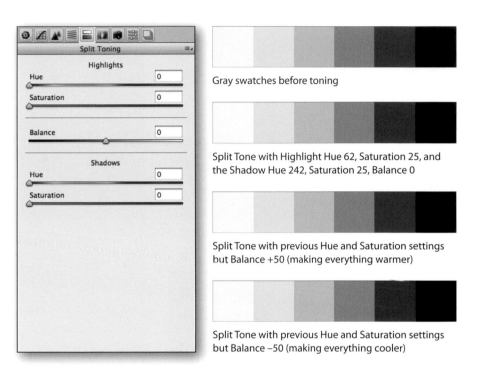

Gray swatches before toning

Split Tone with Highlight Hue 62, Saturation 25, and the Shadow Hue 242, Saturation 25, Balance 0

Split Tone with previous Hue and Saturation settings but Balance +50 (making everything warmer)

Split Tone with previous Hue and Saturation settings but Balance –50 (making everything cooler)

The Lens Corrections Panel

A multitude of lens defects can negatively impact the final quality of photographs. Chromatic aberration and lens vignetting are the only two that Camera Raw's Lens Corrections panel (see Figure 4-18) can help resolve. In addition, certain fringing effects can have a negative impact on digital captures in particular; the color fringing is often found near extreme specular highlights. This effect is often caused by photo site *flooding*—too much exposure at a site flooding over to surrounding sites—or by demosaicing errors. Either or both can cause unwanted color fringe effects when you zoom in on your image. You can access the Lens Corrections panel by pressing Command-Option-6.

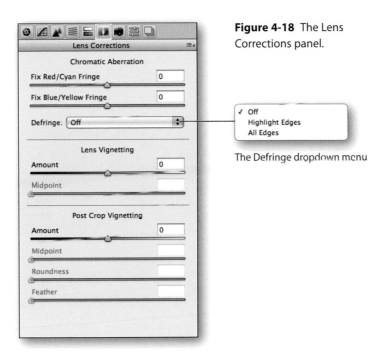

Figure 4-18 The Lens Corrections panel.

The Defringe dropdown menu

The Chromatic Aberration Controls

There are two types of chromatic aberration: one that Camera Raw can work on and one that it can't. Chromatic aberration, where the colors of light can't all be focused on the same plane (the sensor), will result in one type. Camera Raw can't do anything about this.

The type of chromatic aberration that Camera Raw *can* help with is the effect where the lens does focus light at the sensor plane but does so in a manner where the image formed is slightly different in size by color—for example, the Red channel may actually be larger than the other channels. As a result, you'll see color fringing at the corners of your images, particularly with wide-angle and zoom lenses. Even fixed focal length prime lenses may suffer a slight degree of chromatic aberration. So, for best results, you need to address the chromatic aberration. Look back at Figure 4-18 to see the controls; Figure 4-19 illustrates how to adjust the sliders.

Figure 4-19 Fixing chromatic aberration and color fringing.

A small crop of the upper-right corner of an image showing both chromatic aberration and color fringing

Working on the red/cyan fringe

Working on the blue/yellow fringe

The chromatic aberration fixed (to the greatest extent possible)

The results of using Highlight Edges from the Defringe dropdown menu

Fixing chromatic aberration and using All Edges from the Defringe dropdown menu

Remember to concentrate on one slider at a time. To help with this, use the Option (Mac) or Alt (Windows) key to simplify the view. You will notice that even with the chromatic aberration corrections and All Edges on, there is still some very slight fringe—but this is normal. The figure is showing the images at a screen view of 400% to better show the effects in reproduction.

The Lens Vignetting Controls

Many lenses suffer from dark corners for a variety of reasons. Some zoom lenses, because of their extremely complex lens groupings, can't project the image without causing light falloff. Some extreme wide-angle lenses suffer from lens barrel shadows because the lenses are trying to see such a wide angle of view. In either case, light falloff in the corners is common and Camera Raw provides the ability to correct that falloff in the Lens Vignetting controls (see Figure 4-20).

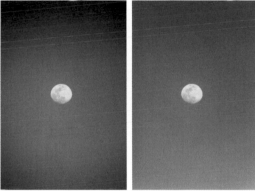

Figure 4-20 Using the Lens Vignetting controls.

Uncorrected lens vignetting

Corrected lens vignetting

Adjusted settings

Amount. Moving the Amount slider to the right lightens the corners and moving to the left darkens them. Darkening the corners is a common creative technique often referred as "hand of god burning," where the center of the image is normally toned and the corners are burned (darkened) down. The Spot Healing, Red Eye, and Lens Vignetting tools are the only methods of adjusting local images in Camera Raw. Note that you apply the lens vignetting correction based on the total image size, not the cropped image. So, if you are cropping the image, the effect is also cropped. This is as it should be for technical corrections of lens vignetting, but it's a problem if a user is using the adjustment to darken the corners.

Midpoint. The Midpoint adjustment varies the area over which the Amount is applied. Adjust to taste. Midpoint is grayed out until the Amount slider is moved from the 0 default setting.

The Post Crop Vignetting Controls

A new set of controls has been added to the Lens Corrections panel, the Post Crop Vignetting controls. They operate on the image after the image has actually been cropped rather than on the entire image as the Lens Vignetting controls do. This is much more a creative tool than a correction tool, but as with any creative endeavor, a little can be good but a lot will not. Figure 4-21 shows how the controls work on an image. This figure shows an image with darkened corners. We could have shown the effect lightening the edges, but while Lens Vignetting is used to lighten the darkened corners, Post Crop Vignetting is more often used to darken the corners to concentrate viewer interest toward the center.

Amount. The Amount setting is just that, the amount of darkening or lightening that will occur in the Post Crop Vignette. We chose a relatively strong -50 setting in Figure 4-21 to make sure the effect would be really visible.

Midpoint. The Midpoint adjustment moves the effect in toward the center or out toward the corner. Often, you'll need to twiddle all the sliders to achieve the final effect you want.

Roundness. This control allows you to adjust how round or oval, or in the extreme, nearly rectangular the resulting effect is applied. A value of -100 will result in almost an image edge-only effect.

Feather. The Feather controls how hard or soft the effect will gradate in and out. Generally, you'll want the effect soft enough so you don't see an obvious start/stop point.

The final result shows moderate use of the controls to provide a gentle darkening of the corners and edges. The best use of this effect is subtle. You should also be aware that the effect is a simplified lightening and darkening, it does not operate using the same Exposure-based adjustment that Lens Vignetting uses so the results will not be the same. Also note that the effect is always exactly centered in the final cropped area of the image. You cannot move the coordinates left/right or up/down. To do that kind of adjustment, you would need to use either the Adjustment Brush or Graduated Filter.

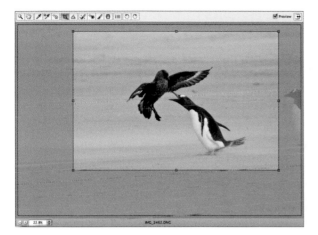

The image cropped before adjustments

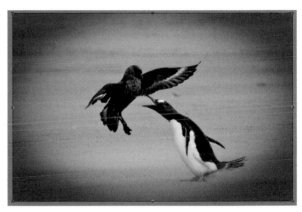

The image with Amount: -50, Midpoint: 35, Roundness: 0 and Feather: 25 settings

The image with Amount: -50, Midpoint: 35, Roundness: 50 and Feather: 25 settings

The image with Amount: -50, Midpoint: 35, Roundness: -50 and Feather: 25 settings

The final adjusted image

The final adjustment settings

Figure 4-21 The Post Crop Vignetting controls.

The Camera Calibration Panel

The controls in the Camera Calibration panel (which you access by pressing Command-Option-7) let you fine-tune the behavior of the built-in camera profiles to tweak for any variations between *your* camera and the one that was used to build Camera Raw's built-in profiles for the camera model (see Figure 4-22).

Figure 4-22 The Camera Calibration panel.

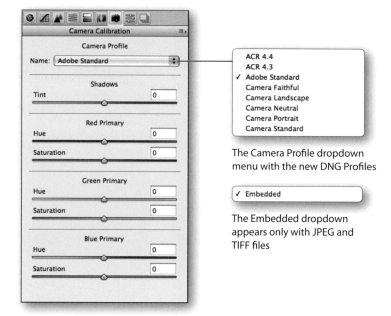

The Camera Profile dropdown menu with the new DNG Profiles

The Embedded dropdown appears only with JPEG and TIFF files

Camera Profile. The Camera Profile dropdown menu displays the version of Camera Raw when the camera was first profiled as well as subsequent updates and the new DNG Profiles for your camera.

The DNG Profiles are automatically picked based on the camera's EXIF metadata. Not all cameras will show all these options, and the naming of the camera-based option will vary based on the naming convention the camera makers use. The options are meant to simulate the camera makers' JPEG rendering based on the settings used on-board the camera. Note, however, that Camera Raw can't automatically pick the profile based on the EXIF metadata so you must manually choose something other than the new Camera Raw 5.2 default of the Adobe Standard profile.

If you have already downloaded and used the previously released beta versions of these profiles, installing Camera Raw 5.2 and the new GM release of the profiles won't change what you've already done. You will need to take

steps to change the profiles. You should consider making presets using only the Camera Calibration subsettings option so you can apply the new profiles easily en masse from within Bridge. If you want to dip your toe in the process of editing DNG Profiles, read the "Using the DNG Profile Editor" section at the end of this chapter.

Non-raw files such as JPEG or TIFF files opened into Camera Raw will have the Embedded profile (the profile that is currently embedded in the image). Files from Sigma cameras will also have the readout set to Embedded.

Figure 4-23 shows applying the Camera Standard profile to simulate the JPEG setting of a Canon 1DsMIII. These shots of Michael Reichmann holding a ColorChecker card were shot using the camera's Raw+JPEG mode while he and Jeff shot together in Niagara Falls, Ontario. So, the camera saved both a raw and JPEG version of the exact same capture. Within the limits of halftone reproduction in CMYK, we think most readers will agree that the raw rendering of the DNG using the Camera Standard profile looks very close to the same image shot in JPEG format.

The JPEG image open in Camera Raw The DNG image after changing the DNG Profile to Camera Standard

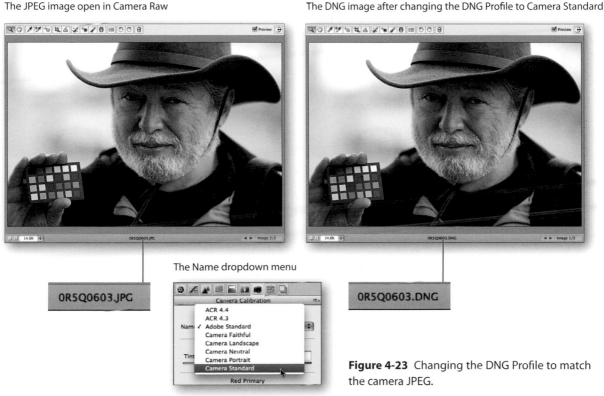

The Name dropdown menu

Figure 4-23 Changing the DNG Profile to match the camera JPEG.

The Camera Calibration Panel Adjustments. Camera Raw can now simulate the color rendering that the cameras produce very accurately. However, you can modify the results of the profiles by further adjustments of the following settings. These adjustments can be used for accuracy as well as creative color rendering.

- **Shadows Tint.** This slider controls the green-magenta balance in the shadows. Negative values add green; positive values add magenta. Check the darkest patch on the target. If it's significantly non-neutral, use the Shadows Tint control to get the R, G, and B values to match as closely as possible—normally, there shouldn't be more than one level of difference between them.

- **Red, Green, and Blue Hue.** These sliders work like the Hue sliders in Photoshop's Hue/Saturation command. Negative values move the hue angle counterclockwise; positive values move it clockwise.

- **Red, Green, and Blue Saturation.** These sliders work like gentler versions of the Saturation slider in Photoshop's Hue/Saturation command. Negative values reduce the saturation; positive values increase it.

The key point to wrap your head around when using the Hue and Saturation adjustments is this: The Red Hue and Red Saturation sliders don't adjust the red value—they adjust the blue and green; the Green Hue and Saturation sliders adjust red and blue; and the Blue Hue and Saturation sliders adjust red and green.

The Presets Panel

TIP Late in the development of Camera Raw 5.2, a new shortcut was added to create a new Preset from the keyboard, Command/Shift P (Mac) or Control/Shift P (Windows) will create a new preset.

You should consider spending some quality time in the Presets panel (see Figure 4-24) because it's key to working efficiently in Camera Raw and Bridge. If you find you are making the same types of adjustments over and over again, you can make your life easier by creating a preset for that condition. Not to be confused with the Camera Raw Default, presets are designed to be broken down by setting groups or individual subsettings. To access the Presets panel, press Command-Option-8. Remember, on Macs, the keyboard shortcut is used by the system unless you change the system preferences.

Figure 4-24 The Presets panel and the New Preset dialog box.

The Subset dropdown menu

The Presets panel

The new Presets button

The New Preset dialog box

Sample Subset selection choosing White Balance

Presets can consist of all settings or, more efficiently, subsettings. When saving a new preset, give it a meaningful name so you know by looking at it what to expect when it's applied. As shown in Figure 4-25, we have a variety of saved presets listed in the panel. Examples vary between camera calibrations (the 1Ds and Rebel presets), clarity settings, and sharpening settings, among others.

Figure 4-25 Saved Presets in Bridge's Develop Settings.

TIP Late in the development of Camera Raw 5.2, a new shortcut was added to create a new Snapshot from the keyboard, Command/Shift S (Mac) or Control/Shift s (Windows) will create a new snapshot.

The reason that saving subsettings is so useful is that you can apply multiple settings, one after the other, to alter the total settings applied to single or multiple files. As long as the subsettings being applied don't overlap, they won't be altered by subsequent subsettings. So, you could apply a camera calibration preset, followed by a clarity setting, followed by additional presets to apply a custom mix of presets. And you can apply these presets either from within the Camera Raw dialog box or from Bridge before ever opening an image in Camera Raw. As shown in Figure 4-25, the presets you create and save also appear in the Develop Settings in Bridge.

The Snapshots Panel

When Camera Raw 5 first appeared in Photoshop CS4, the Snapshots panel didn't yet exist. Well, to be precise, it did exist in the minds of the Camera Raw engineers, but because of timing, it didn't get done in time for the launch of Photoshop CS4. However, they got it done for the release of Camera Raw 5.2, so here it is. To access the Snapshots panel, press Command-Option-9.

Snapshots are multiple saved settings saved as .xmp data either in the raw file's sidecar or within DNG, TIFF, and JPEG images. Figure 4-26 shows the Snapshots panel with a variety of snapshots already saved.

Figure 4-26 The Snapshots panel.

New Snapshot dialog box

The new Snapshot button

When you adjust the settings in a file, you can take a "snapshot" of all the settings that are being applied. This gives you the flexibility to try out new or different adjustments while always being able to come back to the previous settings, even after you close the file and reopen it. Figure 4-26 shows a variety of previously saved snapshots. The obvious ones such as the Color

version and the B&W version make it easy to pop back and forth when you need different rendering. The Lighter tone version and Darker tone version would make it easy to open the same file multiple times for layer stacking or as Smart Objects.

When you click on a snapshot, all the settings stored in the snapshot are applied to the file. You can rename the snapshot by using the context menu (Control-click on Mac, right-click on Windows). Figure 4-27 shows the active snapshot as well as the context menu and the Rename Snapshot dialog box.

Snapshots panel showing the Color Version selected

Selecting Rename from the context menu

The Rename Snapshot dialog box

Figure 4-27 Selected snapshot and renaming.

Once you adjust an image and save a snapshot, it would be nice to be able to change your mind. Well, you can. Even when you've saved a snapshot, if you then make subsequent adjustments that you want to include in the original snapshot without saving a new snapshot, just use the context menu and select the Update with Current Settings option. Figure 4-28 shows the context menu option.

Figure 4-28 The Update with Current Settings option.

The Camera Raw Flyout Menu

Tucked away on the far-right side of the panel is the sometimes obscure flyout menu, where you'll find some really important controls. Some of the items are occasionally grayed out when not in play or relevant, and other controls can have a surprising impact if you don't pay attention. So, look at Figure 4-29 and pay attention.

Figure 4-29 The Camera Raw flyout menu.

Here is an example of what you would see when you have a standard raw image open in Camera Raw without any applied settings.

The menu's top portion contains information and the ability to toggle through several states of your image. In Figure 4-29 we've opened a raw image in Camera Raw. The current state indicates the settings are at the Camera Raw defaults, which means nothing has yet been changed. If the checkmark was alongside the Image Settings, it would indicate that you've made changes that differ from the defaults.

The Previous Conversion option will change the current image's settings to match those of the most recent image opened in Camera Raw. This option can be useful if the current image shares properties with the previously converted image, but it can lead to unpredictable results if the most recently processed image bears no relationship to the current image. The Previous Conversion setting is constantly updated as you work through images.

The Custom Settings changes the moment you alter the settings from the way the image was just opened. The Preset Settings, currently grayed out in Figure 4-29, would show the name of the Camera Raw preset if you had

selected a preset either in Bridge (before opening the image in Camera Raw) or in Camera Raw. So here's the magic decoder ring version:

- **Image Settings.** This option will be checked if the image already had settings when you opened it. If you changed the settings after opening the image, selecting this option will return the settings to the state when the image was last opened.

- **Camera Raw Defaults.** If the image had no settings upon opening, this option will be checked. If, after making adjustments to an image, you want to return to the Camera Raw default settings for this image, select this option.

- **Previous Conversion.** This option will apply settings that match those of the most recent image opened in Camera Raw. This will not be the current image settings but the previous image settings.

- **Custom Settings.** If you make any changes to an image, the Custom Settings will be checked. You can select any of the preceding menu items and toggle between them.

- **Preset Settings.** If you select a Camera Raw preset or a snapshot to apply to the image, the name of that preset or snapshot will be displayed here.

Apply Preset. When you select the Apply Preset flyout menu, you'll get a listing of all the currently saved Camera Raw presets, as shown in Figure 4-30. This list will be the same as the list available in Bridge as well as in the Presets panel. Remember, applying presets is cumulative as long as the settings represent nonoverlapping subsets. In the event any settings overlap, the most recent setting prevails.

Apply Snapshot. If you have saved any snapshots inside the currently opened image, this flyout menu will show the names and allow you to select one to be applied to the image. Also note in Figure 4-31 that "Color Version" is the currently active snapshot.

1DsM2 Adobe Standard
1DsM3 Adobe Standard
Auto-Grayscale
Clarity +15
Clarity +25
Clarity +35
Contrast-Linear
Contrast-Strong
Cross-Processed
Cross-Processed-2
Defringe-All
Defringe-Highlights
Exposure +25
Fill Light +10
Sharpening-High-Frequency-Detail
Sharpening-Landscape
Sharpening-Portrait
Sharpening-Portrait-female
Split-Tone-Brown
Split-Tone-Sepia
Split-Tone-Warm/Cool
test
Vibrance +10
Vibrance +20
Vibrance +30
WB Studio Lighting
White Balance-daylight
White Balance-tungsten

Figure 4-30 The Apply Presets flyout menu showing our previously saved presets.

Figure 4-31 The Apply Snapshot flyout menu showing the image's saved snapshots.

Clear Imported Settings. In Camera Raw 5, this menu choice will be grayed out. It will, however, clear all imported settings when another host, such as Photoshop Elements, doesn't offer controls to make certain adjustments over those controls. This is not the same as the Bridge CS4 Clear Settings command (Edit > Develop Settings > Clear Settings), which does clear all Camera Raw settings.

Export Settings to XMP. The function of this command is similar to that of the main Camera Raw Done button: The current settings in an image will be updated to the XMP metadata either embedded into the file (in the case of DNG, JPEG, or TIFF images) or written in an XMP sidecar file if the image is in a proprietary raw file format.

Update DNG Previews. If the image file that is currently open in Camera Raw is a DNG file, you are given the ability to update DNG previews. Choosing this option opens a dialog box that lets you choose the preview size.

NOTE When you update the DNG Previews, Camera Raw will also embed the DNG profile that is selected in the Camera Calibration panel. For more about this, please see page 96, the Camera Calibration Panel.

Load and Save Settings. Choosing either option opens a dialog box (see Figure 4-32) that allows you to load a specific setting preset that may not be in the Camera Raw Presets folder or to save the file's settings.

Figure 4-32 The Save Settings dialog box.

Choosing the saved settings name and location

The default location for Camera Raw Presets for Mac is:

User/Library/Application Support/Adobe/CameraRaw/Settings

For Windows XP the location is:

Boot drive\Documents and Settings\User Name\Application Data\Adobe\
CameraRaw\Settings

For Windows Vista the location is:

Users\User Name\AppData\Roaming\Adobe\CameraRaw

When saving settings as a preset, you have the same option in this dialog
box as you do in the New Preset dialog box. You select which settings will
be saved if you want to save a subset. After selecting the desired settings,
you'll be prompted to choose a name and location. By default, Camera Raw
enters the filename as the preset name, but unless you want to save the set-
ting for only that image, be sure to give the setting a descriptive name that
will be meaningful to you in a dropdown list.

The Camera Raw Main Buttons

You might assume that the main buttons wouldn't hold any magic clues
or hidden functions. Well, you would be wrong. The main Open, Cancel,
and Done buttons go a bit further than you might expect. As you can
see in Figure 4-33, the main buttons can be in one of eight different
potential conditions.

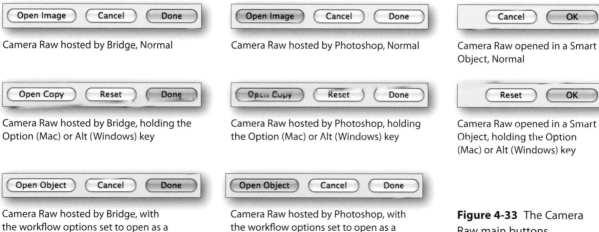

Camera Raw hosted by Bridge, Normal

Camera Raw hosted by Photoshop, Normal

Camera Raw opened in a Smart
Object, Normal

Camera Raw hosted by Bridge, holding the
Option (Mac) or Alt (Windows) key

Camera Raw hosted by Photoshop, holding
the Option (Mac) or Alt (Windows) key

Camera Raw opened in a Smart
Object, holding the Option
(Mac) or Alt (Windows) key

Camera Raw hosted by Bridge, with
the workflow options set to open as a
Smart Object

Camera Raw hosted by Photoshop, with
the workflow options set to open as a
Smart Object

Figure 4-33 The Camera
Raw main buttons.

Since Camera Raw can be hosted as a plug-in from either Bridge or Photoshop, the highlighted buttons are set to indicate which application is currently hosting Camera Raw. Holding down the Option (Mac) or Alt (Windows) key gives you an Open Copy button, which is useful if you want to open an image with different settings and not save the new settings in the metadata. For example, suppose you want to open an image twice: once with a lighter setting and again with darker settings for later blending in Photoshop. Choosing Open Copy will open the image without changing your previous settings. It's also comforting that by default, Camera Raw will auto-resolve filenaming if you need to open the same image multiple times.

If in your Workflow settings you've specified that an image open into Photoshop as a Smart Object, the Open button tells you that by changing to Open Object. Even if you have the Workflow settings set to Smart Object, you can bypass the Smart Object placement and just open the image into Photoshop by holding down the Option or Alt key and clicking Open Copy.

Filename

If you have already made a Smart Object using Camera Raw and you reopen the Smart Object to edit the settings, you will see a third variant of the Camera Raw buttons from inside the Smart Object file.

Image count in filmstrip mode

Figure 4-34 Filename and Image count.

Continuing on our round-the-horn tour are two small and relatively minor (but useful nonetheless) items: the Filename of the currently open image and, when in the filmstrip mode, an indicator of how many images you currently have opened in Camera Raw and the ability to navigate between those images. Figure 4-34 shows both items.

The Workflow Options

On the main Camera Raw interface, the blue info readout at the bottom of the window is a readout of the current settings and also acts as a button to access the Workflow Options dialog. Figure 4-35 shows the readout that is also a button. Camera Raw 5.2 has received some new functionality and a new dialog box (see Figure 4-36).

Camera Raw can be configured to output into Photoshop or save images via the Save button. These processed images can be in a variety of color spaces, bit depths, sizes, and resolutions, and optionally be Smart Objects in Photoshop.

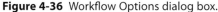

ProPhoto RGB; 16 bit; 3456 by 2304 (8.0MP); 300 ppi

Figure 4-35 Workflow settings info readout/button.

Adobe RGB (1998)
ColorMatch RGB
✓ ProPhoto RGB
sRGB IEC61966-2.1

Space dropdown menu

1536 by 1024 (1.6 MP) –
2048 by 1365 (2.8 MP) –
3072 by 2048 (6.3 MP) –
✓ 3504 by 2336 (8.2 MP)
4096 by 2731 (11.2 MP) +
5120 by 3413 (17.5 MP) +
6144 by 4096 (25.2 MP) +

Size dropdown menu

✓ None
Screen
Glossy Paper
Matte Paper

Sharpen For dropdown menu

Low
✓ Standard
High

Sharpen Amount dropdown menu

✓ Adobe RGB (1998)
ColorMatch RGB
ProPhoto RGB
sRGB IEC61966-2.1
Gray Gamma 1.8
Gray Gamma 2.2

Space dropdown menu (with Gray Gamma options)

8 Bits/Channel
✓ 16 Bits/Channel

Depth dropdown menu

✓ pixels/inch
pixels/cm

Units dropdown menu

Figure 4-36 Workflow Options dialog box.

Space. Camera Raw can output into one of four color spaces or two grayscale spaces. The grayscale spaces will only appear in the dropdown menu when you have Convert to Grayscale selected in the HLS/Grayscale panel, and you don't have any color options enabled, such as Split Toning or a local color tint.

Depth. You can choose to process into either 8 bits/channel or 16 bits/channel, as shown in Figure 4-36.

Size. Camera Raw is capable of resizing the original image size to a fixed number of output sizes based on optimized resampling algorithms. Whether you resample in Photoshop or Camera Raw, the results should be very similar. However, for exact resampling, Photoshop offers more options. The size readout is measured in megapixels (MP) and pixel dimensions only, not image size (see Figure 4-36).

Units. While here in the United States the inch rules, most of the world uses the metric unit, so this is where you can show your "unit colors."

NOTE With the update to Camera Raw 5.2, the interpolation algorithms used in Camera Raw have been changed (and substantially improved). We'll cover this improvement in 5.2 in the next chapter: Just make note of the fact it's no longer considered to be inadvisable to resize now in Camera Raw 5.2.

Sharpen For. New to Camera Raw 5.2 is the ability to do output sharpening for print and screen. Originally introduced in Lightroom 2.0, the output sharpening is based on a collaboration between Adobe and PixelGenius, and incorporates Bruce's sharpening workflow thoughts now available in Camera Raw. It should be noted that sharpening for output should only be done in the size you are opening in Photoshop or saving in a batch Saver operation as the final size of the intended image. If you plan on doing any additional sizing in Photoshop, you should not apply sharpening at this stage. The options for Screen apply to any image that will be viewed on a display—be it a computer display or video. The options for print are divided between Glossy and Matte papers, and are designed for inkjet or photo lab prints, not halftone CMYK output.

Sharpen Amount. If you have sharpening set to None, this menu option will be dimmed. If you do choose to use sharpening, you can select from one of three strengths. We almost always use Standard because the sharpening here in output is tied to the capture sharpening in the Detail panel (and we're pretty good at nailing the capture sharpening), so we really don't seem to need to vary this setting. But it's there in the event you do.

Open in Photoshop as Smart Objects. New to Photoshop CS4 and Camera Raw 5 is the ability to specify in Camera Raw that you want to open a raw file as a Smart Object (see Figure 4-36). This option allows you to make subsequent adjustments to the image while keeping the image unrendered until you flatten it. We'll cover the use of Camera Raw as a Smart Object in Photoshop in the next chapter, *Hands-On Camera Raw*.

The Save Button

If you've already discovered the benefit of using Camera Raw's Save button batch capability, you can skip ahead but with a warning: If you do review this section, you might pick up a thing or three that may make it worth the effort. For those who've never used this functionality, listen up—this is something you should factor into your workflow.

Clicking the Save button brings up the Save Options dialog box, shown in Figure 4-37. This dialog box gives you the opportunity to select a file destination, name, and format. We'll provide an item-by-item breakdown to make sure you understand each and every option.

Figure 4-37 Click the Save button to open the Save Options dialog box.

Destination. The Destination option (see Figure 4-37) allows you to either save the processed file in the same folder as the original or navigate to a different folder. This setting is sticky until changed.

File Naming. If you need to change the processed name to a different file naming convention, this option will allow you to add up to four naming tokens or custom fields to the original filename, as shown in Figure 4-37. If you choose to add a renumbering option, you can alter the starting number. The maximum custom renaming fields is four. If you need more extensive renaming, you can do so after the save process in Bridge.

File Extension. This dropdown gives you the option of uppercase or lowercase file extensions. Note that when you change the extension, the file format options will be set to that file format's options.

File Format. Camera Raw can save processed files in four different formats: Digital Negative (DNG), JPEG, TIFF, and Photoshop PSD (see Figures 4-38 through 4-41). Ironically, that means you can save a JPEG or TIFF file you may have opened in Camera Raw as a linear gamma DNG file. Is it raw? Well, no. The JPEG has already been converted to a gamma-encoded color space, and you can't get the toothpaste back into the tube. You can open a 16 bit/channel TIFF image and save it as DNG, and you may find some useful benefit. But again, it will be a linear gamma, not a true raw DNG file.

The File Format Options by Format

Digital Negative. The Digital Negative (DNG) options (see Figure 4-38) allow you to use lossless compression (almost always a good idea), convert to linear (not a good idea unless you need a linear file), and choose the size of the embedded DNG preview. If the file you are converting is a proprietary raw file, you can choose to embed the original raw file into the DNG.

Figure 4-38 DNG format options.

JPEG. The JPEG format option (see Figure 4-39) gives you the ability to alter the compression settings. Keep in mind that the processed JPEG will contain an embedded profile and all the embedded metadata. So if you are planning on using the processed JPEGs on the Web, they won't be the smallest sizes. Photoshop's Save for Web will do better.

Figure 4-39 JPEG format options.

TIFF. The TIFF options (see Figure 4-40) offer either no compression or ZIP compression in 16-bit or None, ZIP and LZW in 8-bit mode.

Figure 4-40 TIFF format options.

PSD. An interesting option for the Photoshop (PSD) file format (see Figure 4-41) is the ability to preserve cropped pixels upon opening in Photoshop. To access the cropped pixels in Photoshop, select Image > Reveal All.

Figure 4-41 Photoshop format options.

When processing images in Camera Raw in the filmstrip mode, Camera Raw provides a progress countdown, as shown in Figure 4-42. Figure 4-42 also shows how the Save button looks when you hold down the Option (Mac) or Alt (Windows) key. Holding the Option key allows Camera Raw to save images with the last set of save options while bypassing the Save dialog box. If you are serious about saving time, this is a good timesaver because Camera Raw will continue saving images and lining up additional images for a Photoshop processing queue. In fact, you can even go back to Bridge, open more images, adjust their settings, and keep adding additional images to the processing queue.

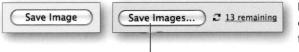

Figure 4-42 Progress countdown when in filmstrip mode.

Save button when Option (Mac) or Alt (Windows) key is pressed

This batching capability is something even Photoshop's Batch processor or Bridge's Image Processor can't do. Camera Raw provides a powerful processing workflow all by itself (well, with Photoshop working away in the background).

Camera Raw Batch Save Workflow

While the grandfather of all automation processes is the Photoshop Batch feature (and Image Processor also gets a good workout), many people don't appreciate the potential time savings that the Save button can offer. So we take a moment to explain another way Save can be useful.

A lot will depend on how quickly you need to edit a shoot. If you are like us, time is often of the essence. Once we open selected images in Camera Raw, we scroll down in the Camera Raw filmstrip mode and make image adjustments as needed. We set up the Workflow Options and the Save dialogs with the format and the save-to location and any renaming or sequence numbering needed. When we finish adjusting one image, we click on the Save button, and then move on to adjust the next image. When we're done with that image, we Option-click the Save button, and move on to the next image. Now, as we adjust subsequent images, in the background Camera Raw is processing and saving the previously adjusted images. The result is when we're done adjusting all the images, we have a folder of processed images waiting for us. That's when the Done button in Camera Raw really means you are done!

Granted, it's not as powerful as Photoshop's Batch. Nor can you process out multiple file iterations like you can in Image Processor. But this batch-save workflow does give you one thing neither of the other processes does—the ability to multitask. So when time really matters, try this alternative workflow. You might be surprised just how fast you can be.

The Zoom Control

Camera Raw will respond to the typical keyboard commands used in Photoshop for zooming. Pressing Command (Mac) or Ctrl (Windows) plus the + or – keys will zoom in or out, respectively. But as you resize the Camera Raw dialog box, it's useful to set the Zoom setting (see Figure 4-43) to Fit in View (the keyboard command is Command-0). Remember that to be able to see the effects of the Detail panel, you must be zoomed to at least 100% (Command-Option-0 or Ctrl-Alt-0). Camera Raw also uses only main fraction zooms such as 66%, 50%, and so on, and no infinite subfractions.

Figure 4-43 Zoom menu.

The Camera Raw Toolbar

We're in the home stretch, folks, so hang in there. The last big set of controls for Camera Raw resides in the main toolbar. Figure 4-44 shows the tool name and keyboard shortcut for each tool. There are three new and very important tools. One major change in Camera Raw 5 is that all the tool options have now moved to their own panels, which take the place of the adjustment panels.

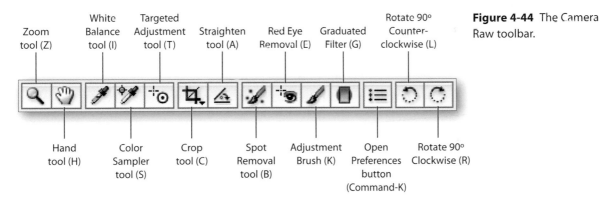

Figure 4-44 The Camera Raw toolbar.

While it could be argued that almost everything in Camera Raw is a tool, the Camera Raw toolbar is the location for what are referred to as "tools." However, for certain functions relating to white balance, cropping, and retouching, this is where you'll turn. Another function of the toolbar is to give you access to Camera Raw's Preferences, which offer critical control over the way Camera Raw behaves. Wherever possible, we suggest using the keyboard commands to make working in Camera Raw as efficient as possible. It should also be noted that by default, when first opening Camera Raw, the default tool selected is the Zoom tool because nothing you do in that tool will actually make a change in your image.

Zoom and Hand Tools

Zoom tool. By default, this tool is considered Camera Raw's home tool. It's the tool that is preselected whenever you launch Camera Raw. It's also considered a "safe tool" in that nothing you do with it will impact your image, only the display of your image. Holding down the Option (Mac) or Alt (Windows) key turns the Zoom tool into the unzoom tool. Dragging a marquee selection on your image will zoom to fill that area in the preview window.

Hand tool. As you might expect, the Hand tool allows you to move the image around in the preview window when zoomed in. Holding down the spacebar will turn any other tool into the Hand tool as long as the spacebar is held down.

White Balance Tool

As shown in Figure 4-45, the White Balance tool allows you to sample an area in your image to determine the optimal white balance settings. Clicking on an area in your image will instruct Camera Raw to set the Temperature and Tint settings to achieve a technically correct white balance setting of Neutral. This is only a starting point; you are free to make further adjustments for effect, but the White Balance tool is useful to establish a technically correct starting point.

When Thomas Knoll designed the white balance adjustment in Camera Raw, he sampled a standard-sized ColorChecker card under two illuminations: D65 and Standard Illuminate A (2850°K). He used the second-to-brightest swatch as the white balance sample point, as shown in Figure 4-46. As a result, if you can include a CC card in your shot, you will have access to the same tools Thomas used. But that's not always convenient, is it? Alternatively, you can use any nonspecular neutral in your image. If you try to use an area in your image that has one or more channels clipped, you'll receive the warning shown in Figure 4-47 telling you it's too bright.

Figure 4-45 The White Balance tool.

The original image

The original White Balance settings before adjustment

The White Balance dropdown menu

Selecting an area in the image to sample

The result of clicking on the image area

Manual adjustment warmer

The warning when Camera Raw is hosted by Photoshop

The warning when Camera Raw is hosted by Bridge

Figure 4-46 The reference swatch used to determine Camera Raw's white balance.

Figure 4-47 The White Balance Error warning.

If you receive this error, look for another area to sample. Trying to adjust white balance using a gray that is too dark is not advised. Since you are working primarily with a linear capture when white balancing raw captures, a middle gray is too far down the tone scale to provide an optimal amount of image data to evaluate. A "graycard" that has traditionally been used by photographers in the past should be avoided because it's too dark, and gray-cards aren't noted for their neutrality. Third-party white balance cards are available whose spectral neutrality have been tested and found to be par-ticularly useful when used as a white balance sample point for Camera Raw. WhiBal cards from www.rawworkflow.com and WarmCards from www.warmcards.com are two popular options.

Regardless of how you first establish your white balance settings, it's impor-tant to understand that "technically correct" and "visually correct" may require different settings. White balancing a warm sunset to be neutral will perhaps be technically correct but visually wrong. We will have examples of when and why you would want to alter the white balance for effect in the next chapter.

Color Sampler Tool

The Color Sampler tool provides persistent color samples where you place them. They are persistent only for that single session in Camera Raw. You can place up to nine individual color samplers, as shown in Figure 4-48.

Figure 4-48 The Color Sampler tool with multiple samples set.

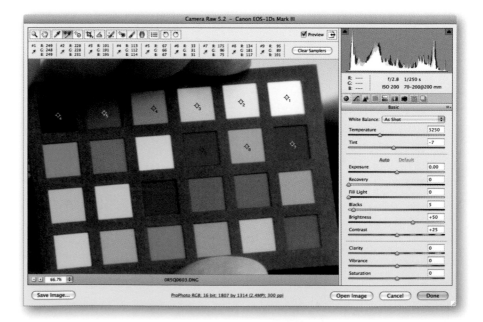

The color samplers are different from the cursor-based RGB readouts in that they are fixed at 5x5 actual image pixels. That way, the readings will be consistent throughout Camera Raw's zoom range. To place them accurately, be sure to zoom in to 100%. The readings respect the Workflow settings and will read out in whatever color space is set there. Once placed, you can move them by clicking on the sample and dragging. To remove them, click the Clear Samplers button.

Targeted Adjustment Tool (TAT)

Originally introduced in Lightroom, the Target Adjustment tool (or TAT for brevity) is a new feature for Camera Raw. The TAT gives users the ability to adjust parameters by simply clicking on the image and mousing up or down to adjust the parameter. The area of the image dictates what parameter will be adjusted. Figure 4-49 shows an exploded view of using TAT on an image to adjust the Parametric Tone Curves and the HSL/Grayscale panels. You can access the TAT by selecting the Targeted Adjustment tool dropdown menu and directly choosing which adjustment panel to activate.

Parametric Tone Curves TAT Adjustment. The TAT will default to adjusting the Parametric Tone Curves regardless of what panel may be visible with the exception of the HSL/Grayscale panel. So, even when you are in the Basic panel, clicking on the TAT tool activates the TAT adjustments in the Parametric panel, even though you still have access to the Basic settings.

To adjust one of the Parametric settings, click on a portion of the image and while holding down the mouse button, push the mouse up or down to increase or decrease the settings. If you have the Parametric Tone Curves panel visible, you can see which setting is active and watch as the settings go up or down. Figure 4-49 shows all four of the Parametric Tone Curves settings being used. The lighter area of the sign activated the Lights parameter. The wooden area toward the bottom engaged the Darks, and the darker portion of the pelican's neck activated the Shadows. The head activated the Highlights.

TIP The sampler behavior is slightly different between the White Balance sampler and the Color Sampler tool. While the Color Sampler tool is fixed to 5x5 image pixels regardless of your zoom, the White Balance tool is 5x5 up to a 100% zoom and remains at 5x5 screen pixels when zoomed higher. So, for the White Balance tool you can zoom into an image to 200–400% and increase the effect accuracy of the sample. Personally, we wish this was also the behavior of the Color Sampler tool as well. Maybe in the next Camera Raw version.

Figure 4-49 Using the TAT.

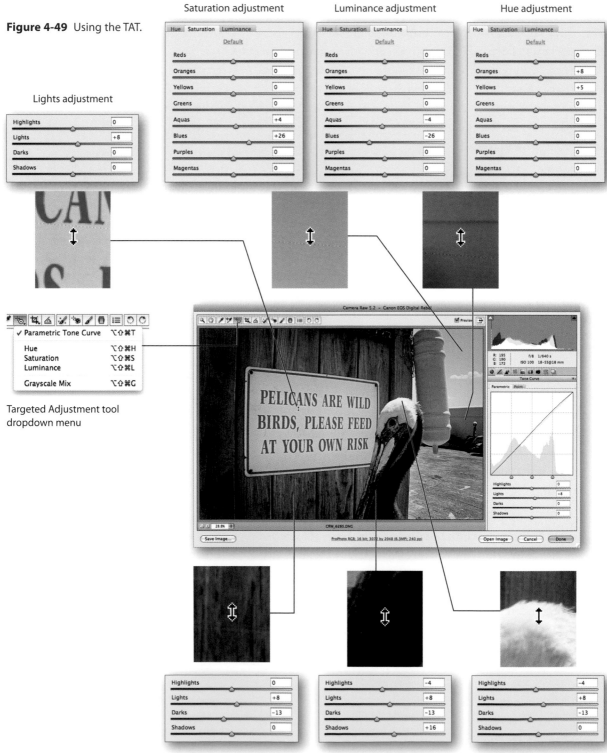

Saturation adjustment

Luminance adjustment

Hue adjustment

Lights adjustment

Targeted Adjustment tool
dropdown menu

Darks adjustment

Shadows adjustment

Highlights adjustment

HSL/Grayscale TAT Adjustments. To use the TAT in HSL/Grayscale, the panel must be visible. Since the default TAT behavior is to use the Parametric curve in all other panels, the user must designate the change of that default. Switching to HSL/Grayscale does that. In Figure 4-49, the TAT was used to adjust the blue sky Saturation as well as the Luminance. The blue saturation was increased and darkened. Then the mustard color Hue was adjusted to be less orange.

You should note that the TAT can also be used when you engage the Convert to Grayscale mode of the HSL/Grayscale panel. Whether you use the TAT for tone or color adjustments, this new usability greatly aids the speed in which you can make critical adjustments. Activating the relevant panel, you simply click in the area of the image you want to adjust and slide the mouse up or down to make the changes. This is good stuff!

Crop and Straighten Tools

The Crop and Straighten tools are just two variations of the same tool. The Crop tool is used to set the image pixels that will be processed by Camera Raw. You can drag out a marquee selection to set the crop and use command keys to alter the behavior of the marquee selection. Holding the Shift key allows you to constrain to a current crop proportion, whereas holding the Option (Mac) or Alt (Windows) key allows the crop to move in or out from the center. See Figure 4-50 for basic crop and straighten tasks. Also note that there is a new behavior after applying a straighten and crop; the resulting preview in Camera Raw (and in the thumbnails in filmstrip mode) reflects the results of those tools.

The Crop tool has some hidden power for those who examine the options shown in Figure 4-51. When you click on the Crop dropdown menu, you can access standard cropping ratios or enter your own custom crop ratio. If you specify the ratio in pixels, you can enter a maximum of 65,000 in either dimension (this will give the effect of upsampling to the maximum size of 512 megapixels) to the image upon processing. The Straighten tool is a semi-modal and related state of the Crop tool that allows you to draw a line to use to calculate the rotation of the horizon line. By default, the rotation will "down-crop" your image to fit into the image area since Camera Raw can't add new pixels to your image. As soon as you release the line, the Crop tool is reselected. You can manually rotate the crop after doing the autostraighten.

Figure 4-50 The Crop and Straighten tools.

Using the Straighten tool option to find a straight line

Image showing Crop tool handles

The resulting cropped image with straighten and crop applied

Figure 4-51 Crop tool drop-down menu and options.

The Crop tool dropdown menu

Custom Crop dialog box

Crop unit options

Warning for maximum crop entry

To remove the crop from the image, either select the Clear Crop command in the Crop tool dropdown menu or click anywhere outside the image preview area in the canvas. If you are zoomed in, only the dropdown menu can be used to remove the crop. If you process your image using the Save function in Camera Raw and process the image to a PSD format, you can undo the crop after the fact in Photoshop.

Spot Removal Tool

The Spot Removal tool (Figure 4-52) provides the ability to do local spot healing and cloning when you need to remove those nasty sensor spots or that blemish on a person's face. In this regard, it competes directly with Photoshop for some quality brush time. But in reality, Camera Raw is not designed to offer extensive retouching capabilities; use it only to remove the occasional sensor spot or facial blemish.

There is a fine line but it's pretty definitive: If you have the exact same spot in the exact same location in your image, you will be a lot better off fixing it in Camera Raw if you can and then sync it across as many images that have that spot. However, if you need to spend considerable time spotting, cloning, or otherwise substantially retouching an image, you'll be better off waiting until after Camera Raw to do so.

As shown in Figure 4-52, the Spot Removal tool lets you set points for either healing or cloning. Healing uses a texture-based source to apply Photoshop's healing logic to adjust the tone and color to blend in the surrounding area of the destination spot. Cloning just moves pixels without the blending logic. The image in Figure 4-52 has a lot of sensor spots on it. It was shot in Antarctica, one of the driest and windiest places on Earth. As such, it's a great place to test the sensor-cleaning skills of photographers. As you can see, the sensor was not very clean (which makes it useful for this example).

After deciding whether you want to heal or clone, place the cursor over the area you want to spot and click. If you click and hold, you can drag the spotting circle to make it larger or smaller. You can also use the brush size control in the interface, but we rarely use that.

Camera Raw uses logic to try to find the best source from which to heal. It's right about three out of four times. In this example, it was wrong. It located an area that was discontiguous with the gradations in the image. By selecting the source circle, you can move it until the gradations align. By selecting the edge of the circle, you can alter the size of the circle. You can select previous spots by clicking on them to alter them. Pressing the Delete key will remove them. You can check your progress by deselecting the Show Overlay option at the top.

Figure 4-52 The Spot Removal tool.

Heal or Clone
dropdown
menu

Spot Removal tool options panel

Placing a
healing spot

Camera Raw's
Autodetection

Adjusting the
source spot

Adjusting the
destination
spot size

Also be aware that healing or cloning is a cumulative process. This means that the order of the healing or cloning will build up the effect. You can start small and add additional larger spot points to build a retouching effect. You can also adjust the opacity of a healing or cloning spot. The Opacity slider allows you to adjust how much of the healing or cloning is blended into the resulting spot. See Figure 4-53. The opacity adjustment is more useful for retouching than spotting because you want to obliterate spots. When retouching a person's face, you may only want to soften a blemish or mole, and the Opacity slider can offer that option.

The default 100% opacity

Opacity reduced to 4%

Figure 4-53
Adjusting opacity.

Spot Healing result

Spot Healing result with reduced opacity

Once you have the sensor spots cleaned for a single capture frame, you can synchronize those spots to additional frames. When doing so, Camera Raw follows these rules: If the Spot Removal tool has autodetected the area on its own, it will autodetect in subsequent images while allowing the autodetect to be based on that subsequent image's unique parameters. If you move the source spot after autodetection, the Spot Removal tool will respect the moved destination and use those same coordinates for syncing.

In practice, this seems to work very well—most of the time. However, even if you let Camera Raw autodetect the optimal source location and it's correct for one image, it may not be correct for subsequent images. So, make a habit of double-checking images that you've synced to confirm that the source and destination healing or cloning is correct.

For spots that move around in an image (for example, a blemish on a person's face), there is no way of syncing multiple images. That sort of job requires image-by-image evaluation and retouching. You should also question whether the best results will be provided by Camera Raw or after the fact in Photoshop. In Camera Raw there is no manual blending or opacity control; either it works or it doesn't. That said, being able to do parametric retouching is an impressive accomplishment for Camera Raw.

Red Eye Removal Tool

The Red Eye Removal tool is another one-trick-pony feature that some people may question, but when you have a shot that contains red eye, you'll appreciate the ability to remove it. Truth be told, it was difficult to find a shot that contained red eye. In over 1 TB of files representing over 90,000 raw images, this is the only example we could find (see Figure 4-54). The shot is of Mac Holbert (left) and Graham Nash (right) at their gallery opening in Seattle. Mac and Graham are partners in Nash Editions, a premiere fine art printing studio. (By the way, you should also check out *Nash Editions: Photography and the Art of Digital Printing*, ISBN 0-321-31630-4.)

Figure 4-54 Red Eye Removal tool.

Main image panel Tool options panel

Placing the pupil selection marquee over the eye

The Red Eye Removal tool's "guess"

The red eye removal result

When the Red Eye Removal tool works, it's great. And it works pretty well most of the time. The key is to not be shy about locating the eye (don't try to be too precise). It's better to draw out the marquee as large as you can. Camera Raw's red eye logic will work to find the eye inside the marquee area and then locate and remove the red. The default Darken setting is 50%. If that value makes the pupil too dark, you can reduce it. You can also alter the pupil size on the slider adjustment. We've found the Red Eye Removal tool useful when the eye size is relatively small (as it often is when shooting groups and you get red eye on several people from the on-camera flash). Unfortunately, it doesn't do much for a cat's or dog's eyes, which may be glowing different colors than red.

The Adjustment Brush

Yes Virginia, there really is a Santa Claus (and he lives in Ann Arbor, Michigan). One of the biggest bits of news for Lightroom 2.0 was the Adjustment Brush because not only did it usher in a new expanded scope of raw image editing, but it's doing so as a nondestructive parametric edit. Well, Camera Raw 5 now has the same set of local adjustments that Lightroom 2.0 unleashed. Figure 4-55 shows the various parameters available in the Adjustment Brush.

Using the Adjustment Brush in Camera Raw shares some passing similarities with Photoshop, but there are some fundamental differences. First and foremost, when painting with the brush, you aren't painting adjusted pixels into the image but instead are modifying a mask through which the adjustments will be processed. In this regard, it shares a closer resemblance to painting in an Adjustment Layer mask. You can paint and then erase the mask. It's common for us to paint large, soft paint strokes and then zoom into the image to erase the mask with a smaller and more precise brush. You should also understand that while you may start by setting a single adjustment parameter, you can go back and add additional adjustments and continue to tweak the original adjustments. In point of fact, it's optimal to adjust as many parameters with a single mask or "pin" as possible because adding many, many new single parameter adjustment masks will slow things down.

Figure 4-55 The Adjustment Brush and options.

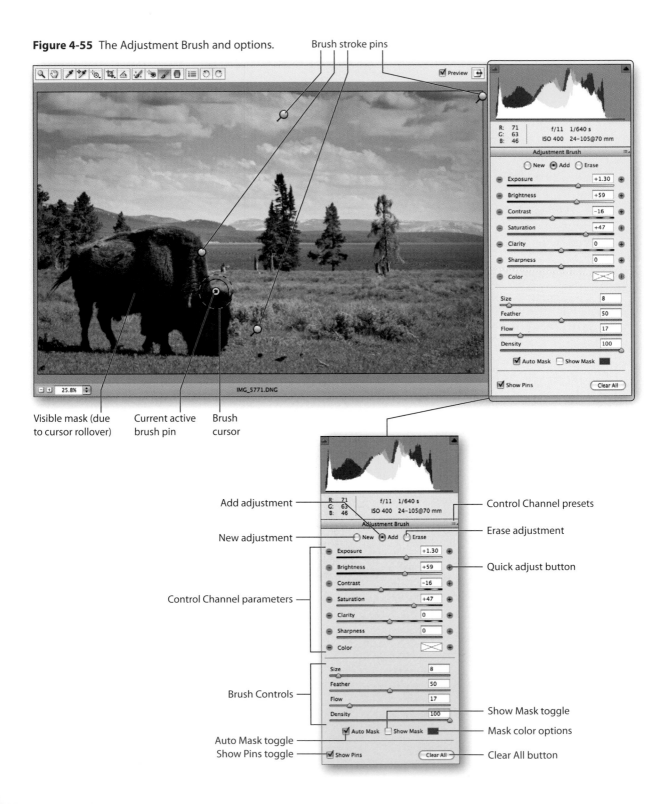

Brush stroke pins

Visible mask (due to cursor rollover)

Current active brush pin

Brush cursor

Add adjustment

New adjustment

Control Channel parameters

Brush Controls

Auto Mask toggle

Show Pins toggle

Control Channel presets

Erase adjustment

Quick adjust button

Show Mask toggle

Mask color options

Clear All button

When you do add additional masks, pins are put on the image. The pins are considered a single discrete mask made up of multiple dabs or strokes and indicated by the pin shape. Clicking on a pin activates the mask and parameters for editing either. All of the mask particulars such as opacity and stroke coordinates are stored along with the adjustments as metadata in the file or file's sidecar.

While the Adjustment Brush is a really cool new tool for the nondestructive adjustment of raw files, you should not anticipate the Adjustment Brush as providing a complete replacement for Photoshop. There will be many tasks more suited to Photoshop's strengths. While possibly doable in Camera Raw, some tasks might not make good workflow sense when doing final high-quality digital imaging. That caveat presented, what you can do with the Adjustment Brush and its related tool the Graduated Filter can greatly improve a raw processing workflow and substantially reduce the amount of time spent in Photoshop.

Control Channels. When making a local adjustment by brush or gradient (the Graduated Filter has the same controls), you select one of the seven control channels offering adjustments. These channels are not a one-to-one match with the similarly named controls offered elsewhere in Camera Raw. The results will be similar, to be sure, but the control channels are tuned for use locally rather than their global cousins.

In Figure 4-56, the tool options for the controls are shown. When starting, you'll begin by either clicking one of the quick set buttons (the + and - circles at either end of the sliders) or grabbing a slider to make the adjustment. After you've applied a brush stroke, the options change from New to Add. This allows additional channels or the original to be adjusted. When you hold down the Option (Mac) or Alt (Windows) key, the additive brush turns into an Erase brush, allowing you to delete portions of the painted mask. Once you've made an adjustment, you can click one of the quick set buttons to pick a new primary adjustment and start a new brush stroke.

TIP If you click on a New brush, it will inherit the last used settings, which may or more likely may not be what you want. We find it useful to click the quick adjust buttons to add a new mask and deselect all the other previous used settings in one click.

Figure 4-56 Adjustment Brush tool control channels and options.

The control channels when adding a new brush adjustment

The controls after an adjustment that allows adjusting parameters

The controls toggled to the Erase mode

Additional channels adjusted

Using the quick setting button

Control Channel Presets. If you find that you're constantly making the same sort of adjustment with the same settings on multiple channels, you should consider making a Control Channel Preset. Why fight the sliders if you already have a preset saved? Figure 4-57 shows one preset already saved named "Skin smoother," which is a combination of + 17 Brightness, -12 Contrast, -30 Clarity, and -42 Sharpness. This preset will gently lighten and decrease contrast in skin while adding negative Clarity and negative Sharpness. This is useful for smoothing skin tones.

To make a new preset, make the adjustments you want to have in the preset (including the color) and select the New Local Correction Setting option in the flyout menu. When you select it, you'll be prompted to name and save the preset (also shown in Figure 4-57).

Skin smoother saved preset

New Local Correction Setting menu command

New Local Correction Preset dialog box

Control Channel Preset flyout menu in the
Graduated Filter tool options

Figure 4-57 Control Channel Presets.

When you save a preset in the Adjustment Brush, the exact same preset will also be available in the Graduated Filter menu, which is a duplicate of this flyout menu. So, what you create in one tool option is available in both.

The Paint Brush Sizing. Camera Raw's brushes are not a fixed pixel size; they are a relative size based on the pixel dimensions of your image. Thus, a size setting of 100 will be the maximum allowed size based on your image.

The size set to 50

The size set to 10

The minimum size (no brush cursor shown, only a crosshair)

The maximum size of 100

Figure 4-58 Brush sizing.

Setting the size to 50 will be 50% of the maximum and so forth until you get to the smallest size. Figure 4-58 shows the relative sizing based on the maximum and minimum for this image.

Brush Feather. Not unlike Photoshop's brushes, you can change the softness and hardness of a brush. Remember that what you are painting is the mask not the adjustment. The brush cursor indicates the current softness by showing an inner more solid line (where the dab will be applied at the full amount of the Flow/Density setting) and an outer circle where the dab drops off to nothing. Figure 4-59 shows different amounts of feather.

Figure 4-59 Brush feathering.

Feather of 100 Feather of 50 Feather at 0

Brush Flow. The Brush Flow modifies how strong the mask will be applied and the resulting buildup of strokes. A low Flow allows you to sneak up on the strength of the resulting effect. So, you can adjust the control parameters to be stronger and then gently apply the effect by using a lower Flow setting and more strokes. Figure 4-60 shows the subtlety of various Flow settings.

Figure 4-60 Brush Flow settings.

Flow 20 Flow 40 Flow 60 Flow 80

Density vs. Flow. While both Density and Flow will modify the opacity of the resulting painted mask, they do so in a different manner. Flow modifies the gentle buildup of strokes; Density sets a maximum threshold of opacity for those strokes. Figure 4-61 shows the difference.

Figure 4-61
Density vs. Flow.

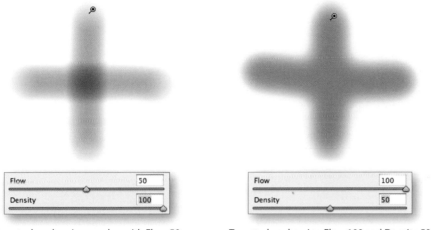

Two strokes showing overlap with Flow 50
and Density 100

Two strokes showing Flow 100 and Density 50

As you can see, a reduced Flow at full Density will result in a buildup in those areas where the strokes overlap. With a Density setting of 50, the maximum density of the resulting strokes will be limited to 50. So, in use, when you're trying to build up an effect, and you do want the overlap to build up, you would use a higher Density with a lower Flow. Where you want to paint in an area that needs a specific mask opacity, the Flow matters less than the threshold set in Density.

Brush stroke and Mask relationship. When you paint a stroke, a pin is added and you'll see the results of the current control parameters. Sometimes it's difficult to know where you have and haven't painted, so you can use the Show Mask toggle or hover the brush cursor over the pin; either will make the mask visible. Figure 4-62 shows a stroke and the stroke's mask.

Figure 4-62 Brush stroke
and mask.

The normal view showing the brush stroke

The view showing the mask

There are options to adjust the color and how the mask is previewed. Clicking on the mask color options brings up a Color Picker that allows you to choose the color that the mask will be shown in and whether the preview will be of the Affected or Unaffected areas. Figure 4-63 shows the mask color options.

Figure 4-63 Mask color options.

The Mask color option dialog box showing a green preview at about a 50% opacity and set to preview the Unaffected Areas

The resulting mask preview set to green

Erasing the Mask. After the mask has been painted in, you can go back into the mask and, while holding the Option (Mac) or Alt (Windows) key, "unpaint" or erase the mask. Figure 4-64 shows erasing a smaller part of the center of the existing paint stroke.

Figure 4-64 Erasing a mask.

Erasing a portion of the stroked mask

Showing the resulting mask

Auto Mask. When you use the Auto Mask option while painting, the mask is generated based on the color and tone of the image area under the center of the cursor when painting is started. This allows you to paint in an area and automatically have the mask set to the shape of the object you paint into. Figure 4-65 shows an example of an area with an Auto Mask.

Image before adjustment

Image after adjustment

Image showing the Auto Mask

Figure 4-65 Using the Auto Mask.

The trick is to make sure the center of the brush cursor remains inside the area where you want the mask to be painted. Note that the Auto Mask option works when erasing a mask, so if you go over an area a bit, you can use it to help erase the over paint.

The Graduated Filter

Using the same set of control channels as the Adjustment Brush, the Graduated Filter allows you to draw out a gradation over which the adjustments are applied. Figure 4-66 shows a diagram of the parts.

The diagram shows you some elements that would not be visible at the same time. For demonstration purposes, we've included the cursor icons for rotate, move and adjust all in one figure. Normally, you would only see a single cursor.

As you do with the Adjustment Brush, you choose single or multiple controls to adjust and then drag out a gradation over which the adjustments will be applied. Rather than the pins of the Adjustment Brush, a Graduated Filter displays lines where green always indicates the starting point and red indicates the ending point. While it's tempting to place many different adjustment filters, doing so will slow down Camera Raw. Each Graduated Filter along with the parameters are stored as metadata in the file or sidecar file. So this is also a nondestructive edit. Ideally, if you need multiple adjustments, deploy as many adjustments in a single filter as you can.

Figure 4-66 The Graduated Filter in use.

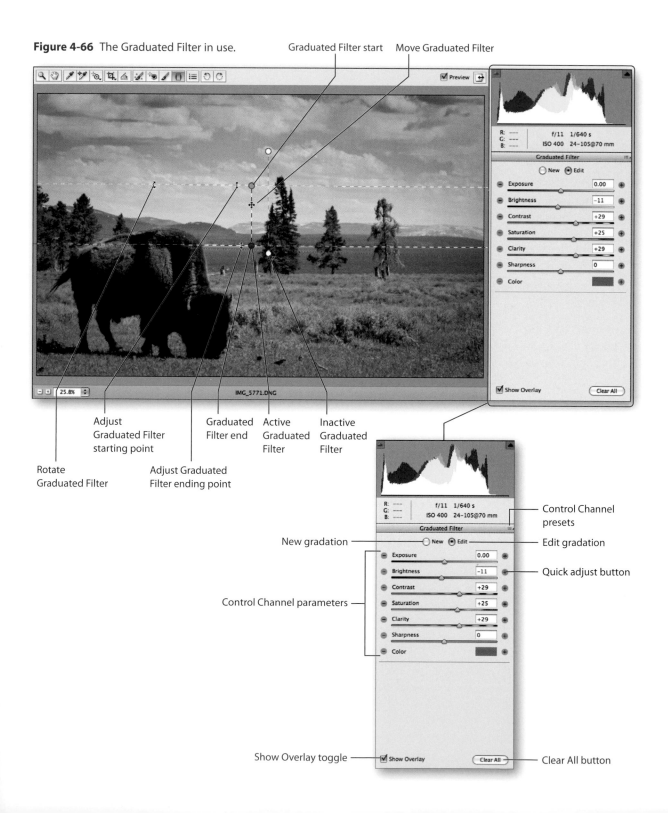

The example in Figure 4-67 shows how to use the Graduated Filter and the Adjustment Brush combined to optimize an image's tone and color. Figure 4-67 shows the image before and after the adjustments.

Figure 4-67 Graduated Filter and Adjustment Brush—before and after.

Globally optimized before local adjustments

After local adjustments

As you can see, Camera Raw 5 with local adjustments can be used to substantially improve your image. Figures 4-68a through 4-68d show step by step how the Graduated Filter and Adjustment Brush tools were combined to do the adjustments.

Figure 4-68a Step by step using the Graduated Filter and Adjustment Brush.

Graduated Filter darkening the sky and adding clarity

Exposure	−0.60
Brightness	−13
Contrast	0
Saturation	0
Clarity	+15
Sharpness	0
Color	

Graduated Filter that increased the sky contrast, saturation, and clarity as well as adding blue color

Exposure	0.00
Brightness	−11
Contrast	+29
Saturation	+25
Clarity	+29
Sharpness	0
Color	

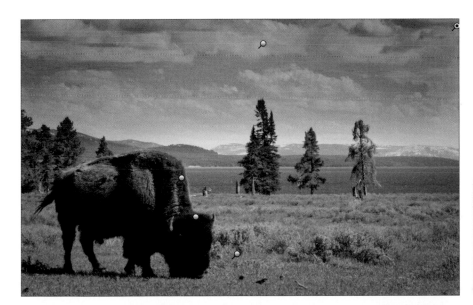

Figure 4-68b Step by step using the Graduated Filter and Adjustment Brush.

Adjustment Brush to add more clarity to sky

⊖ Exposure	0.00	⊕
⊖ Brightness	0	⊕
⊖ Contrast	0	⊕
⊖ Saturation	0	⊕
⊖ Clarity	+50	⊕
⊖ Sharpness	0	⊕
⊖ Color	☒	⊕

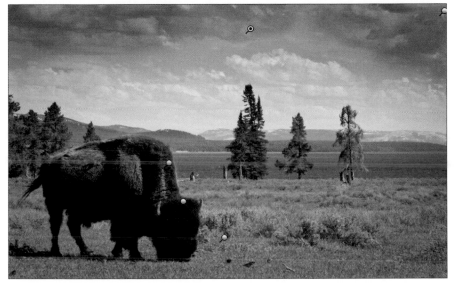

Adjustment Brush to lighten clouds

⊖ Exposure	+0.50	⊕
⊖ Brightness	+10	⊕
⊖ Contrast	0	⊕
⊖ Saturation	0	⊕
⊖ Clarity	0	⊕
⊖ Sharpness	0	⊕
⊖ Color	☒	⊕

Figure 4-68c Step by step using the Graduated Filter and Adjustment Brush.

Adjustment Brush to add green to grass

Adjustment Brush to lighten the buffalo shadows

Figure 4-68d Step by step using the Graduated Filter and Adjustment Brush.

Adjustment Brush to add saturation, clarity, and color to the buffalo

When combining the Adjustment Brush and Graduated Filter, there is no function that currently allows you to use the brush tool on a gradient. So, if a Graduated Filter darkens an object too much, you'll need to use an Adjustment Brush to bring back the color or tonality that the filter over-corrected. This was done to the clouds in the sky (Figures 4-68a and 4-68b) that were darkened too much when the Graduated Filter darkened the sky. You should also be prepared to go back to various adjustment panels to make global corrections where needed. To give you an idea of the time it took to do this series of adjustments, it took about 10 minutes after the global adjustments were made.

Some people may wonder why the local adjustments can't be used to create templates. At this point in time, you can move a Graduated Filter to fine-tune for image-by-image variation, but the Adjustment Brushes can't. Thus, the usefulness of applying local adjustments can't really be easily applied to multiple images. You can, however, use the local adjustments when syncing multiple images. Figure 4-69 shows the steps to sync local adjustments.

Figure 4-69 Synchronizing Local Adjustments.

The selected image's adjustment mask

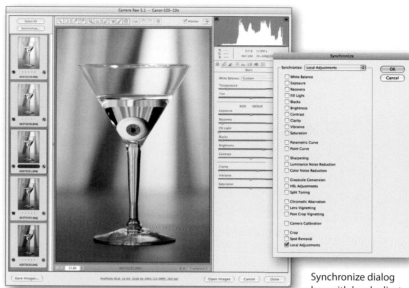

Camera Raw in filmstrip mode with five images selected

Synchronize dialog box with local adjustments selected

TIP We often find that while syncing Graduated Filters seems to work well (partially because filters can be moved), Adjustment Brush syncing is less likely to be useful unless the brush strokes are so generalized that they happen to register across all the images. Also note there is a "gotcha" in that since there is no way to separate the two local adjustments in a sync operation, you may need to work on Graduated Filters, apply them in a sync, and then work image by image with the Adjustment Brush.

The selected image had an Adjustment Brush with the settings of -100 Saturation to completely desaturate the background and another to increase the saturation of the eye. After selecting all five images, the Synchronize button was clicked to bring up the Synchronize dialog box with Local Adjustments selected. This synced all the images with the local adjustments, which worked well because the image was shot using a tripod with no movement between shots.

Color Picker. The one topic that we haven't yet covered in depth is the Camera Raw Color Picker. If you are familiar with Photoshop's Color Picker, that won't do you much good in Camera Raw because it's different. The Color Picker is available in the Adjustment Brush and in the Graduated Filter control channel settings. To access the Color Picker, click the color swatch icon as shown in Figure 4-70.

Once you have the main Color Picker dialog box open, you select a color either in the color spectrum or in the color swatch subpanel. You can save up to five different colors in the subpanel. Once the color is selected, you can adjust the saturation of the resulting color tint.

Selecting the Color Picker

Accessing a saved
color swatch

Figure 4-70 The Camera
Raw Color Picker.

The main Color Picker dialog box

Adjusting the current color's saturation

One limitation of the Color Picker at this point (that we hope will be
addressed in the future) is that you can't grab a color sample from your
image. This adversely impacts the Color Picker's usability. But, once you
have a color selected, you can add that color to the color swatch subpanel for
later use. Figure 4-71 shows adding a new color to the swatch subpanel.

Color Picker dialog box with new color selected

Adding a new color
to the swatches

Figure 4-71 Adding a new
color swatch.

New color added and color is updated
in the Control Channel panel

To add a new color, hold down the Option (Mac) or Alt (Windows) key to
access the paint bucket filler. Once added, it will also update the color in the
swatch on the Control Channel panel. The color selected is persistent when
you switch between the Adjustment Brush and Graduated Filter.

Camera Raw Preferences

Setting Camera Raw preferences is a relatively boring subject, but having control over the preferences is essential to making Camera Raw behave in a predictable and consistent manner. When you get unexpected results, it's useful to check the preferences (see Figure 4-72) to make sure they are set as desired. Unlike in other applications, Camera Raw's preferences are not prone to corruption. So, while it may be typical to reset preferences in Bridge or Photoshop, it's unlikely you'll need to do so in Camera Raw.

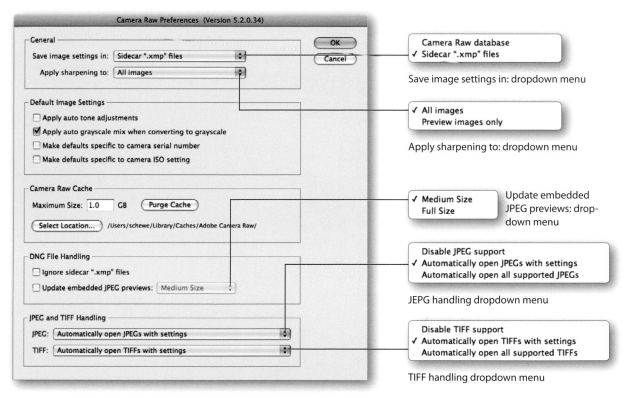

Figure 4-72 The Camera Raw preferences.

You'll note in Figure 4-72 that Camera Raw 5 has some different preferences available. The main Preferences dialog box contains the version number in its title. The preferences are grouped by function and include General, Default Image Settings, Camera Raw Cache, DNG Handling, and JPEG and TIFF Handling. We'll cover each group separately.

General. The General preferences (see Figure 4-72) allow you to control the way Camera Raw deals with its image-setting metadata and whether to apply sharpening to images or only to previews.

Where to save the image settings is important if you ever need to move your images (for example, from a laptop to a workstation). To be honest, we're not really sure there is a good use case for not storing the image settings with the images, but the option is there should you find one. Our preference is to always save the image settings to the XMP metadata either in sidecar files if you are using proprietary raw files or embedded into the DNG, JPEG, or TIFF files since Camera Raw can safely write the XMP into those formats.

Whether or not you want to apply the sharpening settings in Camera Raw to your processed images or only the image previews is the next choice you need to make. In the past, many users didn't choose to use Camera Raw's image sharpening and thus wanted to defer sharpening to a later time. However, it was useful to at least apply sharpening to the previews of images—hence the option. Since Camera Raw 5 has substantially improved sharpening, we suggest using it. Therefore, you'll want to make sure the option is set to All Images.

Default Image Settings. In this section of the preferences (see Figure 4-72) you can choose how Camera Raw will behave regarding its default image settings. Some people found it incredibly difficult to change Camera Raw 3's Auto settings, so now there's a single place to set this default behavior. If you want Camera Raw to always determine the tone adjustments, simply select the Apply Auto Tone Adjustments checkbox. If you often use exposure bracketing, you'll want to deselect this option.

Apply Auto Grayscale Mix When Converting to Grayscale is indeed useful since Camera Raw generally does an excellent initial job. Usually, you'll only need to tweak a color or two to optimize the auto settings further. We keep this selected.

The next two options are pretty powerful. Camera Raw 5 has the ability to make different Camera Raw default image settings based on your camera's serial number and the EXIF embedded ISO setting. For example, if you have two or more camera bodies of the exact same model, you may find the sensors in the bodies to be slightly different. You can then run a camera calibration for each body and set the respective calibration to be active based on the camera's serial number.

Additionally, if you want to have a certain degree of luminance noise reduction set based on the camera ISO, you can now do so. The key in each of these options is to open an image from either a camera with the correct serial number or whose ISO setting is set to the one you want to adjust. Make your adjustments as desired, and then in the Camera Raw flyout menu (see Figure 4-23), select the Save New Camera Raw Defaults command. This will update the Camera Raw defaults for either that camera serial number, that ISO, or both. If you want to remove these new defaults, select Reset Camera Raw Defaults in the flyout menu to return the defaults to Camera Raw's original defaults.

Camera Raw Cache. Camera Raw creates its own cache of image previews to make working with images more efficient. Accessing the same images over and over without a cache would force Camera Raw to generate a new preview from scratch each time. So, Camera Raw instead keeps track of a limited number of image previews and can serve them up when the image is opened in Camera Raw. Depending on your image capture size, these preview files can grow to a rather large size. Most previews are in the 4–5MB file size range. You can see that opening a lot of images could rack up a lot of image preview files. As a result, Camera Raw allows you to set a limit and change the location of where it stores the cache files (see Figure 4-72).

If you have lots of free space on your hard drive, you might want to give Camera Raw a higher limit. If you choose to locate them on a removable drive and that drive is removed, at the next launch, Camera Raw will re-create a cache file in the default location and forget about the cache file in the removable drive.

DNG File Handling. When you are working with DNG files, Camera Raw offers a couple of important options to consider. You can choose to ignore DNG sidecar files (see Figure 4-72). Some applications, rather than writing to the DNG file, will place the XMP metadata in a sidecar file. If you then use a product that does write XMP to the file, you end up with a metadata collision. Which contains the correct metadata about the image, the image file or the sidecar file? The Ignore Sidecar ".xmp" Files option allows you to tell Camera Raw to ignore any DNG sidecar files and only pay attention to the embedded XMP metadata.

In addition, when you change the image settings for a DNG image file, you can choose whether or not to update the embedded JPEG preview, and if you do decide to update, what size to use when updating (see Figure 4-72).

Generally, we feel it's a good idea to always update the embedded preview when working with DNGs.

JPEG and TIFF Handling. When Photoshop CS3 and Camera Raw 4 were released, this option for Camera Raw was, to put it mildly, very confusing. There were multiple locations in Camera Raw, Bridge, and Photoshop where behavior preferences were stored. Camera Raw 5 takes care of that confusion by always being in charge of this behavior.

There are now three options each for JPEG and TIFF images, and you can be assured that changing them will disable or enable the proper behavior by setting the preferences here in Camera Raw 5. We suggest that if you want to use Camera Raw and Lightroom in a single workflow, you may want to be sure that the Automatically Open JPEGs (or TIFFs) With Settings option is selected. This will enable a workflow back and forth between files in Lightroom with settings and files in Camera Raw.

Also, keep in mind that if you have installed any third-party camera software for the handling of raw files, the camera company's software can conflict with Camera Raw's ability to access those files—hence, the Photoshop CS4 preference Prefer Adobe Camera Raw for Supported Raw Files. This option tells Photoshop and Camera Raw to ignore the "other" plug-in and use Camera Raw for supported raw files. See Figure 4-73 for the Photoshop CS4 preference setting that enables Camera Raw to ignore other raw processing plug-ins.

Figure 4-73 Photoshop's preference option to allow Camera Raw to override a third-party plug-in's raw handling.

You might think that everything you could possibly want to know about Camera Raw controls has been covered. Well, almost. There's one additional icon that you may see from time to time: the Camera Raw Warning icon. This warning will appear whenever Camera Raw is in the process of creating an accurate pixel preview of your image. While this warning is displayed (see Figure 4-74), what you are seeing in the preview area of Camera Raw's main dialog box is a low-resolution preview, not the final pixel-accurate preview. Depending on the speed of your computer, you may or may not see

Figure 4-74 The Camera Raw Warning icon.

this warning very often. It's more likely to be visible when you are working with several images loaded in the Camera Raw filmstrip mode and with individual images with multiple local adjustments. And speaking of filmstrip mode, some additional commands are available when working in filmstrip mode. We'll cover those in depth in the next chapter.

The Camera Raw Keyboard Commands

We use keyboard commands wherever possible to make working in Camera Raw more efficient. However, it's always a challenge to remember each and every little possible combination, so in the following charts we've laid out every known keyboard shortcut we're aware of.

Camera Raw Keyboard Shortcuts for Macintosh (single-image mode)

Command	Shortcut
Reset Camera Raw Preferences	Cmd-Opt-Shift and double-click on raw image
Apply Auto Tone Adjustment	Cmd-U
Cancel Auto Tone	Cmd-R
Undo/Redo Toggle	Cmd-Z
Multiple Undo	Cmd-Opt-Z
Multiple Redo	Cmd-Shift-Z
Reset Image Adjustment Settings	Opt-click and click Reset button
Open Image	Cmd-O
Open Copy	Cmd-Opt-O or click Open Copy button
Save Image	Cmd-S
Save Image (bypass dialog box)	Cmd-Opt-S or Option Save
Zoom Out	Cmd-minus sign
Zoom In	Cmd-plus sign
Zoom to Fit	Cmd-0 (zero)
Zoom tool 100%	Cmd-Opt-0 (zero)
Navigate down through image	Page Down
Navigate up through image	Page Up
Temporary Zoom In tool	Cmd-click in Preview
Temporary Zoom Out tool	Opt-click in Preview

Command	Shortcut
Temporary Hand tool	Spacebar
Temporary White Balance tool	Shift
Open Basic panel	Cmd-Opt-1
Open Curves panel	Cmd-Opt-2
Open Detail panel	Cmd-Opt-3
Open HSL/Grayscale panel	Cmd-Opt-4
Open Split Tone panel	Cmd-Opt-5
Open Lens panel	Cmd-Opt-6
Open Camera Calibration panel	Cmd-Opt-7
Open Presets panel	Cmd-Opt-8
Open Snapshots panel	Cmd-Opt-9
Zoom tool	Z
Hand tool	H
White Balance tool	I
Sample tool	S
Targeted Adjustment tool	T
Crop tool	C
Straighten tool	A
Spot Removal tool	B
Red Eye Removal tool	E
Adjustment Brush	K
Graduated Filter tool	G
Camera Raw Preferences	Cmd-K
Rotate 90° counterclockwise	L or Cmd-[(left bracket)
Rotate 90° clockwise	R or Cmd-] (right bracket)
Preview Adjustments on/off	P
Toggle Full Screen on/off	F
Highlight Clipping on/off	O
Shadow Clipping on/off	U
Display Clipped Highlights	Opt-drag Exposure/Recovery

NOTE A late breaking addition to the keyboard commands (the engineers like to change things right up to the last moment) was added for the Targeted Adjustment Tool (TAT). The following keyboard commands (for Mac) can be used to activate the TAT and:

Command	Shortcut
switch to parametric curve TAT	Cmd-Opt-Shift T
switch to Hue TAT	Cmd-Opt-Shift H
switch to Saturation TAT	Cmd-Opt-Shift S
switch to Luminance TAT	Cmd-Opt-Shift L
switch to Grayscale mixer TAT	Cmd-Opt-Shift G

continues on next page

Camera Raw Keyboard Shortcuts for Macintosh (single-image mode) *continued*

Command	Shortcut
Display Clipped Shadows	Opt-drag Shadow
Preview Sharpen Effects (Detail)	Opt-drag Amount/Radius/Detail/Mask
Preview Split Tone Effects	Opt-drag Hue/Balance
Hide Blue/Yellow Fringe (Lens) panel	Opt-drag Red/Cyan
Hide Red/Cyan Fringe (Lens) panel	Opt-drag Blue/Yellow
Increase/Decrease Clone/Heal] and [(right and left bracket)
Add Point to Curve	Cmd and click in Preview
Deselect Point in Curve	D
Select Next Point in Curve	Ctrl-Tab
Select Preview Point in Curve	Ctrl-Shift-Tab

Camera Raw Keyboard Shortcuts for Macintosh (filmstrip-image mode)

Command	Shortcut
Move Up One Image	Up Arrow or Cmd-Left Arrow
Move Down One Image	Down Arrow or Cmd-Right Arrow
Select All	Cmd-A
Deselect All	Cmd-Shift-A
Select Rated Images	Opt Select All
Synchronize (bypass dialog box)	Opt Synchronize
Select First Image	Home
Select Last Image	End
Add to Selection (Discontiguous)	Cmd-click image
Add to Selection (Contiguous)	Shift-click last image
Delete Selected Image	Cmd-Del (Delete or Backspace)
Assign * Rating to Image	Cmd-1
Assign ** Rating to Image	Cmd-2
Assign *** Rating to Image	Cmd-3
Assign **** Rating to Image	Cmd-4
Assign ***** Rating to Image	Cmd-5

Command	Shortcut
Decrease Rating *	Cmd-, (comma)
Increase Rating by *	Cmd-. (period)
Assign Red Label to Image	Cmd-6
Assign Yellow Label to Image	Cmd-7
Assign Green Label to Image	Cmd-8
Assign Blue Label to Image	Cmd-9
Assign Purple Label to Image	Cmd-Shift-0 (zero)

Camera Raw Keyboard Shortcuts for Windows (single-image mode)

Command	Shortcut
Reset Camera Raw Preferences	Ctrl-Alt-Shift and double-click on raw image
Apply Auto Tone Adjustment	Ctrl-U
Cancel Auto Adjustment	Ctrl-R
Undo/Redo Toggle	Ctrl-Z
Multiple Undo	Ctrl-Alt-Z
Multiple Redo	Ctrl-Shift-Z
Reset Image Adjustment Settings	Ctrl-click and click Cancel button
Open Image	Ctrl-O
Open Copy	Ctrl-Alt-O or Alt-click
Save Image	Ctrl-S
Save Image (bypass dialog box)	Ctrl-Alt-S or Alt-click Save
Zoom Out	Ctrl-plus sign
Zoom In	Ctrl-hyphen
Zoom to Fit	Ctrl-0 (zero)
Zoom tool 100%	Ctrl-Alt-0 (zero)
Navigate down through image	Page Down
Navigate up through image	Page Up
Temporary Zoom In tool	Ctrl-click In Preview
Temporary Zoom Out tool	Alt-click in Preview

continues on next page

NOTE A late breaking addition to the keyboard commands (the engineers like to change things right up to the last moment) was added for the Targeted Adjustment Tool (TAT). The following keyboard commands (for Windows) can be used to activate the TAT and:

Command	Shortcut
switch to parametric curve TAT	Ctrl-Alt-Shift T
switch to Hue TAT	Ctrl-Alt-Shift H
switch to Saturation TAT	Ctrl-Alt-Shift S
switch to Luminance TAT	Ctrl-Alt-Shift L
switch to Grayscale mixer TAT	Ctrl-Alt-Shift G

Camera Raw Keyboard Shortcuts for Windows (single-image mode) *continued*

Command	Shortcut
Temporary Hand tool	Spacebar
Temporary White Balance tool	Shift
Open Basic panel	Ctrl-Alt-1
Open Curves panel	Ctrl-Alt-2
Open Detail panel	Ctrl-Alt-3
Open HSL/Grayscale panel	Ctrl-Alt-4
Open Split Tone panel	Ctrl-Alt-5
Open Lens panel	Ctrl-Alt-6
Open Camera Calibration panel	Ctrl-Alt-7
Open Presets panel	Ctrl-Alt-8
Open Snapshots panel	Ctrl-Alt -9
Zoom tool	Z
Hand tool	H
White Balance tool	I
Color Sampler tool	S
Targeted Adjustment tool	T
Crop tool	C
Straighten tool	A
Spot Removal tool	B
Red Eye Removal tool	E
Adjustment Brush	K
Graduated Filter tool	G
Camera Raw Preferences	Ctrl-K
Rotate 90° counterclockwise	L or Ctrl-[(left bracket)
Rotate 90° clockwise	R or Ctrl-] (right bracket)
Preview Adjustments on/off	P
Toggle Full Screen on/off	F
Highlight Clipping on/off	O
Shadow Clipping on/off	U
Display Clipped Highlights	Alt-drag Exposure/Recovery

Command	Shortcut
Display Clipped Shadows	Alt-drag Shadow
Preview Sharpen Effects (Detail)	Alt-drag Amount/Radius/Detail/Mask
Preview Split Tone Effects	Alt-drag Hue/Balance
Hide Blue/Yellow Fringe (Lens panel)	Alt-drag Red/Cyan
Hide Red/Cyan Fringe (Lens panel)	Alt-drag Blue/Yellow
Increase/Decrease Clone/Heal] and [(right and left bracket)
Add Point to Curve	Alt-click in Preview
Deselect Point in Curve	D
Select Next Point in Curve	Ctrl-Tab
Select Preview Point in Curve	Ctrl-Shift-Tab

Camera Raw Keyboard Shortcuts for Windows (filmstrip-image mode)

Command	Shortcut
Move Up One Image	Up Arrow or Ctrl-Left Arrow
Move Down One Image	Down Arrow or Ctrl-Right Arrow
Select All	Ctrl-A
Deselect All	Ctrl-Shift-A
Select Rated Images	Alt Select All
Synchronize (bypass dialog box)	Alt Synchronize
Select First Image	Home
Select Last Image	End
Add to Selection (Discontiguous)	Ctrl-click image
Add to Selection (Contiguous)	Shift-click last image
Delete Selected Image	Ctrl Del (Delete or Backspace)
Assign * Rating to Image	Ctrl-1
Assign ** Rating to Image	Ctrl-2
Assign *** Rating to Image	Ctrl-3
Assign **** Rating to Image	Ctrl-4
Assign ***** Rating to Image	Ctrl-5

continues on next page

Camera Raw Keyboard Shortcuts for Windows (filmstrip-image mode) *continued*

Command	Shortcut
Decrease Rating by *	Ctrl-, (comma)
Increase Rating by *	Ctrl-. (period)
Assign Red Label to Image	Ctrl-6
Assign Yellow Label to Image	Ctrl-7
Assign Green Label to Image	Ctrl-8
Assign Blue Label to Image	Ctrl-9
Assign Purple Label to Image	Ctrl-Shift-0 (zero)

DNG Profile Editor

DNG Profile Editor

Previous versions of Camera Raw forced a user to alter the camera calibration adjustments to account for their particular camera's variations. That capability remains, but the requirements to do so have been largely eliminated. Starting with Camera Raw 4.5 in Photoshop CS3 and continuing with Camera Raw 5 in Photoshop CS4, support for Adobe's new DNG Profiles has been added. The DNG Profiles are a new addition to the DNG Specification that allows for a new type of camera profile to be used with both raw files and DNG converted raw files. To be precise, they are not ICC type profiles, which are designed to be output referred. The DNG Profiles are designed to be scene referred, which is better for the raw processing pipeline because they deal with the color the camera has captured instead of the output colors as regular ICC profiles do.

To introduce the DNG Profile concept, Adobe released beta versions of the profiles in the summer of 2008. Part of this initiative also included the release of a free profile-editing application made available at labs.adobe.com. The DNG Profile Editor allows altering certain existing DNG Profiles that were included in the Camera Raw 5.2 update as well as the custom profiles.

The DNG Profile allows you to choose one of a variety of color rendering profiles included with Camera Raw 5.2. These profiles are designed to replicate the camera maker's own processing looks for various on-camera settings or post processing through the camera maker's software. Each camera

model will have slightly different options, but the default camera JPEG rendering is called Camera Standard. The available profiles will be automatically chosen based on your camera's model number. You cannot choose a different camera profile other than the camera model in the file's EXIF metadata.

Because of this new capability, we have decided to remove the more labor-intensive camera calibration technique made popular by Bruce Fraser back when Camera Raw started. We will make the entire RWCRCS3 section written by Bruce available as a PDF on realworldcameraraw.com. For this edition we will concentrate on exploring the use of these DNG Profiles and the DNG Profile Editor.

> **NOTE** The DNG Profile Editor will be maintained as a free download utility available on the Labs site. It will not be released in combination with any other applications or Camera Raw updates.

Using the DNG Profile Editor

The DNG Profile Editor is a free application available for both Mac and Windows as a download from labs.adobe.com. After you download the application, you will need to convert the proprietary raw file you want to use as a basis for editing to a DNG file. The DNG Profile Editor can only open and work with DNG files. Figure 4-75 shows how to open a DNG image.

Figure 4-75 Opening a DNG converted raw file.

Once you have the image open, you'll need to decide which profile to use for editing. You'll always need to edit an existing DNG profile. The Adobe Standard profile will always be an editable profile (some third-party developers may release profiles where editing is disabled). Figure 4-76 shows the main DNG Profile Editor interface and a DNG image open.

Figure 4-76 The DNG Profile Editor.

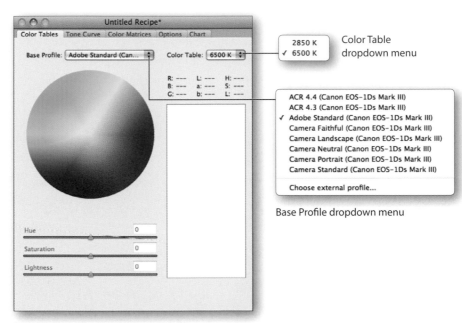

Color Table dropdown menu

Base Profile dropdown menu

DNG Profile Editor application window

DNG image preview window

After selecting the Base Profile and which Color Table to edit, you click on an area in an image that you want to adjust. Figure 4-77 shows moving the eyedropper cursor to the red swatch of the ColorChecker card. Also note that while moving the cursor around the image, you get color readouts in the main application window.

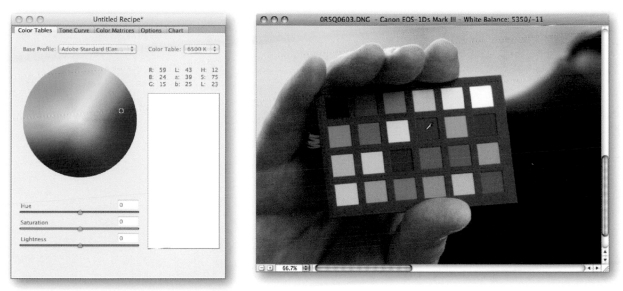

Figure 4-77 Selecting colors to edit.

Color Tables. The first tab in the application is the Color Tables tab, which is designed to edit the color rendering of the profile. The DNG Profile Editor is not designed to be a color correction tool. While you can edit the color and tonality in an image, you should concentrate on editing the color rendering. You can add as many color edits as you want, but there will be a diminishing return. The more edit points you add, the less smooth the profile will render colors. In no case should you add 20 or more points. That will inevitably introduce coarse color rendering that will probably lead to posterization in your image. Generally, we suggest restricting color edits to primary colors only unless you need to fine-tune a client's specific product color. In the past, Jeff has shot for Budweiser and knows that the company is very particular about the color of its logo type. Using the DNG Profile Editor to edit the red rendering of raw captures would be a useful function. Figure 4-78 shows editing the Red Hue and the Blue Saturation and Lightness.

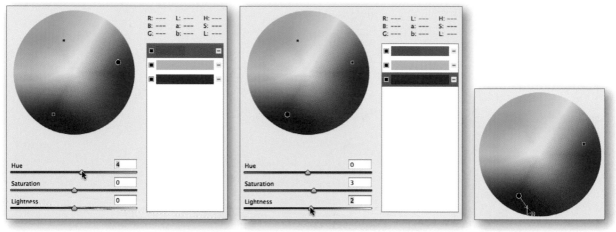

Editing the Red Hue Editing the Blue Saturation and Lightness Moving the color coordinate

Figure 4-78 Editing color rendering.

To edit a color swatch, click on the specific color to highlight it. Clicking the – button will remove the color. When you click the solid box on the left of the swatch, the active color has a highlighted spectral indicator. You can edit the color by using the slider. Dragging the color coordinate changes the color sample starting point. We find this to be a bit coarse and prefer the sliders for accuracy. The sliders also allow the use of the scrubby slider, or you can highlight a text field and use the Up/Down arrow keys. Adding the Shift key moves in units of 5 instead of 1. The color swatch also displays a before/after of the unedited and edited color. The image preview is also updated to show the result of the color edits.

Tone Curve. The Tone Curve tab allows you to alter the base tone curve applied by the edited profile. If you find that you are constantly making the same sort of tone curve edit in Camera Raw, you might want to consider editing the profile's tone curve. We don't suggest making image-specific tone curve adjustments, so this would only apply if the overwhelming majority of your images need the exact same tone curve adjustments. Figure 4-79 shows the Tone Curve tab.

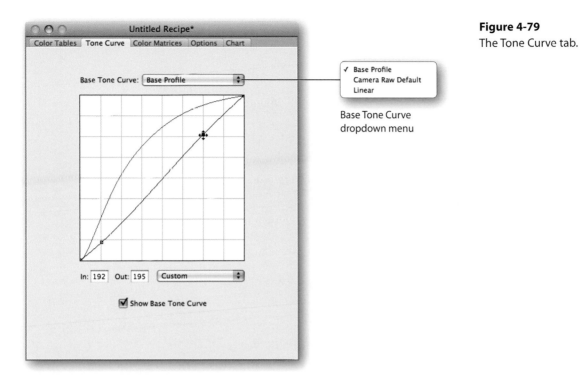

Figure 4-79
The Tone Curve tab.

The Tone Curve works in a similar manner to Camera Raw's point curve editor. Clicking in the image will place a point on the curve to edit. The arrow keys will move the point by a single unit, whereas the Shift key moves in units of 10. The curve edit is previewed in the image window. We suggest only very subtle and camera profile-specific edits, not image corrections that are better suited inside Camera Raw.

Color Matrices. The Color Matrices tab is a replication of the Camera Raw Camera Calibration panel. You can combine a color table and a color matrix edit in your profile, although overdoing either can produce less useful results. There are useful creative effects that can be accomplished in this tab such as a cross-curve color effect. The notable addition to this tab over Camera Raw is the ability to edit the White Balance Calibration, which can't be edited in the Camera Calibration panel. Figure 4-80 shows the Color Matrices tab.

Figure 4-80 The
Color Matrices tab.

NOTE One note of
caution at this point is
that once a DNG Profile is
embedded in an image file,
there is currently no way to
remove it without editing the
.xmp file if it's a proprietary
raw file or a hex-editor for a
DNG file. While this is a bit
disconcerting, we have been
told (by reliable sources) that
the embedded DNG Profile
will do no harm, even if it's
never used.

Options. In the Options tab, you can edit the resulting profile name, add
a copyright notice, and control how the profile will be deployed. If you
are doing this for yourself, you should use the most liberal Allow Copying
option because you can then move the profile around with no restrictions.
The other alternative is to Embed If Used. That means the DNG Profile
will be embedded in the .xmp and move wherever the file does. Never
Embed means the profile must be loaded on your local machine for Camera
Raw to use it, and if you save out a DNG, it will not be embedded in the
DNG. Figure 4-81 shows the Options tab.

Chart. The Chart tab allows you to use a capture that contains a standard
24-patch ColorChecker chart (see Figure 4-82). You place the four color
tabs on the four corners of the shot of the chart and click on the Create
Color Table button.

Figure 4-81
The Options tab.

Figure 4-82
The Chart tab.

Color Tables dropdown
menu

You will see a warning (shown in Figure 4-83), and then the DNG Profile Editor will generate a profile from scratch and load all the color swatches as editable points in the Color Tables tab. From there you edit the colors you need and then save a recipe or DNG Profile.

Using the Chart function of the DNG Profile Editor replaces the older Camera Raw camera calibration scripts that have been used to automate the generation of camera profiles. However, using this function requires a well-lit and well-photographed ColorChecker chart at both D-65 and Tungsten (ideally at Standard Illuminate A or 2850 K°). The less accurate the shots of

the chart, the less accurate the resulting profile will be. You should edit both color charts because most cameras' sensors have different spectral responses under tungsten and daylight light sources.

ColorChecker chart with color corners set

Figure 4-83 Using a ColorChecker to generate a profile.

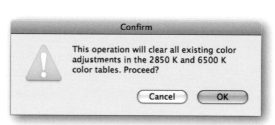

Confirm dialog

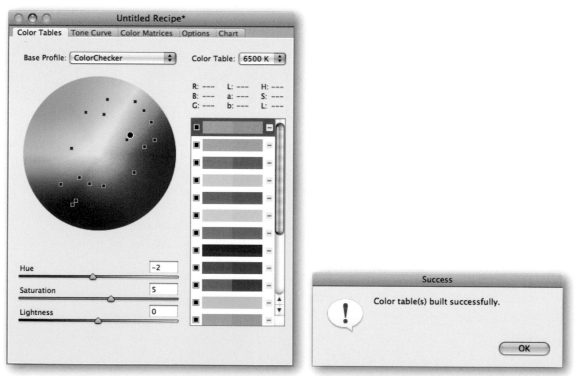

Profile generated from the ColorChecker chart

Success confirmation

Saving a recipe. The editing session while working on a profile can be saved as a recipe so you can come back to the same settings for later fine-tuning and adjustments. The recipe is not the actual profile, it's only the color edits that will be used to create a profile. Figure 4-84 shows the process. You can save the recipe anywhere that's convenient. We suggest creating a working folder where the recipe, the various DNG files, and the DNG Profile Editor are kept organized all together.

The Save Profile Recipe command in the File menu

The Save Recipe As command in the File menu

Figure 4-84
Saving a recipe.

Exporting a DNG Profile. After you've made the required edits, you'll need to export a DNG Profile to a very specific location for Camera Raw to successfully use it. Figure 4-85 shows the process. To export a profile, choose the Export command in the File menu. If you've already named the profile in the Options tab, you'll already have the name filled out upon export. By default, the DNG Profile Editor exports to the correct folder required by Camera Raw. If you've successfully created and exported the profile, the DNG Profile Editor shows you a confirmation; you'll then be able to see the profile in the Camera Raw Camera Calibration panel. Note that to have the profile be used, you will need to quit and relaunch both Photoshop and Bridge CS4. If you also use Lightroom, Lightroom will need to be relaunched as well. Both Camera Raw and Lightroom can use the same profile. However, DNG Profiles can only be used with raw captures (either native files or DNGs). Neither TIFF nor JPEG captures can use DNG Profiles.

The default location for DNG Profiles for Mac is:

User/Library/Application Support/Adobe/CameraRaw/CameraProfiles

For Windows XP the location is:

Boot drive\Documents and Settings\User Name\Application Data\Adobe\CameraRaw\CameraProfiles

For Windows Vista the location is:

Users\User Name\AppData\Roaming\Adobe\CameraRaw\CameraProfiles

Figure 4-85 Exporting a DNG Profile.

Export command

Export DNG Camera Profile save dialog box

Success confirmation

DNG Profile shown in Camera Raw Camera Calibration panel

The DNG Profile specification and the DNG Profile Editor are examples of Adobe's desire to continue to further the technical progress of the DNG file format. The DNG Profile Editor can be used (for free) to make custom profiles for individual use and by others who want to develop DNG Profiles as products. Be sure to check the licensing terms for the DNG Format and SDK.

We really must compliment Adobe and the Camera Raw/DNG team for working so hard on this initiative. Thomas Knoll has envisioned the DNG file format as a solution badly needed in the digital photography industry. A special thanks to Eric Chan who worked so hard (and so fast) on the DNG Profile Editor and the development of the DNG Profiles that were released as part of Camera Raw 5.2.

THE DARKROOM TOOLKIT

In this chapter, we've concentrated on describing each of Camera Raw's tools individually, with simple examples of their effects on images. But it's a mistake to fall in love with a single tool and ignore the others: When all you have is a hammer, everything tends to look like a nail! The way the tools interact is as important as their individual functions.

Many different combinations of Camera Raw settings can produce superficially similar results. But when you look closely or when you start to push the converted images further in Photoshop, you'll invariably find that one combination works better than the others. So in the next chapter, we'll show you how the tools all work together to help you evaluate and optimize your images.

CHAPTER FIVE

Hands-on Camera Raw

EVALUATING AND EDITING IMAGES

Knowing what each control does in Camera Raw is only half the battle. The other half is in knowing how the various controls interact and when (and in what order) to use them. So with these goals in mind, let's first look at a simple scenario: processing individual images, one at a time, in Camera Raw. In later chapters we'll look at the ways Camera Raw lets you apply edits to multiple images and process them in an automated workflow. But unless you've mastered the art of editing one image at a time, these features are as likely to help you destroy multiple images as to enhance them!

It's useful to split the work into three phases, even though the third phase is where most of the work gets done, because if you mess up the first phase, you won't get the results you want. And if you skip the second phase, you may miss critical issues in the image when you execute the third phase. The three phases are:

• Setting up Camera Raw—specifying Preferences and Workflow settings

• Evaluating the image

• Editing the image

We'll look at each phase in depth. But before we go there, we need to get a certain point across—Camera Raw's "default" is only an arbitrary starting point. There's nothing sacred, nor technically or particularly important with the default rendering of your capture. It's only a consistent place from which to start your evaluation and, ultimately, your editing.

Camera Raw Default

You may have noticed that the first time you see your images either on the camera LCD or when Bridge first shows the embedded preview, they look snappier and more saturated than when Camera Raw does its high-quality rendering.

That's because Camera Raw's default rendering is an unbiased representation of what you have in your file, not a final rendering. The main role of the Camera Raw default is to give you a common starting point on which to base your evaluations. It tends to be lower in contrast with less saturation to aid in the evaluation of your image capture. Camera Raw leaves the final rendering up to you. To see what we mean, take a gander at Figure 5-1.

If you look at the Camera Raw "default" rendering, you'll be able to see images with potential but lacking in a variety of criteria. Some of the images are underexposed (or really overexposed), some suffer from too much scene contrast, and others are flat. In some images, the colors are just boring, the crops are wrong, or the image is off kilter.

The same images after Jeff has adjusted them in Camera Raw look a lot different (whether your tastes match Jeff's is another matter entirely). Crops have been corrected, and the tone and the color have been corrected, or in a few cases, converted to black and white and color toned. The corrections made also show up in the corrected images' histograms as you will see later in this chapter.

Some people complain that Camera Raw's default doesn't match the camera JPEG or thumbnail. There's a good reason for this: The embedded thumbnail and the camera JPEG are meaningless. They are neither technically accurate nor particularly useful. The camera JPEG has undergone the camera company's interpretation of what it thinks your image should look like. Generally, those companies' "looks" tend to have too much contrast and added saturation in an attempt to simulate a film transparency. The new DNG Profiles pretty much put an end to that complaint though.

Photographers who in their film days shot color or black-and-white negative film appreciate what the Camera Raw default does, whereas photographers who shot chromes tend to think of Camera Raw's defaults as uninspired, flat renderings. The truth is somewhere in the middle—and that's what we're here to help you understand.

Figure 5-1 Comparing
the default rendering with
user-edited adjustments.

Images at Camera Raw defaults

Images after user-edited adjustments

OK, back to the three phases: setting up Camera Raw, evaluating your
images, and then editing your images.

CAMERA RAW SETUP

The first order of business is to set up Camera Raw to make it work the way you want. To do that, you must open a raw image, because until you actually launch Camera Raw you can't do anything with it. Size the Camera Raw window by dragging the handle at the lower-right corner so that you can see a decent-sized image preview, with the controls conveniently placed. Alternatively, you can click the Full Screen button to allow Camera Raw to take over your entire display. If most of your images are verticals, you may prefer a narrower Camera Raw window than if you mostly shoot horizontals. While the screen shots in this book show Camera Raw at near its minimum size, we like to size the Camera Raw window to fill the entire screen.

Preferences. Next, make sure that Camera Raw's Preferences are set to behave the way you want. There's no right or wrong answer to how the Preferences should be set other than that they should produce the behavior you want and expect. You can open Camera Raw's Preferences by choosing Camera Raw Preferences from the Photoshop Preferences, Camera Raw Preferences in Bridge from the Bridge menu (Mac) or the Edit menu (Windows), or the Camera Raw toolbar. They all get you to the same place—Camera Raw's important Preferences dialog box. See Figure 5-2.

Figure 5-2 Camera Raw Preferences in Photoshop, Bridge, and Camera Raw.

Camera Raw Preferences from Photoshop

Camera Raw Preferences from Bridge

Open preferences dialog (⌘K)

Camera Raw Preferences from Camera Raw

Camera Raw Preferences (as suggested by Bruce and Jeff)

Camera Raw's Preferences are pretty straightforward. You only have four items to really worry about—whether Auto Tone is on/off, where to save settings, how to apply sharpening, and how to handle non-raw files.

- **Save Image Settings In.** Controls where your image settings get saved. It offers two choices: Camera Raw Database or Sidecar .xmp Files. Each has its advantages and disadvantages (see Chapter 4, *Camera Raw Controls*, Figure 4-51).

- **Apply Sharpening To.** Controls whether sharpening applied by the Sharpness slider in the Detail tab is applied to the image preview only or to the converted image. (When you choose Preview Images Only, a label reminding you that you've done so appears beside the Sharpness slider.) In Camera Raw 4.1 and later, we suggest using Camera Raw's image sharpening for capture sharpening.

- **Apply Auto Tone Adjustments.** If you want Camera Raw to take a stab at applying auto tone adjustments, select this option. If you would prefer to do it yourself, make sure this option is deselected.

- **JPEG and TIFF Handling.** If you want Camera Raw to handle JPEG and TIFF files, this is where you make that decision. Note that if you hold down the Shift key when double-clicking an image in Bridge, the Camera Raw dialog box will be bypassed and the image will be opened directly in Photoshop.

If the Preferences are set incorrectly, you'll need to redo all of your work once you've set them the way you want; so always make sure that they're set the way you want—it will save time in the long run.

Workflow settings. The workflow settings govern the color space, bit depth, size, and resolution of the converted image. They're called "workflow settings" because you'll typically change them to produce different types of output. For example, when you want to create JPEGs for online viewing or review, it would make sense to choose sRGB as the color space, 8-bit for bit depth, the smallest size for your camera, and 72 ppi for resolution. But to produce images for large prints, you'd probably switch to a wider color space and use 16-bit for bit depth to accommodate further editing in Photoshop, the "native" size for your camera, and 240 ppi for resolution.

The workflow settings are recordable in actions, so once you've learned your way around, you can easily incorporate the workflow settings you

TIP If the menu item is grayed out, it means that something is wrong with your Bridge cache for that folder (the remedy is to purge cache for this folder or trash the Bridge preferences), or Camera Raw is not properly installed.

want in batch processes: We'll discuss building actions for batch processes in Chapter 9, *Exploiting Automation*.

Five different menus make up the workflow settings (see Figure 5-3).

Figure 5-3 Camera Raw workflow settings.

- **Space** dictates the color space of the converted image. The choices are Adobe RGB, Colormatch RGB, ProPhoto RGB, and sRGB. If you use one of these spaces as your Photoshop RGB working space, choose that space here, unless you're producing imagery for the Web, in which case you should choose sRGB.

 A huge number of words have already been expended on the subject of RGB working spaces, and we don't want to add to them here. The one practical recommendation we'll make regarding choice of working space is to use Camera Raw's histogram to detect colors being clipped by the chosen output space. If a space clips colors, look to see if they're important to you. If they are, choose a wider space. See "Saturation Clipping" later in this chapter.

- **Depth** lets you choose whether to produce an 8-bit or a 16-bit-per-channel image. Unless we're creating JPEGs for Web or e-mail use, we always convert to 16-bit-per-channel images, because they allow a great deal more editing headroom than 8-bit-per-channel images. The inevitable tradeoff is that the files are twice as large.

 If you plan on doing minimal editing in Photoshop, converting to 8 bits per channel may save you time, particularly if you run Photoshop on older, slower machines. Everyone has his or her own pain point! See the sidebar "The High-bit Advantage" for more on 16-bit-per-channel images.

- **Size** lets you choose one of several output sizes. The specific sizes vary from camera to camera, but they always include the camera's native resolution as well as higher and lower ones.

NOTE While the Workflow Options dialog controls the size of the final output, there is another control that can influence this result—the Crop Tool. If you have set the Crop Tool to Custom or altered the basic setup of the Crop tool, you may end up with unexpected (and undesirable) results. Fortunately, the Custom Crop is not sticky between Camera Raw launches but will be saved like any other image adjustment.

On cameras that produce non-square pixels, there's a clear advantage to using Camera Raw to go one size up from native, in which case an asterisk appears beside that choice in the menu—see "Size" in Chapter 2, *How Camera Raw Works*. But for the majority of cameras, the difference is less clear-cut and is equally about workflow convenience as image quality. See the sidebar "When to Resample," later in this chapter, for further discussion.

- **Resolution** lets you set a default resolution for the image. This is purely a workflow convenience—you can always change it later using Photoshop's Image Size command without resampling. If you need 240-ppi images for inkjet printing or 72-ppi images for Web use, set that resolution here to save yourself a trip to the Image Size dialog box later.

- **Sharpen For** lets you apply output sharpening in the Camera Raw processing pipeline. This is useful if the image coming from Camera Raw will never be resized anywhere else, but less so if you plan on doing substantial retouching and resizing in Photoshop.

You can't load and save workflow settings as you can image settings, but you *can* record workflow settings in actions that you can then use for batch-processing. The Size and Resolution settings are sticky per camera model, so always check to make sure that they're set the way you need them.

TIP When You Need a Different Output Space. If none of the four spaces supported by Camera Raw suits your workflow, use ProPhoto RGB as the space in Camera Raw, set the bit depth to 16-bit, and then use Photoshop's Convert to Profile command to convert the images into your working space of choice, using Relative Colorimetric rendering. ProPhoto RGB is large enough that it makes any color clipping extremely unlikely, so the intermediate conversion won't introduce any significant loss.

The High-bit Advantage

Any camera that shoots raw captures at least 10 bits per pixel, offering a possible 1,024 tonal values, but most capture 12 bits for 4,096 levels, and a few capture 14 bits for 16,384 possible tonal values. An 8-bit-per-channel image allows only 256 possible tonal values in each channel, so when you convert a raw image to an 8-bit-per-channel file, you're throwing away a great deal of potentially useful data.

The downsides of 16-bit-per-channel images are that they take up twice as much storage space (on disk and in RAM) as 8-bit-per-channel images, and an ever-shrinking list of Photoshop features don't work in 16-bit-per-channel mode. The advantage is that they offer massively more editing headroom.

If you're preparing images for the Web or you need to use a Photoshop feature that only works in 8-bit-per-channel mode, by all means go ahead and process the raw images to 8-bit-per-channel files. In just about every other scenario, we recommend processing to a 16-bit-per-channel file. Even if you think the image will require little or no editing in Photoshop, it's likely that at some point the image will have to undergo a color space conversion for output. Making that conversion on a 16-bit-per-channel image can often avoid problems such as banding in skies or posterization in shadows that suddenly appear after an 8-bit-per-channel conversion.

Evaluating Images

Before starting to edit a raw image, it's always a good idea to do a quick evaluation. Is the image overexposed or underexposed? Does the subject matter fall within the camera's dynamic range, or do you have to sacrifice highlights or shadows? Camera Raw offers three features that help you evaluate the raw image and answer these questions:

- **The histogram** lets you judge overall exposure and detect any clipping to black, white, or a fully saturated primary.

- **The image preview** shows you exactly how the converted image will appear in Photoshop, and the clipping display, available when you adjust the Exposure and Shadows sliders, lets you see exactly which pixels, if any, are being clipped.

- **The RGB readout and color samplers** let you sample the RGB values from specific spots in the image.

If an image is too dark or too light, you need to decide whether to fix it by adjusting Exposure or Brightness. If it's too flat, you need to decide whether to increase the Contrast or add snap to the shadows with the Blacks control. Camera Raw's histogram helps you make these decisions by showing at a glance what's happening at the extreme ends of the tone scale.

The histogram. Camera Raw's histogram is simply a bar chart that shows the relative populations of pixels at different levels. The colors in the histogram show what's going on in each channel.

Spikes at either end of the histogram indicate clipping—white pixels mean that all three channels are being clipped, and colored pixels indicate clipping in one or two channels (see Figure 5-4).

The histogram can help you determine whether the captured scene fits within the camera's dynamic range. If there's no clipping at either the highlight or the shadow end, it clearly does. If there's clipping at both ends, it probably doesn't. If there's clipping at only one end, you may be able to rescue highlight or shadow detail (if you want to) by adjusting the Exposure slider.

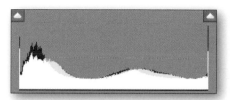

Tonal clipping of black and white

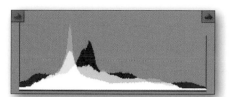

Saturation clipping of red in highlights and magenta in the shadows

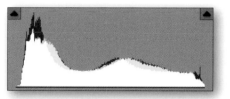

Histogram showing fixed tonal clipping

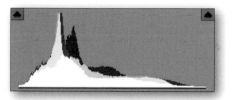

Histogram showing fixed saturation clipping

Figure 5-4 Clipping and the histogram.

The fix for the tonal clipping was to use Recovery for the highlights and reduce the Blacks setting for shadows in conjunction with Fill Light. To fix the Saturation clipping, the Workflow color space was changed from sRGB to ProPhoto RGB.

The histogram also shows clipping in individual channels. Typically, clipping in one or two channels indicates one of two conditions:

- The RGB space selected in the Space menu is too small to hold the captured color. In that case, try switching to a larger space if the color is important.

- You've pushed the saturation so far that you've driven one or more channels into clipping. Again, this isn't necessarily a problem. To see exactly what's being clipped, you can use the Exposure or Shadows slider's clipping display, which we'll discuss next.

Image preview. The main function of the image preview is, of course, to show you how the converted image will appear. But it also offers a couple of indispensable tricks in the form of the highlight clipping display and shadow clipping display, which you access by using the Option key in conjunction with the Exposure and Shadows sliders, respectively. Hold down the Option key, and then hold down the mouse button on either slider to see the clipping display. The display updates dynamically as you move the slider, so it's useful for editing as well as evaluation.

When to Resample

A good deal of controversy and mythology surrounds the question of whether to upsample in Camera Raw do post-conversion in Photoshop. Be very wary of absolute answers—in most cases, the differences are usually quite subtle and likely camera dependent. (And it's also quite likely they're photographer dependent, too!) That said, we'll give half an absolute answer: If you need a smaller-than-native file, it's a no-brainer to choose the size closest to your needs in Camera Raw. The controversy really revolves around upsizing.

With the exception of images captured on non-square-pixel cameras, the differences between upsampling in Camera Raw and upsampling in Photoshop using one of the Bicubic flavors are quite subtle but can be seen, as shown in Figure 5-5.

Figure 5-5a Resampling explored.

Camera Raw Upsampling of 10.6 MP capture to max

Photoshop zoom is at 1600%

The view of the image in Photoshop's Navigator panel

Camera Raw 5.2's upsampling has been improved over previous versions that tended to produce a ringing effect at strong contrast edges. In the 5.2 update, Camera Raw automatically chooses an algorithm very similar to Photoshop's Bicubic Sharper. When upsampling, Camera Raw uses an adaptive Bicubic algorithm depending on the size of the upsample. When in the range of 1x–2x in the linear dimension, the algorithm uses parameters that optimize detail (like regular Bicubic). When the resamples are larger than 2x, the algorithm transitions to parameters that produce smoother results (like Bicubic Smoother). This logic is used in both Camera Raw 5.2 and Adobe Lightroom version 2.2 and later.

Ultimately, it's a question you'll have to answer for yourself. You may even find that some types of imagery respond better to one method, whereas others respond better to another. If you're disinclined to devote a lot of time to testing, another entirely rational strategy is to punt on the whole question and simply do whatever is most convenient in your workflow.

Figure 5-5b Resampling explored.

Sample showing Photoshop Bicubic

Sample showing Photoshop
Bicubic Smoother

Sample showing Photoshop
Bicubic Sharper

Sample showing Camera Raw
Upsampling

The samples in Figure 5-5 were processed through Camera Raw 5.2. The Upsampled Camera Raw version was set to the maximum size for Camera Raw (6041 x 4019 pixels). The Photoshop upsampled versions were processed through Camera Raw at the native file resolution for a Canon 1Ds. The image was upsampled using all three of Photoshop's Bicubic algorithms.

• **Exposure clipping display.** Holding down the Option key as you move the Exposure slider turns the image preview into a highlight clipping display—see Figure 5-6.

Figure 5-6 Exposure clipping display.

In this image, you can see that a few bright highlights are being clipped when the Exposure slider is set to zero.

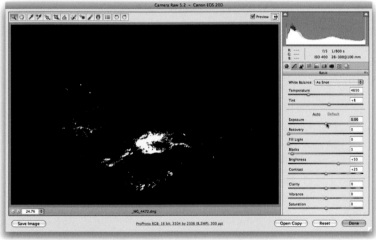

Holding down the Option key while pressing or moving the Exposure slider produces the Exposure clipping display.

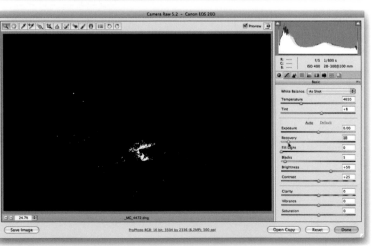

In this bottom image, the Option key is being held while the Recovery slider is being adjusted. The Option key will show highlight clipping in both the Exposure as well as Recovery sliders.

Unclipped pixels display as black. The other colors show you which channels are being clipped to level 255. Red pixels indicate red channel clipping, green pixels indicate green channel clipping, and blue pixels indicate blue channel clipping. Yellow pixels indicate clipping in both red and green channels, magenta pixels indicate clipping in the red and blue channels, and cyan pixels indicate clipping in the green and blue channels. White pixels indicate that all three channels are clipped.

Of all the controls in the Basic panel, the Exposure slider is the most critical due to the nature of linear captures, which devote many more bits to describing the highlights than to describing the shadows. On the vast majority of images, the first edit is to set the Exposure slider so that the highlights are as close as possible to clipping. If the image exceeds the camera's dynamic range, you may choose to sacrifice highlight detail when the nature of the image dictates that the shadow detail is more important. But even then, careful setting of the Exposure slider is vital, and the clipping display is invaluable in making that setting. However, even with highlight clipping, the use of Recovery can tame all but the most blown-out of highlight detail. Recovery combined with careful use of point curves can tease out highlight detail where none may be obvious.

- **Shadows clipping display.** Holding down the Option key as you move the Shadows slider turns the image preview into a shadow clipping display—see Figure 5-7.

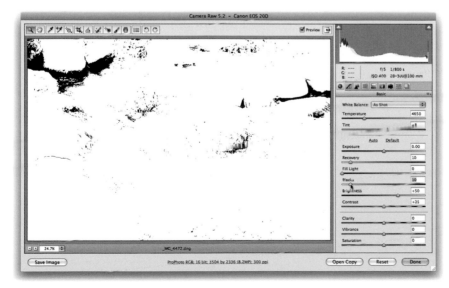

Figure 5-7 Shadows clipping display.

Holding down the Option key while pressing or moving the Blacks slider produces the shadows clipping display for the image shown in Figure 5-6. Both Exposure and Blacks clipping are present, so something will have to give. But in the Curves section of the chapter, we'll show you how to make a silk purse out of a sow's ear (and bring back detail that appears to be lost).

Unclipped pixels display as white. The other colors show you which channels are being clipped to level 0. Cyan pixels indicate red channel clipping, magenta pixels indicate green channel clipping, and yellow pixels indicate blue channel clipping. Red pixels indicate clipping in both green and blue channels, green pixels indicate clipping in the red and blue channels, and blue pixels indicate clipping in the red and green channels. Black pixels indicate that all three channels are clipped.

While the histogram shows you whether or not clipping is taking place, the clipping displays show you *which* pixels are being clipped. If you want to evaluate clipping on single pixels, you'll need to zoom in to 100% view. Camera Raw does its best to show you clipping at lower zoom percentages, but it's only completely accurate at 100% or higher zoom levels.

RGB readout. The RGB readout (see Figure 5-8) lets you sample the RGB values of the pixel under the cursor. At 100% or lower zoom percentages, the readout always reports the average of a 5x5 sample of screen pixels. At higher zoom levels, the readout is an average of 5x5 actual image pixels, which is the minimum sample size.

The RGB readout helps you distinguish between, for example, a yellow cast and a green one, or a magenta cast and a red one. Sample an area that should be close to neutral. If the blue value is lower than red and green, it's a yellow cast; if the green value is higher than red and blue, it's a green cast. See Figure 5-8 for examples.

Figure 5-8 RGB readout showing yellow and green casts.

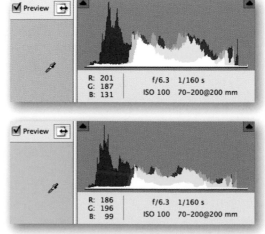

If you need to keep track of important colors in the image, you can use the Color Sampler tool (see Figure 5-9) to place up to nine color samplers. So, including the RGB cursor readout, you can track ten sets of color values.

Figure 5-9 RGB color samplers on nine patches of a ColorChecker.

The evaluation process. The first thing you should do in your evaluation is simply look at the image. We generally suggest setting your Camera Raw defaults without Apply Auto Tone Adjustments selected. You need to be able to see the effects of bracketing rather than having Camera Raw normalize all your exposures. Besides, you can always click the Auto button in the Basic panel to see what Camera Raw might do. At default settings, images usually look flat and are often too bright or too dark.

• The first thing we do is check for clipping. An image that's too dark may be underexposed, requiring an Exposure adjustment, or it may be holding some bright highlights and need a Brightness adjustment to remap the midtones instead. By the same token, an image that's too bright may be overexposed, requiring highlight recovery with the Recovery slider, or it may need darkening of the midtones by reducing the Brightness value. The histogram and clipping displays help determine which is the case.

• It's much easier to add contrast than to reduce it. Depending on the tonal range involved, it may be best to use the Blacks slider, the Contrast slider, the Curve panel, or any combination thereof, but only do so after you've set the endpoints.

• If you need to make big Exposure moves, do so before setting white balance, because changes in the Exposure value can have a big effect on

the white balance. Other than that, it doesn't really matter when you set the white balance.

- After evaluating the tone, evaluate the color starting with white balance. While you might presume that known neutrals should be neutral, that's not always the case. It all depends on the color of light in which you shot. A neutral color shot at sunset *should* be warm in color, not dead neutral. Once a shot is white balanced, you can look at overall saturation or the rendering of certain colors.

- After editing for tone and color, zoom in to 100% or higher, and check for image sharpness, color and luminance noise, and for chromatic aberration and fringing. For maximum image quality, you must correct for chromatic aberration.

The evaluation process has been forever changed with Camera Raw 5's ability to do local tone and color corrections. You no longer need to go to Photoshop just to adjust a local area in your image. However, the local adjustments come at a price—the tools in Camera Raw are not as flexible as those found in Photoshop and adding lots and lots of local adjustments will slow down the processing of raw files, sometimes by a lot. So, use good judgment when deciding when and where to make these corrections. But it's way cool that you can do nondestructive brush and graduated adjustments in Camera Raw!

Editing Images

At last, we come to the heart of the matter—editing images! We always start with the controls in the Basic panel, followed by those in the Tone Curve panel. Depending on what the image needs, a trip back to Basic for additional color work often is followed by a trip to HSL/Grayscale. Then zoom in and adjust the image sharpening settings and check for noise that needs adjusting with the Detail panel, and for chromatic aberration that needs adjusting in the Lens Corrections panel. Normally, we don't make adjustments to individual images in the Camera Calibration panel, reserving it for fine-tuning the response of specific cameras. But on occasion, it can be a handy creative tool, too.

The Basic panel contains the controls that let you set the overall contrast and color balance for the image, and it's always where we start. A simple rule of thumb that has served us well over the years is to fix the biggest problem first. In the case of raw images, this almost always boils down to adjusting tone or white balance.

If the image needs a major exposure adjustment (more than 0.25-stop up or down), it's better to do that before setting the white balance, because the exposure adjustment will probably affect the white balance. If the image needs little or no exposure adjustment, we usually set white balance first.

Aside from setting black and white points and balance, the thing that really separates the men from the boys (or the women from the girls) is deft use of the tone mapping controls in Camera Raw. Deciding where and how to shift your bits with either Parametric or Points editing of a curve will often make or break an image. Parametric editing is smooth and quick, whereas Point editing is precise and can be tedious.

So let's prepare for takeoff to the realm of image editing. Please raise and lock your tray tops and bring your seat to an upright position.

TIP Don't Be Afraid to Reduce Contrast. Many photographers are hesitant to reduce the value of a slider labeled "Contrast," but if you're looking to brighten the dark three-quarter tones without affecting the midtones, reducing the Contrast value will do a better job than increasing the Brightness value. If you're worried about the image going flat, rest assured that you can put plenty of punch back into the shadows using either the Shadows slider or the Curve tab.

Before and After Case Studies

Although the best way to learn something is to try it, the next best way is to watch somebody else do it. So here we present a variety of before-and-after examples, along with a detailed evaluation of the technical (not aesthetic) aspects of the before images and a discussion of each of the editing steps and why those steps were chosen. In most cases, there will be a *Before* image with its before histogram and an *After* image with its histogram.

White Balance

Bruce Fraser shot the image in Figure 5-10 on the back deck of his house in total shade, lit only by blue sky. He used a Canon Digital Rebel and an 18-55mm lens to shoot one of his favorite electric bases. Bruce, if you didn't know, was an enthusiastic and talented (although he would never say so) musician who gave up the music profession to become a writer.

Figure 5-10 White Balance settings.

Image before adjustment

Image after adjustment

White Balance settings at default

White Balance settings after adjustment

Image Evaluation. The Before image shows what Camera Raw generated from its default setting. The setting was As Shot, meaning Camera Raw would try its best to determine the camera's white balance at the time of the shot. Clearly, an image shot under blue skies would be very cool. The 5850° Temperature is incorrect. Several approaches can be taken, as shown in Figure 5-11. You could try another menu item such as Shade, or you could start clicking within the image with the White Balance tool.

Image Editing. It often seems that white balancing is a delicate balancing act. Some people prefer to start yanking on the sliders and adjusting by eye, whereas others prefer to take a more analytical approach. Either approach is suitable depending on what you want. In this case, using the White Balance tool ended up working out well, once an area that *should* be neutral was found. That is often the biggest challenge when trying to use the White Balance tool—finding the right area.

TIP The up and down arrow keys adjust the value in the selected field by the smallest increment (50 Kelvins for Temperature, 1 for everything else). Hold down the Shift key along with the up and down arrow keys to adjust by 10 (or 500 Kelvins for Temperature).

The first selected area ended up overcorrecting the coolness by making the image too warm. The second attempt went in the opposite direction and actually looked worse than the original. The third attempt was "just right," as Goldilocks would say, and we mention her because trying the porridge is what you are doing when using the White Balance tool.

Figure 5-11

Image when settings of Shade was selected

Image showing White Balance tool on the tuning peg

Panel showing Shade selection

Panel showing results

Image showing second attempt

Imaging showing White Balance tool on quitar name

Panel showing second results

Panel showing final results

Point Curve

Bruce shot the image in this example (see Figure 5-12) with a Canon 20D camera using a 28-300mm lens. With the ISO set at 400 it could be argued that the shot was overexposed, but we'll show that with careful curves adjustment, that's not the case.

Figure 5-12 Point Curve Editor.

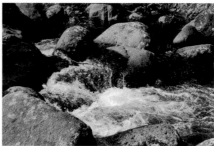

Image before adjustment Image after multiple edits

Histogram after edits Histogram of image at Camera Raw default

Image Evaluation. The image in Figure 5-12 is the same image used to show the tone clipped histogram from Figure 5-4. Examining the histogram shows there's tone clipping in both the extreme highlights and the deep shadows. As you'll see in the edits (see Figure 5-13), we needed to bring the extreme highlights down to help eliminate the clipping. As you can see in the *After* histogram, we've completely eliminated the tone clipping. This is a case where the image wasn't so much overexposed as it was too bright in the midtones and higher.

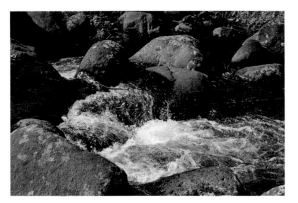

Figure 5-13

Basic	
White Balance:	Custom
Temperature	4800
Tint	+8
Auto Default	
Exposure	–0.75
Recovery	50
Fill Light	15
Blacks	13
Brightness	+49
Contrast	+11

Image after Basic panel adjustments

The Basic tone settings

Image Editing. The first step in the image editing was to use the Basic panel's controls for moving the image levels around to better show the detail we wanted. The Exposure and Recovery sliders came first, followed by Fill Light and Blacks. You might ask, why increase the Blacks clipping point? We've found that by over lightening using Fill Lights, we'll often get better results using a higher than needed Fill Light setting and then adjusting the Blacks to clip a bit higher. When used in tandem, you can increase the shadow detail while still getting nice deep blacks.

You'll notice that both the Brightness and Contrast settings were adjusted as well and that we added midtone contrast by using Clarity. We find Clarity to be a wonderful adjustment that benefits almost every image when used in moderation. The end result of the Basic panel adjustments was an image that was now too dark overall—particularly in the midtones.

When working with the Point Editor, we find it useful to work zoomed in and to use the ability to see where an area of interest in the image may fall on the curve. As shown in Figure 5-14, we're interested in the area just below the extreme highlights. By Command-clicking in the image, we place a point and then use the arrow keys to make the point lighter.

You'll also notice that the midtones that got too dark because of the Basic panel adjustments have now been corrected (see Figure 5-15). It's not at all unusual to bounce back and forth between the Basic panel and the Tone Curve panel to make multiple adjustments, because the results influence each other. The Brightness and Contrast sliders of Basic are crude tools, whereas the Point Editor is for fine-tuning.

Figure 5-14

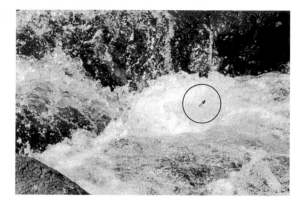

Zoomed-in view showing the use of the eyedropper to see where in the curve an area of the image may be

Curve showing the cursor location

The result of holding down the Command key to place a point

Using the arrow key to adjust the point

Figure 5-15

Image detail of *before*

Image detail of *after*

This example teaches one of the most important lessons about working with raw images that are in a linear gamma. There's a ton of detail clumped all together at the top of the range of a digital capture that can, with careful adjustment, be teased out and used, even if the clipping indicators of the image's histogram shows clipping.

Exposure Problems

Sometimes your camera meter misinterprets the scene or sometimes you, the photographer, might make a tiny mistake. In any event, getting the right exposure *and* getting the shot can be a difficult task. That's one of the critical benefits of shooting raw; it allows you to make amends for an incorrect exposure in camera.

Overexposure

In the first example (see Figure 5-16), we have a shot by Jeff where he takes the concept of *Expose To The Right* (ETTR) to a radical extreme.

Image with default rendering

Image after edits

Figure 5-16
ETTR to the max.

Default histogram

Histogram after edit

Image Evaluation. Jeff shot this image with a Canon 1DsMIII in Niagara Falls, Canada. This is one of a bracket of shots he took with a 70-200mm 2.8 IS lens with the intent (and desire) to allow the motion of the water to blur out. Shot at F22, he bracketed a variety of shutter speeds in an attempt to get the correct motion in the water. This exposure was at ½ second, and while it had the correct motion, it was way overexposed. Camera Raw to the rescue! Check out the histogram at the Camera Raw default rendering, just a tiny sliver way up in the extreme highlights. Then look at the results. This is the most radical recovery of highlight detail we've seen and proves just how much data is in that brightest stop of exposure. Hooray for linear.

Image Edits. As you can see in the Basic panel the Blacks slider is set to the maximum of 100 (this image may be a good case for having the slider go to 150). Also note that there's not a lot of Recovery being applied; there's not a lot to "recover" actually. The Brightness is way down to -113, but Contrast remains at the default. The Parametric also has some extreme adjustments to the Shadows. The main area of image adjustments occurred in the Parametric Editor of the Tone Curve panel (see Figure 5-17).

Figure 5-17
Panel edits.

Basic panel edits

Parametric edits in the Tone Curve panel

Originally created for Lightroom, the Parametric Editor has more advanced controls over contrast than the Basic panel's Contrast slider but is much quicker (and easier) to use than the Point Editor.

In addition to the panel adjustments, Jeff also deployed the Adjustment Brush to add color and darken certain areas of the water, as shown in Figure 5-18.

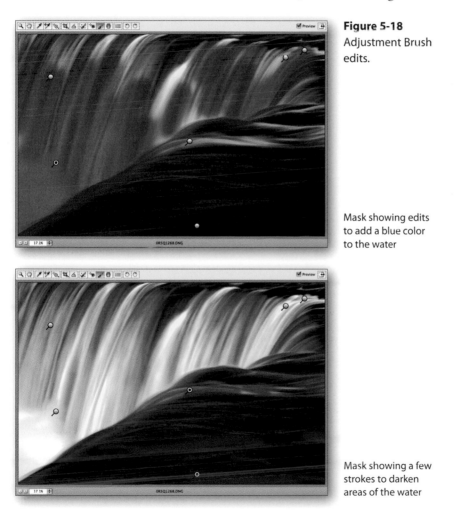

Figure 5-18
Adjustment Brush edits.

Mask showing edits to add a blue color to the water

Mask showing a few strokes to darken areas of the water

As extreme of an example as this is, we of course do recommend trying to get the optimal exposure at the time of shooting. This case, where the lens was set to its maximum F stop, really wasn't an "incorrect" exposure, but it would have required a neutral density filter to get a "normal" exposure.

Underexposure

This next example is one where it's unclear if the meter was fooled or the photographer goofed. In either case, the result was at least a 1–1 ½ stop underexposure (see Figure 5-19).

Figure 5-19 Fixing an underexposure.

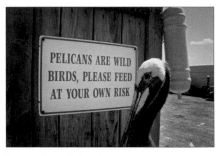

Image with default rendering

Image after edits

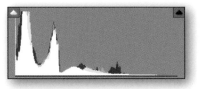

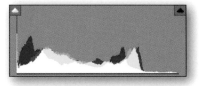

Default histogram

Histogram after edit

Image Evaluation. The term underexposure pretty much sums this image's main problem—a whole lot of image data at the left of the histogram that will need moving up the scale. I suppose this should be called *Expose To The Left* (ETTL) and should generally be avoided. However, it's well within the range that Camera Raw can do something about. The Pelican, shot with a Canon Digital Rebel and an 18-55mm lens wasn't going to hold still for very long, so Jeff just shot it as is. The meter was set to Aperture priority with no exposure compensation, so Jeff feels this underexposure was the camera's fault (and he's sticking by that story).

Image Editing. Since underexposures result in left weighted image date, the edits need to redistribute the data higher in the scale. This was accomplished by increasing Exposure to a plus 1.40 (about 1.5 stops of underexposure correction). To compensate for the move, the Blacks were also adjusted higher as well as Fill Light and Recovery (to try to keep the pelican's head from blowing out).

Additional tone curve tweaks were also accomplished in the Parametric Editor of the Tone Curve. The net result was to lighten the entire image while still not incurring any highlight clipping (see Figure 5-20).

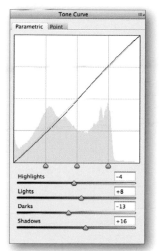

Figure 5-20 Image edits.

Basic panel settings Tone Curve panel edits

Wide Dynamic Range

When you shoot outside in a blazing sun you're bound to have situations where the dynamic range of the scene is near or exceeds that of your camera's sensor. This is just the situation Jeff encountered while shooting George Jardine (formerly of Adobe) along I70 at the Ghost Rock Canyon. The image in Figure 5-21 was shot with a Canon Digital Rebel with a 10-22mm lens.

Image Evaluation. The original scene has a wide contrast range that must be brought under control using both global and local controls. The global adjustments will need to redistribute the data downward. The biggest problem is the sky, which can be adjusted with a Graduated Filter. See Figure 5-21 for the *before/after*.

Figure 5-21 Dealing with a wide dynamic range.

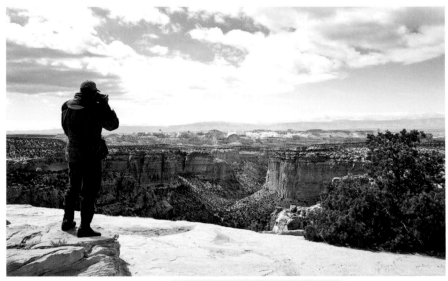

Image with default rendering

Default histogram

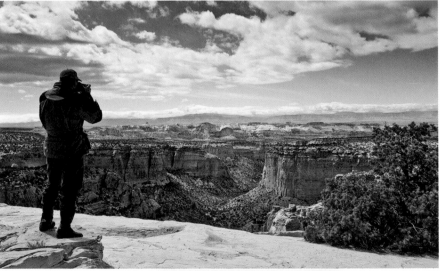

Image after edits

Histogram after edit

Image Editing. Starting at the top, Exposure is reduced while Recovery is added to help tame the extreme light areas. A Fill Light setting is used to pull up a lot of shadow detail while the Blacks setting is brought up to clip a bit higher because of the Fill Light setting. Brightness and Contrast are also increased, and you'll note a healthy dose of Clarity, Vibrance, and Saturation was added as well (see Figure 5-22).

Figure 5-22
Panel adjustments.

Basic panel adjustments

Parametric adjustments in the Tone Curve panel

HSL/Grayscale adjustment reducing Blues luminance

As you can see from the local adjustments shown in Figure 5-23, substantial texture was recovered in the highlights while increasing the deep shadows without losing blacks. This is a rather extreme case that Camera Raw 5 is able to handle; in previous versions of Camera Raw, the only real solution for dealing with such an extreme dynamic range would have been to double-process the image for assembly in Photoshop.

Figure 5-23
Local adjustment edits.

Graduated Filter adjustment strongly reducing the sky exposure

Mask showing an Adjustment Brush to increase the Clarity and the Saturation

Narrow Dynamic Range

This image shot by Jeff in Antarctica (see Figure 5-24) suffers from the opposite problem as the previous example. The image was shot with a 1DsMII using a 70-300mm lens, and the overall effect is *flat* light. One could argue it's a bit underexposed (if you are a believer in ETTL).

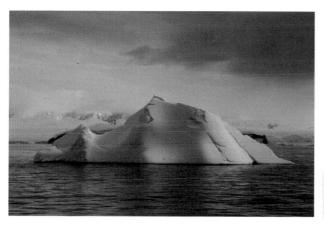

Image with default rendering

Default histogram

Figure 5-24 Dealing with a narrow dynamic range.

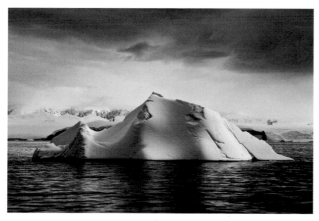

Image after edits

Histogram after edit

Image Evaluation. This image suffers from narrow dynamic range, which is a pretty easy fix in Camera Raw. There are no real blacks or whites but just shades in between (which is obvious from the before histogram). Even with substantial moves, there still isn't any clipping, in part due to the tools used.

Image Edits. Obviously, the image needed contrast but with a degree of subtlety (see Figure 5-25). We increased the Brightness and Contrast but added a touch of Recovery to dampen the contrast bump. The fact that Exposure needed an increase pretty much proves that Jeff engaged in ETTL again. Then we used the Parametric and the Point Editors of the Tone Curve to do the final tone distribution. Often, a contrast increase results in an increase of saturation due to the way the adjustment is applied. As a result,

we pulled back on the saturation of the Blues to keep the colors of the deep sky and the iceberg from becoming too colorful.

Basic panel adjustments

Parametric Tone Curve

Point Tone Curve

HSL/Grayscale to reduce Blues saturation

Figure 5-25
Panel adjustments.

We also employed four different Graduated Filters to adjust the sky gradation and to darken the foreground corners. Since we needed the gradations in specific regions, the Post Crop Vignette tool would not have solved the problem. Figure 5-26 shows the Graduated Filters used. All were used to darken and/or increase Clarity.

Figure 5-26 Graduated Filter adjustment edits.

Image Detailing

The image of the "mutant" 15-foot King penguin (see Figure 5-27) was shot on South Georgia Island on Jeff's recent Antarctic photo expedition. It was shot with a Canon 1Ds MII camera with a 24-70mm lens at 70mm. The reason the angle is so extreme is that Jeff was literally lying down with the camera almost touching the ground. Readers of the previous edition of this book will recognize this image because it was used on the cover. But we thought it would again be useful as an example because the changes offered in Camera Raw 5 mean that we can actually do more to improve the image right inside Camera Raw without having to resort to using Photoshop (as we had to do with the cover image last year).

Figure 5-27
Image detailing, take 2 (the second time around).

Image with default rendering

Image after edits

Default histogram

Histogram after edit

Image Evaluation. When looking at the default histogram, there's nothing about the image that jumps out at you, and that's what was wrong with the image—nothing is really jumping out. From the histogram you can see a clump of image data just below the highlights and another clump just above the shadows with very little in between. So the trick is to move the image data around for better distribution (and to make the penguin look as big as possible).

Image Edits. The biggest changes occur in the Basic panel and the Parametric Editor of the Tone Curve panel (see Figure 5-28). A slight Exposure increase is offset with a lot of Recovery (although the Recovery didn't actually do too much in this image). The Exposure adjustment was combined with Fill Light and Blacks adjustments as well as a strong move in Brightness and Contrast. All of the Basic panel adjustments were then readjusted inside the Parametric Editor in the Tone Curve panel. This is often needed since the Tone Curve adjustments interact with and can offset or change the Basic moves. There's nothing wrong with this approach of interactive adjustments, technically. It just requires bouncing around in the various Camera Raw panels to tune your image.

Figure 5-28

Basic panel adjustments

Saturation tab of
HSL/Grayscale panel

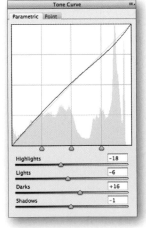

Parametric Tone Curve
adjustments

Did we mention we really like Clarity? We also used liberal amounts of both Vibrance (to increase the saturation of nonsaturated colors) and Saturation (to increase the saturation of all colors). For the parka, we popped over to HSL/Grayscale to adjust the saturation of the orange to tame it down.

The major changes are that we lightened the deep shadows and added to the color of the image. You'll note that the White Balance is at Custom. The default As Shot came in at a Temperature of 6000°, which, while neutral, was too warm. We cooled it down a small amount. See, doesn't the penguin look larger?

What really separates the previous edition's adjustments (that had required a trip into Photoshop) was the fact that with Camera Raw 4, we could not bring out the eye detail of the penguin. Now, with Camera Raw 5 we can. Figure 5-29 shows the local adjustments used.

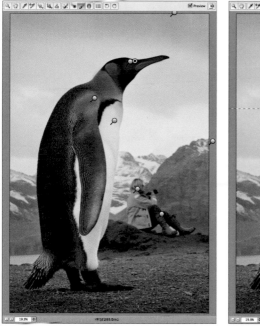 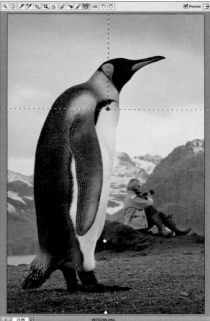

Figure 5-29
Local adjustment edits.

Mask showing an Adjustment Brush to lighten the penguin's eyes. Additional masks were used to lighten the breast of the penguin as well as the orange of the coat. The sky was also darkened and Clarity was added.

Graduated Filter adjustments darkening the sky and the foreground.

Saturation Clipping

Figure 5-30 shows that the image at default is flat and relatively low in saturation due to the lighting, yet when you look at the histogram, it has saturation clipping. Why? The saturation clipping is primarily due to the small color gamut of the chosen workspace of sRGB.

Figure 5-30 Saturation clipping.

Image at Camera Raw default

Image after adjustments

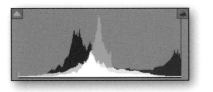

Default histogram

sRGB IEC61966–2.1; 16 bit; 4423 by 2949 (13.0MP); 360 ppi

sRGB workflow color space

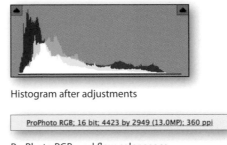

Histogram after adjustments

ProPhoto RGB; 16 bit; 4423 by 2949 (13.0MP); 360 ppi

ProPhoto RGB workflow color space

Image Evaluation. Well, aside from lifeless and uninspired color and flat tone, there's nothing wrong with this image that a few seconds in Camera Raw can't fix. The single biggest fix is to change the workflow color space from sRGB to ProPhoto RGB to remove the saturation clipping. Were we to continue in sRGB, the additional edits to the image would drive even more color to clipping. Other than that, punching up the tone and color would be obvious choices to improve the image.

Image Edits. A +20 Exposure adjustment combined with a +15 Blacks adjustment brought more life to the image. Even with the saturation clipping (in sRGB), we decided the colors needed a boost so we increased the saturation of Yellows and Greens. To add a bit of darkening in the corners, we also added Post Crop Vignetting as shown in Figure 5-31.

Figure 5-31
Panel adjustments.

Basic panel adjustments

Hue adjustments in HSL/
Grayscale panel

Post Crop Vignetting
adjustments in the Lens
Corrections panel

Most all of the work that we do in Camera Raw takes place in ProPhoto
RGB in 16 bits per channel. The fact is that this image at default still has
saturation clipping. Today's digital cameras are capable of capturing so much
more that we feel it's a shame to use such a color-limiting gamut as sRGB.

Color Split Toning

Jeff shot this image (see Figure 5-32) in the Old Town neighborhood of
Chicago. The image was shot with a Canon 10D and a 17-35mm lens at 21mm.

Figure 5-32
Color split tone.

Image at Camera Raw default

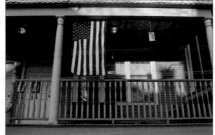

Image after adjustments

Histogram at default

Histogram after adjustments

TIP Turn Off Sharpening. To see the color fringes clearly and to judge the optimum settings for the sliders, turn off any sharpening you've applied with the Sharpness slider in the Detail tab. The color fringes are usually most prominent along high-contrast edges, and sharpening applies a halo to such edges that makes it harder to see exactly where the color fringes start and end.

TIP Option-drag the Sliders to Hide the Other Channel. Red/cyan fringing is usually much easier to see than blue/yellow fringing, but chromatic aberration is almost always a combination of both. Holding down the Option key as you drag either of the Chromatic Aberration sliders hides the channel that isn't being affected by the adjustment, making it much easier to apply exactly the right amount of correction to both channels.

Image Evaluation. The most obvious problem with this image is that it suffers from underexposure. But if you look at the histogram at default, you'll see that increasing the camera exposure would have resulted in a potential for tone clipping. So, the main problem is one of underexposure of the shadow information, something Camera Raw 5 is pretty good at dealing with. If you look at the before/after, you'll see that there's been a substantial redistribution of shadow information while adding a color toning effect to make the highlights warmer and the shadows cooler.

Image Editing. In the Basic panel we lightened the overall tone of the image by increasing Exposure and Brightness, and added some Fill Light (see Figure 5-33). To make sure highlights didn't get clipped, we included some Recovery, and again, since we added Fill Light—the Blacks needed a bit more clipping. We also used Clarity and Vibrance. In the Tone Curve panel, the Parametric Editor enabled us to further lighten the Darks and Shadows.

Then it was on to the Split Toning panel. As you can see from the adjustments, we added a lot of amber warming saturation. To offset the highlight warming, we added shadow cooling. The hues we selected are close approximations of traditional photographic Light Balancing (LB) filters. Because the warming saturation was so high, we needed to adjust the Balance slider to keep the highlight saturation from encroaching too far into the shadows. Adding negative numbers enhanced the shadows, and adding positive numbers enhanced the highlights.

After the split toning, we needed to make adjustments in the Hue, Saturation, and Luminance tabs of the HSL/Grayscale panel (see Figure 5-33). We adjusted the Hues of Blues and Purples as well as the Saturation of Aquas and Blues, and lightened the Luminance of Blues.

Because of the chromatic aberration caused by the camera lens as well as the overall fringe at high-contrast edges (that were worsened by increasing Vibrance and Saturation edits), we needed to correct for the defects (see Figure 5-34). We zoomed into 400% at the far upper-left corner of the image to make the adjustments.

Split toning is often associated with adding color toning to grayscale images, but the effect can be useful for color images as well.

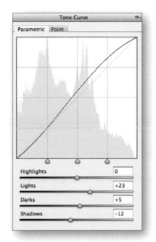

Basic panel adjustments

Parametric Editor Tone Curve adjustments

Hue adjustments in HSL/Grayscale

Saturation adjustments in HSL/Grayscale

Luminance adjustments in HSL/Grayscale

Split toning adjustments

Figure 5-33
Panel adjustments.

Figure 5-34

400% zoom in upper-left corner

Lens Corrections panel adjustments

Local B&W Conversion

Doing a global color-to-B&W conversion is sort of a one-way street. Everything gets turned into a monochrome (or toned) result. However, with Camera Raw 5's Adjustment Brush you can now easily do localized conversions to B&W while still keeping color in the image. This image by Jeff (see Figure 5-35) is a prime example if not a slightly disturbing one—the eyeball was a glass eye (Jeff doesn't like to mess around with *real* eyes).

Figure 5-35 Local B&W conversion.

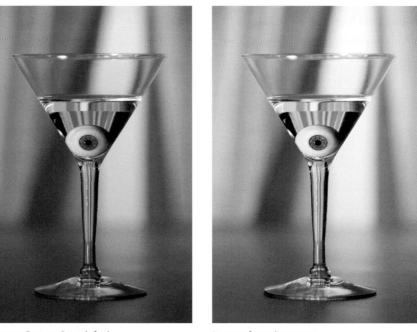

Image at Camera Raw default Image after adjustments

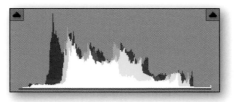 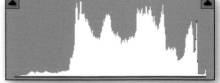

Histogram at default Histogram after adjustments

Image Evaluation. Jeff shot this under studio light, but the color balance was very warm—too warm. However, simply doing a White Balance adjustment never completely eliminated color casts in the background. Previously, Jeff had processed this image in Photoshop and done a local color-to-B&W adjustment there. Now it can all be done in Camera Raw 5.

Image Edits. The only real edits were done using the Adjustment Brush. Figure 5-36 shows the two masks that were used.

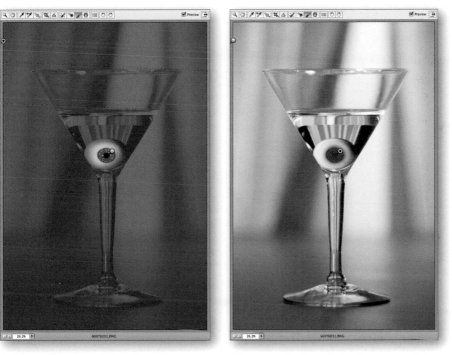

Figure 5-36

Adjustment Brush mask showing the area that had a -100 Saturation adjustment, turning it into grayscale

Adjustment Brush mask showing an area of the eye that was slightly lightened and with an increase of saturation

The easy way to work is simply to take a really large brush and paint over the entire image with a 100 Flow and Density. Then selectively erase those areas you want to remain in color—in this case, just the center of the eyeball. It would be nice to be able to take a mask, copy it, and invert it (Photoshop can do that very easily), but that's a feature we hope to see in the future. In this case, it was again very easy to simply paint in the center of the eye to lighten it slightly and also increase the saturation of the eye color.

Converting from Color to B&W

The image shown in Figure 5-37, which Jeff shot of legendary New York photographer Jay Maisel, was done at Jeff's studio in Chicago while Jay was in town to do a lecture. Jeff got Jay to sit still for about 35 captures at which point Jay said, "You got enough," stood up and walked over to Jeff's 4' x 4'

light and looked into it. Jeff was able to get a couple of captures before Jay decided he wanted to see what Jeff had just shot (one of the joys of digital).

Figure 5-37 Color to B&W.

Image at Camera Raw default

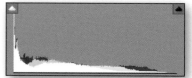

Histogram at default

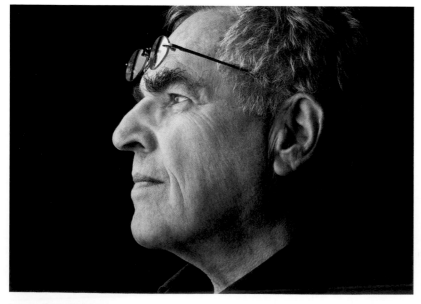

Image after adjustments

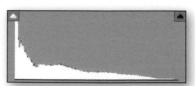

Histogram after adjustments

Jay liked the shots but was a bit disturbed when Jeff took one of the captures and converted it to B&W in Camera Raw. You see, Jay doesn't have much use for B&W (he's a brilliant color photographer). His response was, "Oh, that's too bad," when he saw the color go out of the image. However, he liked this shot enough to ask to use it to promote the workshops he gives throughout the year at his Bowery "bank building," a multistoried former bank in the Bowery. See www.jaymaisel.com for more information.

Image Evaluation. Aside from a slight underexposure (tough to get a meter reading when somebody is walking into the light), about the only thing wrong with the original image was that it was in color. Converting to B&W would produce a much stronger portrait.

Image Edits: Tone. Not a lot of edits were done in the Basic panel except for an increase in Fill Light (which actually was shown to be needed after the B&W conversion). There was an additional tone curve adjustment in the Parametric Editor, as shown in Figure 5-38.

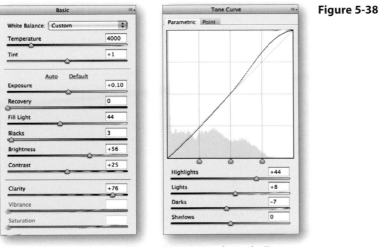

Figure 5-38

Basic panel adjustments

Parametric edits in the Tone Curve panel

Image Edits: Conversion. When making color-to-grayscale conversions, we try to see what Camera Raw will come up with on its own by clicking the Auto button after converting to B&W. We adjusted the color to optimize the resulting conversion. After the conversion, a gentle split tone was done to give the color a "platinum" toned look (see Figure 5-39).

Figure 5-39

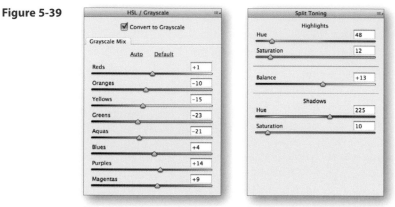

HSL/Grayscale adjustments Split Toning panel adjustments

Local Adjustments. As you can see in Figure 5-40, Jeff used seven Adjustment Brush masks to adjust the tonality in a local manner. The highlighted mask was used to lighten the areas using Brighten. The lower pins represent masks, which used a minus Clarity to soften the skin (Jay's a very well-preserved 70+ years old, but light is terribly unforgiving). A zoomed in view shows detail work to lighten the reflection in Jay's eyes.

Figure 5-40 Adjustment Brush.

Adjustment Brush masks to lighten and apply a minus Clarity

Detail work in the eyes

Landscape Sharpening

This next example (see Figure 5-41) starts off with the image corrections and then moves on to the image sharpening. The image was shot on a

gloomy and rainy day in Oxford, England, while Jeff was visiting Martin
Evening (to work on their joint book).

Image at Camera Raw default

Image after adjustments

Figure 5-41
Landscape sharpening.

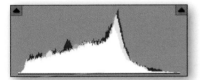

Histogram at default

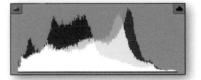

Histogram after adjustments

Image Evaluation. The image is basically well exposed but looks too cool
and flat. With a gloomy and rainy old England, Camera Raw can certainly
brighten the day (even if can't keep it from raining).

Image Edits. Lots of Clarity and Vibrance, and even a bit of plain old
Saturation were thrown in. We also added a split tone to warm up the high-
lights and cool down the shadows. Figure 5-42 shows the panel adjustments.

Figure 5-42

Basic	
White Balance:	Custom
Temperature	5050
Tint	+4
Auto Default	
Exposure	+0.05
Recovery	0
Fill Light	0
Blacks	9
Brightness	+50
Contrast	+28
Clarity	+74
Vibrance	+66
Saturation	+19

Basic panel adjustments

Split Toning	
Highlights	
Hue	49
Saturation	25
Balance	+46
Shadows	
Hue	225
Saturation	40

Split Toning panel adjustments

Next, let's discuss the image sharpening for this image. To see the results, we started at Camera Raw's default and zoomed into an area of the image that shows a variety of edge width detail to make adjusting the settings more accurate. Figure 5-43 shows a before/after with the starting default sharpening and the final sharpening applied.

Figure 5-43

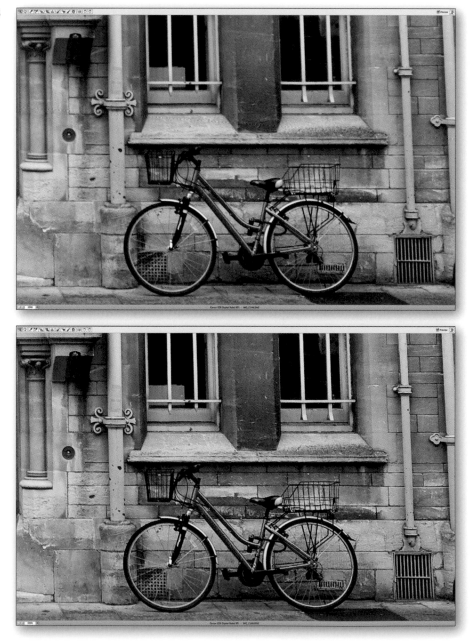

Sharpening settings at default with zoom at 200%

(Amount: 25, Radius: 1, Detail: 25 and Masking: 0).

Sharpening settings adjusted with zoom at 200%

(Amount: 50, Radius: .6, Detail: 50, Masking: 32)

We suggest you evaluate the Amount settings by holding down the Option key while adjusting the slider. This removes the color information, thus allowing you to concentrate on just the texture.

Amount Setting. At this beginning stage, you should realize that the settings would only be preliminary because changing the remaining settings will have an impact on the Amount setting. The aim here is just to get the adjustment to a better starting point. The key to making this adjustment is to take it to the point where it's obviously too much and then back off (see Figure 5-44). You might be surprised how far you can take it before seeing bad things happen. Remember also that image sharpening in the Detail panel is designed for "capture sharpening," not sharpening for an effect.

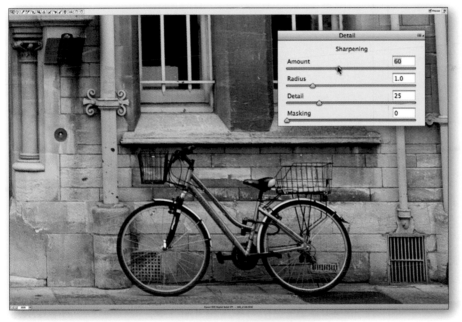

Figure 5-44

Detail panel: adjusting Amount while holding down Option

Amount preview showing grayscale image

Radius and Detail Settings. The Radius setting allows you to adjust the edge width of the image sharpening. The general rule is the higher the frequency of the edges, the lower the radius you want to use. In this landscape image, we wanted to emphasize the texture. The Detail setting adjusts how much halo suppression is applied to the edge sharpening. We often move back and forth between Radius and Detail, and then go back to Amount for fine-tuning (see Figure 5-45).

Figure 5-45

Detail panel: Radius
panel adjustment

Image preview of
Radius adjustment

Detail panel: Detail
panel adjustment

Image preview of
Detail adjustment

Masking. Even though Camera Raw defaults to no masking, in general you'll want to at least check the results of edge masking (see Figure 5-46). The non-edge surface areas often don't need additional sharpening at this capture-sharpening stage. We made a slight adjustment, enough to mask off the major areas. Note that generating the masking does require some compu-tational processing, so on slower computers you may notice a slight delay. The Masking settings won't matter—it's the creation of the mask in the first place that takes the time.

Figure 5-46

Masking panel adjustment

Image preview of masking

The Zoom setting for these preceding three figures is 200%, so you may think the sharpening is aggressive. It is, but if you look at the final image at 100% zoom, you'll see that the image is just *sharp enough*.

Noise Reduction. Since this shot was taken with the ISO setting of 400, a touch of noise reduction is called for—not a lot, just a light amount, as shown in Figure 5-47.

Figure 5-47 Adjusting the Luminance Noise Reduction while leaving the Color at Default.

Sharpening Preferences. Before actually processing, you should double-check to make sure that your Camera Raw Preferences are properly set (see Figure 5-2). All this work would be for naught if your Preferences were set to sharpen preview images only. (We know because we've been there, done that.)

Portrait Sharpening

Figure 5-48 shows a shot by Martin Evening, author and beauty photographer based in London. Martin used a Canon 1Ds MIII camera with a 70-200mm F2.8 IS lens at about 85mm and shot under studio strobe lighting. The model was Courtney Hopper from the London Storm agency.

Figure 5-48
Portrait sharpening.

Image at Camera Raw default

Image after adjustments

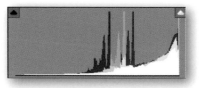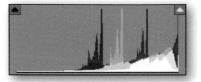

Histogram at default

Histogram after adjustments

The image was shot while Jeff was visiting London to work on Martin's and Jeff's Photoshop book titled *Adobe Photoshop CS4 for Photographers: The Ultimate Workshop* (yeah, it's a long title but it has to be long enough for both Martin and Jeff to get their names on it). This example illustrates the creative use of the Camera Calibration panel as well as Split Toning to achieve a cross-processing effect for the image.

Image Evaluation. Well, even the *before* image is quite nice, but Martin wanted to get a more fashionable look from the image. So he used a technique he describes in *The Adobe Photoshop Lightroom 2 Book: The Complete Guide for Photographers.* The technique involves intentionally using the wrong processing solution to achieve a more "whacked out" look (see Figure 5-48).

Image Editing: Global. Other than slight adjustments of Recovery and Blacks, the main adjustment Martin made was to add Brightness (see Figure 5-49) and reduce contrast. Additionally, he removed a bit of saturation with a –25 Vibrance adjustment. In the Split Toning panel, he applied a Warm/Cool split. Finally, in the Camera Calibration panel, he adjusted the Red and Green Primary Hue and Saturation as well as Blue Primary. As you can see from the before/after in Figure 5-48, the results are quite subtle, with the skin color gaining a yellow cast and the shadows taking on a slight cool look.

Basic panel adjustments

Split Toning panel adjustments

Camera Calibration panel adjustments

Figure 5-49
Panel adjustments.

Figure 5-50
Local adjustments.

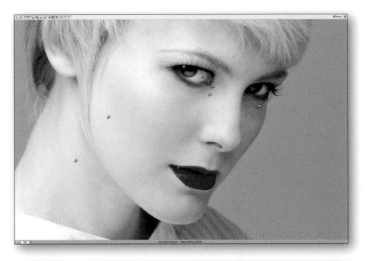

Adjustment Brush to reduce the
red saturation

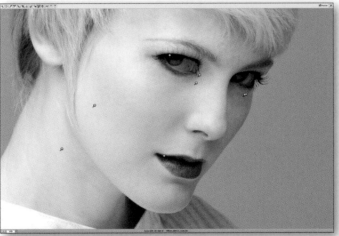

Adjustment Brush to lighten
the eyes

Adjustment Brush to add a
negative Clarity to smooth
the skin

Image Editing: Local. There were three main Adjustment Brush image corrections: a mask to desaturate the red lips, a mask to lighten the eyes, and a minus Clarity to smooth the skin. There are more pins showing but they are duplicates with different parameters, as the three shown in Figure 5-50.

Amount. Figure 5-51 shows Camera Raw's default sharpening at a 100% zoom; for the preview, he held down the Option key while adjusting the Amount slider.

Figure 5-51 Image preview adjusting the Amount (with the Option key to show the preview).

Radius and Detail. Since he was primarily interested in sharpening only the low-frequency aspect of the image, he adjusted the Radius slider a bit wider to 1.4 pixels (Figure 5-52). He also adjusted the Detail slider down to increase the halo suppression on the sharpening. Increasing the radius and reducing the detail is common for portraits because you generally want to sharpen things like eyes and lips more so than the texture of the skin.

Figure 5-52

Adjusting the Radius slider

Adjusting the Detail slider

Figure 5-53

Adjusting the Masking slider

Masking. Arguably the most important aspect of portrait sharpening is properly specifying the edge masking. In this case, Masking is set relatively high to 70 (Figure 5-53). This restricts the sharpening only to those white areas in the image while tapering off in the black areas. This is strictly a judgment call because at this stage, you really only want to recover the apparent sharpness lost by the capture. By increasing the Radius, lowering the Detail, and adding Masking, we reduced the original amount of the sharpening to only those areas we wanted to sharpen. Again, the aim is to get the image to look good at a 100% zoom (see Figure 5-54).

Figure 5-54 The final image at 100% zoom.

Now admittedly, this wouldn't be the final result of this image. Martin would do his typical excellent retouching job. But this processed image would give him a crisp image from which to start. Nice job, Martin!

TIP Navigating Zoomed In. When you zoom in to do close-up spot healing, there's an easy way of navigating screen to screen. If you start at the far upper left, you can use the Page Down key to go down to the bottom. But if you keep doing Page Down, Camera Raw will automatically switch to the top of the next column and continue going down as you keep clicking on Page Down. So, you can start at the extreme upper left and use the Page Down key to finally end up in the lower right corner. Navigating in this manner will assure you that you've seen the entire image while zoomed in.

Syncing Spot Healing

In this section we'll explore Camera Raw's newly renamed Spot Removal tool and how to use it—and when you should (or shouldn't) use it. The main Spot Removal tool is the spot healing function, but there is also an old-style cloning function (which we tend to not use in Camera Raw). We say newly renamed because in Camera Raw 4 it was named the Retouching tool (we think the Spot Removal tool is more aptly named; we really don't do "retouching" in Camera Raw).

Spot healing was a real departure for Camera Raw in that for the first time what might be considered retouching can now be done parametrically. The upside is that you can now accomplish just about everything right in Camera Raw, but the downside is that Camera Raw's retouching capabilities are more limited than Photoshop's. For example, while you can vary the size of the spot healing, you can't do other blending as you can in Photoshop. While Photoshop's retouching functionality is superior, in Camera Raw you can use spot healing to remove sensor dust spots on multiple images, which is more efficient than waiting until you get the images open in Photoshop.

When deciding whether to do the work in Camera Raw or Photoshop, let workflow be your guide. For example, if you have a series of images with sensor spots in the same place, doing the cleanup in Photoshop is simply inefficient when you could spot heal an example image in Camera Raw and sync those spots across a large number of images. Syncing the spot healing means setting the spots in one image and then using the Synchronize command in Camera Raw's filmstrip mode to apply the spot healing to multiple images.

TIP Match Zoom Percentage. If you want to view the images at a zoom percentage other than Fit in View (the default view), select all the images in the filmstrip, and then choose the desired zoom percentage from the Zoom menu or use the Zoom tool. Then as you navigate through the images, each one is displayed at the zoom percentage you specified.

Yes, you can also do light-duty retouching on a person's face to remove a blemish. But unlike a sensor spot that results in a defect in the same place and size on a sensor, a zit on somebody's face is going to move around as you shoot various angles and crops. In that case, it makes a lot more sense to apply the retouching only to the final selected few images rather than laboriously retouching image by image in Camera Raw.

To effectively do spot healing syncing, you'll need to work in Camera Raw's filmstrip mode. If you had to adjust every slider on every image, you might conclude that Camera Raw was an instrument of torture rather than a productivity tool. Fortunately, the combination of Camera Raw, Bridge, and Photoshop offers several ways of editing multiple images. One of these,

often the most useful, is built right into Camera Raw. When you select multiple images to open, either by selecting them in Bridge or in the Open (File > Open) dialog box, Camera Raw opens them in filmstrip mode—see Figure 5-55.

Figure 5-55 Camera Raw's filmstrip mode.

In filmstrip mode, Camera Raw offers a great deal of flexibility. You can select all the open images using the Select All button, which applies all your edits to every image. You can also select contiguous ranges of images by Shift-clicking or nonconsecutive images by Command-clicking. When the focus is on the filmstrip, you can navigate through the images using the up and down arrow keys, and select them all by pressing Command-A.

In Figure 5-56 the image on the left shows sensor spots before healing and the image on the right after healing. The key here is to understand that when you initially place a spot healing spot, Camera Raw will try to determine the optimal place from which to sample. It's right more often than wrong, but when you need to do spot healing for syncing, Camera Raw has a unique behavior. If you've placed a spot and allowed Camera Raw to determine the source automatically, Camera Raw will, when synced across multiple images, use its own auto-detection in all the resulting spots after syncing. If you've placed the spot and altered the source location manually, it will respect the manual relocation of the source. So, when syncing across images, it's useful to try to let Camera Raw auto-detect the source because it will do so for that spot on all the resulting images.

Sensor dust spots

Spots healed

Figure 5-56

Figure 5-57 shows the results of going through the entire image and spot healing all the sensor spots. Jeff shot these images in Antarctica, and dust and wind made sure his sensors were filthy. If you look at Figure 5-57, the only places where there are spots are where there were originally sensor dust spots. Jeff didn't try to do any additional "retouching" that would in any way be image-specific because he didn't want to sync image-specific spots. (You only want to sync spots that are the same relative size and in the same location, frame by frame in the series of images.)

Figure 5-57 Image showing dust spots healed.

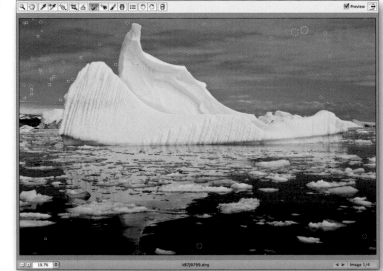

Select and Synchronize. You can use the buttons (see Figure 5-58) or simply use the keyboard shortcuts to select and synchronize. From there, once you synchronize, you'll specify which aspects of the Camera Raw settings you want to sync.

Figure 5-58

Selecting All

All images selected

Clicking on Synchronized images

Clicking the Synchronize button opens the dialog box shown in Figure 5-59. You can either manually deselect all the subsettings or choose Spot Removal from the dropdown menu. If you made other image adjustments settings you also wish to sync, you can do so. But we recommend isolating spot healing to a single task to keep things from getting too confusing.

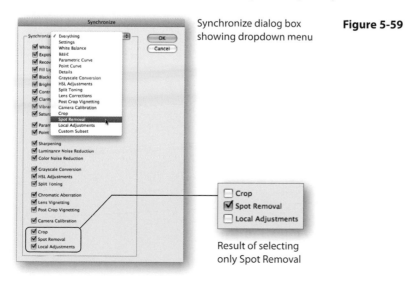

Synchronize dialog box showing dropdown menu

Figure 5-59

Result of selecting only Spot Removal

Once you've synced across multiple images, you still need to check those additional images to be sure that the synced spots are falling in the correct location and not giving unexpected (or undesirable) results. See Figure 5-60.

Figure 5-60 Making image-specific adjustments of the spot healing sources.

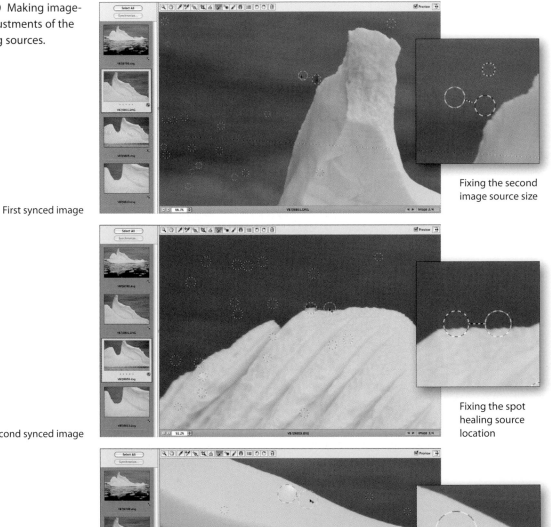

First synced image

Fixing the second image source size

Second synced image

Fixing the spot healing source location

Third synced image

Fixing the third image source location

Since in our example the majority of the spot healing source and destination spots fall in suitable locations, we'll only need to fix a few spots. You'll want to be sure to zoom in and go all around the image just to double-check. When they're wrong, they're pretty obvious.

If you can't see the forest for the trees (the sensor spots for the spot healing spots), you can turn off the "feedback overlay," as shown in Figure 5-61.

Image with final spot healing spot

Image with the Show Overlay deselected

Show Overlay toggle button

Figure 5-61

You can still apply spot healing even with the overlay hidden, but it's pretty confusing. So if you have the Spot Healing tool selected and you don't see any spots or the tool isn't giving you feedback, make sure this option is selected.

Opening Multiple Files as Layers

A new feature added to Bridge CS4 is the ability to open multiple images directly as layers in Photoshop. This can play a major role when using Camera Raw because if you do bracketing and you want to combine the brackets (kind of like a poor man's HDR but with more control), it's now really easy. You start off by adjusting your images as you normally would

in Camera Raw. Figure 5-62 shows four images loaded into Camera Raw in the filmstrip mode.

Figure 5-62 Adjusting images in the Camera Raw filmstrip mode.

At this point, you would do the image adjustments that you normally do—the better the image components are optimized, the better the final results will be. White balance is, of course, critical as well as capture sharpening, and any Lens Corrections should be done at this stage. We would caution you to use Recovery and Fill Light with gentle settings (if any) because overuse may cause problems in the assembly stack. Rather than actually opening the images at this point, you click the Done button to return to Bridge (see Figure 5-63).

Figure 5-63

Bridge with
images selected

The Bridge Load Files
into Photoshop Layers
command

The images loaded into Photoshop layers

Aligning the images. Once the images are loaded into a layer stack, it's important to do an Auto-Align Layers command in Photoshop. Even if you've shot the images on a secure tripod, any slight misregistration will cause problems. The Auto-Align Layers command will do a remarkable job, even if you shoot handheld (although we do suggest the use of a tripod for what we are doing here). Figure 5-64 shows the alignment process.

Selecting all the layers

Choosing the Auto-Align Layers command in Photoshop's Edit menu

The Auto-Align Layers dialog box (we use Auto)

The Progress bar

Figure 5-64 Aligning the layers.

Working with the layers. Once you have the layer stack aligned, we usually change the order of the stack. In this case, we've chosen to put the second from the darkest image at the bottom and build up from there. Figure 5-65 shows the reordered layer stack (with layer masks already applied).

Working with layer masks. The aim here is to pick which parts of which layer will give you the best exposure for various parts of the image. The dynamic range of this series of images is simply too great to hope to adjust a single exposure. Different layers will have optimal exposures for certain areas of the image. The key to using the layer masks is to expose those areas. Figure 5-66 shows all layers turned on with the white portions of the layer masks allowing that portion of that layer to show through.

Figure 5-65 Reordering the layers.

Image

Layer stack reordered

Figure 5-66 Adjusted layer masks.

Image

Layer masks used to adjust layer opacity

Using Blend If. The top layer, the darkest exposure (layer OR5Q2859. DNG), still needed some different blending adjustment, which is not easily done by painting. For this layer we used the Layer Style dialog box to make blending adjustments. You can access this dialog box by double-clicking the layer icon, or choosing from the Blending Options menu (Layer > Layer Style > Blending Options), or choosing from the Layers panel flyout menu. Figure 5-67 shows the menus and dialog box.

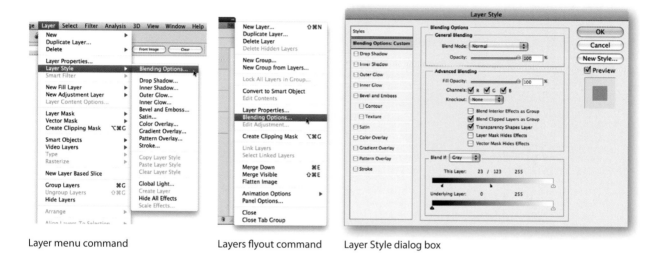

Layer menu command Layers flyout command Layer Style dialog box

Figure 5-67 Layer Style.

Adjusting the Blend If slider for This Layer at the bottom makes the key adjustment. We are only blending the darkest portion of the top layer into the lighter portions of the layer stack. By using the Option (Mac) or Alt (Windows) key you can split the sliders so the blend will fall over a range of levels. In this adjustment, we've set the layer blend to start to taper off at level 123 and none of the image will blend into the image below level 23. The blending allows the dark portion of the image to only impact the middle and lighter values. This is being used to add darkness to the brightest portions of the image—the sky and tree tops.

Shadows/Highlights adjustment. We're almost done, but there's still a tweak to the overall image that can now be done in Photoshop. We previously warned you about not overdoing Recovery or Fill Light in Camera Raw because it may have a negative impact later; well this is later, and it is OK to use the Shadows/Highlights command in Photoshop to further adjust the dynamic range of the image (see Figure 5-68).

Figure 5-68 Shadows/Highlights command.

Merge Visible on new layer

Adjusting layer opacity

Shadows/Highlights command

Shadows/Highlights dialog box

Since the Shadows/Highlights command can't be used as an adjustment layer (it needs real pixels to do its thing), we use an old trick to do a merge of the visible layers to a new layer. Simply add a layer at the top of the stack, and from the Layers panel flyout menu choose Merge Visible but with a trick: Hold down the Option (Mac) or Alt (Windows) key and the Merge Visible will merge all visible layers into that single layer. Figure 5-68 shows

the process. The settings in the Shadows/Highlights dialog box are pretty aggressive. We usually counter that by lowering the opacity after running the command.

Figure 5-69 shows the results of using the new Bridge CS4's ability to Load Files into Photoshop Layers plus a few other tricks. Clearly, this technique adds another weapon to the arsenal of digital photography when dealing with extremely high dynamic range scenes.

Figure 5-69

Final results Final results detail view

Really Smart Objects

Smart Objects in Photoshop aren't new, but with Camera Raw 5 you have new capabilities. Mixing Camera Raw's newfound local image corrections with Smart Objects adds another dimension to using raw files. Camera Raw allows you to open a raw image embedded inside a Photoshop file while maintaining the raw editing capabilities. It's as close as you'll come in Photoshop to using Camera Raw as an adjustment layer.

For this example, Jeff shot a studio still life shot of flowers using a Canon 1Ds MIII on a camera stand. The camera stand was important because the

intent of this exercise was to shoot two shots with different lighting: one with a hard light and one with a soft light to get a result that simulated light coming from a window. The hard-light shot was adjusted warmer in Camera Raw to simulate sunlight, whereas the soft-light image was adjusted cooler to simulate skylight. We start in Camera Raw in filmstrip mode with the two images selected, as shown in Figure 5-70.

Figure 5-70

Two images selected in Camera Raw filmstrip mode

Workflow Options set to open as Smart Objects in Photoshop

The two images opened in Photoshop

Combining Images into Layers. Once you have the two images opened in Photoshop, the next step is to combine the two Smart Object image layers into one image. Figure 5-71 shows the process of dragging the layer icon from the hard-light image (IMG_0017) into the soft-light image (IMG_0011). When starting to drag the Smart Object layer, hold down the Shift key to pin register the moved image in the destination image.

Figure 5-71

IMG_0011 image
receiving the new layer

IMG_0017 Layers panel

After combining the images, you'll end up with two Smart Object layers. We chose to stack the hard-light image on top of the soft-light image, but it could have worked the other way around just as well (the layer masks we'd make would be different). Figure 5-72 shows the result of adding the two layers together.

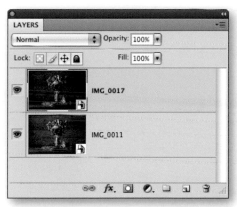

Figure 5-72 The combined Smart Object layers.

At this stage, you can open the Smart Object version of Camera Raw and have full access to Camera Raw 5's controls. We used the Adjustment Brush to vary certain areas of the image (in this case, the IMG_0017 Smart Object) and to add a Graduated Filter to darken the corners and top of the image. Figure 5-73 shows the local adjustments.

Adjustment Brush adjustments Graduated Filter adjustments

Figure 5-73 Local adjustments.

The Adjustment Brush was used to darken the left corner, slightly desaturate the front flower, lighten the clippers, and lighten the leaves on the right. The Graduated Filter was used to darken the corners and top of the image. Once you click the OK button in Camera Raw you'll see a Progress bar indicating Preparing Smart Object (see Figure 5-74). Depending on the number of local adjustments, the size of the capture, and how slow your machine is,

this can seem to take a long time. We sympathize: We wish it went faster but Camera Raw has to rerender the adjustments and provide Photoshop with the "pixel" results. Figure 5-75 shows painting in a layer mask to vary the opacity (visibility) of IMG_0017.

Figure 5-74 Rendering Smart Object progress.

Figure 5-75
Using a layer mask.

Painting in the layer mask

Layers palette showing the mask.

We're close to being done, but there's something further we needed to do that you can't do in Camera Raw—Lens Blur for the background. For that we'll need an actual pixel-based layer to blur. We did the same Merge (Option > Merge) trick we used in Figure 5-68 to render the combined Smart Objects into a pixel layer. Figure 5-76 shows the process.

A new merged visible layer on top Selecting the Lens Blur filter

Figure 5-76 Adding a Lens Blur.

The Lens Blur dialog box

We added a layer mask to the resulting blur to selectively add the blur. Figure 5-77 shows using the layer mask and the addition of a second blurred layer made by duplicating the previous blurred layer and rerunning the Lens Blur filter while lowering the opacity to 50%. Hey, just like any good photographer we figure if a little is good, more is better, right?

Figure 5-77
Lens Blur results.

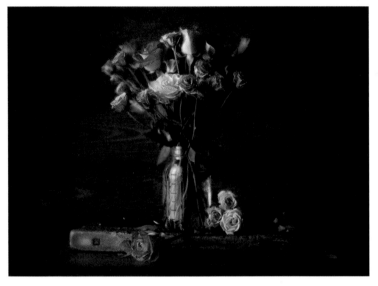

Image after the Lens Blur

Layer panel showing layer mask

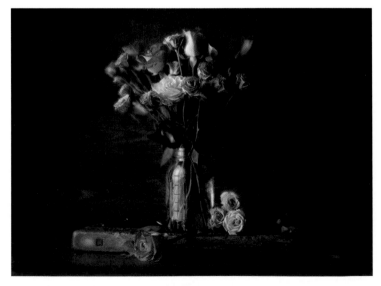

Image after second Lens Blur layers is added

Layer panel showing two Lens Blur layers with second at 50% opacity and stronger layer mask

The final results are shown in Figure 5-78. The detail shows the effect of adding the Lens Blur to give a selective focus effect and soften the wood background. Smart? No, it's a Smart Object!

Figure 5-78 Final results.

Full image

Image detail

Beyond Camera Raw

Camera Raw has evolved into a powerful tool for tweaking and processing digital capture images, individually or in groups. But if you've just returned from a day's shoot with 700 images, Camera Raw really isn't the place to start. In this chapter, we focused on the kinds of detailed edits you typically want to make to your selects, but even if you're the world's greatest photographer, it's unlikely that every image from a shoot will deserve this kind of attention.

Moreover, editing the pixel data is only part of the job. Before opening a single image from a shoot, you should add metadata. At minimum, add your copyright notice and a few select keywords. Then go about the business of sorting the wheat from the chaff, and only after you've accomplished these tasks should you start optimizing images. So in the next chapter, we'll look at another key component of the workflow: Bridge.

CHAPTER SIX
Adobe Bridge

YOUR DIGITAL LIGHT TABLE

In Photoshop CS, the File Browser with Camera Raw 2 became an important tool for anyone who shot raw. In Photoshop CS2, the File Browser was replaced by a standalone application, Adobe Bridge, which incorporated all of the File Browser's capabilities and added new ones of its own, including the functionality of Camera Raw 3. Now at version 3, Bridge CS4, in combination with Camera Raw 5, has grown into the mission-critical cockpit of a raw processing workflow.

You can make your initial selections from a shoot using Bridge as a digital light table. When you want to convert your images, you can host Camera Raw in Bridge and have it convert images in the background. You can also use Bridge to add and edit metadata—one of the first things you should do to a new folder of raw images is add your name and copyright notice to each image. And finally, you can use Bridge to add keywords to images so that you can find them easily now or several years later; see the sidebar "All About Metadata," later in this chapter.

Bridge CS4 has gotten pretty complex, so in this chapter we'll introduce you to its various components, explain what they do, and show you how to use them to manage your images and processing tasks efficiently. But bear in mind that Bridge serves the entire Adobe Creative Suite, not just Photoshop, so don't expect a comprehensive Bridge CS4 reference guide here—we're only going to talk about the features that apply to digital photography and primarily to a raw workflow.

TIP The *Start Bridge at Login* is the new way to automatically launch Bridge. There's no longer a Photoshop preference to have it automatically launch when you open Photoshop. However, if you really want to automatically launch Bridge CS4 when you open Photoshop, here's a work-around: Record an action, insert the menu item Browse in Bridge from the File menu. Then in the Scripts Manager, enable select action > your recorded Bridge Open action, and add this action as a script to occur whenever Photoshop CS4 is launched.

Launching Bridge

When working on single-display systems, you'll usually keep Bridge hidden or in a Compact mode unless you are actually using it. On dual-display systems, it's a good idea to keep Bridge open on the second monitor all the time.

The simplest way to launch Bridge is the same way you launch any other application on your platform of choice. You have the following options, as shown in Figure 6-1:

- Choose Browse in Bridge from Photoshop's File menu.

- Click the Launch Bridge button in the Options bar.

- Check Start Bridge At Login—that way, whenever you start your computer, Bridge automatically launches too.

Choose Browse in Bridge from the Photoshop File menu.

Click the Launch Bridge button in the Photoshop Options bar.

Check the Start Bridge At Login option in Bridge's Advanced preferences.

Figure 6-1 Launching Bridge.

CONFIGURING BRIDGE WINDOWS

Whereas the old File Browser in Photoshop CS was limited to a single window, in Bridge CS4 you can open as many windows as you like. Each window shows the contents of a folder or volume (subfolders appear as folder icons), and you can configure each window to your liking.

Arranging Windows

A few tricks can help you manage your Bridge windows configuration:

- You can minimize windows to the Dock (Mac) or Taskbar (Windows).

- You can set windows to Compact mode.

- You can set windows to Ultra-Compact mode.

In Compact and Ultra-Compact modes, Bridge windows by default "float" above Full-mode windows, so they're easily available—see Figure 6-2.

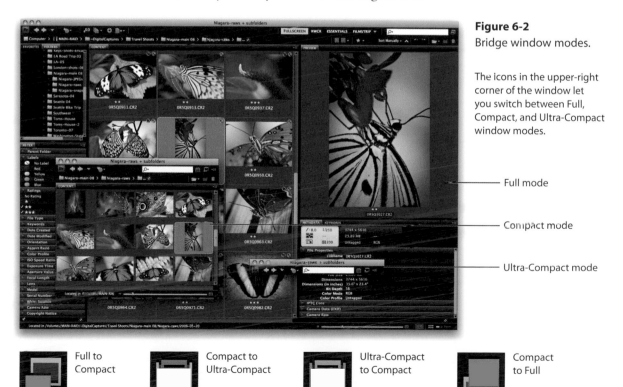

Figure 6-2
Bridge window modes.

The icons in the upper-right corner of the window let you switch between Full, Compact, and Ultra-Compact window modes.

———— Full mode

———— Compact mode

———— Ultra-Compact mode

Full to Compact

Compact to Ultra-Compact

Ultra-Compact to Compact

Compact to Full

Pathbar indicating subfolders

✓ Show Reject Files
 Show Hidden Files
✓ Show Folders
 Show Items from Subfolders

The command Show Items from Subfolders from Bridge's View menu.

You can cycle through all the open Full-mode windows by pressing Command-' (left single quote) on the Mac or Alt-Tab in Windows. However, the shortcut doesn't apply to Compact or Ultra-Compact windows, so it's just as well that they float by default. If the floating behavior annoys you, you can turn it off for individual Compact or Ultra-Compact windows from the flyout menu sported by those window modes (see Figure 6-3), but be aware that doing so could make your Compact and Ultra-Compact windows hard to find.

Figure 6-3 Compact and Ultra-Compact window menu.

> New Window
> New Folder
> **Compact Window Always On Top**
> View
> ✓ Path Bar
> Quit Bridge

TIP One curious side effect of the floating compact windows is that Bridge can have multiple windows as the foreground window, and sometimes simply clicking on the one you want to switch from Compact to Full or vice versa doesn't work. If you select one or more thumbnails in that window, though, the shortcut will apply to that window.

You can toggle between modes by pressing Command-Return (Mac) or Ctrl-Enter (Windows). The shortcut toggles between Full and either Compact or Ultra-Compact modes, depending on which of the Compact modes you last applied to the window.

Bridge Window Components

In Full mode, Bridge windows contain up to eight different areas called *panels.* (A ninth area called the Inspector panel is only used for Version Cue.) The Content panel always contains image thumbnails, and the seven remaining panels—the Folders, Favorites, Preview, Metadata, Keywords, and Filter panels and the new Collections panel—are resizable and can be rearranged in the window or even hidden. See Figure 6-4a and 6-4b for a complete breakdown of the panels, buttons, and icons.

The Content panel displays image thumbnails at different sizes. The Folders panel lets you quickly browse through folders and allows you to move or copy files by dragging or Option-dragging (Mac) or Alt-dragging (Windows) to a Folder icon in the Folders panel. The Preview panel shows a preview of the selected image or images. The Metadata panel displays the metadata associated with the selected image—you can control which fields are displayed. The Keywords panel lets you create keywords and sets of keywords, assign them to images, and perform searches. The Filter panel permits you to make a wide range of filtering configurations to reduce the thumbnails being viewed, and also allows sorting. The new Collections panel allows you to create regular Collections and Smart Collections.

Figure 6-4a Full-mode window components.

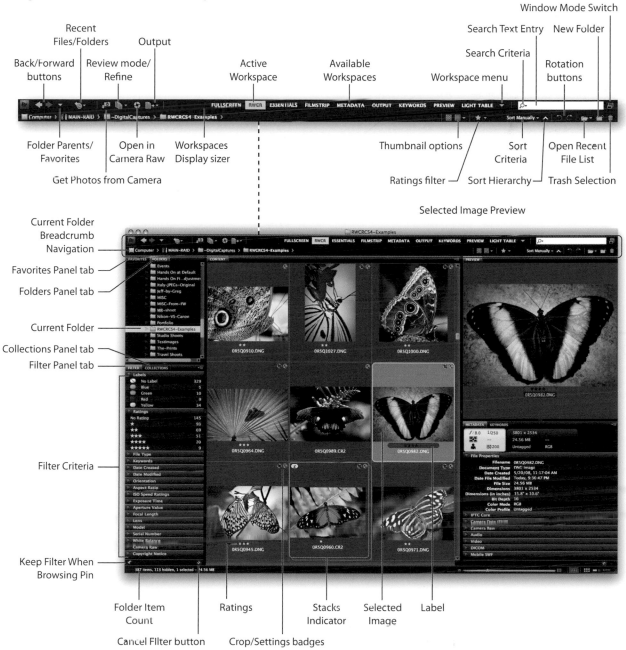

Figure 6-4b Full-mode window components.

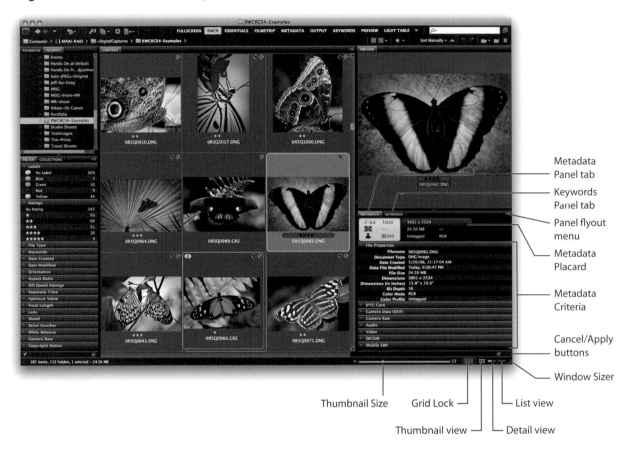

Metadata Panel tab

Keywords Panel tab

Panel flyout menu

Metadata Placard

Metadata Criteria

Cancel/Apply buttons

Window Sizer

Thumbnail Size

Grid Lock

Thumbnail view

List view

Detail view

Image Thumbnails

Bridge is all about looking at and working with lots of images. Fundamental to this task are the thumbnail views of those images, so it's important to know how to configure Bridge thumbnails. In Figure 6-5, the image thumbnail is displaying the current rating (you'll learn about ratings in the section "Additional Filter Criteria" a bit later), a red label, and four additional lines of image information. Figure 6-6 shows how to set up Bridge to display the information you want.

High-quality image thumbnail

Crop and Settings badges

Figure 6-5 Bridge image thumbnails.

Additional info showing: Filename, Date Created, Exposure, Keywords, and Copyright

Label indicator Rating indicator

Figure 6-6 Thumbnails performance, options, and file handling.

Preference settings

Details dropdown menu

Thumbnail Quality options

In the Thumbnails Preference window, you'll see two sections: Performance and File Handling and Details. Pay close attention to the following descriptions:

Performance and File Handling. Here you tell Bridge not to generate a thumbnail for images over a specified number of MB in size.

Details. This section allows you to display additional information in the Content panel along with the default filename. Figure 6-5 shows the filename along with the lines Date Created, Exposure, Keywords, and Copyright. The Details section is also where you set the preference for showing or hiding tooltips. You can hide all the image information by choosing View/Show Thumbnails Only or pressing Command-T (Mac) or Ctrl-T (Windows). The dropdown menus in the Details section reveal a wide variety of options to display in the additional lines.

Thumbnail Quality Options. When browsing, you can have Bridge use the embedded image thumbnail (if there is one) or generate a low-quality preview. This low-quality preview will not be accurate, but Bridge CS4 can generate it very fast. To see an accurate high-quality preview, you must select either High Quality On Demand or Always High Quality in the main Bridge window Thumbnail Options dropdown menu. This is different from the previous Bridge version, which included the quality settings in the Thumbnails preferences. Since this is a window-specific option, no longer having the options in the preferences is an improvement.

We find that the tooltips are often irritating and get in the way (see Figure 6-7), so we generally turn them off. One thing we often use is the context menu, which you access by Control-clicking (Mac) or right-clicking (Windows). Context menus help you maintain efficient control over images and Bridge functionality.

The Crop and Settings badges (Figure 6-8) come in handy to determine, at a glance, whether you've already applied Camera Raw settings to an image and whether you've cropped the file. New to Bridge CS4 is the ability to filter based on these criteria.

Thumbnail
tooltips

0R5Q0982.DNG
Date Created: 5/20/08, 11:17:04 AM
Date Modified: Today, 3:10:34 PM
24.56 MB
3801 x 2534
Label: Red
Description: Close up photo of a Blue Morpho
butterfly from South America.
Keywords: Canada, Niagara Falls, Ontario,
South American butterflies, Blue Morpho,
Morpo peleides

Thumbnail
context menu

Figure 6-7 Tooltips and
the Context menu.

Figure 6-8 Crop and
Settings badges.

Thumbnail Stacks

A useful feature of Bridge CS4 is the ability to stack images into a logical
group, thereby improving image organization and reducing the visual
clutter in the Content panel. As shown in Figure 6-9, you can select mul-
tiple images and stack them. By default, the stack order will be the order
of the current sort. In Figure 6-9, the image order represents a bracket of
exposures from lightest to darkest. This is the order in which they were
shot (sorted by Date Created).

Thumbnail indicator
for collapsed stacks

Expanded stacks

Image promoted to the top of the stack

Promote to Top of Stack
command

Figure 6-9 Stacking images.

When images are stacked, the lightest exposure will be on top. However, you may want the "best" exposure on top. You can select the image you wish to be on top and choose the Promote to Top of Stack command from the Stacks menu. Alternatively, you can manually move the images in the order you desire before stacking.

Configuring Bridge Panels

You can customize Bridge in a multitude of ways. The default configuration is shown in Figure 6-10.

Figure 6-10 Standard Bridge configuration.

A standard configuration

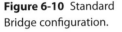

The Content panel layout options

In the default configuration, the Content panel is in the center with additional panels on either side. This arrangement is efficient for general use, but you could choose among a variety of additional standard views, as shown in Figure 6-11. The flyout menu on the Content panel allows you to configure the thumbnails with a vertical or a horizontal scroll, or you can use the default of Auto (which is what we generally use). Clicking the Window configuration buttons at the bottom of the Bridge window accesses the preset view options.

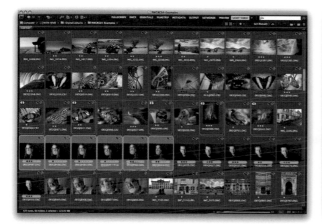

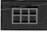 LIGHT TABLE–Thumbnails view shows just the image thumbnails with up to three lines of additional metadata. The icon shows the locked grid view option.

 FILMSTRIP–Filmstrip view shows the image thumbnails arranged along the bottom of the window with large previews of the selected images displayed above. This figure is showing two 100% loupe views for checking fine detail or focus. The icon shows the regular thumbnail option.

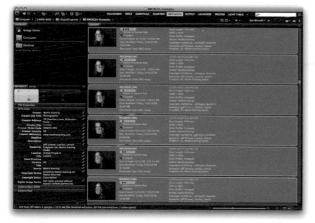

 METADATA–Metadata view shows the thumbnails as a list, along with additional metadata. The icon shows the detail view option.

 METADATA List View–This shows a viewing option called List View that shows image info in a movable list table. The icon shows the list view option.

Figure 6-11 Bridge configurations with view options.

Figure 6-11 shows three main default window configurations with an additional List View option. You can access additional configurations from the Window menu, as shown in Figure 6-12, or simply select them from the main Bridge window. But the real power of customization is when you configure all the panels and their sizes and save your own custom Workspace. You can drag panels around, combine the ones you want and hide the others, and then save both the window locations and the current sort order as part of your Workspace. You can name them and even include keyboard shortcuts.

Figure 6-12 Bridge Workspaces.

The Workspace flyout menu

The New Workspace dialog box

As shown in Figure 6-12, we've made some custom Workspaces so we can quickly access custom Bridge configurations (the RWCR workspace is saved so we can return to it easily for screen shots). Constantly tweaking the default panels and sizes is just an exercise in frustration. We suggest creating your own Workspaces so you'll know exactly where things are and thus work more efficiently.

Bridge Filter and Sort

With the File Browser and the original CS version of Bridge, filtering and sorting were, uh, well, let's say *primitive*. That's no longer the case. The Filter panel features a complex series of filtering based on 18 criteria, along with the ability to sort.

Sort. Figure 6-13 shows the sort criteria available in the Sort dropdown menu (you can also select the sort order from the main View menu). You can save the sort order in your Workspace as well as specify the order by Bridge window (when you have multiple windows showing multiple folders). So, you could have two or more windows displaying different sort orders. This is useful when you combine the sort with various filters.

Sort available in the main Bridge window

Sort available in the menu

Figure 6-13 Bridge sorting.

Filter. The Filter panel is extremely powerful and first-time users may think it intimidating. Figure 6-14 shows only the Labels filter (we've collapsed the other categories). You choose a filter and click on it, and Bridge displays only those images that fit the criteria. In Figure 6-14, Bridge is set to show only the Red and Yellow labeled images; all other images are filtered out. Note that the Bridge labels are set to colors instead of the Bridge CS4 defaults. We've done this to maintain backward compatibility with previous versions of Bridge and with our own label conventions. If we didn't make this change, our previous labels would display in white. Figure 6-15 shows the Labels preferences.

Figure 6-14 Bridge Filter panel.

Advanced Bridge Labels Preferences. You can set the labels to whatever you wish, but when there is a mismatch, the mismatched labels will display as white. In Figure 6-15, the first thumbnail is shown with the label settings at Bridge CS4 defaults. The next thumbnail shows the Red label correctly named "Red." The Filter panel will display the current preferences, and the Metadata panel will display the embedded label name.

Additional Filter Criteria

Other criteria for sorting images include ratings and file type associations.

Ratings. In addition to labels, the other primary image-selection aid is ratings. Ratings can be applied on a scale of one to five stars. Combining labels with ratings results in 36 potential selection classifications. In addition, you can mark an image as a "Reject" by pressing the Delete key (look back at Figure 6-13, which shows the menu command for Show Reject Files).

As shown in Figure 6-16, you can select which ratings to filter for—with these selections, for instance, only the 4- and 5-star ratings would be visible. Additionally, you can assign ratings either from the Label main menu or by using keyboard shortcuts. Note that you can choose whether to require a Command key in combination with the keyboard number.

Figure 6-15 Bridge Labels preferences.

Bridge Labels Preferences at default

Image label showing mismatch

Image label correctly matched

Bridge Labels preferences changed to custom colors

Ratings filter

Label menu,
including ratings

Figure 6-16
Ratings filter and menu.

Figure 6-17 File type filter. (Filtering on DNG file type.)

File Type Associations. The File Type filter allows you to specify what file types will be shown. If you have a mixture of file types in a folder, you can choose to show only a single type. Figure 6-17 shows two potential mixtures. In one example, both DNG and processed TIFF files appear. In the next example, a combination of raw plus JPEG files is shown. This would be typical if you set your camera to shoot both raw and JPEG. Note that raw and JPEG files are treated as separate files as far as renaming or other functions applied to the files.

At this point, let's talk a bit about file type associations and how Bridge handles them. Figure 6-18 shows the Bridge CS4 Preferences panel for file type associations. The key is to understand that Bridge, by default, surrenders the file handling to the system's preferences. But that is not always what you may want or need. In the Bridge preferences, you can dictate how Bridge will handle the file associations and what application will open the selected images.

Figure 6-18 File type associations.

Preferences

The dropdown menu, which you access by clicking on the application (rightmost) column in the preferences, allows you to both check and change Bridge's current associations. As shown in Figure 6-18, the example file format is PSD (Photoshop's native format) and the Finder Settings indicate Adobe Photoshop CS4, which is fine. However, you can choose another application for Bridge to default to either by selecting that application name in the dropdown menu or by clicking the Browse option and navigating to the desired application. Bridge will then use that newly specified application when you double-click to open the file from within Bridge.

Figure 6-19 shows additional Filter criteria. Note that each category can be "live" and thus used in combination to show only those images that meet the criteria you set. Keep in mind that setting the filtering will have a major impact on the thumbnails' visibility, so if you find that you are missing some images, double-check the filter criteria to see if you've excluded them in a filter. If you want to eliminate all the filters, click the Cancel button at the bottom of the Filter panel. If you wish to keep the filters live while browsing other folders, be sure to click the Pin button.

Figure 6-19 Additional Filter criteria.

Keywords	
No Keywords	53
(Multiple values) dogs	1
adobe buildings	11
alone	31
America's Loneliest Highway	51
Animals	38
Antarctic 2007 Expedition	69
Antarctic cruise	36
Antarctic Peninsula	11
Antarctica	87
Antarctica 2005 Expedition	49
Argentina	61

Keyword filter

Orientation	
Landscape	364
Portrait	71
Square	1
Aspect Ratio	
1:1	1
2:3	361
3:4	38
4:5	1
5:7	5
16:9	29

Orientation and Aspect Ratio filters

Color Profile	
sRGB IEC61966-2.1	34
Untagged	402
ISO Speed Ratings	
100	139
125	12
160	4
200	178
320	2
400	90
500	1
800	4
1600	6

Color Profile and ISO Speed Ratings filters

Model	
Canon EOS 5D	6
Canon EOS 10D	20
Canon EOS 20D	3
Canon EOS D30	1
Canon EOS DIGITAL REBEL	18
Canon EOS DIGITAL REBEL XT	32
Canon EOS DIGITAL REBEL XTi	58
Canon EOS-1D Mark II	6
Canon EOS-1DS	12
Canon EOS-1Ds Mark II	130
Canon EOS-1Ds Mark III	113
FinePix A820	34
P 45+	3

Camera Model filter

 Keep Filter When Browsing pin

 Cancel button

Metadata Panel

Metadata is data about the data. You'll see the important role this data can play when dealing with a ton of images.

Jeff has taken the liberty of bringing Bruce into the discussion using a portrait of Bruce shot at Jeff's studio in early 2006 (see Figure 6-20). The image was shot using studio strobe with a Canon 1Ds MII camera. Camera Raw was used to convert the image to grayscale.

Figure 6-20 Metadata panel

Metadata panel with Preview panel on top

Metadata placard. The Metadata panel shows a rich readout of various categories of metadata embedded in the file or sidecar file. By default, the panel header is the metadata placard, which provides both symbolic and numerical readouts of EXIF metadata (see the sidebar "All About Metadata" to learn about EXIF). As shown in Figure 6-20, the placards reveal information similar to what you might see on the back of your camera. The exact options and how they display will vary by file type and camera model. For example, a raw file won't display either a color space or a pixel density because it's an unprocessed raw file; a camera JPEG would.

Some camera's metadata will display a White Balance mode, while in the same location other cameras will display a focus mode. There's no way for a user to control what does or doesn't display in the placard. It's kind of potluck—you get what you get. If you don't want to waste the display space, you can choose to hide the placard.

Metadata readouts. Below the metadata placard is the main metadata display area. In Figure 6-20 both the file properties and the Camera Raw metadata fields are expanded to show their readouts. You can control which categories are expanded and which display in the panel using the Metadata Preferences, as shown in Figure 6-21.

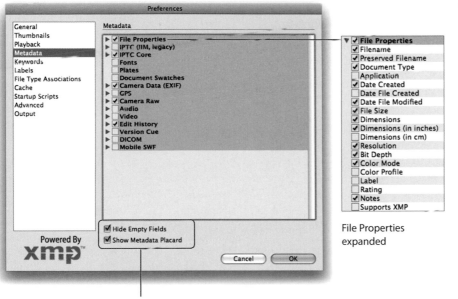

Figure 6-21 Metadata Preferences.

File Properties expanded

Optional checkboxes

Metadata Preferences. In the Metadata Preferences you can select which schema categories (in bold) and which fields you want to display. Scroll through the list, turning schemas and fields on or off as you wish. Some fields will have little importance, while others will be crucial to display. We recommend that you always display the File Properties schema, which provides important information about selected images. Unless you also do design work, you'll probably not be overly concerned with the Fonts or Plates schemas. Notice the two checkboxes at the bottom of this Preferences dialog box: you can choose the option Hide Empty Fields (suggested), and specify whether to make the metadata placard visible.

While the topic of metadata is covered in depth in Chapter 8, *Mastering Metadata*, it may be useful to explain a bit just what we're talking about. So, check out a tantalizing morsel in the sidebar "All About Metadata."

All About Metadata

Metadata (which literally means "data about data") isn't a new thing. For years Photoshop's File Info dialog box has allowed you to add metadata such as captions, copyright info, and routing or handling instructions. But digital capture brings a much richer set of metadata to the table.

Most current cameras adhere to the EXIF (EXchangeable Image File) format "schema," or standard, which supplies with each image a great deal of information on how it was captured, including the camera model, the camera serial number, shutter speed, aperture, focal length, flash setting, and of course the date and time. This is a schema published by the Japan Electronics and Information Technology Industries Association (JEITA).

IPTC (International Press Telecommunications Council) metadata has long been supported by Photoshop's File Info feature, allowing copyright notices and the like. Other types of metadata supported by Photoshop CS4 include GPS information from GPS-enabled cameras (it's immensely cool that our good friend and photographer Stephen Johnson's stunning landscape images include GPS metadata that will allow people to identify where they were shot 10 or 100 years from now and note how the landscape has changed). CS4 has the DICOM schema (Digital Imaging and Communications in Medicine) as well as the ability to store Edit History (from Photoshop) and a few other non-photo-related schemas.

An important schema for photographers who shoot raw is the Camera Raw metadata. You apply Camera Raw settings, stored as XMP metadata, to instruct Photoshop how you want the image to be processed before making the conversion. Using the History Log feature, you can record every Photoshop operation applied to the image as metadata.

Adobe has been assiduous in promoting XMP (Extensible Metadata Platform), an open, extensible, W3C-compliant standard for storing and exchanging metadata. All the Creative Suite applications use XMP, and because XMP is extensible, it's relatively easy to update existing metadata schemas to be XMP compliant. However, it will probably be some time before all the other applications that use metadata, such as third-party digital raw converters, get updated to handle XMP. But let's be very clear: XMP is not some proprietary Adobe initiative. It's an open, XML-based standard. So if you find that another application is failing to read XMP metadata, contact the publisher and tell them they need to get with the program!

Right now, unless you're a programmer or a very serious scripting wonk, there may not be a great deal you can do with much of the metadata, at least, not automatically. But it already can be used for Camera Raw's camera serial number or ISO defaults to vary noise reduction with a capture's ISO or serial number–specific calibrations. The more information you have about an image, the better your chances of being able to do useful things to it automatically—and the more things you can do automatically, the more time you can spend doing those things that only a human can do, such as exercising creative judgment.

IPTC metadata. The IPTC metadata display (see Figure 6-22) can either be the older-style IPTC legacy schema or the newer-style IPTC for XMP (IPTC Core) schema adopted in Spring 2005 and included in all Creative Suite applications since CS2. You should be aware that not all third-party applications have adopted the IPTC Core version of the standard, but metadata entered in IPTC Core is "crosswalked" (also written to) the appropriate IPTC legacy schema fields that match.

NOTE One of the new features of Bridge CS4 is the revamp of the File Info metadata dialog box. You'll learn how it has changed in Chapter 8, Mastering Metadata.

IPTC metadata display

File Info dialog box showing the IPTC tab

Figure 6-22 IPTC metadata.

IPTC metadata is directly editable in Bridge using the Metadata panel or in the File Info accessed in the main File menu. However, other than simple quick edits, entering extensive metadata field by field and image by image is nothing if not tedious. Those people who value their sanity (and their free time) will do well to explore the simplicity and speed of creating and using metadata templates, a collection of prepopulated fields that can be applied quickly to masses of images. You can even apply metadata templates when first copying image files from your camera card to your hard drive if you use Bridge's Photo Downloader (see the section "Image Ingestion with Bridge," starting with Figure 6-46). In Figure 6-23 we show how to create and edit a metadata template.

Figure 6-23
Metadata templates.

Selecting Tools > Create
Metadata Template

Create Metadata Template dialog box

 NOTE If you check
one of the boxes and
do not put anything in the
corresponding text field,
that's a "null value," and any
existing values in the field
will be eliminated. So be sure
to check the check boxes!

Creating Metadata Templates. Select the menu item Create Metadata Template from the Tools menu. The dialog box for creating and editing a metadata template are the same—only the function is different—so we've omitted the edit dialog box from the figures for brevity.

When creating your IPTC Core templates, enter only those fields that you know for an *absolute fact* you wish to have embedded in your files and make sure everything is correctly spelled. There's nothing quite so embarrassing as having somebody who reads your metadata notice a spelling error. And if you shoot thousands of images and embed those spelling errors, it's a lot of work to correct. You should also try to resist the temptation to use abbreviations unless there is no chance of ambiguity. In Figure 6-23, Jeff has correctly spelled his name (not always an easy task for him) and the title Photographer. For the state he's entered Illinois instead of the common abbreviation "IL" because non-English speakers may not know what IL refers to. It's pretty safe to use USA for the country name.

Other fields are left empty because it's simply not the correct time to enter image-specific metadata such as keywords. The concept of metadata is to start with big "granularity" and constantly refine (grind down) to the point where you may indeed need to enter some important metadata image by image.

When using templates, start by adding the big stuff in the template and finish off images with the refined stuff entered by image. Even then there's always the opportunity to select multiple similar images and enter certain values directly from the Metadata panel. So don't think of a template as a lock or a limitation, but rather as a starting point for settings that are more efficient when applied en masse.

To apply a template, use one of these commands:

- The Append Metadata command (see Figure 6-24) applies the template metadata only where no metadata value or property currently exists in the file. Append isn't available if you've selected multiple files from within Bridge. The Append command will also only add to any existing values that may already be in the file's metadata.

- The Replace Metadata command (also shown in Figure 6-24) completely replaces any existing metadata in the file with the metadata in the template.

Keep in mind this critical distinction: if you've already entered some metadata, Append will only update those fields and Replace will overwrite what's already there. In general, we suggest you use the more conservative Append unless you know for sure that you want to replace the metadata with the values in the template.

Figure 6-24 Applying metadata templates.

Append Metadata Replace Metadata

EXIF metadata. The Metadata panel's EXIF readout is based on the Metadata Preferences (see Figure 6-21) and displays useful metadata written at the point of capture by your camera. Bridge conveniently translates the embedded EXIF metadata; in its initial form, it's not particularly readable and therefore a lot less usable, as shown in Figure 6-25.

EXIF metadata is considered read-only by Bridge, which means you can't go into the field values and change them. There are some third-party tools that allow you to do that, but their use is controversial depending on what your intent may be. For example, it can be argued that if you traveled to a different time zone and forgot to change your camera's onboard clock, you would want to correct the time offset. However, what is not considered proper is to spoof or otherwise alter legitimate metadata, such as the camera model or brand you used to capture the image, for nefarious purposes.

Figure 6-25 EXIF metadata.

EXIF metadata displayed in the Metadata panel

EXIF metadata displayed in the File Info Advanced properties dialog box

Keywords Panel

The Keywords panel holds arguably the most useful and potentially valuable of all the metadata that you can enter into your images. Valuable, you may wonder? Aside from the benefit of enabling you to find images now and in the future, using rich keywords can increase the real value of your images. Imagine two images of equal technical and aesthetic properties; if someone was searching for an image for a big fat licensing fee, that person would

most likely locate the image with the best and most complete description in the form of keywords. We'll get further into the issues surrounding properly choosing keywords in Chapter 8, *Mastering Metadata*. For now let's concentrate on how the Keywords panel displays keywords and how they are organized.

Keywords panel. Figure 6-26 shows how the Keywords panel is organized. At the very top are the currently assigned keywords. This is a static display and not the place where you would edit or assign keywords. You enter keywords in the previous IPTC editable field (see Figure 6-22). Alternatively, you can add a checkmark to any of the listed keywords below the Assigned Keywords area.

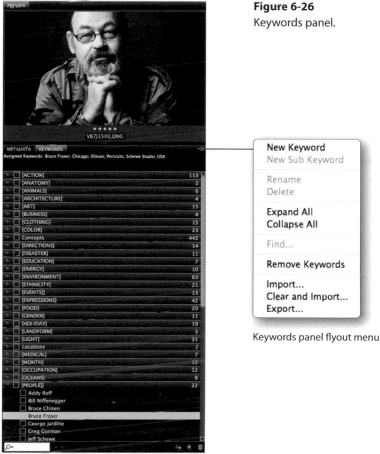

Figure 6-26
Keywords panel.

Keywords panel flyout menu

Keywords and Preview

Bridge can organize keywords into logical categories. In this example, the keyword "Bruce Fraser" is located in the PEOPLE category. So, Bruce Fraser is a subkeyword of PEOPLE. In this case the structure is called hierarchical keywords—more about that in a moment.

Keywords panel flyout menu. The flyout menu from the Keywords panel allows you to add, rename, or delete; expand or collapse; find or remove; or import or export keywords. You'll find the flyout menu can sometimes be a bit frustrating. Keywords will appear in the Metadata panel, but you can't edit any keywords in the top display, only in the bottom of the panel. You can edit keywords in the Keyword list. Renaming or deleting the keyword won't remove it from any images that the keyword has been embedded into; it only changes the keyword in your list.

To add a new main-level keyword, simply choose New Keyword. To add hierarchical subkeywords, select an upper-level keyword first. You can import and export keyword lists, and if you wish to move your keyword list to other computers, this is the operation you'll need to do. The keyword list is machine specific and specific to only your current user.

Keywords Search

Keywords button tools

Figure 6-27 Keywords panel Search and buttons.

You can also use the Keyword Search function and the buttons at the bottom of the Keywords panel, as shown in Figure 6-27.

Working to improve your keywording skills is important if you are a working photographer. But all photographers will receive the benefit of using at least some descriptive keywords. Our good friend and colleague Seth Resnick must take the award for most avid "keyworder" we know. It's not at all unusual for Seth to add up to 50 keywords (or more) to fully describe and categorize an image. His keyword list set is well over a thousand keywords. The goal is to maintain a logical and consistent keyword vocabulary —a "controlled vocabulary" if you will.

Keyword Preferences. How Bridge handles your keywords is important. Figure 6-28 shows the options in the Keywords Preferences in Bridge; here's what they do:

- The **Automatically Apply Parent Keywords** option allows you to choose to apply the main keywords as well as the subkeywords in your images. This turns your keyword organizational listing into a keyword tool to expand on the potential keywords embedded into files. Whether you choose this option should be dictated by how you've organized

your keyword set. If you wish both Parent (the main keywords) and Child (the subkeywords) to be applied, choose this option. However, if your keyword set has been created for organizational purposes only, you may wish to leave this option unchecked. If you check this option, the parents will be applied. If you then decide you want to remove those keywords, you'll have your work cut out for you because there's no quick and easy way to remove those additional keywords. Choose your course wisely.

- The **Write Hierarchical Keywords** option dictates how your keywords will be embedded when you apply hierarchical keywords. Unfortunately, there's no single standard delimiter that is both cross-platform and widely accepted by other applications. At this point, it's risky to settle on a single delimiter; you should check with the intended recipients of your images to learn how they need the hierarchical keyword delimiter set before choosing this option.

- **Read Hierarchical Keywords**, as long as it is in agreement with the way a keyword set has been exported, is a relatively safe option. You can check a keyword set to see which delimiter has been used; make sure you select that delimiter before making a change.

Figure 6-28 Keywords Preferences.

Whether you use hierarchical keywords and embed both Parent and Child keywords in your files are important considerations. Generally, it's safer to exchange images with "flattened" keywords to make sure all the keywords you want to embed are embedded and in a form that is most widely accepted. Just about anybody who uses keywords can use flattened keywords, so that is the most conservative choice at this time.

Bridge CS4 Tools

Now we'll explore the tools that Bridge CS4 offers for working with images. One tool you'll use often lets you rename files using a naming convention of your choice. We'll explore how you can rename files to improve organization in Chapter 7, *It's All About the Workflow*. But before you develop a naming convention, you have to understand how to use the Batch Rename tool.

Batch Rename

In the Tools menu, Batch Rename (see Figure 6-29) is the command used to change the names of files, often a "batch" of files. For the purposes of organizing, searching for, and locating the image(s) you want, it's useful to develop a naming convention that will aid in your efforts.

Figure 6-29 Batch Rename.

Batch Rename command in the Tools menu

Buttons for deleting or adding categories

Batch Rename dialog box

As shown in Figure 6-29, the Batch Rename dialog box lets you select various criteria to include in a new filename. In the example shown, it's simply a text string followed by a three-digit sequence number, a standard approach when grouping a series of images for some purpose. You'll notice at the end of the New Filenames line there are plus and minus buttons. These buttons are used to add or delete categories. You can add up to ten separate renaming categories, as shown in Figure 6-30.

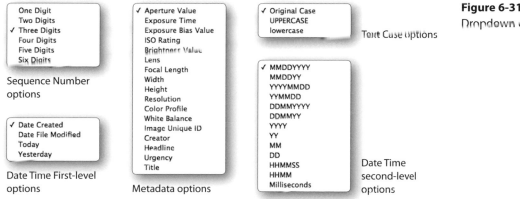

Text drop down menu

New Filenames detail

Figure 6-30 Maximum New Filenames categories.

In this example, we've added all ten of the New Filenames categories—not something we'd recommend you do, but it is possible. Ideally, you should keep the filenames to a minimum. Also, make sure you stick to a straight alphanumeric naming convention and avoid adding special characters.

For each of the main categories there will be various options—for text strings, you can have a text entry box, and for other items, you can have dropdown menus. Consider these choices carefully (see Figure 6-31).

Sequence Number options

Date Time First-level options

Metadata options

Text Case options

Date Time second-level options

Figure 6-31 Dropdown options.

NOTE One of the new features of Bridge CS4 is the ability to save a Batch Rename set up as a preset. The main Batch Rename now has Save and Load buttons, so if you use a common renaming you should consider saving the setup.

While Batch Rename gives you a lot of options, it doesn't offer a text string replace function—we sincerely wish it did. You should also watch out for this serious gotcha: Batch Rename does allow you to change the file extension, but you should be careful since doing so could make the file unreadable by both Mac and Windows systems. It would be OK to change a .tiff extension to .tif, but you cannot change a TIF file to a JPEG simply by changing the extension from .tif to .jpg.

The inclusion of EXIF metadata as a naming component is intriguing, but the most potentially useful piece of metadata, Date Time Digitized, should be treated with some caution. The option looks in the metadata for the DateTimeOriginal property. If it's not present, it looks for DateTimeDigitized. If that isn't present either, the feature uses the IPTC DateCreated property. It's possible for these three dates and times to be different, so test this option carefully and make sure you understand its behavior with your raw files before using it on live jobs—see Chapter 8, *Mastering Metadata*, for further discussion.

Figure 6-32 shows the Options section of the Batch Rename dialog box. The options include the following:

Preserve Current Filename in XMP Metadata. This option lets you add a custom metadata tag containing the filename. If you've already applied Camera Raw settings before renaming, you can skip this option because the Camera Raw settings metadata already contains the original filename. However, if you're renaming otherwise-untouched raw files and you want the original filename to be retrievable, it's a good idea to check this option.

Figure 6-32 Renaming options and Preview.

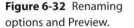

Renaming options

Preview
Current filename: **DSCF0190.JPG**
New filename: **Italy_001.JPG**

Renaming Preview

Compatibility. On today's computers, filenames can be longer than in the past (the old limit for Macs was 31 characters including the extension; for DOS, it was eight characters plus the extension). But there is a 256-character limit (including the extension) for current Mac and Windows filenames. Names that long combined with long pathnames can cause problems moving files to and from servers and in running Batch operations.

A safer maximum is 128 characters, but even that may become unreadable in applications and be truncated (usually by dropping off middle parts of names). You should also be careful to make sure you don't include spaces in the names of files intended for a Web server, as many will replace a space with the % sign. Dashes (-) or underscores (_) are acceptable. When in doubt, check all three options.

Renaming Preview. The Renaming Preview shows you a real-world example of how the renaming options will look using the filename of the first image selected.

Cache

One of the most frustrating aspects of Bridge is the need for cache, and we're not talking money here. When Bridge first looks at a folder, it must go through, item by item, and build a cache of everything in the folder. With camera JPEG files, that process can be pretty darn quick. For large raw files, however, it can seem to take forever.

TIP One of the useful things that the Preserve Current Filename in XMP Metadata option allows is easy undoing of batch renaming. Simply choose Batch Rename and specify Preserved Filename. Your files will be renamed to their original filenames.

Figure 6-33 Bridge Cache.

Bridge Cache Preferences

Cache flyout menu

Purge Cache for Selection (from the thumbnail context menu)

Figure 6-33 shows the Cache Preferences and the Tools > Cache menu commands:

Cache Preferences. In Figure 6-33 we've checked the option Automatically Export Caches To Folders When Possible. Why? Well, unless you plan to work on one computer and never move portable drives around, you'll always want to make use of your time invested in creating folder caches.

With this option unchecked, the Bridge CS4 Cache database will be in a single, central location. Any time you mount a portable drive that your installation of Bridge CS4 has not yet seen, it will have to cache the files. So, if you work with files on a laptop and do the imaging back at the studio on a workstation, you definitely want this option checked. The When Possible aspect is important to understand. If you mount a CD or DVD, it's considered a read-only media, so obviously Bridge won't be able to export the cache and must keep it in its own database.

TIP For users with monitors larger than 1024 x 1024 and for whom the quality of Preview image matters, it is important to check "Generate Monitor Size Cache" in Preferences > Advanced. Bridge determines the largest monitor connected to the computer and generates the Preview cache for that size.

We've also checked the option Keep 100% Previews In Cache. This is just as useful as exporting cache to the folders because if previews have been generated, you may as well get a return on that time investment when moving the folders.

Compact Cache is an option that can help eliminate old and unused cache files. The Purge command is a total elimination of all internal cache files; it won't affect already exported cache files.

Cache flyout menu. If you are caching a new folder for the first time and you have a lot of images and subfolders, we suggest you point to the main folder and select the Build and Export Cache command, and then take a run to Starbucks for some coffee. This command tells Bridge to cache all the images and folders that are contained in the main folder; if you have a lot of images and you've set your thumbnail generation to High Quality, that process can take a while.

It's an undeniable fact that Bridge's Cache is a bit temperamental. We wish this wasn't so, but one of the main Bridge troubleshooting suggestions for situations where image thumbnails either don't appear or appear incorrectly is to issue the Purge Cache command for that folder. New to Bridge CS4 is the ability to force a purge for a single image, as shown in Figure 6-33. You'll find this command in the context menu when you select a thumbnail in the Content panel.

If that doesn't fix it, you move on to the next step: you reset the Bridge Preferences, as shown in Figure 6-34. Resetting the settings, or more accurately the preferences, is something that you should do whenever you encounter any unusual or obnoxious behavior from Bridge. If, heaven forbid, Bridge ever crashes on you, the first thing you should do upon restarting Bridge is hold down the keyboard commands for resetting the preferences. (On the Mac you simultaneously hold Command-Option-Shift

when double-clicking on the Bridge application; in Windows, you press Ctrl-Alt-Shift.) You'll see the dialog box shown in Figure 6-34. Your preferences may have been corrupted, thus causing the crash, or they may have been corrupted *because* of the crash—but either way, the odds of Bridge behaving better after a crash improve when you reset the preferences.

Figure 6-34 Reset Settings dialog box.

Photoshop Tools

We will be covering Batch and Image Processor in the Photoshop Tools flyout menu in depth in Chapter 9, *Exploiting Automation*, but since the flyout menu appears in the Bridge Tools menu, let's explore these tools here as well (see Figure 6-35).

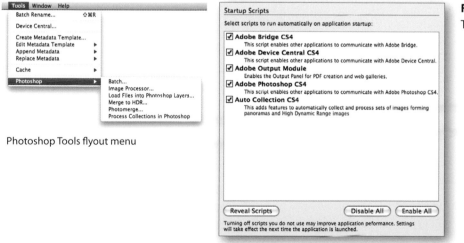

Photoshop Tools flyout menu

Bridge Startup Scripts Preferences

Figure 6-35 The Photoshop Tools in Bridge.

Tool Scripts. Bridge CS4 comes with six tools that "call" Photoshop and perform the selected task. All of the Photoshop commands are actually called by JavaScript (a cross-platform scripting language) and are not performed by Bridge.

- **Batch** is the basic Photoshop automation feature. It lets you open images, run a Photoshop Action on them, and save them with a new filename if you choose. (In the case of raw files, you can't save over the original and have to rename the files.)

- **Image Processor** differs from Batch in one important capability: it lets you save multiple versions of images, such as a full-resolution TIFF and a downsampled JPEG, each in its own folder, without writing insanely complicated actions.

- **Load Files into Photoshop Layers** allows you to select multiple images in Bridge and open them as separate layers in a single Photoshop document.

- **Merge to HDR** lets you merge bracketed exposures of the same scene into a High Dynamic Range (HDR), 32-bit floating-point-per-channel image. Merge to HDR allows over-range encoding and hence preserves highlights that are brighter than pure white, often referred to as "overbrights." This feature has been primarily used in the movie industry, but its introduction in Photoshop has brought it into the photographic mainstream. To use Merge to HDR successfully, you'll benefit from a heavy tripod, a cable release, and mirror lockup (to keep the camera from shaking).

- **Photomerge** is Photoshop's stitching routine for creating panoramas from a series of images.

- **Process Collections in Photoshop** lets you process an entire Bridge Collection and process sets forming panoramas and HDR images.

The procedure for invoking these automation features from Bridge is the same: you select the images and choose the tool you want from the Tools > Photoshop submenu. Photoshop then goes to work, opening the images using the Camera Raw settings you've applied (or the camera-specific default settings if you haven't applied settings to the image), and then processes the images using the settings you've specified for the automation. You can continue to work in Bridge while Photoshop processes the images.

Scripts Preferences. The Startup Scripts (see Figure 6-35) allow you to selectively enable or disable scripts upon launch of Bridge. Changes in the Startup Scripts take effect after closing and re-launching Bridge. If you have one of the Creative Suite bundles, you'll see scripts for each of the main applications in the bundle.

Bridge's Edit Menu

The Edit menu features the Develop Settings menu and the Find command—two tools that Camera Raw users will find invaluable for an efficient Bridge workflow.

Develop Settings

Rather than having to open images into Camera Raw to assign presets, you can do so right from Bridge using the Develop Settings menu. Select an image and copy the settings, then select other images and paste those settings. We use the Develop Settings tool so often we know the keyboard shortcuts by heart. On the Mac, to copy an image's settings press Command-Option-C; in Windows press Ctrl-Alt-C. To paste the copied settings, press Command-Option-V on the Mac and Ctrl-Alt-V in Windows. Now let's look at Figure 6-36 to see how to copy and paste settings the slow way.

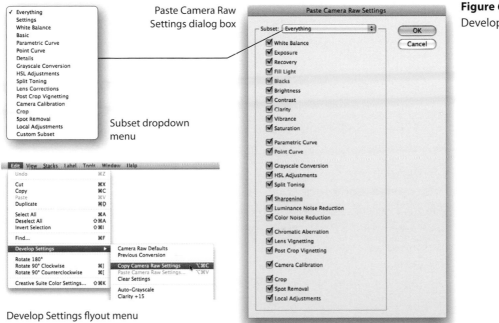

Paste Camera Raw Settings dialog box

Subset dropdown menu

Develop Settings flyout menu

Figure 6-36 Bridge's Develop Settings.

To copy the settings, select an image whose settings you wish to apply to a multitude of subsequent images. Open the image into Camera Raw if you wish to double-check the settings. A little time spent confirming that the image indeed has the settings you wish is time well spent.

The Paste Settings command will be grayed out if there are no current settings in the clipboard, as shown in Figure 6-36. From the flyout menu you can also select Camera Raw Defaults, Previous Conversions, and any of your saved Camera Raw presets.

Remember, you can apply multiple consecutive presets and achieve an accumulated result. So, I could select the 1DsMIII Daylight Preset that contains my camera profile only and then reselect the Clarity +10 settings to add just a Clarity addition to the 1DsMIII settings. Neither of these would alter any of the other subsettings that were not saved in the preset.

Paste Camera Raw Settings. When pasting the settings, Camera Raw will present you with the dialog box shown in Figure 6-36. Here you can select the settings or subsettings you want to paste. It's useful to use the Subset menu to choose only those settings you want to paste.

Find Command

Even if you properly name your files and enter copious keywords and other metadata, the ability to find exactly the image you are looking for is hampered by the sheer volume of images photographers produce. Bridge has a built-in Find tool (see Figure 6-37) that is robust enough to help you find exactly what you are looking for—even if the images you are looking for extend to a multitude of folders.

Figure 6-37
Bridge's Find tool.

Find menu

Find dialog box

Find. Not unlike the functionality in the Batch Rename dialog box, the Find dialog box allows you to click the Add button to include additional search criteria. You can add a total of 13 criteria entries from a list of up to 31 categories, as shown in Figure 6-38. Depending on the categories chosen, you can then have a second-level qualifier, as you can see in Figure 6-39.

Figure 6-38 Find Criteria options.

Criteria categories

Figure 6-39 Find criteria qualifiers and match options.

Results Match options

Qualifiers for numeric-based categories

Qualifiers for text-based categories

Depending on the category, you'll find one of two criteria category qualifiers. By mixing and matching criteria and qualifiers, you can produce a search for exactly what you are looking for.

Results. In the Results portion of the dialog box (see Figure 6-37), you can control how the match is handled, as Figure 6-39 shows. If you select If All Criteria Are Met, the results will be returned only if each and every category and the qualifiers are met exactly. If you select If Any Criteria Are Met, results will be matched if *any* of the search criteria is met.

Quick Searching

New to Bridge CS4 is the ability to perform a quick search right in the main Bridge window. You're still invoking the main Bridge Find command, but you use the current folder as the search folder, and you can access some additional options as well.

Figure 6-40 Quick Find and options.

Quick Find text entry

Quick File options

Quick Find. To use Quick Find, simply enter **test** in the text box. The only search area will be the current folder. The dropdown menu allows you to use different search options, including recent searches (previous searches in Figure 6-40 include Bruce Fraser and Shoe Tree). The results will be found very quickly. Figure 6-41 shows the result of searching for the word *humpback* in a single folder. The results appear in the Content panel.

Search results

Find dialog box

Figure 6-41 Search results and New Search options.

If you click the New Search button in the upper-right corner of the Content panel, you can alter or refine the search results. The New Search dialog box is basically the same as the Find dialog box, but the Quick Find text will already be entered in the Criteria fields.

Collections

In previous versions of Bridge, Collections were simply saved searches. That worked okay, but Collections didn't provide a robust organizational environment. With Bridge CS4, Collections have been enhanced. There are now two separate types of Collections; Smart Collections and simple Collections. See Figure 6-42 for a description of the Collections panel functions.

Collections panel tab

Smart Collections

Simple Collections

Edit Smart Collection button New Collection button Trash selection

New Smart Collection button

Figure 6-42
Collections panel.

Smart Collection. Unless you are doing a quick search, consider making a Smart Collection in Bridge. The Smart Collection dialog box is similar to the Find command, as you can see in Figure 6-43. You have the same Source and Criteria and Results matching. Give the Smart Collection a useful name. The order is by alphanumeric order, so take care when naming that you end up with a useful order.

Figure 6-43
Smart Collections.

Smart Collection dialog box

New Smart Collection name
entry box

Collections. Simple Collections are just that: a collection of images from wherever you happen to add them from. The images can be from any mounted volume or across any folders. Collections are particularly useful when putting together groups of images for output or making slide shows of selected images. Figure 6-44 shows the process of creating a new Collection.

Figure 6-44 Using Collections.

Images selected in Bridge

Dialog box confirming addition of selected images

New Collection name entry

It's really as simple as selecting images and then clicking the New Collections button. You will be prompted to confirm that you want to add the selected files in the Collection. Once you click Yes, you will see a New Collection name entry box. As with Smart Collections, the order is dictated by alpha-numeric hierarchy, so a good naming scheme is useful.

Once a Collection is created, you can add to it by dragging selected images and dropping them on the Collection, as shown in Figure 6-45. You can also delete images from the Collection by using the image thumbnail context menu, which you can also see in Figure 6-45, or by clicking the Remove From Collection button that appears in the Content panel of a Collection.

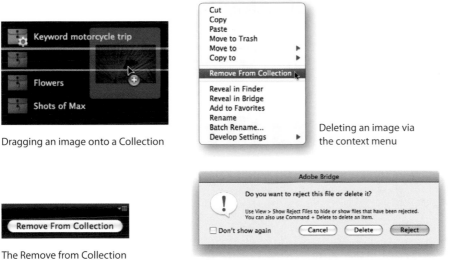

Figure 6-45 Working with a Collection.

Dragging an image onto a Collection

Deleting an image via the context menu

The Remove from Collection button

Dialog box confirming the deletion

Keep in mind that using the Delete key on your keyboard will actually *delete* the image, not just from the Collection but also from the folder it resides in. We find this very disturbing, especially since it seems so natural to use Delete to remove an item from a Collection. If you have chosen Don't Show Again, using the Delete key will delete the image without any warn-ing. Having had to go burrowing into our trash once too many times, we have come to the conclusion that this behavior should be changed. Until that time, we've modified our habits and use only the context menu or the Remove button.

Figure 6-46 Choosing Slideshow from the View menu.

Slideshow

Bridge's Slideshow function (see Figure 6-46) is a useful method for viewing images one at a time and with nice transitions between the images. We can't show you what slide shows look like in the context of this book—they are designed for playing on a computer display—but we describe how to use them.

Slideshow. The Slideshow feature (press Command-L) offers an alternative to Bridge's light table metaphor by presenting selected images as a slide show that also allows you to apply ratings and rotations while enjoying the benefits of a large image preview. If you prefer to review your selects as before-and-afters rather than (or as well as) side-by-sides, you'll find the Slideshow feature extremely useful. Press H (with no modifier) to display all the keyboard shortcuts that apply in Slideshow mode (see Figure 6-47).

Figure 6-47 Slideshow commands and options.

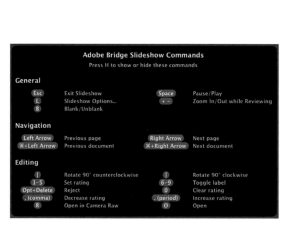

Slideshow commands (press H to show/hide)

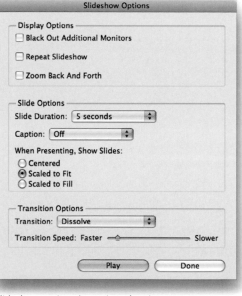

Slideshow options (press L to show)

You can run the slide show in a window or in full-screen mode with the image either scaled to fit the screen (the entire image is displayed at the maximum size that will fit your screen) or scaled to fill your screen (the image is cropped to the aspect ratio of your screen and displayed at maximum size). You can zoom in to see images at 100% through 800% while panning around the image. And while the slide show is playing, you can assign ratings and labels.

Slideshow offers the easiest way to review and rank your raw images at full-screen resolution, and is a valuable addition to your workflow. If your transitions are less than smooth, you may need to alter your Bridge Preferences, as shown in Figure 6-48. By default, Bridge will use your video card's GPU function to accelerate the transitions. If your video card doesn't have enough video RAM, check the option Use Software Rendering, which allows smoother transitions, but keep in mind that Bridge will use more RAM resources.

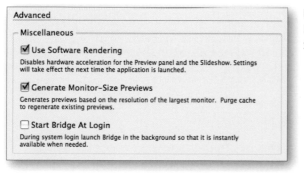

Figure 6-48 Advanced Preferences showing Use Software Rendering.

Review Mode. Related to (and using the same engine) is a variation of the Slideshow called Review Mode (see Figure 6-49). Again, using the video card's GPU, Review Mode offers an animated method of moving through images. Loupe and ratings and label marking are also supported. While it's a bit of eye candy (to our eyes at least), we're sure there will be a few people who like the effect of going through their images in this manner.

Figure 6-49 Review Mode.

While in Review Mode, you can subtract an image using the down arrow button. If you click the New Collections button, the images will be turned into a new Collection. In addition to using the menu command from the

View menu (see Figure 6-46), you can use the shortcut Command-B (Ctrl-B for Windows) to start the Review Mode, and press the Esc key to escape from it.

OUTPUT WITH BRIDGE

Bridge CS4 has finally come of age: it can actually do something with images all by itself. Bridge now offers an output function. The astute reader will have noticed a few things missing from the Photoshop Tools menu (refer back to Figure 6-35 for some clues). Bridge no longer has to rely on Photoshop for making contact sheets or PDF slide shows, and it can now create Web photo galleries all by itself.

Output

You can output PDFs or Web galleries from a new workspace in Bridge CS4 that's called (not too surprisingly) Output. Access the Output workspace by choosing Window > Workspace or by clicking the Output button (see Figure 6-50).

Figure 6-50 The Output menu and button.

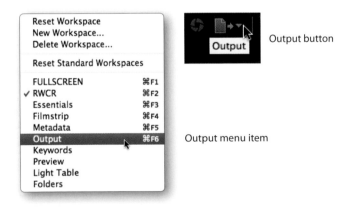

Web Output. The new Web gallery output from Bridge is pretty darn good (arguably much better than Photoshop's previous Web output!) and offers a lot of sophistication and power. Figure 6-51 shows taking a Collection of the Schewe family dog (his name is Max). Jeff created a Web gallery and posted on his Web site (www.schewephoto.com/MAX if you care to see it). A Collection is a natural starting point because you can reorder the images to reflect how you want them to appear in the gallery. You can still use the Filter panel to select exactly which image will be in the gallery.

Figure 6-51 Making a Collection into a Web gallery.

The starting "Max" Collection

The Collection in the web Output workspace

The Web Output workspace has more than a passing similarity to Adobe Photoshop Lightroom's Web module. In fact, you can create a Lightroom Flash Gallery—this is one of the template options, as shown in Figure 6-52.

Figure 6-52 Gallery options.

You have the ability to customize the look and feel, and you can use a custom color palette to give your gallery a refined look, as shown in Figure 6-53. There is one frustrating limitation with the Web Output as it currently works; you can't save all the settings as a custom template. As a result, if you find a gallery design you really like, we suggest you record the settings so you can return to the exact look and feel.

Figure 6-53 Custom Color palette options.

Once you have your Web gallery set up, the next stage is to process it and either save it on your local hard drive or upload it directly to your Web site. Bridge offers either choice. We tend to save it locally and use Adobe Dreamweaver to modify the gallery before uploading. Then once we have it set up the way we want, the direct upload can save time. Figure 6-54 shows both options.

Figure 6-54 Gallery creation and uploading.

Save to Disk · Upload

PDF Output. The functionality and user interface of the PDF Output are similar to those of the Web Output. Figure 6-55 shows the same series of images but now with the PDF settings. The output goal is to produce a PDF with either a contact sheet–like arrangement or a PDF slide show.

Figure 6-55 PDF Output and settings.

The main template (see Figure 6-56) allows you to determine the format of the resulting PDF. Further customization is available in the Page Preset, or you can use a custom page size. The Layout panel allows you to set up your PDF as a contact sheet or as single images. Overlays allows you to include filenames, which you'll find useful for contact sheets.

Figure 6-56 PDF Output
Setting options.

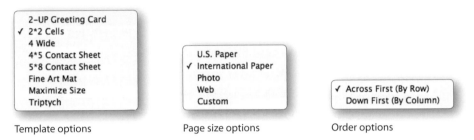

Template options Page size options Order options

If you want the resulting PDF to behave as a slide show, you'll need to set the options in the Playback panel (see Figure 6-57). Note that PDF slide shows do not have the smooth transition found in Bridge slide shows and are limited by the PDF engine. The only transition we make much use of is the fade.

Figure 6-57 PDF Slide show
settings.

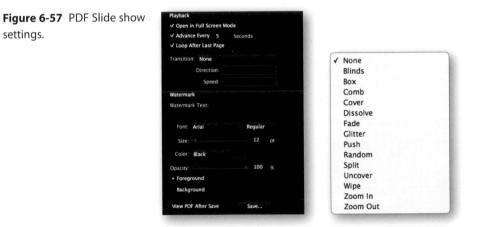

Playback panel Transition options

The Output from Bridge has its own preferences that control behavior and the output. Figure 6-58 shows the three settings.

Figure 6-58
Output preferences.

Use Solo Mode (see Figure 6-58) is a nod to Lightroom; it allows you to have all the output panels collapsed except for one. Clicking on a panel opens it and closes the previous one. If you have not used a well-thought-out file-naming convention, you may have filenames that won't translate well to a Web photo gallery. The second option, converting Multi-Byte Filenames to Full ASCII, can help. The last option, Preserve Embedded Color Profile, is important when creating PDF output.

Image Ingestion with Bridge

One of the useful features of Bridge CS4 is the Adobe Photo Downloader, a script that automatically copies (ingests) images from cameras or mounted camera cards onto your hard drive. Although third-party applications are available that can do the same thing, doing so directly from Bridge can enhance your digital workflow because it integrates the ingestion process into Bridge. Whether or not Bridge will automatically launch the Photo Downloader is dictated by the Bridge Preferences you set (see Figure 6-59).

By default, the Photo Downloader comes enabled. If you don't want Bridge to prompt you every time you mount a card, you can turn the option off in the Preferences, as shown in Figure 6-59. You can still use the command from the File menu to launch the Photo Downloader. You'll be prompted with a message asking you whether you want to enable the autolaunch. You can choose No and click the Don't Show Again option.

Figure 6-59 Adobe Photo
Downloader preferences.

Bridge Preferences for Adobe Photo Downloader

Get Photos from Camera
command in the File menu

Photo Downloader message dialog box

Photo Downloader dialog boxes. When using the Photo Downloader,
you have the option of either a Standard or Advanced dialog box, as shown
in Figure 6-60. If you only wish to copy images from a card to your hard
drive, use the Standard dialog box. You can specify Import settings, create
subfolders, and rename the files you're importing. You can even convert to
DNG and save a duplicate set of images in a secondary location (which we
strongly suggest you do).

The Advanced dialog box (which you open by clicking the Advanced Dialog
button) offers some additional functionality. You can browse through the
images and select which ones to import. You also have the option to apply
metadata templates; that way, you start the import process by adding impor-
tant and useful metadata at the very beginning.

When importing, you can choose to bring the images into a specially created
set of folders, rename the files, and apply metadata templates (see Figure
6-61). You should test these options carefully. The worst time to find out
that the Photo Downloader behaves in a manner you don't expect is in the
middle of an important shoot.

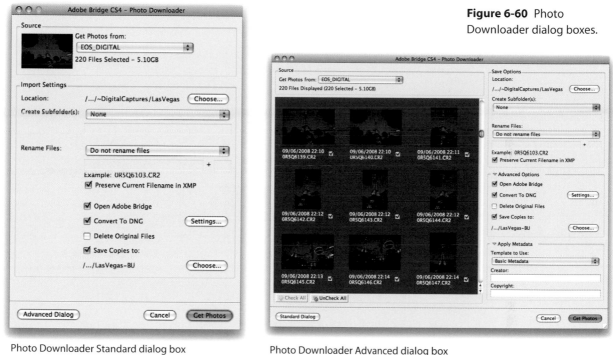

Figure 6-60 Photo Downloader dialog boxes.

Photo Downloader Standard dialog box

Photo Downloader Advanced dialog box

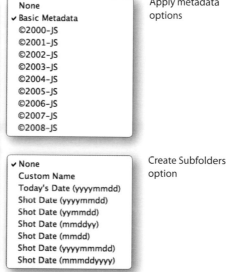

✓ Do not rename files
Today's Date (yyyymmdd)
Shot Date (yyyymmdd)
Shot Date (yymmdd)
Shot Date (mmddyy)
Shot Date (mmdd)
Shot Date (yyyymmmdd)
Shot Date (mmmddyyyy)
Custom Name
Shot Date (yyyymmdd) + Custom Name
Shot Date (yymmdd) + Custom Name
Shot Date (mmddyy) + Custom Name
Shot Date (mmdd) + Custom Name
Shot Date (yyyymmmdd) + Custom Name
Shot Date (mmmddyyyy) + Custom Name
Custom Name + Shot Date (yyyymmdd)
Custom Name + Shot Date (yymmdd)
Custom Name + Shot Date (mmddyy)
Custom Name + Shot Date (mmdd)
Custom Name + Shot Date (yyyymmmdd)
Custom Name + Shot Date (mmmddyyyy)
Same as Subfolder Name

Image renaming options

None
✓ Basic Metadata
©2000-JS
©2001-JS
©2002-JS
©2003-JS
©2004-JS
©2005-JS
©2006-JS
©2007-JS
©2008-JS

Apply metadata options

✓ None
Custom Name
Today's Date (yyyymmdd)
Shot Date (yyyymmdd)
Shot Date (yymmdd)
Shot Date (mmddyy)
Shot Date (mmdd)
Shot Date (yyyymmmdd)
Shot Date (mmmddyyyy)

Create Subfolders option

Figure 6-61 Adobe Photo Downloader options.

While the Photo Downloader can also import images directly from cameras connected to your computer, this is a practice we don't encourage. We'll cover the reasons for this in the next chapter, but suffice to say that although it may seem like a good idea at the time, it can end badly.

Once you select the options for importing the images, you'll be provided with a progress dialog box to gauge the time it will take to complete the import (see Figure 6-62).

Figure 6-62 Adobe Photo Downloader progress dialog box.

After a successful download, Bridge will still need to create thumbnails using the options you've specified in the Thumbnail preferences. The advantage is that you can point Bridge to the folder you selected as the location for the download and be building thumbnails as you import additional cards.

Figure 6-63 shows Bridge pointed to the folder after a successful download (Bridge will automatically jump to that folder).

Figure 6-63 Photo Downloader results.

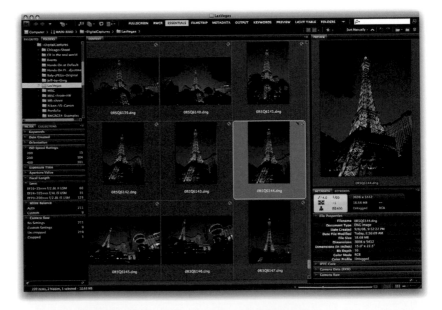

When using Adobe Photo Downloader, you are given the option to delete the original files in both the Standard and Advanced dialog boxes, as shown in Figure 6-64. We feel using this option is a bad idea. Aside from the fact that the "best practice" suggests formatting the card in the camera it will be used in, the idea of deleting your originals before confirming you have a successful download of your originals is, we think, a recipe for disaster. There once was an air force mechanic by the name of Murphy, and we feel that this fellow would *never* suggest this approach (yes, there really was a Murphy behind Murphy 's Law).

Figure 6-64 Photo Downloader options.

We feel this option violates one of the key principles of a safe and efficient workflow; image verification, which we discuss in Chapter 7, *It's All About the Workflow*. Suffice to say that we never delete the originals before verifying that we have indeed successfully downloaded the originals. Better safe (and a bit slower) than really, really sorry.

OPENING IMAGES

If you think that opening an image is simply a matter of double-clicking its thumbnail, you're missing some important nuances of Bridge's behavior. First and foremost is the distinction between opening raws (or JPEG and TIFF) in Camera Raw hosted by Bridge and opening them in Camera Raw hosted by Photoshop.

We'll discuss the workflow reasons for choosing one or the other in the next chapter, *It's All About the Workflow*. Table 6-1 shows the mechanics.

Table 6-1 Opening raw images

To do this...	Press this...
Open raw images in Camera Raw hosted by Bridge, leaving Photoshop unaffected	Mac: Command-R; Windows: Ctrl-R
Open raw images in Camera Raw hosted by Photoshop, bringing Photoshop to the foreground, and leaving Bridge visible in the background	Mac: Command-O Return, or Command-down arrow; Windows: Ctrl-O, Enter, or Ctrl-down arrow
Open raw images in Camera Raw hosted by Photoshop, bringing Photoshop to the foreground, and hiding Bridge	Mac: Option-Return, or Command-Option-down arrow; Windows: Alt-Enter, or Ctrl-Alt-down arrow
Open raw images directly into Photoshop, bypassing the Camera Raw dialog box, bringing Photoshop to the foreground, and leaving Bridge visible in the background	Mac: Shift-Return, or Command-Shift-down arrow; Windows: Shift-Enter, or Ctrl-Shift-down arrow
Open raw images directly into Photoshop, bypassing the Camera Raw dialog box, bringing Photoshop to the foreground, and hiding Bridge	Mac: Option-Shift-Return, or Command-Option-Shift-down arrow; Windows: Alt-Shift-Enter, or Ctrl-Alt-Shift-down arrow

In addition, double-clicking thumbnails opens images in Camera Raw hosted by either Bridge or Photoshop if you've selected the option Double-Click Edits Camera Raw Settings in Bridge in the Behavior panel of the General Preferences—see Figure 6-65. Various other keyboard shortcuts may or may not open raw images, depending on this preference setting.

Figure 6-65 General Preferences Behavior options.

Behavior

☑ When a Camera is Connected, Launch Adobe Photo Downloader

☑ Double-Click Edits Camera Raw Settings in Bridge

☑ ⌘+Click Opens the Loupe When Previewing or Reviewing

Number of Recent Items to Display: 10

Working in Bridge

Camera Raw 5 is a wonderful raw converter, and Bridge CS4 is a pretty capable image manager, but what really makes Photoshop CS4 a compelling solution for a raw digital workflow is the integration between the components. As soon as Bridge encounters a folder of raw files, Camera Raw kicks in automatically, generating thumbnails and generous-sized previews that allow you to make good judgments about each image without actually converting it so that you can quickly make your initial selects.

Note that the high-quality previews are based on Camera Raw's default settings for your camera. If you find that they're consistently off, it's a sign that you need to change your Camera Default settings—see "The Camera Raw Flyout Menu" in Chapter 4, *Camera Raw Controls*.

Then, when you've decided which images you want to work with, Bridge lets you apply conversion settings from Camera Raw by writing them to the image's metadata, again without doing an actual conversion, using either the Paste Settings command from the Develop Settings menu or, if you need to see larger "zoomable" previews, in Camera Raw itself.

When we do conversions other than quick one-offs, we almost always do so as batch processes, incorporating other actions—we might set up one batch to produce high-res JPEGs for client approval, another to produce low-res JPEGs for e-mailing, and still another to prepare images for localized editing in Photoshop, with adjustment layers already added so that much of the grunt work is already done for us. Then, when the computer is busy doing our work for us, we're free to busy ourselves with other projects.

In the next chapter, we'll examine the process from bringing images into Bridge to producing final images in much more detail, but in the meantime here's a thumbnail sketch of the kinds of work you do in Bridge.

Selecting and Sorting

One of the biggest bottlenecks in a raw digital workflow is in making your initial selects from a day's shoot. Bridge helps you get past this bottleneck with the Rating and Label features.

Start by copying the files from the camera media to your hard drive—we've learned from bitter experience to avoid opening images directly from the camera media in all but the direst emergency. Then point Bridge at the folder full of raw images and wait the few minutes while it builds the thumbnails and previews and reads the metadata.

Next, enter the copyright notice on all images by pressing Command-A to Select All and either using a metadata template from the Metadata panel menu or clicking in the copyright field in the IPTC section of the Metadata panel and typing in the notice manually.

Yes/No sorting. For simple binary sorts, load Bridge's Filmstrip View workspace, and then use the arrow keys to advance from one image to the next. For the keepers, press Command-1 or Command-' (apostrophe) to apply a single-star rating. The rest you simply bypass (though you may rotate images that need it by pressing Command-[or Command-] to rotate them left or right, respectively).

When you've gone through all the images, choose Show 1 or More Stars (Command-Option-1) from the Filter panel so that you can start processing the keepers without being distracted by the rejects. (Of course, later on you'll probably choose Show Unrated Items Only from the same menu for a closer look at the rejects.)

Further Ratings. If a yes/no/maybe approach appeals to you more than a straight binary choice, you can take a second pass through the 1-star-rated images, and add one or more stars to those images that deserve them. You can also take advantage of Bridge's Label feature to add another layer of differentiation that you can use separately from or in addition to the star ratings.

Sequencing. Last but not least, if you're the type who thinks in terms of sequences of images rather than single images, you can drag the thumbnails into the order you want, just as you did with film on a light table. Once you've sequenced the images, you can use Batch Rename to rename the files, including a numbering scheme that reflects your custom sort order.

At this stage, we often look at the images using Slideshow mode for a quick reality check. We find that we'll sometimes notice things in the slide show that weren't obvious from looking at the Preview panel or the thumbnails, and we may adjust ratings accordingly.

Applying Camera Raw Settings

The slowest possible way to process raw images in Photoshop CS4 is to open them one by one, make adjustments in Camera Raw, click OK to open the image in Photoshop, and then save it. Unless you're working for an hourly rate, we don't recommend this as a workflow.

Instead, we suggest opening images that require similar edits simultaneously in Camera Raw, and then use the Synchronize button to apply the edits to multiple images. If you feel unusually confident, you can edit one image in Camera Raw, and then use Copy/Paste Camera Raw Settings from Bridge's Edit menu to apply that image's settings to others, but seeing a large zoomable preview in Camera Raw is often invaluable.

Processing images. Once you've applied settings to the images, you either save them by opening them in Camera Raw, selecting them all, and clicking Save X Images, or use Batch to convert the images and also run an action. We'll discuss Batch in more detail in Chapter 9, *Exploiting Automation*.

Of course, some images deserve more attention than others, and hence get processed more than once. One of the problems that digital makes worse rather than better is never knowing when you're finished! The key to working efficiently is to go from the general to the specific, starting out by making all the candidate images look good rather than great, and applying general metadata and keywords to large numbers of images. Then you make more detailed edits and more specific metadata entries to smaller numbers of images until you're left with the ones that genuinely deserve individual treatments. With planning and forethought, you can handle huge numbers of images relatively painlessly.

It's Smart to Be Lazy

Any way you slice it, shooting digital virtually guarantees that you'll spend more time in front of the computer and less time behind the lens. But the power of automation is there to let you make sure that when you *are* sitting in front of the computer, you're doing so because your critical judgment is required.

One of the great things about computers is that once you've figured out how to make the computer do something, you can make it do that something over and over again. You can save yourself a great deal of work by teaching Photoshop how to do repetitive tasks for you. That way, you can concentrate on the exciting stuff. We'll look at automation in detail in Chapter 9, *Exploiting Automation*. But an efficient workflow takes more than automation. It also takes planning. So before tackling automation, we'll look at workflow and strategy in the next chapter, *It's All About the Workflow*.

CHAPTER SEVEN

It's All About the Workflow

THAT'S FLOW, NOT SLOW

In the previous chapters, we showed you how to drive Camera Raw and Bridge in detail (some might say *exhaustive* detail). But knowing what buttons to push to get the desired result just means you know how to do the work. To turn that understanding into a practical *workflow*, you need to understand and optimize each part of the process. So this chapter will contain plenty of details, but we'll put them in the context of the big picture.

A raw workflow consists of five basic stages. You may revisit some of them—going back and looking at the initial rejects, or processing the images to different kinds of output files—but everything you do falls into one of these stages (see Figure 7-1):

- **Image ingestion.** You start by copying the raw images to at least one hard drive on the computer.

- **Image verification.** You point Bridge at the newly copied images and let it cache the thumbnails, previews, and metadata.

- **Preproduction.** You work with the images in Bridge, selecting, sorting, ranking, and applying mctadata, and then editing with Camera Raw.

- **Production.** You process the raw images to output files.

- **Postproduction.** You deal with all the files so you can print, post, deliver, and archive.

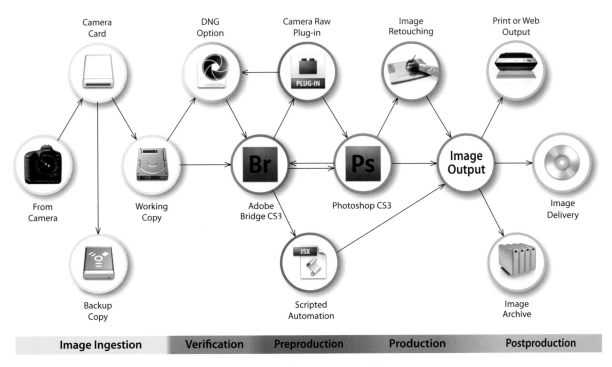

Camera Card · DNG Option · Camera Raw Plug-in · Image Retouching · Print or Web Output · From Camera · Working Copy · Adobe Bridge CS3 · Photoshop CS3 · Image Output · Image Delivery · Backup Copy · Scripted Automation · Image Archive

Image Ingestion · Verification · Preproduction · Production · Postproduction

Figure 7-1 The digital photography workflow chart.

Figure 7-1 is a graphic representation of a typical workflow through the five main stages. Note that the gradation between image ingestion and verification is fairly distinct. There's little variation at this stage. The lines between preproduction, production, and postproduction, however, are less defined since, depending on what you are doing, you may need to move about and even round-trip images in your workflow.

In this chapter, we'll look at all five stages of the workflow, but the major emphasis is on the preproduction stage—the work you do in Bridge— because about 80 percent of the actual work happens in this stage, even if it only takes about 20 percent of the time spent. But all five stages are, of course, vital.

Image ingestion. If you screw up during the ingestion phase, you run the significant risk of losing images, because at this stage, they only exist on the camera media.

Image verification. If you're tempted to skip the second stage, image verification, you may not find out that you've lost images until it's too late to do anything about it. Whenever possible (with the full recognition that it

isn't always possible), you shouldn't touch an image until you know that you have two good copies that aren't resident on the camera media. It may sound paranoid, but that doesn't mean Murphy's Law won't get you! If you allow Bridge to verify the images before you reformat the camera media, you'll have a chance of recovering your images if something goes awry in the ingestion phase. If you shoot new images over the old ones and the copies are bad, those images are likely gone forever.

Preproduction. The preproduction phase is where most of the work takes place, though it's not where you spend the most time. Preproduction generally means doing the minimum number of things to the maximum number of images so that you get to the point where you can pick the hero images that are truly deserving of your time, while leaving the rejects handy for revisiting.

Production. The production phase is where you hand-polish the select images that deserve the bulk of your time and attention, hand-tuning the Camera Raw settings and bringing the images into Photoshop for the kinds of selective corrections that Camera Raw simply isn't designed to do. The exercise of your creative judgment is one aspect of the workflow that you can't automate, but automation can and will speed up the execution of that creative judgment.

Postproduction. Once you done everything you need to do, you'll still have to deal with the images you've produced in an organized manner so you can print them, deliver them to clients, or access them if (and when) you need them in the future.

Before looking at the individual phases, you need to make some strategic decisions, and to make those decisions wisely, you need to absorb three basic principles of workflow efficiency.

WORKFLOW PRINCIPLES

There are likely as many workflows are there are types of photographers— maybe more! One of the wonderful things about Bridge CS4, Camera Raw 5, and Photoshop CS4 is the incredible workflow flexibility they offer. The price of this flexibility is, of course, complexity. There are multiple ways to accomplish almost any task, and it may not be obvious at first glance which way is optimal in a given situation.

In this chapter, we'll look at the different ways of accomplishing the basic workflow tasks and explain the implications of each. That's the tactical level. But to create a workflow, you also need a strategy that tells you how and when to employ those tactics.

Even an individual photographer may need more than one workflow. There's a big difference between the workflow you need to follow when you're on a shoot, with the client looking over your shoulder and you need to agree on the hero shots before you strike the lighting and move on, *and* the workflow you'd like to follow when you're reviewing personal work with no deadlines attached. These two scenarios represent extremes, and there are many points on the continuum that lies between them.

We can't build your workflow for you, since we don't know your specific needs or your preferences. What we *can* do is introduce you to the components that address the different workflow tasks, and offer three key principles of workflow efficiency that can guide you in how to employ them:

- Do things *once,* efficiently.

- Do things automatically whenever possible.

- Be methodical in how you work.

Do Things Once

When you apply metadata such as copyright, rights management, and keywords to your raw file, the metadata is automatically carried through to all the TIFFs, JPEGs, or PSDs that you derive from that raw file, so you only need to enter that metadata once.

By the same token, if you exploit the power of Camera Raw to its fullest, many of your images may need little or no work postprocessing in Photoshop, so applying Camera Raw edits to your images is likewise something that can often be done only once.

A key strategy that helps you do things once, and once only, is to start with the general and proceed to the specific. Start with the things that can be done to the greatest number of images, and proceed to make increasingly more detailed treatments on ever-decreasing numbers of images, reserving the full treatment—careful hand-editing in Camera Raw and Photoshop, applying image-specific keywords, and so on—to those images that truly deserve the attention.

Do Things Automatically

Automation is a vital survival tool for simply dealing with the volumes of data a raw workflow entails. One of the great things about computers is that once you've told them how to do something, they can do that something over and over again. Photoshop actions are obvious automation features, but metadata templates and Camera Raw presets are automations too, albeit less obvious ones.

We rarely open an image from Camera Raw directly into Photoshop unless we're stacking multiple renderings of the raw file into the same Photoshop image. Even then, we'll take advantage of the Option-Open shortcut that opens the images as copies so that we don't have to rename them manually in Photoshop—that too is an automation feature!

In the vast majority of cases, when creating converted images that Photoshop can open, we do so using either Batch or Image Processor, and apply actions that do things like sharpening and creating adjustment layers. That way, when we open the image in Photoshop it's immediately ready for editing without us having to create layers first.

We'll discuss automation in more detail in Chapter 9, *Exploiting Automation*, but the workflow message is this: if you find yourself doing the same things over and over again, they're good candidates for automation.

Be Methodical

Once you've found a rhythm that works for you, stick to it. Emergencies will happen, and sometimes circumstances will force you to deviate from established routine, but that should be the exception rather than the rule. Being methodical and sticking to a routine makes mistakes less likely, and allows you to focus on the important image decisions that only you can make.

For better or worse, computers always do *exactly* what you tell them to, even if that's jumping off a cliff. Established routines help ensure that you're telling the computer to do what you really want it to do and *only* what you want done.

PLANNING AND STRATEGY

An efficient workflow requires planning. Bridge CS4, Camera Raw 5, and Photoshop CS4 offer dazzling arrays of options. You can flail around and try everything—it's actually not a bad way to get your feet wet, though we hope you'll use the information in this chapter to make your flailing somewhat methodical—but at some point, you have to decide what works best for you and stick with it.

Among the things you need to decide, and stick with, are the following:

- **Bridge cache.** You can use a centralized cache, or use distributed caches. Each has its strengths and weaknesses, but your life will be simpler, and your workflow more robust, if you pick one approach and stick to it.

- **Camera Raw settings for individual images.** You can save the Camera Raw settings for each image in the Camera Raw database, in sidecar .xmp files, or in the case of DNG, JPEG, or TIFF formats, in the file itself. It's slightly easier to switch from one approach to another in Bridge CS4 with Camera Raw 5 than it was with previous versions, but doing so still requires considerable work and a great deal of care.

- **File naming conventions.** We rely on folder naming and keywords and other metadata to help us organize and find images (see Figure 7-2). But that isn't an approach that works for everyone. If you do rename your raw files, pick a naming convention that makes sense to you and stick with it.

- **Labels and ratings.** The labels and ratings you apply in Bridge or Camera Raw are simply arbitrary flags. Labels and ratings give you two sets of indicators, each of which contains six possible values when you include no label and no rating. It's entirely up to you what they mean. Again, pick a system that makes sense to you and stick with it!

You'll need to make plenty of decisions when you're working on your images. It's a Bad Idea to start making decisions about any of these factors when you're working on a tight deadline, because doing so introduces complexity (of which you already have enough) and increases the chance of unintended consequences (which you want to avoid).

Never Enough Storage

Figure 7-2 shows how Jeff organizes his digital captures. There is over one terabyte (TB) of digital captures stored in named folders and subfolders. All these images reside on an internal striped array of three 750GB drives. Jeff copies the ~DigitalCaptures folder to an external FireWire RAID 5 array drive every night using Retrospect backup software. That external FireWire drive is also copied to a separate mirrored pairs of FireWire drives. So, Jeff has the primary working files on fast internal drives and the same files on three separate external drives.

Although the nightly Retrospect backup is scheduled automatically, Jeff can call up the script at any time to force an immediate backup. Periodically, he also copies the entire ~DigitalCaptures folder to a NAS (Network Attached Storage) drive on his network. Keep in mind that this folder contains only capture files, not processed and retouched files (those reside in separate folders, which are also backed up on mirrored drives).

All of this represents a total of just under 8TB of total online storage, with an additional 4TB via the NAS drive—and Jeff is shopping for additional storage options. You can never have enough storage!

Figure 7-2 Jeff's digital capture organization.

Who Has the Cache?

Bridge's cache performs the important task of storing image thumbnails, previews, and sort order. For file types that don't support sidecar .xmp files or allow writing directly into the file, it also stores keywords and metadata. Bridge's Cache Preferences let you choose whether to use a central cache or distributed caches (see the "Cache" section in Chapter 6, *Adobe Bridge*).

The only downside to using distributed cache files in Bridge CS4 is that the Bridge engineers have told us that a centralized cache may be just a bit quicker. If you are working on a low-end computer, you can use a central cache instead, but do so with the clear knowledge that you run the risk of losing thumbnails, previews, and custom sort orders when you do any of the following:

• Rename a folder outside of Bridge.

• Copy a folder outside of Bridge.

• Burn a folder to removable media such as CD-ROM or DVD.

• Copy a folder to a different computer.

You can work around these limitations of the central cache by making sure that you use the Export Cache command from Bridge's Tools > Cache submenu, but you're introducing complexity that is unnecessary with distributed caches and thus creating more opportunities for operator error. If you're downloading images to a laptop computer in the field, with the eventual goal of transferring them to a desktop machine back in the studio for further processing, we'll come straight out and say that it's just crazy to use a central cache on the laptop. (Using a central cache on the desktop Bruce deemed merely eccentric and Jeff thinks is goofy.)

A second argument against a central cache is that when you use it, you're putting all your eggs in one basket. You can control where the central cache gets stored, so you don't have to store it in the default location on your startup drive where it's vulnerable to permissions issues and other ills, but like pets, all hard drives eventually die. Storing all your caches in one folder incurs the risk that you'll lose them all with a dead drive. With distributed caches, every folder contains a cache automatically. You can copy and rename your folders without having to think about it, and when the inevitable does happen, you've only lost what was on that drive (which was, of course, backed up in multiple locations).

Strategies for Settings

You can save Camera Raw settings either in the Camera Raw Database or in sidecar .xmp files or write the settings directly into file formats that accept XMP metadata. Superficially, it may seem that the same arguments apply to the Camera Raw Database as apply to the centralized Bridge cache, but in fact it's not that simple.

The Camera Raw Database indexes images by their total content, not just by their filenames, so you can copy, move, or rename them willy-nilly without losing track of your raw settings—but only as long as the images remain on the same computer as the Camera Raw Database. Move them to another machine, and the settings are gone (or, rather, they're still on the originating computer where they'll do absolutely no good). You can work around this limitation by always remembering to use Camera Raw's Export Settings to XMP command to write out the XMP metadata for the image. But that's a lot of "always remembering."

If you use sidecar .xmp files for proprietary raws instead, Bridge does its best to keep track of them. As long as you use Bridge to copy, move, and rename your raw files, the sidecar files travel with them automatically. But if you copy, move, or rename your raw files *outside* of Bridge, it's up to you to keep track of your sidecar files and move them with the images manually. Again, it's not an ideal solution.

There's a third alternative, which is to use the DNG format. This is a topic that's sufficiently nuanced to deserve its own discussion, so see the next section, "Working with DNG." Those of you with sharp eyes will doubtless have noticed that almost all of the screen shots in this book use DNG images. Unless you like to bounce back and forth between Camera Raw and your camera vendor's proprietary raw converter, a DNG workflow makes more sense than one based on proprietary raws. The convenience of having all the metadata, including Camera Raw settings, stored right in the file itself outweighs the onetime speed bump entailed in converting the raws to DNG. But if you want to use your camera vendor's converter, and your camera doesn't write DNG, you should stick with proprietary raws for your working files, at least for now. You may, however, want to consider using DNG with the original raw embedded as an archival format. See "Archiving Images," later in this chapter.

Working with DNG

The DNG format is, as previously noted, Adobe's proposed standard for a documented, open, nonproprietary raw format.

From a workflow standpoint, DNG files offer at least one major advantage: they're designed to be metadata-friendly. So if you use DNG files, you don't need sidecar .xmp files to hold your Camera Raw settings or other metadata. Instead, all these things get written directly into the DNG file so they can't get lost or disassociated from the image.

DNG Downsides and Advantages

There are really only two downsides to the DNG format:

- You have to convert your proprietary raw files to DNG, which takes time.

- The DNG files can't be opened by your proprietary raw converter.

If, like us, you're perfectly happy with Camera Raw and don't plan on using your camera vendor's proprietary raw software, the second point is moot, but if you prefer to bounce back and forth between Camera Raw and the proprietary converter, DNG isn't well suited to doing so. You can embed the original raw in a DNG, but you have to take the time to extract it before you can work with the proprietary raw, so DNG with original raw embedded is intended more as an archival format than as one suited for everyday use.

That leaves the first point. The slow way to get to DNG is to run all your proprietary raws through the Adobe DNG Converter application before you start working on your images. That's not always an acceptable solution since it takes some time.

A better method, the one we favor, is to make selects and initial edits on the proprietary raw files, then to use Camera Raw hosted by either Bridge or Photoshop, depending on which application we want to continue using, to batch-save the raws to DNG. Once we've saved everything as DNG, we make an archive using DNG with the original raw images embedded. Then we simply discard the proprietary raw files.

We do this to exploit the advantages of the DNG format. First and foremost, all the information in the proprietary raw files' sidecar .xmp files—Camera Raw settings, keywords, copyright and rights management metadata—gets saved directly into the DNG so we no longer need to worry about sidecar files.

A second benefit of DNG is that it can contain a full-sized or medium-sized JPEG preview that third-party asset managers can use instead of having to spend time parsing the raw data before it can display the image. Photoshop and Bridge make use of the embedded preview in a limited way—Photoshop displays the preview in the File > Open dialog box, and Bridge uses it to display the initial thumbnail before building its high-quality previews. One reason that Photoshop and Bridge don't make greater use of the embedded previews is that Camera Raw 4 doesn't update the preview when you edit a DNG in Camera Raw unless you instruct it to via the Camera Raw Preferences or the Update DNG Previews (see Figures 7-3 and 7-4). (Camera Raw does update the preview when you save a new, edited DNG, however.) Obviously this is not an ideal situation for those who want to use DNG with third-party asset managers.

Figure 7-3 Camera Raw's DNG file-handling preferences.

Figure 7-4 Updating DNG Previews.

Update DNG Previews command in Camera Raw's flyout menu

Embedded JPEG Previews size options

Camera Raw's DNG File Handling

As shown in Figure 7-3, the first preference item, Ignore Sidecar ".xmp" Files, addresses a relatively obscure situation that arises only when you have a DNG and a proprietary raw version of the same image in the same folder and they're identically named except for the extension. If you edit the proprietary raw file, Camera Raw also applies the edits to the DNG. The pref-

erence setting lets you tell Camera Raw to ignore sidecar files and leave the DNG alone in this situation.

The second preference item, Update Embedded JPEG Previews, lets you tell Camera Raw to always update the preview when you edit a DNG. The penalty for doing so is that you take a speed hit because the previews take time to build and save. The advantage is that the embedded previews accurately reflect the current state of the image.

You can also defer the speed hit by working with this preference turned off. Then, when you want to update the previews, choose Update DNG Previews from the Camera Raw menu. You'll see the dialog box shown in Figure 7-4, which allows you to update the Medium Size or Full Size preview.

You can skip the dialog box by pressing Option or Alt when you choose Export Settings, in which case Camera Raw will update the preview size you selected the last time you opened the dialog box.

Preview Size

When you choose Full Size preview, Camera Raw actually embeds both Full Size and Medium Size previews, so smart applications can extract only the amount of data they need for thumbnails while allowing you to zoom to see the actual pixels. The only downsides to Full Size previews are that they take slightly longer to build and make a slightly larger file. If you need only thumbnail support in a third-party application, you can save yourself a little time by using the Medium Size option, but the savings are small, and if you change your mind later and decide you need full-sized previews, any savings are wiped out.

Full Size gets you the best of both worlds, and since Camera Raw is flexible about when you take the speed hit, it's the option we prefer.

Bear in mind too that you can choose which application, Bridge or Photoshop, gets tied up building the previews so that you can continue working in the other application while the one hosting Camera Raw builds the previews in the background. On a fast computer, this takes scant seconds. On a slow machine, you'll notice the delay.

You may have noticed that most all of the screen shots in this book use images in DNG format. When Bruce initially made the decision to use DNG in the book, he confessed that he did so partly for political reasons, but Jeff does so for workflow reasons. Once you come to enjoy the benefits of the DNG workflow, and the absence of sidecar files, you'll never go back to proprietary raws.

What's in a Name?

We don't make a practice of renaming raw files, simply because we haven't found a compelling reason to do so. That said, we know a good many photographers whose sophisticated naming schemes are a core part of their workflow, so we're not in any way against the practice.

If you *do* want to make a practice of renaming your raw files, we suggest the following two simple rules:

- Adopt a naming convention that makes sense to you and stick to it (in other words, be methodical).

- What's in a name? Anything you want, but if you want that name to be consistently readable across platforms and operating systems, stick to a strict alphanumeric character scheme—no spaces (the underscore works everywhere) and no special characters.

 The only place a period should appear is immediately in front of the extension—today's OSs have a tendency to treat everything following a period as an extension and promptly hide it, so periods in the middle of filenames are likely to cause those filenames to be truncated. Many special characters are reserved for special uses by one or another operating system. Including them in filenames can produce unpredictable results, so don't!

Aside from these two simple rules, file-naming conventions are limited only by your ingenuity and character length (we suggest a maximum of 128 characters for current OSs, but even that can become unreadable in most applications due to truncation). Don't overlook metadata as a source for naming elements, and expect to see ingestion scripts that offer more metadata-related naming features than Bridge's Batch Rename (see Figure 6-29 in Chapter 6, *Adobe Bridge*) both from Adobe and from third-party scripters.

Ratings and Labels

Bridge and Camera Raw offer two independent mechanisms, labels and ratings, for tagging images (well, three if you count flagging, which we don't use). Each mechanism offers six possible values: if you use them in combination, you can have 36 possible combinations of ratings and labels, which is almost certainly more than most people need!

If you think you can use a system with 36 values productively, knock yourself out. Otherwise, we suggest keeping things simple. We prefer to avoid using labels because they introduce large blobs of color into an environment where the only color we want to see is the color in the images, so we primarily try to use ratings instead. The rating system was designed to mimic the time-honored practice of making selects on a light table by marking the keepers from the first round with a single dot, adding a second dot to the keepers from the second round, and so on. That's how we use it—it's simple and effective.

We do make limited use of labels for various special, esoteric purposes. For example, Jeff has applied the Blue label to his ever-growing collection of shots for stitching into panoramic images and a Green label for shots intended for HDR assembly. Labels are handy for this kind of use because they can operate completely independently of the star-based rating system. If you can think of uses for them, go ahead and use them, but don't feel that just because a feature exists, you have to use it.

Remember that if you want to use labels to communicate something about images to someone else, you and they need to use the same definitions of the labels. If they're different, the recipient will get a bunch of images with white labels, indicating that a label has been applied, but with different label text than is currently specified in their Labels preferences. (See Figure 6-15 in Chapter 6, *Adobe Bridge*.) They can search the metadata for your label text, but since labels are meant to be an easy visual way to identify *something* about the images, you'd likely be better off using keywords instead.

Simplicity Is Its Own Strategy

Camera Raw, Bridge, and Photoshop offer an amazing number of options. Only a genius or a fool would try to use them all. If, like us, you're neither, we recommend keeping things as simple as possible without making any overly painful compromises.

The four issues that we've explored in this section—Bridge cache, Camera Raw settings, naming conventions, and rating/labeling strategies—are things that can't be changed without going through considerable pain. You can certainly spend some time trying out the options before setting your strategies in stone, but once you've found the approach that works best for you, don't change it arbitrarily. If you do, it's entirely likely that you'll lose

work, whether it's Camera Raw edits, Bridge thumbnails, ratings, or simply winding up with a bunch of incomprehensibly named files. Any of these violates the first workflow principle—do things once, efficiently—and you pay for it with that most precious commodity, your time.

THE IMAGE INGESTION PHASE

Transferring your images from the camera to the computer is one of the most critical yet often one of the least examined stages of your workflow. It's critical because at this stage, your images exist only on the camera media. It's not that Compact Flash (CF), Secure Digital (SD), or microdrives are dramatically more fragile than other storage media—it's simply that there's only one copy! Losing previews or Camera Raw settings is irritating, but you can redo the work. If you make mistakes during ingestion, though, you can lose entire images.

The following ground rules have stood us in good stead for several years—we've had our share of equipment problems, but thus far, we've yet to lose a single image (that matters):

- Don't use the camera as a card reader. Most cameras will let you connect them to the computer and download your images, but doing so is a bad idea for at least two reasons. Cameras are typically very slow as card readers, and when the camera is being used as a card reader, you can't shoot with it.

- Never open images directly from the camera media. It's been formatted with the expectation that the only thing that will write to it is the camera. If something else writes to it, maybe nothing will happen, but then again, maybe something bad will.

- Don't rely on just one copy of the images—always copy them to two separate drives before you start working.

- Don't erase your images from the camera media until you've verified the copies—see "The Image Verification Phase," later in this chapter.

- Always format the cards in the camera in which they will be shot, never in the computer.

Following these rules may take a little additional time up front, but not nearly as long as a reshoot (assuming that lost images can in fact be reshot).

Camera Media and Speed

All CF cards (or SD cards, or microdrives) are not created equal, and vendor designations like 4x, 24x, 40x, 80x, Ultra, and Write Accelerated aren't terribly reliable guides as to the performance you'll get with your personal setup.

There are two distinctly different aspects to CF card speed:

- Your burst shooting rate is dictated by the speed with which the camera writes to the CF card in the camera.

- Your image offloading speed is dictated by the speed with which images can be read from the CF card onto your computer's hard disk.

In either case, the bottleneck may be the CF card, or it may be the hardware used to write to it (your camera) or read from it (your card reader).

Compact Flash write speed. Most of today's high-speed CF cards can write data about as fast as the camera can send it. However, older cameras may not be able to deliver the data fast enough to justify the premium prices the fastest cards command.

The best source we know for comparative data on different cameras' write speeds to different cards can be found on Rob Galbraith's Web site, http://www.robgalbraith.com; look for the CF/SD link on the front page. Note that the database no longer gets updated for some older cameras, so if the notes say something to the effect of "this camera will benefit from the fastest card available," look in the table to check which card that actually was and when that page was last updated.

Compact Flash read speed. The card reader and even the operating system can play an equal role in determining read speed to that of the card itself. Card readers almost invariably use one of five interfaces: USB 1.1, USB 2.0, FireWire 400 or 800, and recent PCI Express Card readers.

Almost any card available today can max out the speed of a USB 1.1 reader. In theory, USB 2.0 is faster than FireWire, but in practice, as the EPA says, "your mileage may vary"—we've generally found FireWire to be both faster and more reliable than USB 2.0, particularly with fast cards such as the SanDisk Extreme III and the Lexar Pro 233x product lines.

Mac OS X users should take note that OS X versions prior to Panther (OS 10.3) were very slow at reading 2GB and larger cards that use FAT-32 formatting. Panther fixed the problem and there doesn't seem to be any issue with Leopard although Apple's USB 2.0 implementation seems slow.

Microdrives. In addition to solid-state CF cards, microdrives—miniature hard disks in Compact Flash form factor—are also available. Microdrives were introduced when solid-state CF cards were still quite limited in both speed and capacity.

Today, solid-state CF cards have outstripped microdrives in both capacity and speed, and they also have enormous advantages in durability. Like all hard drives, microdrives use moving parts machined to very fine tolerances, so they don't respond well to impacts—it's easy to destroy both the data and the drive itself by dropping it. Solid-state CF cards are a great deal more robust—while we don't recommend abusing them in any way, Bruce had one that survived being run over by a Ford Explorer! (Bruce was driving.)

Microdrives may make a comeback, with much higher capacities than before, but right now such designs are still on the drawing board.

Secure Digital (SD) cards. If microdrives are the wave of the past, SD cards are the wave of the future, though at the time of this writing only a handful or so of professional DSLR cameras support them. The main impetus behind the development of SD is the built-in encryption, which is inviting for the music and movie industries, since it will let them distribute copyrighted material digitally.

For camera use, SD is still relatively new, and few cameras except point-and-shoot cameras use it—the Canon EOS 1DsMkIII lets you use both CF and SD, but the SD card seems intended as a spare for when the CF card gets full. The capacities of the current generation are still lower than the largest CF cards—at the time of this writing, SDHC (High Capacity) 8GB cards are common and we're just starting to see 16GB and 32GB SDHC cards—but the fastest SD cards are slightly faster in the camera than are the fastest CF cards, though they're considerably slower at transferring data from the card to the computer. Both of these statements are subject to change. All the recommendations for handling and using CF cards apply equally to SD.

Formatting Camera Media

Always format your camera media, whether CF card, microdrive, or SD card, in the camera in which it will be used! Your computer may appear to let you format the card while it's loaded in the card reader, but it's quite likely that it will either do so incorrectly or offer you a set of options from which it's easy to make the wrong choice.

Formatting CF cards on Windows systems can, at least in theory, be done correctly, but the only time we'd recommend doing so is if you've used software supplied by the card vendor to perform data recovery or diagnostics *and* the software recommends formatting. Formatting CF cards under any flavor of the Mac OS is a recipe for disaster without using the card maker's software. Formatting cards in the camera in which they will be used is always safe and guarantees that the format will be the one your camera can use.

TIP When Disaster Strikes. If you wind up with a card that's unreadable but contains data you want to recover (it's rare, but it can be caused by doing things like pulling the card out of the reader without first ejecting it in software), do not format it! Doing so will guarantee that any data that was still on the card will be permanently consigned to the bitbucket. Major CF card vendors such as SanDisk and Lexar include data-recovery software with the cards (which for our money is sufficient reason to stick with those brands). Before attempting anything else, try the recovery software. If that fails, and the data is truly irreplaceable, several companies offer data recovery from CF cards, usually at a fairly hefty price—a Google search for "Compact Flash Data Recovery" will turn up all the major players.

Camera Card Capacities

Bigger isn't always better, and in the case of CF cards, large capacities often come at premium prices. An 8GB card will generally cost more than twice as much as a 4GB one, and so on.

Using two smaller cards rather than one big one offers an immediate workflow advantage. When the first card is full, you can switch to the second one to continue shooting while the first card is being copied to the computer. By the time the second card is full, the first one will have finished copying and you can format it in the camera and continue shooting.

Ingesting Images

We always copy images onto a hard drive before attempting to open them. (Actually, we always copy the images onto two different hard drives. We may be paranoid, but Bruce never lost a digital capture and Jeff has only lost images due to yanking a CF card before the camera was done writing to it.)

It's possible to connect the camera to your computer and actually open the images while they're still on the CF card. It's likewise possible to put the CF card in a card reader and open the images directly from the CF card. But "possible" doesn't mean it's a good idea! It's possible to run a Porsche on kerosene or to perform brain surgery with a rusty Phillips screwdriver, and

we consider either one about as advisable as opening images directly from the camera media.

We always copy to two hard drives for the simple reason that hard drives break, usually at the least convenient moment they could possibly choose to do so. If you simply can't take the time to make two copies, consider setting up a mirrored (not striped) RAID array. Mirrored RAID arrays copy the data to two drives simultaneously, so unless both drives fail simultaneously (which is extremely unlikely), you'll always have a copy of the data. RAID level 5 (distributed parity) offers a good compromise between speed and reliability—the data is distributed with parity bits across three drives, so even if one drive fails, the array can be rebuilt (though it takes a while to do so).

You can even kill two birds with a single stone by using a casing that allows hot-swapping of the drives, and use the drive mechanisms themselves, suitably boxed, to archive the data. Hard disks are much faster than CD-R or DVD-R; will almost certainly last at least as long, particularly if they're simply being stored; and can cost less than a dollar per gigabyte—see the section "Archiving Images" at the end of this chapter.

When you're shooting in the field and using a laptop to offload the images, we suggest you carry a portable FireWire drive and make a second copy of all the images on the portable drive. When time permits, make both copies directly from the camera media. Failing that, make one copy from the camera media, then copy from one hard drive to the other. When there's absolutely no time to spare, you can work from a single copy of the images, but in that situation, always verify the images by letting Bridge build previews before formatting the camera card from which they came.

However you choose to accomplish the task, our overriding recommendation is that you wait until the copy from camera media to hard drive is complete and verified before you try to do anything at all to the images.

Figure 7-5 shows using Adobe Photo Downloader to ingest images from a CF card. These shots are from Jeff's family vacation—well, actually from a 5,000-plus-mile motorcycle trip he took from Chicago to California and back.

Note in Figure 7-5 that Jeff did *not* rename his files but preserved the original filename in XMP. He also chose to convert to DNG upon copy, backed up the images to a secondary drive, and applied his basic ©2008 metadata template.

Figure 7-5 Image ingestion using Adobe Photo Downloader.

Photo Downloader
Advanced dialog

Photo Downloader progress

THE IMAGE VERIFICATION PHASE

Once you've copied the raw files to your hard disk, the next thing to do is point Bridge to the folder containing the raw images. Bridge is command central for dealing with hundreds or even thousands of images. You'll use it to make your initial selects, to apply and edit metadata including Camera Raw settings, and to control the processing of the raw images into a deliverable form.

But before you start doing any of these things, it's a good idea to give Bridge a few minutes to generate the thumbnails and previews and to read the image metadata. The old File Browser was pretty much unusable while it was building previews. As a standalone multithreaded application, Bridge is much more responsive while it's building previews, but whenever possible, it's still a good idea to let it finish building the cache for the folder before you start working.

The reason is simple. While you can identify raw images as soon as the thumbnail appears, and open them in Camera Raw, the thumbnails are generated by the camera, and Bridge simply reads them. To build the high-quality previews, though, Camera Raw actually reads the raw data.

Verifying Images

If Camera Raw has any problem reading the images, the problems will only show up on the high-quality thumbnail and preview. The initial thumbnails are the camera-generated ones, and they don't indicate the raw file has been read successfully. The high-quality thumbnails *do* indicate that the raw file has been read successfully, so wait until you see them before you erase the raw image files from the camera media. For this reason, when using raw files always set your Bridge Preferences to generate high-quality thumbnails. It takes a bit longer, but you get the benefit of image verification for your time invested.

If there's a problem with the raw data, you won't see a high-quality preview, so the preview-building process verifies that the raw data has been copied correctly. It's the first time you actually see a processed version of the raw image created from the raw file on the computer.

If you see a problem at this stage, check the second copy (if you made one) or go back to the camera media—you haven't reformatted it yet, right? It's fairly rare for the data to become corrupted in the camera (though it does sometimes happen, particularly in burst-mode shooting or if you remove the card before the buffer has been written), so the first suspect should be the card reader.

If you have only one reader available, try copying the problem images one by one. If you have a second reader available, try copying the files using the second reader. If this copy fails, try running the rescue software provided by the card vendor. If none of these suggestions works, your options are to reshoot, to accept the loss and move on, or to resort to an expensive data-recovery service.

Feeding the Cache

Bridge's cache holds the thumbnails, previews, and sort order information for each folder at which you point it. (In the case of other file types, the cache may contain additional information, but with raw files, the thumbnails, previews, and sort order are the only pieces of data that are uniquely stored in the Bridge cache.) With a brand-new folder of images, there's no custom sort order, so the caching process consists of reading the thumbnails and EXIF metadata, and building the high-quality previews.

This is a two- or three-pass process depending on your Bridge Thumbnails Preferences. The first pass reads the files and metadata, the second pass extracts any embedded thumbnails, and the third pass uses Camera Raw to build the high-quality previews—it's this third pass that lets you verify the raw images. When you point Bridge at a folder of raw images for the first time, it goes to work. The first thing you'll see is a spinning progress wheel (which we've learned to hate)—see Figure 7-6.

Figure 7-6 Examining folder contents.

With the typical hundred images per folder that cameras write, the initial blank icons and spinning wheel flash by so quickly that if you blink, you may miss them. The next indicator is the spinning wheel. This second pass takes a little longer, because it's extracting the camera-created thumbnail and metadata from the raw images—see Figure 7-7.

Figure 7-7 Low-quality thumbnails.

Getting embedded low-quality thumbnails

Extraction progress indicator

The last phase of the cache-building process is also the most crucial one—generating previews. In this phase, Bridge uses Camera Raw to build higher-quality thumbnails than the ones that appear initially. (They're downsampled versions of the result you'd get if you processed the raw file using the current Camera Default settings for the camera that shot the images in Camera Raw.) Even in print at this small size, you can see the difference between the thumbnails in Figure 7-7 and the ones in Figure 7-8; the low-quality thumbnails have a black border.

Figure 7-8 High-quality thumbnails.

Generated high-quality previews

Progress indicator showing that the HQ previews are done

Once Bridge has completed the process of generating the previews, it displays a message that states the number of images in the folder, indicating that it's ready for you to proceed to the preproduction phase (see Figure 7-8). Large previews appear instantly when you advance from one image to another, so you can work quickly.

Interrupting the Cache

TIP Download to Your Fastest Drive. The cache-building process is largely dependent on disk speed, so the faster the drive to which you download the raw images, the faster Bridge builds the cache. Consider dedicating a partition on your fastest drive, the same size as your camera media, for downloading and caching your raw images. If you use distributed caches in Bridge, you can then copy the folder to another drive without having to do anything else to keep your thumbnails and previews intact.

In an ideal scenario, you'll follow the procedures described in the previous section, but in the real world, scenarios are often less than ideal. In this section, we'll cover a couple of ways to start work while Bridge is still building its cache. You're still verifying the images, just not necessarily in the order in which Bridge loaded them.

If you need to see and start working with a specific image right away, you can force Bridge to read all the data and build the preview by selecting the thumbnail in the Bridge window. Bridge gives preference to that image, and generates a preview before moving on to the other images, even if you do so during the thumbnail pass. You can also scroll the Bridge window to give preference to a series of images—Bridge always builds previews for those images whose thumbnails are currently visible in the main window first.

The most effective way of getting images while Bridge is still caching is to select the thumbnails, then press Command-O to open the images in Camera Raw filmstrip mode hosted by Photoshop. Camera Raw builds the previews very quickly, and because it's hosted by Photoshop, it doesn't have any effect on Bridge's caching performance. You can apply ratings or labels in Camera Raw in addition to editing the images. The only thing you can't do is apply keywords, or metadata other than labels, ratings, and Camera Raw settings.

Caching Multiple Folders

Most cameras create subfolders on the camera media with 100 images in each. If you use larger-capacity cards, you may have three or four image folders. The fastest way to deal with multiple folders is to copy all the image folders to a single enclosing folder. Then, when the copy is complete, point Bridge at the enclosing folder and choose Build Cache for Subfolders from Bridge's Tools > Cache menu. Bridge builds a cache for each subfolder in

the enclosing folder, reading the thumbnails and metadata and generating previews for all the images contained in the subfolders. It displays a status message so you'll know when it's done.

THE PREPRODUCTION PHASE

The absolute order in which you perform tasks like selecting, sorting, renaming, keywording, and so on isn't critical, so the order in which we'll discuss them is, we freely admit, arbitrary. In those cases where the result of one task depends on the prior completion of another, we'll point that out. We do, however, offer one golden rule.

Start with the operations required by the largest number of images, and complete these before you start handling individual images on a case-by-case basis. For example, the first thing you always do with a folder full of new raw images is select all the images and enter a copyright notice by applying a metadata template. In our workflow example, this step was done at ingestion.

Similarly, if you know that you want to add the same keyword or keywords to all the images in a shoot, you can do it now (see "Applying Keywords and Metadata," later in this chapter). But if you don't care about copyrighting or keywording your rejects, you can make your initial selects first.

Selecting and Editing

Some photographers like to do a rough application of Camera Raw settings on all the images before they start making selects by flagging or ranking. Then they look at a large preview for each image and apply a flag or rank accordingly. Others may take a quick scan of the thumbnails and weed out any obvious junk before proceeding. Still others may want to do keywording and metadata editing before they start making selects. Bridge can accommodate all these different styles.

Start by loading a Bridge configuration that works for the task you want to start with—if you need to refresh your memory on configuring Bridge's layout for different tasks and saving those layouts as workspaces, see "Configuring Bridge Windows" in Chapter 6, *Adobe Bridge*.

Selecting by thumbnail. If the thumbnail view lets you see enough detail to make initial selects, choose an all-thumbnail view, then click-select the keepers or the rejects, whichever is easier (see Figure 7-9). You can apply a rating as you go.

Figure 7-9 Selects by thumbnail.

Selecting by preview. To see more detail, you can look at each image's preview. Bridge's Filmstrip view (see Figure 7-10) lets you see a large preview with a single row of thumbnails. The left and right arrow keys let you navigate from one thumbnail to the next and display the corresponding preview. Shift-clicking selects all contiguous files between the last-selected image and the one on which you click. Command-clicking selects noncontiguous images one at a time. Bridge has the ability to see multiple images in the Preview panel as well as the ability to check an image detail at 100% using the Loupe tool. You can preview up to nine images at once.

With this method, it's easier to apply a label or rating as you go rather than rely on selecting thumbnails—see "Rating and Labeling," later in this chapter.

Selecting in Slide Show. Bridge's Slide Show view lets you review images one at a time at up to full-screen resolution. Slide Show offers the largest overall preview you can get without opening the image in Camera Raw and zooming. You can't select images in Slide Show view, but you can apply labels or ratings.

Figure 7-10 Selects by preview in Filmstrip mode.

Press right arrow to go to the next image. Press left arrow to go to the previous image.

Two-up previews using Bridge's Loupe tool to check details

TIP If you want to compare the actual image pixels at full resolution, you can do so by opening the same images in Camera Raw twice, with one Camera Raw session hosted by Photoshop and the other hosted by Bridge. (Press Command-O to open the selected images in Camera Raw hosted by Photoshop, then return to Bridge and press Command-R to open them again in Camera Raw hosted by Bridge.) Then arrange the two Camera Raw windows so that you can see the preview in each one (see Figure 7-11).

Comparing images. When you're making selects, you often need to compare images. In Slide Show view you can see before-and-afters, but we'll offer this obscure and sneaky technique for comparing images side by side—using Camera Raw twice to view either the same image with different settings or two images.

If you use this technique, remember that the settings that are applied to the image are those written by the last copy of Camera Raw to touch it.

Camera Raw hosted by
Photoshop (underneath)

Camera Raw hosted by Bridge (top)

Figure 7-11 Simultaneous Camera Raw sessions.

Rating and Labeling

Physically selecting thumbnails is certainly one way to distinguish keepers
from rejects, but it's ephemeral. A better method, which can be used with any
of the techniques described in the previous section, is to use ratings or labels.
Ratings and labels become part of the image's metadata that you can use to
search and filter which images get displayed (see Chapter 6, *Adobe Bridge*).

As we mentioned earlier in this chapter, we prefer using ratings to labels, but
the choice is entirely up to you. In this section we'll discuss the mechanics
of applying and using ratings.

You should also be aware that Bridge has the concept of *rejects*. As shown in
Figure 7-12, you use the Delete key to mark the image as a reject. We can't
express strongly enough that we think doing *anything* with the Delete key
other than deleting images is an incredibly bad idea—and there is no key
you can use other than the Delete key. Personally, we don't use this function
as is and wish it were deployed in some other manner.

Figure 7-12 If you use the Delete key to mark an image as a reject, you'll see this warning.

One-star rating for binary sorts. If you want a flagging mechanism for binary, yes/no sorting and selecting, you'll be happy to find that the keyboard shortcut Command-' (apostrophe) lets you toggle a one-star rating on and off.

If you've selected a mixture of images, some of which have a one-star rating and some of which are unrated, pressing Command-' works the same as the old File Browser's Flag command—the first application adds one star to the unrated images and preserves the one-star rating for those that already have it. When all the selected images have the same attribute (all rated with one star, or all unrated), the command acts as a toggle, adding a star to unrated images or removing it from those rated with one star.

However, if the selection also contains images rated with more than one star, pressing Command-' will apply a one-star rating to these images, so you need to be a little careful with your selections.

If you have no old habits, or if you're happy to unlearn those that you have, Command-1 applies a one-star rating to all selected images, and Command-0 removes the rating for all selected images. You can apply the rating to one image at a time (which is the most convenient method in Filmstrip view, and the only possible method in Slide Show view), or to multiple selected images (which is often convenient in Thumbnails view).

Once you've applied the star ratings, you can segregate or sort the rated and unrated images in any of the following three ways—see Figure 7-13.

- Click on 1 Star (press Command-Option-1) in Bridge's Filter panel (this can also display images that have more than one star rating, but if you're using this mechanism for an initial yes/no select, none of your images will have more than one star as yet; in our example, we've already jumped ahead and made selects).

- Select Sort by Ratings from the Sort menu.

- Choose Find (press Command-F) from Bridge's Edit menu, then in the Find dialog box, choose Rating Equals ★ (one star).

The one-star approach is great for making quick, yes/no, binary decisions—keep or reject—but for more nuanced choices, you can add stars to the rating.

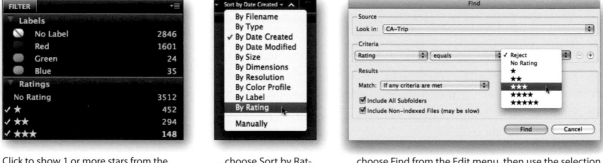

Click to show 1 or more stars from the Filter panel, or…

…choose Sort by Ratings to group rated and unrated images, or…

…choose Find from the Edit menu, then use the selection criteria shown in the dropdown menu.

Figure 7-13 Separating and sorting rated and unrated images.

Multistar ratings. The techniques for applying multistar ratings are the same as those for applying a single star. Command-0 will remove the rating, and Command-1 through Command-5 will apply one to five stars. Command-. (period) adds a star to the current rating, and Command-, (comma) reduces it by one star.

There are basically two ways to approach rating your images. Use whichever one works for you:

- Make an initial one-star pass, then go through the one-star images and apply an additional star to those images that deserve it, then go through the two-star images and apply a third star to those that deserve it. Many photographers find that four levels (unrated, one, two, or three stars) is enough, but you can go all the way to six if you see the need.

- Apply all your ratings in a single pass.

If you're collaborating with others in determining the hero shots, the first approach is probably more suitable. The second approach lends itself better to situations where you're the only person making the call. You should also consider just how important selection editing is. Once you've made these decisions, the rest of the work will generally only be done to the selects.

Keep in mind that right after shooting an image you might have an emotional attachment for what you thought you were trying to accomplish. Your first reaction to your images may be clouded by what you consider to be successes or failures in technique and not the image in its own right. That's why we suggest multipass editing and revisiting your images after a period of time to confirm your choices or find other hidden gems you missed in the heat of the moment.

The techniques shown in Figure 7-13 are equally applicable to multistar ratings as they are to single-star ones. The Filter panel lets you find all images that have various numbers of stars. The Sort command allows you to put them in order by rating.

Labels. The main reason we don't use labels is that they introduce extraneous color in Bridge windows. But the Label mechanism is also less well suited to rating images than the star-based rating system. It's intuitively obvious that a five-star rating is either better or worse than one star, while there's no clear hierarchy between, say, yellow and green.

The stars are incremental, but the labels are not—they're simply arbitrary labels. You can apply any of the first four labels using Command-6 through Command-9, but there's no concept of promoting or demoting images from one label to another.

Labels are also less portable than ratings. Your labels will show up as white on any machine that uses a different label definition than yours, which is almost certain to happen if you use something other than the default label definitions (red, yellow, green, blue, and purple), and reasonably likely to happen even if you do use the default definitions, since the recipient may not. They can always search for your label text, but it's probably simpler just to use ratings.

Applying Camera Raw Settings

There are basically three ways to approach the task of applying rough Camera Raw edits to multiple images. Remember, at this stage in the workflow, you're simply aiming for good, not perfect. (Perfect comes later, when you've whittled the images down to the selects you'll actually deliver.)

To work efficiently, look for and select images that require approximately the same edit. Once you've done so, you can apply the edits in any of the following three ways—you can mix and match techniques as required.

Edit by presets. If you've saved presets in Camera Raw's Presets panel—see "The Presets Panel" in Chapter 4, *Camera Raw Controls*, if you need a refresher—you can apply them to all the selected images by choosing Develop Settings from Bridge's Edit menu, then choosing the preset from the submenu. See Figure 7-14.

Figure 7-14
Editing in Bridge using Presets.

Choosing saved presets. Saved presets appear at the foot of the Develop Settings submenu.

Images with incorrect white balance settings

Images after the presets have been applied

Saving presets as subsets is particularly powerful, because you can simply choose them in succession. Each one affects only the parameters recorded when you saved it, so you can load a preset for white balance, followed by one for exposure, for brightness, for contrast, for calibrate settings, and so on.

This approach is useful for fine-tuning results after you've done a rough edit using Copy/Paste Camera Raw settings, or for applying very general settings, such as lighting-specific adjustments, that you don't want to include in your default settings. In Figure 7-14, Jeff has chosen a preset named *Daylight White Balance* because his camera had inadvertently been set to tungsten. Since there were so many shots incorrectly set, it was easier to use a preset to correct them.

Edit by example in Bridge. Select the first image that needs an edit, and then open it in Camera Raw. Your choice of host application Bridge or Photoshop—depends on what else is going on. If Photoshop is busy batch-processing files, host Camera Raw in Bridge. If Bridge is busy building the cache, host Camera Raw in Photoshop. If they're both busy, host Camera Raw in Bridge—Bridge's multithreading lets you work in Camera Raw with surprisingly responsive performance even while Bridge itself is busy doing other tasks.

Make your edits—white balance, exposure, whatever the image needs—and then dismiss the Camera Raw dialog box by clicking Done (it's the default option in Camera Raw hosted by Bridge, but not in Camera Raw hosted by Photoshop).

Choose Develop Settings > Copy Camera Raw Settings from Bridge's Edit menu, or press Command-Option-C. Then select all the other images that need the same edit and choose Apply Camera Raw Settings > Paste Camera Raw Settings from Bridge's Edit menu (press Command-Option-V). If necessary, select the combination of subsets or settings you want to apply from the Paste Camera Raw Settings dialog box, and then click OK. See Figure 7-15.

The Camera Raw settings you choose are applied to the selected images.

This approach works well when you need to apply the same settings to a large number of images that are identifiable by relatively small thumbnails, because you can select them quickly. But if you need to make small changes to the settings for each image, the following approach using Camera Raw in filmstrip mode is better suited.

Figure 7-15 Copy and Paste Camera Raw settings.

Edit the first image in the series… …then choose Copy Camera Raw Settings.

Select the remaining images in the series, then choose Paste Camera Raw Settings. Choose the settings you want to apply from the Paste Camera Raw Settings dialog box, shown at right.

The resulting settings are pasted into the selected images.

Edit in Camera Raw. The method that offers the most flexibility, and the one we prefer, is to open multiple images in Camera Raw. There's a limit to the number of images you can open simultaneously in Camera Raw hosted by Bridge (based on available RAM)—we've been able to open 1,500 images simultaneously in Camera Raw and, while it took a couple of minutes to launch, it worked perfectly.

That said, it's more practical to work with smaller sets of images. If you open 10 or more images, you'll get a dialog box asking if you really want to open 10 files. We recommend clicking the Don't Show Again checkbox, and cheerfully opening as many images as your machine can reasonably handle without bogging down—if the hardware is at all recent, it's almost certainly a considerably larger number than 10.

When you open multiple images, Camera Raw works in filmstrip mode. The current image is the one whose preview is shown in the preview window—see Figure 7-16.

TIP Many people like loading a lot of images in Camera Raw (Bruce's books may have had something to do with that). Well, it seems that the Photoshop CS3 engineers decided to limit the number of images Camera Raw 4 can load when hosted in Photoshop to a couple of hundred but the Camera Raw team thought that was a "bug" not a feature, so it was "fixed" for Camera Raw 5 and you can once again load more the 200 images when hosted by Photoshop. Here is proof, a screenshot showing 1,810 images loaded in Camera Raw 5.

Selected images (all are selected)

The current image shown in the preview area is "most selected."

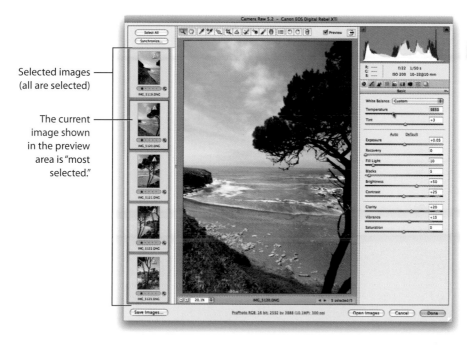

Figure 7-16 Camera Raw in filmstrip mode.

These images are intended for merging to a panoramic, so it's useful to match up the settings across all the images.

Camera Raw in filmstrip mode offers two basic methods for editing multiple images besides the obvious one of editing images one by one, as shown in Figure 7-16.

- **Select multiple thumbnails.** When you select multiple thumbnails in Camera Raw, only the first (chronologically) selected image shows in the preview, but any edits you make apply to all the selected images, so you are in effect editing multiple images simultaneously. You'll see yellow warning triangles appear on the thumbnails while Camera Raw is updating them to reflect the edits, and then disappear when the new thumbnail is built. Camera Raw's title bar displays the filename of the image that's being previewed.

When you're working with multiple selected images in Camera Raw, the up and down arrow keys move through the selected thumbnails, ignoring the unselected ones. The current image, called "most selected," has a slightly heavier border than the others, but the filename is a more obvious guide as to which image is the current one. See Figure 7-17.

The Synchronize button and dialog box let you synchronize the selected images' settings to those of the current image.

The Synchronize dialog box lets you choose what parameters to sync.

The results of syncing

Figure 7-17 Synchronize Camera Raw setting.

- **Use Synchronize.** Camera Raw's Synchronize feature is similar to copying and pasting Camera Raw settings. The Synchronize button lets you apply the settings of the current image to all the other selected images, so you need to pay attention to which image is in fact the current one!

 When you click the Synchronize button, the Synchronize dialog box (which is identical to the Paste Camera Raw Settings dialog box in all but name) appears, allowing you to choose which settings will be applied to the selected images—see Figure 7-17. To skip the dialog box and apply all the settings, Option-click the Synchronize button.

You can mix and match both of these approaches, while enjoying the benefits of zoomable previews, and not just Undo but Multiple Undo just like Photoshop (Command/Option-Z to move back and Command/Shift-Z to move forward). And if you simply can't resist the temptation, you can fine-tune individual images too. Of all the methods of editing multiple raw images, we find this one the most powerful and the most flexible.

Sorting and Renaming

By default, Bridge sorts images by filename, so new digital captures will appear in the order in which they were shot because the camera applies consecutive numbering to each image. You can vary the sort order by choosing any of the options on Bridge's Sort dropdown menu or the Sort submenu item under View > Sort (see Figure 7-18).

Figure 7-18 The Sort submenu in the Bridge View menu.

TIP The local adjustments don't currently work when multiple images are selected in Camera Raw. You'll need to apply the local adjustment to a single image and then sync them to additional images. Local adjustments will also work when copying and pasting.

TIP Always Include the Extension as the Last Item in Photoshop's Batch. When you use proprietary raw files, each image is accompanied by a sidecar .xmp file that differs in name from the raw file only by the extension. If you include the extension as the last element, the sidecar files will be renamed correctly along with the raw files. If you fail to do so, the batch rename will fail with a message that reads "file already exists."

You can also create a custom sort order by dragging the thumbnails, just as you would with chromes on a light table. When you do so, the Bridge automatically switches to "Sort Manually" on the Sort menu. The manual sort order is stored in the Bridge cache for the folder. If you use distributed caches, you can move or rename the folder and Bridge will still remember the sort order. But if you combine images from several folders into a different folder, you have in effect created a new sort order, and it may well not be the one you wanted. A simple way to preserve that order is to use Batch Rename to rename the images; be sure to use a numbering scheme that reflects your custom sort order.

TIP Process JPEGs Separately. The Batch Rename command is smart enough to handle sidecar .xmp files, but if you shoot raw and JPEG, and you have three files whose names are distinguished only by their extension rather than two, you need to do a little more work. First, use the search tool to search for all the JPEGs, and run the batch rename on them. Then use the search tool again to find all the raws and run the same batch rename. You'll wind up with correctly named raws, JPEGs, and sidecar .xmp files for each image.

Or you may wish to batch-rename your raw images using some other scheme entirely. For example, our good friend and colleague Seth Resnick, who has put more sheer ingenuity into building his workflow than anyone else we know (he even teaches about workflow through http://www.d-65.com), uses a sophisticated naming scheme that, to the initiated, at least, conveys a great deal of information at a glance.

For example, he might rename a raw file called 4F3S0266.dng to 20080423STKSR3_0001.dng. This decodes as follows. 20080423 defines the date on which the image was shot (April 23, 2008), so the files are automatically sorted by date order. STK indicates that the image was shot for stock, and SR indicates that it was shot by Seth Resnick. The number 3 indicates that it belonged to the third assignment or collection of images of the day, while the 0001 indicates that it was the first image in the collection. The .dng is the file extension that defines the file type. Figure 7-19 shows how to set up the either Bridge's Batch Rename or Photoshop's Batch dialog box to accomplish this renaming. Unless you want to run an action on the raw files and save them, it makes more sense to use Bridge's Batch Rename rather than Photoshop's Batch, but when the goal is to produce renamed converted images, Photoshop's Batch is the way to go.

Figure 7-19 Batch renaming.

The top dialog box is the Bridge Batch Rename tool.

The bottom (underneath) dialog box is Photoshop's Batch. Note the use of the EXTENSION field.

Applying Keywords and Metadata

The key to being efficient with keywords and metadata is the same as that for being efficient with applying Camera Raw edits. Look for and select images that need the same treatment, and deal with them all at once.

IPTC metadata. The only metadata that is editable in Bridge (or in Photoshop, for that matter) is the IPTC metadata (see Figure 7-20). For recurring metadata such as copyright notices, metadata templates provide a convenient way to make the edits—see Figure 6-23 in Chapter 6, *Adobe Bridge*.

Alternatively, you can select multiple images and then edit the metadata directly in the Metadata panel. Click in the first field you want to edit, and type in your entry. Then press Tab to advance to the next field. Continue until you've entered all the metadata shared by the selected images, and then click the checkmark icon at the lower right of the palette, or press Enter or Return, to confirm the entries. Unfortunately, the only method of marking an image as copyrighted is via File Info. We hope this shortcoming is addressed in the future.

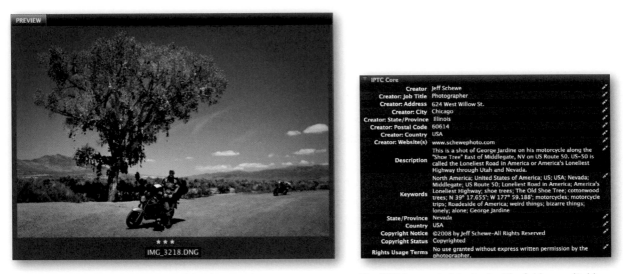

This image of George Jardine in front of the Shoe Tree in Nevada is being displayed in the IPTC Metadata panel

The IPTC Core metadata display. The fields are editable. Note the addition of extensive keywording.

Figure 7-20 IPTC editing in the Metadata panel.

Keywords. Keywords show up in the IPTC section of the Metadata palette, and you can enter or edit them there—but consider working with the Keywords panel. The Keywords panel (see Figure 7-21) contains individual keywords grouped into sets (represented by the folder icons). The default keywords and sets are pretty useless, but you can easily replace them with ones that are more meaningful for your purposes.

Figure 7-21 Adding keywords to the shot of George.

To apply a keyword, select one or more images and then click in the column to the left of the keyword. A checkmark appears in the column, and Bridge writes the keyword to each file's sidecar .xmp file. To remove a keyword, select the images and then deselect the checkmark.

Deleting a keyword from the Keywords panel doesn't delete the keyword from any images to which it has been applied; it only deletes it from the palette. So we find that it makes sense to keep only keywords you know you'll use a lot stored in the keyword group.

Hierarchical keywords let you organize keywords, but they also offer a very useful functionality—they can let you apply to selected images any parent keywords in the group by clicking next to the parent keyword names (depending on how you've set your Bridge preferences to handle hierarchical keywords; see Figure 6-28 in Chapter 6, *Adobe Bridge*).

When you click next to a keyword to apply it, Bridge starts writing it to the selected images. If you then add another keyword, Bridge will write both keywords to the images it hasn't yet touched, but then it has to go back and add the second keyword to the images it had already processed.

All the work you do in Bridge is aimed at setting up things to produce converted versions of your chosen raw images, with the correct Camera Raw settings to get the tone and color you want, and including all the metadata you've entered. So let's look at this stage of the workflow: actually converting your raw images.

THE PRODUCTION PHASE

When it comes to efficiency in converting raw images, automation is the key. An efficient workflow almost always converts raw images in batches using actions or scripts rather than you simply opening them in Photoshop. Final deliverable images nearly always require some handwork in Photoshop. For the intermediate phases, however, we often save images directly out of Camera Raw, use Bridge's Batch function to call Photoshop, or use Image Processor if we need both a JPEG and a TIFF version of the images.

Even when we anticipate significant handwork in Photoshop, we try to work as efficiently as possible. In worst-case scenarios, such as when you need to stack multiple renderings of the same image, there are more and less efficient ways to do the job. We'll discuss the various built-in automation features in detail in Chapter 9, *Exploiting Automation*, but here's the strategic overview.

Background Processing

One of the most useful additions to the raw workflow toolkit is the capability of Camera Raw to save images in the background, hosted either by Photoshop or Bridge—see Figure 4-34 in Chapter 4, *Camera Raw Controls*. We use background saving for two distinct purposes:

- When we've completed our initial rough edits, metadata addition, and keywording, we open the whole folder in Camera Raw, select all the images, click Save x Images, and save them as DNG using the Compressed (Lossless) option, with Full Size JPEG preview. We save the DNGs to a new folder, and then either discard the proprietary raw files or run them through the DNG Converter application to create DNG files with the original raw files embedded as archives.

 In both cases, all the metadata, including Camera Raw settings, and any keywords applied are written into the DNG files, so we no longer need to worry about sidecar files. The choice of which application hosts Camera Raw for background saving depends entirely on how many images need to be processed: if you have fewer than a couple of hundred, you can use either, but if you have several hundred, use Bridge.

- When we need to save a bunch of JPEGs or, less commonly, TIFFs without running any actions on them, we change the file format in Camera Raw's Save Options dialog box to the one we need and save the files in the background. Again, the choice of which application hosts Camera Raw's background saving depends on what we want to do during the save process.

Bear in mind that when Camera Raw is tied up saving in one application, it's still available for use in the other.

Automated Conversions

Background saving is useful when you've done everything the image needs in Camera Raw, but Camera Raw can't do everything you may need to do for most images. For example, we always sharpen in Photoshop using PhotoKit Sharpener, and often perform selective corrections to parts of the image in Photoshop, which Camera Raw simply can't do. But when doing so, we don't open the image in Photoshop and start editing. Instead, we use one of the options on Bridge's Tools > Photoshop menu to do as much of

the work as possible. We'll discuss these in much greater detail in Chapter 9, *Exploiting Automation*, but for now, here's the 30,000-foot overview.

Batch. This is the Big Daddy of all the automation features, and is capable of doing just about anything that Photoshop can be made to do. To run Batch using selected images in Bridge as the source, you *must* invoke Batch from Bridge's Tools > Photoshop menu. If you try to launch Batch from Photoshop, you'll find that Bridge is grayed out as a source. The basic idea is that Batch takes selected images in Bridge as its source and opens them in Photoshop using the Camera Raw settings for each image. Then it runs an action on the images in Photoshop, and either leaves them open in Photoshop, saves them in a destination folder (optionally renaming them in the process), or, a potential big hurt-me button, saves and closes the files in place.

Most raw files are read-only in that Photoshop can't write the raw formats, but some cameras create their raw files as TIFF. If you have one of these cameras, avoid Save and Close like the plague, because it will overwrite your raw originals with the processed versions!

PDF Output. This option, new to CS4, lets you create a slide show in PDF format or a multipage PDF with one image per page. For the slide show, you can specify how long each image stays on screen and choose a transition, but you can't add captions or copyright notices. It's quick and easy, but limited. The PDF Output option lets you build a contact sheet. You can specify a page size, select how many images appear per page, choose whether to preserve rotation or orient all images the same way for best fit, and choose whether or not to include filenames as captions, with the choice of font and size.

Image Processor. This option lets you save up to three versions of the selected images, a JPEG, a TIFF, and a Photoshop file, each in its own folder. You can resize the image independently for each format, run an action on the images, and embed a copyright notice (though in our opinion, you should already have done so long before you launched Image Processor). Image Processor is the easiest way to save a low-res JPEG and a high-res TIFF in the same operation.

You can customize the layout and add captions—automated options are any one of filename, copyright notice, description, credit, or title, all picked up from the IPTC metadata, or a custom text string. This is a surprisingly deep little feature.

Web Output. This option is like a contact sheet for the Web, but since it's a digital contact sheet, it offers the option of including feedback links. This feature has surprising depths, which we'll look at in detail in Chapter 9.

All the work you do in Bridge forms the foundation for future automation. Images are converted using the right Camera Raw settings at the correct orientation, and the converted images contain all the metadata you attached to the original raws. Since this work is so important, you should understand how it gets saved and stored, and that means knowing a little about Bridge's cache.

Sample Production Workflow

To demonstrate a sample workflow, we'll describe the workflow Jeff used to deal with all of the images captured on his motorcycle trip–almost 4,500 shots–and reduce the edit to under 150 final selected images for posting to the Web.

Jeff used the Bridge filter to review only shots taken with his Digital Rebel Canon camera. That eliminated nearly 1,400 captures. He then went through the images to rank the select edit–3 stars for the images–and used a variety of methods to adjust the images. The methods employed Camera Raw presets, copy and paste, and multiple images in Camera Raw. Jeff then processed the final tally of 135 images (see Figure 7-22) using Image Processor called from Bridge.

Figure 7-22 The final 135 images selected prior to calling Image Processor.

The images were processed using Image Processor (Figure 7-23) to produce 16-bit TIFF images that Jeff then manually arranged to better tell the story. The intent was to tell the story of the trip. Figure 7-24 shows dragging an image, ironically the UNSTOPPABLE image (which turned out not to be a poor choice of name) to explain a bike breakdown on the side of the road in Iowa. The bike was fixed in 4 hours and Jeff was still able to ride 550 miles that day. To make sure the order would be locked in, the images were renamed after all of the arrangement was finished.

Figure 7-23 The settings used for Image Processor, Jeff only wanted to work with 16-bit TIFFs.

Images being arranged manually

Batch Rename for the CA-Trip naming

Figure 7-24 Arranging the order and renaming the images.

Once the images were renamed, Jeff used the new Bridge CS4 Web Output feature and selected the Lightroom Flash Gallery template (see Figure 7-25). A screenshot of the final gallery in a Web browser is also shown. If you want to see the resulting Web gallery, visit the RealWorldCameraRaw.com Web site.

Figure 7-25 The final output.

Web output in Bridge

The final Web page

The trip also included a stop by the Peachpit Press office in Berkeley, California. Jeff was welcomed by Publisher Nancy Aldrich-Ruenzel and Lisa Brazieal, the production editor for this book and also a motorcyclist. Rebecca Gulick, the project editor on this book, was also present (see the shot of the three—that's Nancy on the left, Rebecca center, and Lisa in leathers on the right). Peachpit arranged a breakfast welcome for a visiting book author (usually a lunch but Lisa and Jeff had to leave on the ride together so it was still early in the day).

Lisa and Jeff hooked up with a fellow rider Mike "Catfish" Chaplin, who served as a guide for the ride across the central valley and up into the Sierra Nevada Mountains. Lisa, Mike, and Jeff had dinner (where Lisa toasted Bruce Fraser), and then Mike and Lisa went West to go home while Jeff went East to Carson City, Nevada, for the night. Figure 7-26 shows a contact sheet of the thumbnails Jeff shot that day.

Figure 7-26 The 30 shots from the day Lisa and Jeff rode together.

Tethered Shooting

We've hesitated to include this because we don't claim to have tested the process with a large number of cameras, and it's not a workflow that's sanctioned by any of the vendors involved. But if you wish Camera Raw offered tethered shooting, you may want to give this a try:

- Use your camera vendor's software to control the camera.

- Set it up to shoot to a folder on your hard drive.

- Point Bridge at that hard drive.

In theory, this should work. In practice, it *has* worked with our (Canon) cameras, but comes with no warranties, expressed or implied. It doesn't take long to determine whether it works with your camera. When it does, you can open the image in Camera Raw without even waiting for Bridge to read the thumbnail—as soon as the icon appears, you can open the image.

POSTPRODUCTION

Once you're done with the immediate processing and consumption (printing, delivery to clients, and so forth), you might think your job is done. Nope, far from it! You still need to deal with all of your original and processed files. The better organized you are at this stage, the greater the likelihood you'll be able to find your images when you need them in the future (and you will need them in the future).

Archiving Images

You've heard of photographers who don't bother to archive their raw images once they've processed them to gamma-corrected color ones. That seems about as sensible as throwing out all your negatives because you've made prints that you like! Given the huge amount of processing that goes into converting a digital raw capture and the fact that the techniques for doing said conversions are only likely to get better, it seems extraordinarily short-sighted at best not to archive your raw captures. The issues then become when, in what form, and on what media you archive them.

When to archive. When you first copy the raw images to the computer, you should almost always copy them to two different drives. One copy becomes your working copy; the other serves immediately as a short-term backup and then, after conversion to DNG with the original raw file embedded, as a long-term archive.

Once you're done with selecting, sorting, ranking, and renaming, and you've applied initial Camera Raw edits and saved the files in DNG format to bind the metadata, you archive these too. Yes, it makes for a heavy storage requirement, but storage space is relatively inexpensive, while time is expensive and images are irreplaceable.

What to archive. You should archive anything that you or someone else may need to retrieve at some time in the future. It's really that simple.

Don't confuse archives and backups. Backups are usually short-term insurance. Archives are long-term storage, designed to remain undisturbed unless and until the data is required. An archive isn't a substitute for backups, and backing up isn't a substitute for archiving!

Archive media. Strictly speaking, there's no such thing as an archival medium for digital storage—any of the even slightly convenient solutions available for recording ones and zeroes will degrade over time. Archives must be maintained!

There are really two problems in archival storage. The obvious one is the integrity of the storage medium. The less obvious but equally critical one is the availability of devices that can read the storage medium. There's probably still magnetic tape from 1970s mainframes that has good data on it, but good luck finding a drive that can read it.

Any archiving strategy *must* include periodic migration of the data onto new media, preferably taking advantage of improvements in technology. Bruce had migrated most of his early-'90s CD-ROMs onto either DVD-Rs or to large-capacity hard disks. Jeff used to use tape storage (and has a collection of drives to try accessing the tapes when needed) but has switched to online hard drive storage with mirrored arrays for digital captures. And unless something better comes along you'll probably need to constantly refresh that data onto the even larger, faster, and cheaper hard drives that will be available in the future with capacities measured in terabytes or petabytes (1,024 terabytes) rather than gigabytes.

One word of caution for those buying terabyte drives: make sure you understand the implications. Many less expensive drives measured in terabytes are actually two or more drives in a striped RAID configuration that show up as single large volumes. If one of those drives fail, the entire volume is toast.

Also a word of caution about NAS (Network Attached Storage): while often set up with a robust RAID 5 redundant array, NAS drives are actually mini-servers often running an embedded Windows OS. Not all offer AFP (Apple File Protocol) for Macs, and you'll need a well-setup and well-maintained gigabit network to use them reliably. That said, they often offer the best gigabyte/buck quotient with reliable and reasonably fast I/O.

Burnable CDs and DVDs, both read-only and rewritable, differ from com-mercially pressed CDs and DVDs in an important way. In the com-mercially manufactured disks, the data is stamped on a foil layer made of metal. (It's about the same thickness as the foil in a cigarette pack, but it's metal nonetheless.) Burnable CDs and DVDs use a photosensitive dye layer to record the data—the dye changes color when the laser writes to it. Photographers should be well aware of the fragility of dyes. So use whatever storage medium you find convenient, but recognize that it *will* fail, and plan accordingly.

At this point in time, we wish we could give you a magic bullet solution to long-term archiving of digital captures but there's simply no real good solution right now. For archiving we recommend keeping multiple copies of important work on multiple drives in, ideally, multiple locations.

Whether you use local internal or external hard drives, RAID 5 NAS, or dedicated servers, the rule is the same: have a lot of copies in case something dies. It's not a question of if it'll die, but when.

Delivering Images

How and in what media you deliver, print, or post images to Web sites is beyond the scope of this book other than to explain its role in your overall workflow. Jeff would like to make one strong suggestion after years of working with commercial clients: even if time dictates that you FTP or otherwise transmit your images electronically, you would do well to make the delivery of CD or DVD copies of your prepared images as the final contractual deliverable for jobs.

Why? Well, once you burn a CD or DVD, it's read-only media, so if somebody else screws up your image downstream of delivery, you can always point to those unchangeable files on the CD or DVD as proof of the condition of the image when delivered.

It's also becoming far more commonplace for photographers to be asked for copies of the original "raw files" for purposes of verification and provenance of the digital imaging applied to your delivered images. For this purpose, DNG is starting to become an important file format for final delivery in any photographic field, such as journalism or science, that needs proof of what you've done to your images.

With the advent of far more advanced tools in the Camera Raw arsenal, it's now possible to deliver tone-adjusted, color-corrected, cropped, and even spot-healed images that anybody with Camera Raw can look at to verify what has been done to the image. And all the image settings and other embedded metadata makes this a lot safer to do because it's all contained in one package. While still somewhat limited in retouching, many users of Camera Raw 5 need far less of Photoshop than they used to. DNG allows you to put your "stamp" on the image in terms of looks, rendering, and even the literal "stamp" of your name and contact information.

MAKE THE WORK FLOW

Bridge is a deep, complex, and very powerful tool that puts you in charge of an even deeper, more complex, and more powerful workflow system. Bridge lets you do many things once, and once only, so that you don't need to keep doing them over and over again, whether it's applying Camera Raw settings, entering copyright notices, or rotating and cropping images. The time you spend in Bridge will be amply repaid further down the line.

You can make the work flow even faster if you plan it. Bridge lets you carry out operations in any order you choose, but the most efficient way is to proceed from the general to the specific, starting with the operations that every image needs (such as a copyright notice) and continuing with the more individualized and specific needs of progressively smaller numbers of images.

For some things, such as entering descriptions or captions, you'll have to work image by image, and you'll almost certainly want to fine-tune the Camera Raw settings for your hero images on an individual basis. But you probably don't need to hand-tune every single image that you shoot. Instead, use Bridge to whittle down the large collection of raws to the images that truly deserve individual attention, and save the handwork for those.

CHAPTER EIGHT

Mastering Metadata

THE SMARTER IMAGE

Metadata, which literally means "data about data," isn't a new idea by any means. Library catalogs are good examples of long-established metadata systems—the data is what lies between the covers of the book, while the metadata includes information *about* the book—who wrote it, who published it, when both parties did so, what it's about, and where in the library it's located, for starters.

Metadata isn't new to photography either. Photojournalists have long relied on the metadata properties specified by the IPTC (International Press Telecommunications Council) to make sure that their images get delivered correctly with the appropriate photo credit and photo caption. But three factors are bringing metadata to the front burner for all photographers, not just photojournalists:

- Digital cameras embed a wealth of useful metadata right in the raw file.

- Adobe is in the process of using its considerable clout to promote XMP (Extensible Metadata Platform) as a documented, open, extensible standard for creating, storing, and sharing metadata.

- Digital photographers are drowning in digital captures and need a way to organize, search, and track them efficiently rather than just shove them in a digital shoe box.

Digital captures are already rich in metadata straight out of the camera, but one of the problems that has plagued early adopters has been a plethora of proprietary and often incompatible methods of writing and storing metadata. This is an ongoing battle.

The EXIF (Exchangeable Image File Format) "standard," for example, is sufficiently vague that the exchangeability pretty much applies exclusively to JPEGs. Camera vendors are allowed a great deal of freedom (the phrase "too much freedom" may apply here) to use private proprietary fields in EXIF to encode important information.

Moreover, the EXIF standard contains quite a few redundancies: Exposure-Time and ShutterSpeedValue tags both record the same information but use different encodings, as do the FNumber and ApertureValue tags. Some vendors use one, some use the other, entirely at their own whim—in short, the EXIF standard is a textbook example of what happens when a group of vendors whose sole aim in life is to compete with one another get together to make a standard.

Bridge's Metadata panel tries to protect you from the EXIF mayhem by always reporting values consistently—for example, it always reports an Exposure value as shutter speed and aperture setting. If you need to see the original EXIF data, or if you're simply wondering why some other image browser doesn't report things in exactly the same way, you can see the original untranslated EXIF data by choosing File Info from either Bridge's or Photoshop's File menu, then clicking Advanced and opening the EXIF properties list—see Figure 8-1.

Figure 8-1
Metadata mayhem.

Bridge's Metadata panel translates the raw EXIF metadata into a friendly, useful format.

File Info's EXIF properties list in the Advanced panel shows the raw EXIF metadata.

The Metadata Placard Magic Decoder Ring

The Metadata placard, that camera-looking thing at the top of the Metadata panel, uses icons similar to what you might see on a camera LCD to show you information. The following tables provide a legend for the White Balance and the Meter Mode icons.

Table 8-1 White Balance Icon Legend.

White Balance	Icon	White Balance	Icon
As Shot	[icon]	Tungsten	[icon]
Auto	[AWB]	Fluorescent	[icon]
Daylight	[icon]	Flash	[icon]
Cloudy	[icon]	Custom	[icon]
Shade	[icon]		

Table 8-2 Meter Mode Icon Legend.

EXIF Tag	Canon	Nikon	Olympus	Generic
0	[icon] = Unknown	[icon] = Unknown	[icon] = Unknown	[icon] = Unknown
1	N/A	N/A	N/A	Average
2	[icon] = Center Weighted Average	[icon] = Center Weight	[icon] = Center Weight	[icon] = Center Weighted Average
3	[icon] = Spot	[icon] = Spot	[icon] = Spot	[icon] = Spot
4	[icon] = Multi-spot	N/A	N/A	[icon] = Multi-spot
5	[icon] = Evaluative	[icon] = Matrix	[ESP] = Digital ESP	[icon] = Pattern
6	[icon] = Partial	N/A	N/A	[icon] = Partial
255	[icon] = Other	[icon] – Other	[icon] = Other	[icon] = Other

The intent here isn't to beat up on the camera vendors (well, not much), but rather to demonstrate just how badly we need a standard framework for handling metadata as well as pixel data. That's why XMP is so important to the future not only of photography, but of all the enterprises that consume photography: XMP is to metadata what DNG is to raw pixel data—a great idea waiting to happen. Until such time as XMP (or some other standard that's *really* standardized) comes into play, we're all pioneers, and recognizable as such by the collection of arrows protruding from our backs!

WHAT IS XMP, AND WHY SHOULD I CARE?

XMP is an Adobe initiative to promote a standard for metadata, but it's not a proprietary initiative. Instead, it's an open standard, it's documented, it's extensible, and it's even somewhat readable by humans. It is, in fact, a subset of XML (Extensible Markup Language) in combination with RDF (Resource Description Framework), which is in turn a subset of SGML (Standard Generalized Markup Language), the international standard metalanguage for text markup systems recorded in ISO 8879. One might say that XMP is the "alphabet soup" of metadata.

If you want to delve deeply into XMP, we suggest you start by looking at the available documentation. You can find several useful documents at www.adobe.com/products/xmp/ (this is XMP's home product page—look to the right for the Downloads and Custom File Info panels).

We're not going to teach you how to write XML code from scratch in this chapter (it's a bit more difficult than writing actions, but a good bit easier than writing JavaScripts), but we *will* show you what XMP metadata looks like and explore some of the ways in which you can work with it.

Growing Pains

Because XMP is still relatively new (introduced by Adobe in April 2001) and not yet completely adopted industry wide, you'll almost certainly encounter some growing pains if you try to work with a mixture of applications, some that fully support XMP, and others that as yet do not. There are two things you can do to lessen, if not eliminate, the pain:

- Ask the vendors of those applications that don't yet support XMP to do so.

- Learn how Photoshop and other Adobe and non-Adobe applications use XMP to record metadata, and find out just which files contain which pieces of information.

The first is up to you. The second is the core topic of this chapter. The metadata that you enter in Bridge for your digital capture files will persist through all the converted images that you create from the original files unless you take deliberate steps to remove it. This is mostly a huge advantage to photographers—you can enter the information once, for the original file, and know that it will be present in all the derivatives that you create from that file, not as a sidecar file (those are only necessary with read-only raws) but embedded directly in the .dng, .tif, .psd, .jpg, or .eps image file.

You know that your copyright notice will be embedded in the image and, even better, you know that if you deliver the image on read-only media like CD or DVD, you can prove willful violation of the Digital Millennium Copyright Act of 1998 should someone else remove it. This will become even more important if the U.S. Congress (or other governments outside the United States) moves forward with changes to the U.S. Copyright statutes relating to "Orphan Works." Copyrighted works where no author can be found may become Orphan Works that reduce author protections.

However, you may not always want to provide your clients with all that metadata. Some benighted souls still have attitude when it comes to digital capture: it's doubtful that they could identify the source of the image from the pixels, but they can do so easily from the metadata.

_MG_5589.dng

Raw file icon

Metadata may seem mysterious at first, but with only minimal effort you can gain a great deal more control over it. And if you're willing to do some serious heavy lifting, you can accomplish magic!

XMP Is Text

The first important thing to learn is that sidecar .xmp files are simply text files, readable by any text editor or word processor, that conform to a specific syntax and that are saved with an .xmp extension. So it's easy to read and, if necessary, edit XMP metadata. Figure 8-2 shows a raw file (with an OS X icon preview) and an .xmp file with matching names. The .xmp file is considered a sidecar file; in Bridge, if you rename or move the raw file, the

_MG_5589.xmp

Sidecar .xmp file icon

Figure 8-2
Raw file and sidecar file.

TIP Forcing an XMP File for a DNG File. Normally, a DNG file would not have a sidecar file. To write a sidecar .xmp file for a DNG, first select the image in Bridge. In the File Info panel, select the Advanced tab; then click Save. This will allow you to save a sidecar file that you can open or edit in a text reader. Remember this tip when you need to see the embedded metadata in a DNG file. One of DNG's benefits is that you don't have to worry about sidecar files unless you want a peek inside.

.xmp file gets renamed or moved as well. Separating the raw file from the .xmp file from the Finder, however, will disassociate the metadata from the raw file, so avoid doing this.

The second important thing to learn is how the user interface in Camera Raw and Bridge relates to the .xmp files that are stored in various locations on your computer. When you apply keywords or copyright notices, where does that data actually get stored? The answers may surprise you, but if you're at all curious, it's highly instructive to take a peek inside a sidecar .xmp file and examine the saved Camera Raw Settings and various other metadata with a text editor.

For the truly motivated, the third lesson involves the things you can do by customizing .xmp files. If you're really gung-ho, you can actually use XMP to make your own Custom File Info panels. The IPTC schema, for example, was very much tailored to the needs of editorial shooters in its beginning. You can use Custom File Info panels to make it easy to add metadata to your images that more closely suits your needs (although the procedure for doing so in CS4 has become complicated).

XMP UNCOVERED

Thus far, the discussion has been a little abstract. Now we'll bring things down to earth and look at some actual XMP metadata, starting with a sidecar .xmp file.

Figure 8-3 shows Bruce's *Hamish* image, and Figure 8-4 shows what its accompanying sidecar .xmp file looks like when it's opened in a text editor.

Figure 8-3 Bruce's *Hamish* image.

Figure 8-4 The sidecar .xmp file opened in a text editor.

At first glance, the metadata file may seem overwhelming, but once you break it down into its various components, things start to make more sense. We'll walk you through the different chunks of text in the sidecar file and show you the corresponding elements in Bridge's File Info panel so you see the relationship between the two.

Sidecar .xmp Decoded

The first few lines say that this is an .xmp metadata document, identified by means of a *namespace*. A namespace is the decoder for a particular XMP *schema*, which is the collection of properties the document deals with. Namespaces avoid conflicts between properties with the same name but different meanings in different schemas. For example, the Creator property in one schema may be the human who created a resource, while in another it refers to the application used to create the resource.

Schema names look like URLs, but they're actually URIs—Uniform Resource Indicators—that may or may not point to a Web page. The second chunk of text, shown in Figure 8-5, contains the Camera Raw settings.

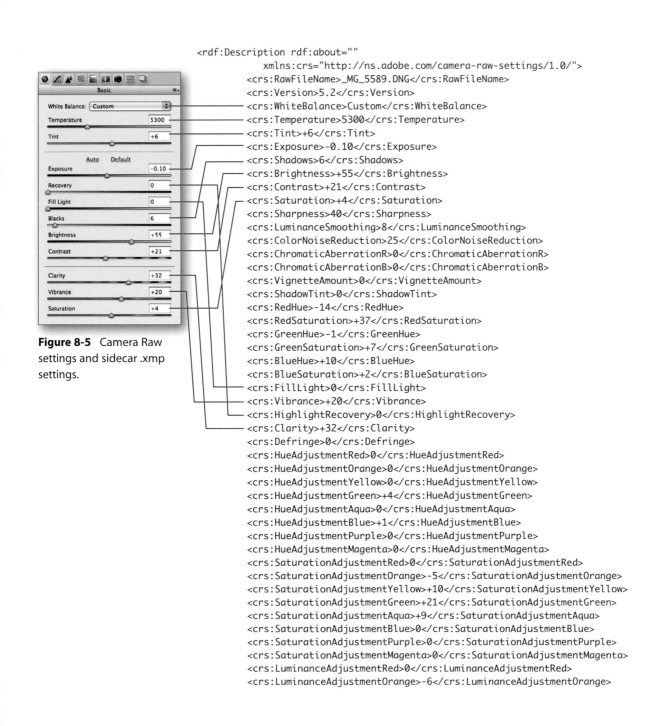

Figure 8-5 Camera Raw settings and sidecar .xmp settings.

```
<rdf:Description rdf:about=""
        xmlns:crs="http://ns.adobe.com/camera-raw-settings/1.0/">
<crs:RawFileName>_MG_5589.DNG</crs:RawFileName>
<crs:Version>5.2</crs:Version>
<crs:WhiteBalance>Custom</crs:WhiteBalance>
<crs:Temperature>5300</crs:Temperature>
<crs:Tint>+6</crs:Tint>
<crs:Exposure>-0.10</crs:Exposure>
<crs:Shadows>6</crs:Shadows>
<crs:Brightness>+55</crs:Brightness>
<crs:Contrast>+21</crs:Contrast>
<crs:Saturation>+4</crs:Saturation>
<crs:Sharpness>40</crs:Sharpness>
<crs:LuminanceSmoothing>8</crs:LuminanceSmoothing>
<crs:ColorNoiseReduction>25</crs:ColorNoiseReduction>
<crs:ChromaticAberrationR>0</crs:ChromaticAberrationR>
<crs:ChromaticAberrationB>0</crs:ChromaticAberrationB>
<crs:VignetteAmount>0</crs:VignetteAmount>
<crs:ShadowTint>0</crs:ShadowTint>
<crs:RedHue>-14</crs:RedHue>
<crs:RedSaturation>+37</crs:RedSaturation>
<crs:GreenHue>-1</crs:GreenHue>
<crs:GreenSaturation>+7</crs:GreenSaturation>
<crs:BlueHue>+10</crs:BlueHue>
<crs:BlueSaturation>+2</crs:BlueSaturation>
<crs:FillLight>0</crs:FillLight>
<crs:Vibrance>+20</crs:Vibrance>
<crs:HighlightRecovery>0</crs:HighlightRecovery>
<crs:Clarity>+32</crs:Clarity>
<crs:Defringe>0</crs:Defringe>
<crs:HueAdjustmentRed>0</crs:HueAdjustmentRed>
<crs:HueAdjustmentOrange>0</crs:HueAdjustmentOrange>
<crs:HueAdjustmentYellow>0</crs:HueAdjustmentYellow>
<crs:HueAdjustmentGreen>+4</crs:HueAdjustmentGreen>
<crs:HueAdjustmentAqua>0</crs:HueAdjustmentAqua>
<crs:HueAdjustmentBlue>+1</crs:HueAdjustmentBlue>
<crs:HueAdjustmentPurple>0</crs:HueAdjustmentPurple>
<crs:HueAdjustmentMagenta>0</crs:HueAdjustmentMagenta>
<crs:SaturationAdjustmentRed>0</crs:SaturationAdjustmentRed>
<crs:SaturationAdjustmentOrange>-5</crs:SaturationAdjustmentOrange>
<crs:SaturationAdjustmentYellow>+10</crs:SaturationAdjustmentYellow>
<crs:SaturationAdjustmentGreen>+21</crs:SaturationAdjustmentGreen>
<crs:SaturationAdjustmentAqua>+9</crs:SaturationAdjustmentAqua>
<crs:SaturationAdjustmentBlue>0</crs:SaturationAdjustmentBlue>
<crs:SaturationAdjustmentPurple>0</crs:SaturationAdjustmentPurple>
<crs:SaturationAdjustmentMagenta>0</crs:SaturationAdjustmentMagenta>
<crs:LuminanceAdjustmentRed>0</crs:LuminanceAdjustmentRed>
<crs:LuminanceAdjustmentOrange>-6</crs:LuminanceAdjustmentOrange>
```

```
        <crs:LuminanceAdjustmentYellow>+6</crs:LuminanceAdjustmentYellow>
        <crs:LuminanceAdjustmentGreen>-23</crs:LuminanceAdjustmentGreen>
        <crs:LuminanceAdjustmentAqua>0</crs:LuminanceAdjustmentAqua>
        <crs:LuminanceAdjustmentBlue>0</crs:LuminanceAdjustmentBlue>
        <crs:LuminanceAdjustmentPurple>0</crs:LuminanceAdjustmentPurple>
        <crs:LuminanceAdjustmentMagenta>0</crs:LuminanceAdjustmentMagenta>
        <crs:SplitToningShadowHue>0</crs:SplitToningShadowHue>
        <crs:SplitToningShadowSaturation>0</crs:SplitToningShadowSaturation>
        <crs:SplitToningHighlightHue>207</crs:SplitToningHighlightHue>
        <crs:SplitToningHighlightSaturation>9</crs:
SplitToningHighlightSaturation>
        <crs:SplitToningBalance>0</crs:SplitToningBalance>
        <crs:ParametricShadows>-43</crs:ParametricShadows>
        <crs:ParametricDarks>-25</crs:ParametricDarks>
        <crs:ParametricLights>+3</crs:ParametricLights>
        <crs:ParametricHighlights>+17</crs:ParametricHighlights>
        <crs:ParametricShadowSplit>25</crs:ParametricShadowSplit>
        <crs:ParametricMidtoneSplit>50</crs:ParametricMidtoneSplit>
        <crs:ParametricHighlightSplit>75</crs:ParametricHighlightSplit>
        <crs:SharpenRadius>+0.8</crs:SharpenRadius>
        <crs:SharpenDetail>50</crs:SharpenDetail>
        <crs:SharpenEdgeMasking>25</crs:SharpenEdgeMasking>
        <crs:PostCropVignetteAmount>0</crs:PostCropVignetteAmount>
        <crs:ConvertToGrayscale>False</crs:ConvertToGrayscale>
        <crs:ToneCurveName>Medium Contrast</crs:ToneCurveName>
        <crs:CameraProfile>ACR 2.4</crs:CameraProfile>
        <crs:CameraProfileDigest>E4380867144284BB740715E697F42EB3</crs:
CameraProfileDigest>
        <crs:HasSettings>True</crs:HasSettings>
        <crs:HasCrop>False</crs:HasCrop>
        <crs:AlreadyApplied>False</crs:AlreadyApplied>
        <crs:ToneCurve>
          <rdf:Seq>
            <rdf:li>0, 0</rdf:li>
            <rdf:li>32, 22</rdf:li>
            <rdf:li>64, 56</rdf:li>
            <rdf:li>128, 128</rdf:li>
            <rdf:li>192, 196</rdf:li>
            <rdf:li>255, 255</rdf:li>
          </rdf:Seq>
        </crs:ToneCurve>
```

This chunk of text is what Photoshop and Bridge use to keep track of the custom settings for each raw image. It contains the image's Camera Raw settings in a somewhat legible form. As more parameters are added to Camera Raw's capabilities, this list grows.

New to Camera Raw 5 are three new parameters: the Adjustment Brush, the Graduated Filter, and Snapshots. Figure 8-6 shows the Camera Raw dialog box with the matching properties from the File Info dialog box.

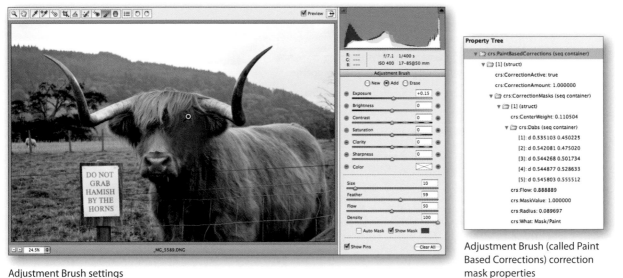

Adjustment Brush settings

Adjustment Brush (called Paint Based Corrections) correction mask properties

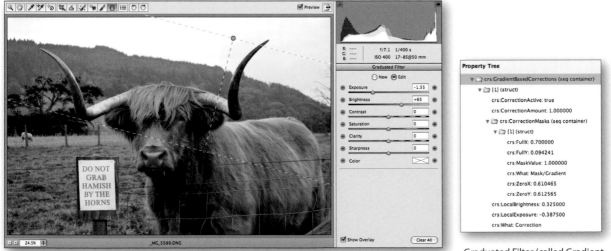

Graduated Filter settings

Graduated Filter (called Gradient Based Corrections) properties

Figure 8-6 Camera Raw 5 metadata properties.

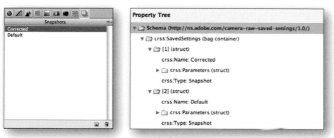

Snapshot panel Snapshot (called Saved Settings) properties

The next two chunks of text (Figure 8-7) hold the EXIF data from the raw file. They correspond to the first and second entries you see in the Advanced panel of File Info—EXIF Properties, and the auxiliary EXIF data protocol described in http://ns.adobe.com/exif/1.0/aux.

Figure 8-7 EXIF data.

 TIP You can't strip EXIF metadata from a raw file, but if you don't want EXIF data in your final file, simply copy the image pixels in Photoshop, then paste them into a new document. This strips all metadata, not just EXIF, so make sure you add back any metadata you want to preserve in the delivered image.

```
<rdf:Description rdf:about=""
        xmlns:exif="http://ns.adobe.com/exif/1.0/">
    <exif:ExposureTime>1/400</exif:ExposureTime>
    <exif:ShutterSpeedValue>8643856/1000000</exif:ShutterSpeedValue>
    <exif:FNumber>71/10</exif:FNumber>
    <exif:ApertureValue>5655638/1000000</exif:ApertureValue>
    <exif:ExposureProgram>1</exif:ExposureProgram>
    <exif:DateTimeOriginal>2005-08-04T03:05:20-07:00</
exif:DateTimeOriginal>
    <exif:ExposureBiasValue>0/1</exif:ExposureBiasValue>
    <exif:MeteringMode>5</exif:MeteringMode>
    <exif:FocalLength>50/1</exif:FocalLength>
    <exif:ExifVersion>0221</exif:ExifVersion>
    <exif:MaxApertureValue>496875/100000</exif:MaxApertureValue>
    <exif:ISOSpeedRatings>
        <rdf:Seq>
            <rdf:li>400</rdf:li>
        </rdf:Seq>
    </exif:ISOSpeedRatings>
    <exif:Flash rdf:parseType="Resource">
        <exif:Fired>False</exif:Fired>
        <exif:Return>0</exif:Return>
        <exif:Mode>2</exif:Mode>
        <exif:Function>False</exif:Function>
        <exif:RedEyeMode>False</exif:RedEyeMode>
    </exif:Flash>
</rdf:Description>
<rdf:Description rdf:about=""
        xmlns:aux="http://ns.adobe.com/exif/1.0/aux/">
    <aux:SerialNumber>620428392</aux:SerialNumber>
    <aux:Lens>17.0-85.0 mm</aux:Lens>
    <aux:LensInfo>17/1 85/1 0/0 0/0</aux:LensInfo>
    <aux:ImageNumber>213</aux:ImageNumber>
    <aux:FlashCompensation>0/1</aux:FlashCompensation>
    <aux:OwnerName>Bruce Fraser</aux:OwnerName>
    <aux:Firmware>1.1.0</aux:Firmware>
</rdf:Description>
```

TIP When Jeff was preparing Bruce's Hamish image for the book, he had Photoshop CS4's History Logging option turned on. In Figure 8-8 the History tab of File Info shows exactly what Jeff did to the image to prepare it for reproduction in this book. Jeff resized the image and sharpened the output before converting the image to CMYK. With Photoshop's Logging option set to Detailed, everything shows up in the History metadata.

EXIF metadata in a raw file isn't editable by any means short of opening the raw image file with a metadata editor, which is a risky operation. If you edit the EXIF data in the sidecar file, the EXIF data baked into the raw file returns the next time you open it because the original data overwrites the edits. In principle, we are opposed to anything that would allow changing the EXIF metadata—it's an essential part of the image's provenance, and we should be able to rely on its veracity. (We can make an exception to address issues with date and time inaccuracies resulting from camera clock problems such as time zone differences.)

Next comes the Photoshop Properties section, followed by the remaining interesting and useful properties.

TIFF properties

XMP rights and info properties

Figure 8-8 Additional metadata properties.

Dublin Core Properties

Photoshop History panel

Why, you may quite reasonably ask, are we torturing you with this kind of information? Our purpose for showing you all this is twofold:

- Understanding the contents of the metadata files makes the whole process by which you enter and store metadata a great deal less mysterious.

- It's often easier to use a text editor to remove metadata selectively from images than it is to do so using Photoshop or Bridge.

FILE INFO EXPLAINED

For Photoshop CS4 and Bridge CS4, the File Info dialog box got some much needed (and perhaps overdue) attention. The interface has been changed to a Flash-based UI and additional schemas have been added along with important new functionality (see Figure 8-9).

Figure 8-9 File Info dialog box.

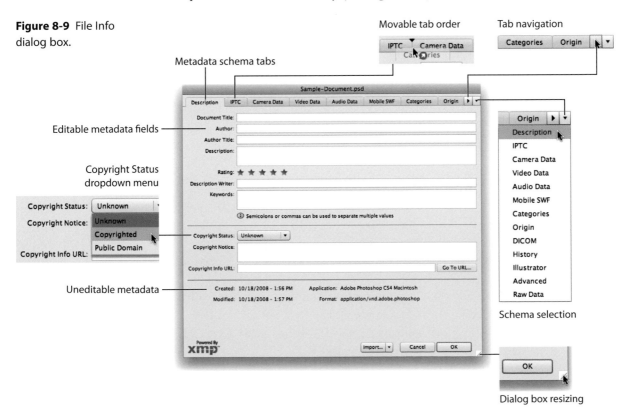

Schema Tabs. The tabs along the top of the dialog box provide access to that schema's metadata information. You click on a tab to reveal the panel's data. You can also select a schema from the dropdown menu and reorder the tabs by dragging them. The entire dialog box is now resizable—it may not seem like a big deal, but it is for the purpose of usability. Previous File Info boxes were fixed in size.

Figure 8-9 shows the File Info dialog box for the main Description schema, which includes editable fields for direct entry as well as the Copyright Status dropdown menu. Some of these fields will also be crosswalked (translated) into the IPTC panel.

Figure 8-10 shows the way Jeff prefers to keep the File Info dialog box: with the size expanded and tabs reordered.

Figure 8-10 Customized File Info dialog box.

The Advanced panel has additional viewing controls and options. Normally, the schemas are collapsed but can be expanded for viewing, as shown in Figure 8-11. When all properties are fully expanded, it's a long list and pretty tough to see and read everything. Generally you would want to view only a specific schema's set of data.

Full Advanced panel with properties collapsed

Detail with properties expanded

Figure 8-11 Advanced schema.

While the File Info dialog box has gotten much better, it's not the best place to do heavy metadata editing. Its primary purpose is for checking metadata that does not appear in the Bridge Metadata panel or for creating metadata templates to use in Bridge or when importing. While Bridge has the ability to make templates, we prefer to make them here in the File Info dialog box for one main reason: the Bridge Metadata Template maker fails to create a template that marks an image as copyrighted (a serious issue and one that the XMP engineers consider a "bug" not a "feature"). So, this next section describes how to make a good template from File Info.

METADATA TEMPLATES

Back in Chapter 6, we showed you how to save and use metadata templates. If you save and apply them through Photoshop's or Bridge's user interface, they'll work seamlessly most of the time. But if you open one of your saved metadata templates in a text editor, you may be in for a surprise at how simple it all seems.

Previous versions of Photoshop and Bridge made a mess of templates by including extraneous data and offering no easy way to edit the templates.

Photoshop CS4 and Bridge CS4's tools allow you to create, open, and edit templates, and we find the new functionality more useful than Bridge's Create Metadata Template.

Figure 8-12 shows the Description and ITPC metadata fields with the basic information filled in. (Note that we didn't put in Jeff's phone number and email address for obvious reasons, but when he sends out images to clients, those fields are indeed completed.) The Copyright Status has been marked as Copyrighted. This represents a good collection of basic information that should be filled in for every image.

Figure 8-12 Filling in a template.

The Description panel

The top of the IPTC panel

The bottom of the IPTC panel

In this case, rather than start with a raw file, Jeff simply starts with a new document he named Sample-Document. Sample-Document contains only the metadata Photoshop creates and puts into every file. We have been burned in the past (with previous versions of Photoshop and Bridge) that included, by accident, residual carryover metadata from the capture files. While the new File Info dialog box seems to have fixed that, old habits (and good habits) die hard, so here is what we do just to be sure.

Once the basic metadata is entered, select Export from the dropdown menu at the bottom of the File Info dialog box. Figure 8-13 shows the process of exporting a new template and naming it.

Figure 8-13
Exporting a template.

The Export option in the menu

Naming the template

In practice, we've found that the File Info dialog box defaults to the correct location for installation of the templates. But to be sure, click the Show Template Folder option.

Once you've saved the template, confirm that it's in the right place by checking either the File Info dropdown menu or Bridge's Metadata flyout menu, as shown in Figure 8-14.

Figure 8-14
Exported template.

The File Info dropdown menu

The Bridge metadata flyout menu

You can also load a template and make some changes and resave over the original template. Simply make the required changes and resave. You'll be prompted with a warning that the file already exists. If you are sure, go ahead and replace it. Figure 8-15 shows the warning.

Figure 8-15 Warning you'll see when overwriting a template.

In the File Info dialog box, you can also import metadata to embed, most likely from an existing template (although we don't think this is the most efficient method of doing so). Selecting Import in the menu (see Figure 8-16) will allow you to navigate to an XMP file (likely a template) and apply it to the file currently displayed in the File Info dialog box.

Figure 8-16 Selecting Import.

Three options (Figure 8-17) will appear after you select Import. Pay close attention to avoid dire consequences.

Figure 8-17 Import options.

Append (default)

Replace

Clear and replace

Clear Existing Properties and Replace with Template Properties:
Replaces all metadata in the file with the metadata in the XMP file.
This option will not impact any inherent metadata such as EXIF or
noneditable metadata.

**Keep Original Metadata, but Replace Matching Properties from
Template:** Replaces only metadata that has different properties in the
template and only those properties that match. As an example, if you have
a template that contains only a creator (to correct an improperly made
template), and the file has keyword and description information, it will
only replace the creator property.

**Keep Original Metadata, but Append Matching Properties from
Template:** The default, this option applies the template metadata only where
no metadata value or property currently exists in the file, with the exception
of "bags," or "sequential" properties, that can hold multiple values such as
keywords. This option will append the keyword to the existing entry.

Figure 8-18 shows the location where the metadata templates reside in
Mac OS X.

Figure 8-18 Metadata
Templates location in Mac
OS X.

The Show Templates command
in File Info

The actual location of the .xmp file

Mac OS: /Users/<username>/Application Data/Adobe/XMP/Metadata Templates

Windows XP: C:\Document and Settings\<username>\Application Data\ Adobe\XMP\Metadata Templates

Windows Vista: C:\Users\<username>\AppData\ Roaming\Adobe\XMP\ Metadata Templates

If you have selected a large number of raw files and opened File Info to apply a template, there will be a delay in the actual writing of the metadata to the file (if it's a DNG, TIFF, or JPEG) or to the sidecar file if it's a proprietary raw file. If you immediately open those same raw files with Camera Raw and adjust the file settings, there will be a race between File Info and Camera Raw to finish writing the metadata—and regardless of which function finishes first, you will lose.

Another potential "gotcha" is when you choose to import the template properties using the Clear Existing Properties and Replace with Template Properties option. This option is designed to wipe out existing properties and replace them with the template properties. Be aware that unintended consequences may occur.

So, for these reasons we strongly suggest that you avoid using the File Info dialog box to add templates to multiple files simultaneously. We recommend using templates from within Bridge CS4's Metadata panel or, when ingesting images, using the Adobe Photo Downloader. The Bridge Metadata panel offers only the two conservative choices of replace and append, and since it is Bridge doing the metadata updates, Camera Raw metadata updates will not conflict.

NOTE The "race to finish" issue is serious enough that it may have be addressed in future Bridge updates. We recommend that you use the File Info dialog box only for viewing or editing an individual file's metadata or for creating metadata templates. If you want to edit the metadata for multiple files at once, do so from within the Bridge CS4 Metadata panel.

CUSTOM FILE INFO PALETTES

Custom File Info palettes let you change the order of existing metadata fields or add new fields. Adding new fields is the "extensible" part of Adobe XMP. In this section we'll discuss rearranging existing fields.

The panels that appear in File Info are created by XML files and additional components. They are installed in the following locations:

Mac OS: /Users/<username>/Application Data/Adobe/ XMP/Custom File Info Panels/2.0/panels

Windows XP: C:\Document and Settings\<username>\Application Data\ Adobe\ XMP\Custom File Info Panels\2.0\panels

Windows Vista: C:\Users\<username>\AppData\ Roaming\Adobe\ XMP\ Custom File Info Panels\2.0\panels

This is not an undertaking for the casual user. The primary reason for using custom File Info panels is to simplify adding custom metadata that doesn't fit easily into the fields provided in the File Info dialog box. If you are interested in creating custom panels, we suggest looking at the XMP SDK and downloading the documentation for building custom File Info panels. At the time of this writing, no examples of third-party panels were available, so instead we show two examples provided by the XMP SDK (see Figure 8-19).

Basic Control sample panel Yahoo Search sample panel

Figure 8-19 Custom metadata panels.

The Basic Control sample panel shows translated properties from other schemas as well as the custom schema possibilities. The Yahoo Search sample shows a panel that offers the ability to do a Yahoo search on entered keywords in order to access additional information (and perhaps check spelling). In this example, Jeff entered Bruce's name to see what showed up. It seems that Yahoo associates Bruce with Camera Raw.

XMP is extensible enough that industrious individuals or groups can create new namespaces and add XMP metadata properties. One new standard for CS3 was the DICOM schema (Digital Imaging and Communications in Medicine). New ones will be included as additional standards become established. In CS4, the number of schemas has been expanded with four new additions: Video Data, Audio Data, Mobile SWF, and Illustrator. Metadata, it seems, is beginning to go mainstream.

EDITING XMP METADATA

We would be remiss if we didn't offer at least a short sample of XMP metadata editing to show how simple it can be. In this example we'll edit a preset saved in Camera Raw. The original preset deals with only one setting, Exposure, which is saved with a parameter of +25. We'll edit that in a text editor and resave it to create a new preset that changes the Exposure setting to +15 instead of +25.

Original XMP text

```
<x:xmpmeta xmlns:x="adobe:ns:meta/" x:xmptk="Adobe XMP Core 4.2-c020 1.124078,
Tue Sep 11 2007 23:21:40        ">
<rdf:RDF xmlns:rdf="http://www.w3.org/1999/02/22-rdf-syntax-ns#">
  <rdf:Description rdf:about=""
    xmlns:crs="http://ns.adobe.com/camera-raw-settings/1.0/">
   <crs:Version>4.1</crs:Version>
   <crs:Exposure>+0.25</crs:Exposure>
   <crs:HasSettings>True</crs:HasSettings>
  </rdf:Description>
 </rdf:RDF>
</x:xmpmeta>
```

XMP text that changes the Exposure value from 25 to 15

```
<x:xmpmeta xmlns:x="adobe:ns:meta/" x:xmptk="Adobe XMP Core 4.2-c020 1.124078,
Tue Sep 11 2007 23:21:40        ">
 <rdf:RDF xmlns:rdf="http://www.w3.org/1999/02/22-rdf-syntax-ns#">
  <rdf:Description rdf:about=""
    xmlns:crs="http://ns.adobe.com/camera-raw-settings/1.0/">
   <crs:Version>4.1</crs:Version>
   <crs:Exposure>+0.15</crs:Exposure>
   <crs:HasSettings>True</crs:HasSettings>
  </rdf:Description>
 </rdf:RDF>
</x:xmpmeta>
```

Figure 8-20 Camera Raw Preset editing.

The Preset panel before the .xmp edit

The Preset panel after edit and saving a new .xmp file

Remember, this is a very simple editing example (see Figure 8-20). Editing XMP metadata is not an undertaking for the casual user. The syntax is unforgiving—it's either right or it doesn't work at all—and you'll need to read and digest the documentation referenced earlier in this chapter. The primary reason we wanted to show this example is that it's often easier to use a text editor to edit settings selectively from presets than it is to do so using Photoshop or Bridge. The upside is if you do manage to mangle the preset settings, it's only a preset—which can be easily redone.

KEYWORDS AND DESCRIPTIONS

When you add keywords and descriptions to your images, you're adding tangible value to them. For some, it's merely an exercise in light-duty organization, while for others it's a matter of pure economics.

Keywords. Sometimes called tagging or metalogging, *keywording* is the practice of adding descriptive words that relate to your image for the purpose of cataloging or organizing photographs. This can be as complicated as following an exact taxonomy (classification), or it can be as simple as describing the *who, what, where, when,* or *why* and sometimes *how* of the image.

In the IPTC field for keywords, you can enter as few or as many keywords as you want. Be sure to separate multiple keywords with a colon or semi-colon. You should capitalize only those words that generally need to be, like proper nouns—keywords are case sensitive. They can consist of single or multiple words or even a short phrase, but resist the temptation to add extraneous words that don't relate directly to the image.

Be sure to list word variations and alternative spellings, such as *gray* and *grey*. Use gerunds (verbs that function as nouns) and participles rather than verbs, such as *eating* rather than *eat* or *traveling* rather than *travel*. In general, use the plural rather than the singular form of a word unless the plural spelling is different than merely adding an "s." For example, *baby* and *babies* would be appropriate.

Some keywords can be conceptual attributes, but use these selectively. When keywords such as *beautiful* or *tranquil* are used to describe a landscape, they soon lose any special meaning. Also be careful of anthropomorphizing animals—not everybody will "get it" and you might confuse someone.

Above all, be consistent in your approach and, if you are a poor speller, keep a dictionary handy. There's nothing quite so embarrassing as misspelling a keyword for the world to see. Using a "controlled vocabulary" is critical; for more information, see the Web site run by photographer David Riecks (www.controlledvocabulary.com).

Description. Captioning is the process of telling the story surrounding the photograph. Writing a good caption is a natural starting point for the addition of keywords (which will often present themselves while you're composing the captions). Here are some rules of thumb: use proper grammar and punctuation, use proper sentence structure, capitalize the first word in a sentence and proper nouns, avoid clichés like the plague, and of course, keep a dictionary handy (or bookmarked). If you know exact locations or scientific names, use them, but don't guess. Base your descriptions on solid fact, not speculation or fiction. Avoid writing a novel; the IPTC Description field is neither large enough nor intended for creative writing.

Adding keywords and captions is work. If you are doing it only for yourself, keep everything simple and add only as much as you feel necessary. But if you are engaged in licensing stock photography, using excellent keywords and descriptions means money in the bank. We offer as proof the following example from Seth Resnick, one of the most prolific stock shooters we know. While on an Antarctic photographic expedition (accompanied by his cabin mate Jeff Schewe), Seth spent his time shooting when there was light but spent the rest of his time downloading images to his computer, creating metadata templates, and adding extensive keywords and captions (see Figure 8-21).

Within ten days of his return, not only did Seth have nearly 1,000 images at various stock agencies, he already had his first sale. Seth added a total of 66 keywords for the image shown in Figure 8-21. Excessive? Not according to Seth, who explains that it takes about 40–50 keywords to properly keyword an image for stock photography searches. He also wrote an extensive description relating where the image was shot; Seth even included a reference to Sir Ernest Shackleton, who is buried just beyond where the elephant seals were lying. (Guess which keyword triggered his first sale? *Ecotourism.* It seems that several major media stories had started a buzz about tourism with an eco-friendly approach.)

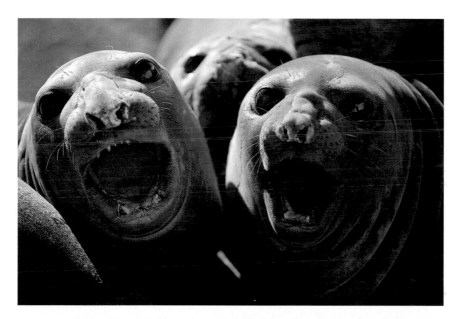

Figure 8-21 Seth Resnick's approach to keywords and descriptions.

Seth's shot of elephant seals

▼ **IPTC Core**

Seth's IPTC metadata entries

Creator	Seth Resnick
Creator: Job Title	Photographer
Creator: Address	5660 Collins Ave #17 B
Creator: City	Miami Beach
Creator: State/Province	Florida
Creator: Postal Code	33140
Creator: Country	USA
Creator: Website(s)	http://www.sethresnick.com

A large Elephant Seal growls at intruders revealing large teeth at Grytviken Whaling Station, South Georgia Island. The elephant seal is the largest seal species in the world, surpassing even the walrus in size. The males grow to 20 feet and can weigh as much as 4 tons.

The Southern Elephant Seal (Mirounga Leonina) is the largest species of seal. Both sexes have a thick layer of blubber, but the bulls have a large inflatable nose. This species spends most of their lives in the sea where they consume a diet that consists of cephalopods and fish. Elephant seals are great divers and of their time in the water 93 % is spent beneath it. the average dive duration is about 22 minutes but there is a record of an elephant seal remaining submerged for 120 minutes . They also dive to an average depth of of 1880 feet or almost 1/2 mile.

Description Grytviken Whaling Station, South Georgia Island was a large base of operations for Antarctic whaling. In the summer of of 1925 South Georgia's peak whaling year– 23 ships caught and killed 7,825 whales including 5,709 Fin and 1,855 Blue whales, to produce more than 400,000 barrels of oil. In the following year the catch included 3,689 Blue Whales. By 1930 more than 40,000 whales were slaughtered. Grytviken Whaling Station was closed in December, 1966 and is now the site of a scientific research station managed by the British Antarctic Survey.

Grytviken is also the grave site of British Antarctic explorer Sir Ernest Shackleton who died at sea off South Georga Island in January 5th, 1922. He was returned to London where his widow, Emily Dorman, requested his burial take place on Grytviken. He was returned to Grytviken and buried on March 5, 1922.

Keywords Animals; Chordata; Mammalia; Carnivora; Pinnipedia; Phocidae; Mirounga leonina; elephant seal; southern elephant seal; Seals; Antarctic; Antarctica; Grytviken Whaling Station; King Edward Cove; South Georgia Island; South Sandwich Islands; Southern hemisphere; South Atlantic Ocean; Southern Ocean; Sub–Antarctic region; belch; blubber; climate; cold; Eco tourism; Ecotourism; ecosystem; environment; environmental impact; extinction; extreme; extreme environment; eyes; face; fat; fin–foot; fin–footed; flipper; fur; gargantuan; gigantic; global warming; growl; hunted; insulation; loud; mammal; marine mammal; migrate; mouth; nose; oil; over exploitation; pink; pinniped; predator; protected; seal oil; slaughter; snort; teeth; unspoiled; untouched; virgin; water

Description Writer	Seth Resnick
Location	54° 16' 53.4" S; 36° 30' 28.8" W
Country	Overseas territory of the UK, also claimed by Argentina.
Source	Seth Resnick Photography
Copyright Notice	© 2007 Seth Resnick All Rights Reserved
Copyright Status	Copyrighted
Rights Usage Terms	No Usage Rights of Any Kind Granted Without Written Authorization From Seth Resnick

Making Images Smarter

Metadata has been around in one form or another for a long time, but in many ways it's still in its infancy. Having a standard in the form of XMP is one factor that will doubtless accelerate its evolution, and the ready availability of basic shooting parameters from the EXIF data is another.

Today, photographers can gain a considerable measure of security by knowing that their copyright and rights management notices are embedded right in the image. In the future, you can reasonably expect to see software that makes more intelligent use of metadata—automatically applying the right lens corrections based on focal length, or the right noise reduction based on ISO speed, for example. You can also look forward to seamless integration with XMP-compliant asset managers and databases. If you are interested in what the future for metadata for photographers may hold, or wish to get involved, check out the Metadata Working Group (MWG; www.metadataworkinggroup.org). The MWG formed in 2006 and is a consortium of leading companies focused on the following goals: preservation and seamless interoperability of digital image metadata and interoperability and availability to all applications, devices, and services. The MWG has published a set of technical specs that describe how to effectively store metadata into digital media files.

Images rich in keywords and descriptions add tangible value to your collections and make finding your images easy both now and in the future.

You'll doubtless encounter speed bumps along the way, but if you understand how image metadata works, you'll be in a much better position to troubleshoot any problems you encounter than those who just treat the whole thing as incomprehensible magic. We hope this chapter has provided a starting point for further metadata explorations.

CHAPTER NINE

Exploiting Automation

WORKING SMARTER, NOT HARDER

The goal of doing all the work we've discussed so far in this book is to set up your digital captures with the correct Camera Raw settings and the right metadata so that you can produce deliverable processed images with the minimum amount of effort. The minimum amount of effort, in this case, means taking full advantage of Photoshop's rich automation features, so that you can simply press a button, walk away, and let the computer do your work for you.

One of the great things about a computer is that once you've made it do something, you can make it do that something over and over again, exactly the same way, automatically, without coffee or bathroom breaks. Tapping the power of automation is key to building an efficient workflow, so in this chapter we'll show you how to leverage the work you've done in Bridge and Camera Raw to produce deliverable images in a variety of formats.

Bridge serves as command central for all the operations we'll discuss in this chapter. They all boil down to a two-step process:

- You select the images that you want to process in Bridge.

- You run one of the options from Bridge's Tools > Photoshop menu to produce converted images. (When you want to use images selected in Bridge as source, you *must* call the automations from Bridge rather than Photoshop.)

The Photoshop submenu offers a variety of useful routines for creating images in a deliverable form, but by far the most powerful and flexible is the Batch command.

BATCH PROCESSING RULES

The Batch command (which you access by choosing File > Automate in Photoshop or Tools > Photoshop > Batch in Bridge) is one of Photoshop's most powerful features. It's conceptually very simple. You point it at a batch of images, it runs an action on them, it (optionally) renames the images, and then it does one of the following:

• Saves new files

• Delivers open images in Photoshop

• Saves and closes, overwriting the source files or creating new ones

As you'll see shortly, though, the devil is in the details, and some of the details in the Batch dialog box are distinctly counterintuitive. Figure 9-1 shows the Batch dialog box before customizing any of the settings.

Figure 9-1 The Batch dialog box.

The dialog box is split into four sections, each of which controls a different aspect of the batch process's behavior:

- **Play** lets you choose an action from an action set that will be applied to all the images.

- **Source** lets you designate the source—the images on which the batch will be executed—and also lets you choose some very important options whose functionality will become apparent later.

 You can run a batch on a designated folder that you choose in the Batch dialog box by clicking the Choose button; on opened files; on images imported through the Photoshop File menu's Import command; or, when Batch is called from Bridge's Tools > Photoshop menu, on the images that are currently selected in Bridge. For processing raw images, the source will invariably be a folder or the selected images in Bridge.

- **Destination** lets you control what happens to the processed images. None delivers them as open images in Photoshop; Save and Close saves and closes the processed images; and Folder lets you designate a folder in which to save the processed images. It also includes the renaming features offered by Batch Rename.

 When you process raw images, you'll always choose either None or, much more commonly, Folder. Save and Close often ends up being a "hurt-me" button, because its normal behavior is to overwrite the source image. With raw files this is usually impossible and always undesirable. Photoshop can't overwrite files in formats it can't write, including most raw image formats, but if you use Camera Raw to process JPEG or TIFF files, there's a real danger of overwriting your original files if you choose Save and Close. So avoid it unless you are really, really sure!

- **Errors** lets you choose whether to stop the entire batch when an error is encountered or log the errors to a file. We usually stop on errors when debugging an action used in Batch and log them to a file when running a batch in a production situation. However, when processing raw files, the batch typically either works on all files or fails on all files.

The difficulties that users typically encounter in running Batch are in the way the selections in the Source and Destination sections interact with the action applied by the batch operation. Here are The Rules. (Note: These are *our* rules, and we swear by them. They don't represent the only possible

NOTE The Batch function can be opened launched by Bridge or Photoshop. However, the only way you can select images to run a batch from Bridge is if Bridge has launched the batch operation. The batch operation from Photoshop is limited to running on folders, imported images, or open files. While Bridge can communicate to Photoshop via scripts, there's no way for Photoshop to query Bridge to discover selected images.

As a result, we suggest always starting from Bridge when calling the Batch function if you need to run a batch on specific images rather than an entire folder of images.

approach, but by the time you're sufficiently skilled and knowledgeable to violate them with impunity you'll have long outgrown the need for a book like this one!)

Rules for Opening Files in a Batch Operation

To make sure that the raw files get opened and processed the way you want them in a batch operation, you need to record an Open step in the action that will be applied in Batch. In the case of raw images, you'll want to make sure that Camera Raw's Settings menu is set to Image Settings so that it applies the custom-tailored Camera Raw settings you've made for each image, and you'll also want to make sure that Camera Raw's workflow settings—Space, Bit Depth, Size, and Resolution—are manually set to produce the results you want.

Now comes one of the counterintuitive bits. If you record an Open step in the action, you must check Override Action "Open" Commands. When you select this option, you'll get a warning as shown in Figure 9-2. If you don't, the batch will simply keep opening the image you used to record the Open step in the action. Override Action "Open" Commands doesn't override everything in the recorded Open command; it just overrides the specific choice of file to open, while ensuring that the Selected Image and workflow settings get honored.

Figure 9-2 The Batch warning when selecting Override Action "Open" Commands.

TIP When you are recording an Open step, you need to open an image from within Photoshop in order for Photoshop to record the Open step. We suggest having a raw file on your desktop to use when recording this first step. Remember, this is only to record the Workflow options, not the file's name or location.

Some people find this set of behaviors so frustrating and counterintuitive that they latch onto the fact that you can run Batch using an action that doesn't contain an Open step and thus doesn't require messing around with the checkbox. The problem with doing so is that you lose control over Camera Raw's workflow settings—the batch will just use the last-used settings. So you may expect a folder full of 6,144 by 4,096-pixel images and get 1,536 by 1,024-pixel ones instead, or wind up with 8-bit sRGB instead

of 16-bit ProPhoto RGB. If you simply follow *The Rules*, you have complete control over the workflow settings—the correct ones get used automatically.

Rules for Saving Files in a Batch Operation

To make sure that the processed files get saved in the format you want, you need to record a Save step in the action that will be applied in Batch. This Save step dictates the file format (.tif, .jpg, .psd) and options that go with that format—TIFF compression options, JPEG quality settings, and so on.

Now comes the second counterintuitive bit. You must check Override Action "Save As" Commands: otherwise, the files don't get saved where you want them, with the names you want, or possibly don't get saved at all! Selecting the option will give you the warning shown in Figure 9-3. When you check Override Action "Save As" Commands, the file format and file format parameters recorded in the action's Save step are applied when saving the file, but the name and destination are overridden by the options you specified in the Batch dialog box.

Figure 9-3 The Batch warning when selecting Override Action "Save As" Commands.

Rules for Running a Batch Operation

Two other settings commonly trip people up. Unless you check Suppress File Open Options Dialogs, the Camera Raw dialog box pops up whenever the batch opens a file and waits for you to do something. Checking this option just opens the image directly, bypassing the Camera Raw dialog box. The Camera Raw settings for each image are used, but the batch operation isn't interrupted by the appearance of the dialog box.

If the workflow settings recorded in the action result in an image in a color space other than your Photoshop working space, you should also check Suppress Color Profile Warnings; otherwise, the batch may get interrupted

by the Profile Mismatch warning—the day always gets off to a bad start when you find that the batch operation you'd set up to generate 2,000 Web-ready JPEGs overnight is stalled on the first image with a warning telling you that the file is sRGB when your working space is ProPhoto RGB!

Playing by the Rules

If you follow the relatively simple set of rules we've provided, your batch operations won't fall prey to any of these ills, and they'll execute smoothly with no surprises. If you fail to do so, it's likely that your computer will labor mightily and then deliver either results that are something other than you desired or, even more frustrating, no results at all or, heaven forbid, your original files ruined!

So with The Rules in mind, let's look first at creating some actions and then at applying them through the Batch command.

RECORDING BATCH ACTIONS

Actions are incredibly powerful. They can open, save, and close new images as well as duplicate existing images. They can add or delete layers, channels, and paths, and run filters or scripts or even other actions. They can run custom processing in different color spaces such as Lab and return the results to the original image, displaying them as new layers with altered opacities or blend modes. Actions can alter Photoshop Preferences (as you will see in the first example) or call up commands from menu items or tool presets. You can even have Photoshop automatically run an action when you first launch the application or open an image. One of the few things actions can't record is the use of a painting tool; you can record selecting the tool, but then you must perform the painting manually.

Recording actions may seem intimidating at first, but automating commonly repeated tasks frees you to spend more time doing those things that only you can do—perfecting your images.

Writing actions for batch-processing raw images is relatively simple. You don't need to worry about making sure that the action can operate on files that already have layers or alpha channels, or that are in a color space other than RGB. You're always dealing with a known quantity.

Bear in mind that if your actions call other actions, the other actions must be loaded in Photoshop's Actions palette, or the calling action will fail when it can't find the action being called. An easy way to handle this is to make sure that any actions on which other actions are dependent are saved in the same set as the actions that depend on them.

We'll start out with simple examples and proceed to more complex ones.

Simple Action—Save as JPEG

We'll start with a simple action that opens a raw image at a reduced resolution, runs a Fit Image script, and saves the image as a maximum-quality JPEG in the sRGB color space.

Creating an action and action set. Start out by creating a new action set called "Batch Processing" in which to save the actions you'll create in the rest of this section. The first step is to create a new action set, which you do by opening the Actions palette, clicking the folder icon, and then entering the appropriate name in the resulting dialog box and clicking OK to dismiss it. The new set then appears in the Actions palette—see Figure 9-4.

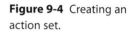

Figure 9-4 Creating an action set.

To create a new action set, click the Create New Set icon, enter a name, then click OK. The new set appears in the Actions palette.

Creating a new action. Before creating the action, select a raw image in Bridge that has already had custom Camera Raw settings applied. That way, once you've created the action, you can start recording immediately without recording any extraneous steps, such as selecting a file, and you can correctly record the Camera Raw Selected Image setting.

Click the Create New Action icon in the Actions palette (see Figure 9-5), enter the name—Save JPEG Preview—in the resulting dialog box, and then click Record to dismiss the dialog box and start recording the action.

Figure 9-5

Naming the action

Creating a new action

Recording the Open step. The first step is to open the image in Camera Raw so that you can include the correct Camera Raw settings in the action. When you use the action in Batch, the Camera Raw dialog box won't appear, so it's essential to get these settings right when you record this step. Open the image by pressing Command-O (you must open the image in Camera Raw hosted by Photoshop), and the Camera Raw dialog box appears (Figure 9-6).

Figure 9-6 Recording the Open step.

When you record an Open step, it's critical that the Settings menu be set to Image Settings and that the workflow settings be set the way you want them for the batch operation.

Selecting Image Settings in the Camera Raw dialog box

Selecting the workflow options

You need to record two key settings for this action in the Camera Raw dialog box:

- Set the Settings menu to Image Settings to ensure that each image gets opened using its own custom settings.

- Specify the workflow options. In this case, we've chosen sRGB in 8 Bit/Channel and a reduced resolution with a 72 ppi resolution setting.

Then click OK to open the image. (If the Profile Mismatch warning appears, click OK to dismiss it. This doesn't get recorded in the action, and you'll suppress the warning when you use the action in Batch.) The image opens, and the Open step appears on the Actions palette.

The next series of steps will guide you through recording a short series of action steps to process the now open file. We're doing this for a couple of reasons; merely recording an Open and Save step isn't particularly instructive and in the *Real World*, you'll need to record actions that do more once you get an image open.

Recording processing steps. Don't worry too much if you make a mistake along the way. Actions can be edited to correct many errors, or you can simply toss them and start again. The series we'll show consists of these steps: setting your Photoshop Preferences to change the Image Interpolation, running a Fit Image script, saving as a JPEG, performing a close step, and then resetting your Photoshop Preferences back to where they may have started. Sound complicated? Not really, particularly if you practice the steps prior to recording the action in the first place—practice makes perfect. See Figure 9-7 for the steps to record.

Go to the Photoshop Preferences and record the step of changing Image Interpolation preferences to Bicubic Sharper then...

...go to File > Automate > Fit Image and enter 1024 and 1024 for Width and Height.

Figure 9-7 Recording additional processing steps.

Changing your Image Interpolation sets your Preferences to use the proper interpolation for downsampling and will be picked up and used by the next step of Fit Image. Whether you started with a landscape or portrait mode image doesn't matter because Fit Image will make all images fit within a pixel dimension of 1024 x 1024 pixels—handy when running batches. Once you've recorded these steps, the next step to record is the act of saving the file.

Recording the Save step. To record the Save step, choose Save As from the File menu, or press Command-Shift-S. The Save As dialog box appears. The filename and the destination for saving that you enter here have no impact on the batch process. See Figure 9-8.

Figure 9-8 Recording the Save step.

When you apply the action in a batch operation, the filename and destination will be overridden, but the format options in the JPEG Options will be used.

Make sure that the format is set to JPEG, and incorporate any other settings in this dialog box that you want to include in the action. In this case, we'll leave all the options unchecked—any RGB file that we create without an embedded profile can safely be assumed to be sRGB, and we don't care about icons or thumbnails—but if you want any of these options included in your batch-processed files, check them now.

Click Save to proceed to the JPEG Options dialog box, set the desired quality, set the Format Options to Baseline for maximum compatibility with JPEG-reading software, and then click OK. The file is saved on the Desktop and the Save step appears in the Actions palette. It doesn't matter where you save the file, but the Desktop is always a handy place. The Batch command will override the location anyway. Then close the image so that the Close step appears in the Actions palette.

The final step in this example action (see Figure 9-9) is to record resetting your Image Interpolation back to Bicubic so general use of resizing and image rotation uses this better general-purpose interpolation.

Figure 9-9 Recording the Preference reset step.

Stop and Save. Click the Stop button in the Actions palette to stop recording. Photoshop allows you to save action sets but not individual actions; so if you want to save an action as soon as you've written it, you need to select the action set that contains it in the Actions palette and then choose Save Actions from the Actions palette menu—see Figure 9-10.

Selecting Stop Recording

Choosing Save Actions

Set naming

Figure 9-10 Stopping the recording and saving the action set.

Note that until you save actions explicitly using the Save Actions command, they exist only in Photoshop's Preferences, and Photoshop's Preferences only get updated when you quit the application "normally" by using the Quit command. If Photoshop crashes, or you suffer a power outage, any unsaved actions will be lost. A simple action like this one probably wouldn't have you running to the Save Actions command, but if you make any actions that are even slightly complex, it's a very good idea to save them before doing anything else.

You can save actions anywhere, but if you want them to appear automatically in the Actions palette even after deleting Photoshop's preferences, save them in the "standard" Actions folder location shown here:

- Location of stored user actions—Mac: User/Library/Application Support/Adobe/Adobe Photoshop CS4/Presets/Actions

- Location of stored user actions—Windows XP: \Documents and Settings\User\Application Data\Adobe\Adobe Photoshop CS4\ Presets\Actions

- Location of stored user actions—Windows Vista: User\AppData\ Roaming\Adobe\Adobe Photoshop CS4\Presets\Actions

When you expand the steps in the Actions palette by clicking the triangles beside those that have them, you can see exactly what has been recorded for each step—see Figure 9-11. When you use this action in Batch with the appropriate overrides selected (see "Batch Processing Rules," earlier in this chapter) the filenames and folder locations you recorded will be overridden by the settings in the Batch dialog box, and all the other settings you've recorded here—the Camera Raw workflow settings and the JPEG Save Options—will be honored.

Figure 9-11 The Save JPEG Preview action.

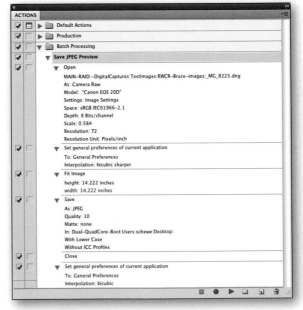

Variants. You can create variants of this action by recording different Open or Save steps. For example, you can create larger JPEGs by changing the Size setting in the Camera Raw dialog box to one of the larger sizes, and you can embed thumbnails or create lower-quality JPEGs by making those settings in the Save As and JPEG Options dialog boxes, respectively. To save in a different format, with different options, just choose the desired format and options when you record the Save step.

Complex Action—Save For Print

The following example is a more complex action that produces 16 bit/channel TIFFs with sharpening applied and adjustment layers set up ready for final editing and printing from Photoshop. It's designed for use on "hero" images that merit individual manual edits in Photoshop. It doesn't actually *do* any of the editing, because results are returned as layers and the required final edits will almost certainly be different for each image in a batch. Instead, it simply does a lot of the repetitive grunt work involved in setting up an image for fine-tuning, so that when you open the image, all the necessary adjustment layers are already there, waiting for you to tweak them.

Creating a new action. Record this action in the same set as the previous one, since it's also designed for raw processing. As before, select a raw image that has had custom Camera Raw settings applied before you start recording the new action. Then click the Create New Action icon in the Actions palette, enter the name "Save For Print" in the New Action dialog box, and then click Record to start recording.

Recording the Open step. As before, start by launching Camera Raw by double-clicking the selected image. In the Camera Raw dialog box, again make sure that Settings is set to Selected Image. This time, though, you'll make some different workflow settings.

- In the Space menu, choose ProPhoto RGB, our preferred working space.

- Set the Depth menu to 16 bit/channel, because you'll want to make the edits in Photoshop in 16 bit/channel mode.

- Set the Size menu to the camera's native resolution.

- Enter 360 pixels per inch in the Resolution field, because you'll almost certainly check your edits by printing to an inkjet printer at 360 ppi.

Then click OK to open the image. The image opens, and the Open step appears on the Actions palette.

Adding the edits. This action adds four different editing layers (actually, two layers and two layer sets) to the image before saving and closing. First, choose Image Size with the Resample Image option unchecked, and set 10 as the width. For this example we're working with a Canon 20D image, which is an 8.3-megapixel camera. Setting the width to 10 will give an uninterpolated file resolution of 350.4 ppi. The aim is to get an image that will print about 10" x 6.6" at the file's native resolution (Figure 9-12).

Figure 9-12 Image Size without Resample Image, width set to 10.

Figure 9-13 PhotoKit Output Sharpener selecting Inkjet Output Sharpeners, Inkjet 360 Glossy.

Since we've already set the image capture sharpening in Camera Raw, the only additional sharpening will be for print output (Figure 9-13). We're adding sharpening layers using PhotoKit Sharpener from Pixel Genius LLC (you can use your sharpening tool of choice at this stage). Then we'll add a Curves adjustment layer and a Hue/Saturation adjustment layer, and put those layers into a layer group named "Soft Proof Group." The steps are as follows.

Even though the image resolution doesn't match the 360 Glossy settings exactly, PhotoKit Sharpener users should use the next closest setting and *not* resample to get an exact resolution match.

We've found that when soft-proofing for inkjet output, we almost always need to add a Curves adjustment to adjust the dynamic range of the image to the printer paper combination. The adjustment made in this example is only a rough guess, but you can do some fine-tuning after opening the image and using soft proofing in Photoshop (Figure 9-14).

In general, one of the severe limitations when recording actions is that they record the literal name in the action, so you'll need to make sure new layers have explicit names and not just Curve 1, 2, 3, and so on. The naming step makes absolutely sure that errors don't occur in subsequent recorded steps that may be looking for an explicit name on which to act (Figure 9-15).

Figure 9-14 Adding a Curves adjustment layer.

Figure 9-15 Renaming the Curves adjustment layer.

There's one small issue. PhotoKit Sharpener produces an open (expanded) layer set, and the *Curves Adjustment* layer gets created inside the set. There's no way to record closing or expanding a layer set, so you need to record a step that moves the Levels layer to the top of the stack (Figure 9-16), using the shortcut for Layer > Arrange > Bring to Front (Command-Shift-]).

Add a Hue/Saturation layer—remember to rename this layer as well. We've named this layer adjustment Hue/Sat Adjustment, as shown in Figure 9-17. This layer is automatically created in the correct positions in the stack, so you don't need to employ any more layer-moving trickery, but we are going to move both adjustment layers to a newly created layer group, as shown in Figure 9-18.

Figure 9-16 Moving the adjustment layer to the top of the layers stack.

Figure 9-17 Adding a Hue/Saturation adjustment layer.

The Layers palette with the Hue/Sat Adjustment layer selected

The Layers palette adding the Curve adjustment layer by Command-clicking on the layer

Selecting New Group from Layers in the Layers palette

Figure 9-18 Adding a new layer group containing the adjustment layers.

When you open the resulting images in Photoshop, you can start editing immediately by double-clicking the adjustment icon in each adjustment layer without having to do the work of creating them first. Ideally you should make the adjustments after turning on soft proofing in Photoshop by choosing View > Proof Setup > Custom and selecting the correct profile for your printer and paper combination. If you don't need the adjustment layers, you can easily throw away the unused ones. All the edits will be performed in 16 bit/channel mode for the best quality.

Recording the Save step. Record the Save by choosing Save As from the File menu. Again, save it on the Desktop for easy disposal later. This time, choose TIFF as the file format, make sure that the Layers and Embed Color Profile checkboxes are selected (creating untagged ProPhoto RGB files is a Very Bad Idea). Then click Save to advance to the Tiff Options dialog box, as shown in Figure 9-19.

Figure 9-19

Recording the Save As to TIFF format

Recording the TIFF Options

In the TIFF Options dialog box, choose ZIP for both Image Compression and Layer Compression, and then click OK to complete the save—see Figure 9-19.

Finally, close the image (so that the batch operation will do so too), and click the Stop button in the Actions palette to stop recording. Figure 9-20 shows the resulting action in the Actions palette with all the steps expanded.

As with the earlier, simpler action, when you use this action in a batch process with the necessary overrides applied in the Batch dialog box, the filenames and locations will be overridden by the Batch settings, while everything else in the Open and Save steps will be honored.

Figure 9-20

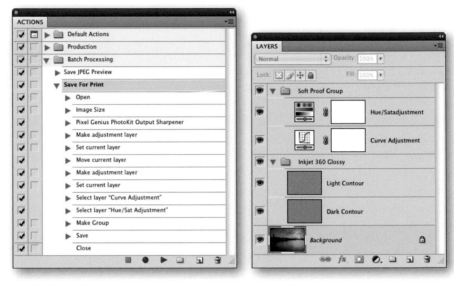

The final Save For Print recorded action

The final layer creation and arrangement on a sample file

Working with Actions

Here we present some real-world tips and techniques for recording, editing, and using actions.

Recording and editing actions. While we've already shown example actions you can make, it would be useful to start at the beginning to show recording and editing actions. Figure 9-21 shows a basic recording of a feather action.

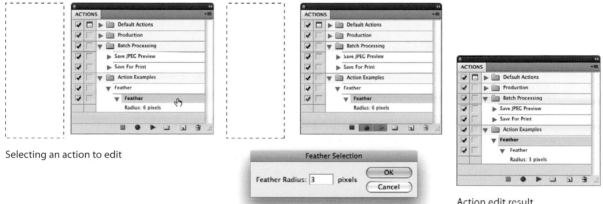

Figure 9-21 Recording an action.

Starting the recoding of an action

Selecting the Feather menu

Entering the Feather Radius

Just like the previous Save JPEG Preview action, once recorded the action shows the parameters recorded in the dropdown when viewed in expanded form (see Figure 9-22). What may not be obvious is just how easy it is to edit the recorded action after the fact.

Figure 9-22 shows the basic steps required for simple action editing. You simply target the action step (not the entire action) and double-click. This launches the step so that you can modify its recorded parameters. After the edit, the new parameters are stored in the action.

Selecting an action to edit

Rerecording the parameters

Action edit result

Figure 9-22 Editing an action.

One problem you may encounter is that the condition or state of the parameter must exist when running or editing the action. Figure 9-23 shows the dreaded "Command not available" warning that Photoshop displays if the condition required to run or edit an action is not available.

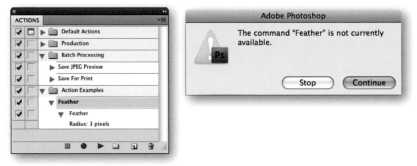

In Figure 9-23, double-clicking on the Feather action has issued this warning. The action recorded the feather parameter, which means a selection is needed in order to do a feather on the selection. Absent an active selection, the Feather command simply can't run. Whenever you see the "Command not available" warning, you'll know something is missing. Rerecording or editing an action parameter requires that the original state be available.

Action palette controls. In the Actions palette, an action can be configured to behave a certain way, such as prompting for a dialog, as shown in Figure 9-24.

Figure 9-24 Action palette controls.

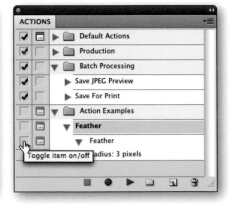

Toggling a forced dialog box Toggling an item on/off

In addition, within a multistep action you can turn off certain steps. This means you can record several versions of the same step with different parameters and test the results of the interaction of the parameters by toggling individual steps on and off.

In the previous example, in which we hard-coded the feathering amount into a recorded action, toggling the dialog option (shown in Figure 9-24) would force the dialog to display, and parameters can then be entered extemporaneously. This is merely a manual entry option in those cases where you may wish to have more control. Alternatively, you might consider the use of a different sort of recorded step, an *Insert Menu Item*, as shown in Figure 9-25.

Recording Insert Menu Item actions. You can also record the selection of a menu item. In Figure 9-25, we're recording an Insert Menu Item action step for turning on Photoshop's soft proofing and specifying a saved soft-proof setup.

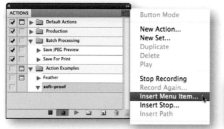

Figure 9-25 Recording an Insert Menu Item action step.

Selecting the Insert Menu Item step after recording has begun

The Insert Menu Item dialog box with None Selected

Navigating to a saved soft-proof setup

The Insert Menu Item dialog box shown with the selected item

Action Options. Selecting Action Options from the Action palette flyout menu opens a dialog box that lets you rename the action and assign it a function keyboard shortcut, as shown in Figure 9-26.

Figure 9-26 Renaming an action and assigning it a function key.

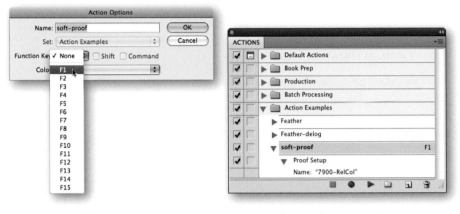

Action Options dialog box Assigning a function key to an action

Playback Options. Just under Action Options in the Action palette flyout menu is a command for accessing the playback options for an action. You have three main options: Accelerated, Step by Step, and Pause. In most cases, simply choose the Accelerated option, but if you want to troubleshoot an action, select the Step by Step or Pause option instead. Since Photoshop CS2, the process of running actions has been made much faster—so fast that Photoshop doesn't even bother to try to refresh image windows, palettes, or other parts of the Photoshop user interface. Choosing Step by Step forces actions to run more slowly and display the step that's running in the Action palette. But if that's still too fast to check an action operation, you can insert a hard pause, say 5 seconds, so that you can follow along and make sure the correct action steps are running in the manner you expect. See Figure 9-27.

Figure 9-27 Playback Options.

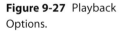

Playback Options menu item Playback Option dialog box

Copying an action. In addition to rerecording an action step, there are other options available when editing actions. One common one is to simply delete it. As you'd expect, dragging an action or step to the Action palette trashcan will delete it. But did you know you can copy action steps as well? While the Copy and Paste commands don't work, Option-dragging an item does. Alternatively, you can drag either an action or action step to the New Action icon, as shown in Figure 9-28.

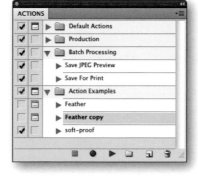 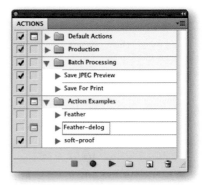

Dragging the action to the New Action icon

Result of the copy process

Double-clicking to rename the action

Figure 9-28 Copying an action.

When writing a lengthy and complicated action, if you wish to change a few parameters it's useful to do so on a copy rather than on the action you laboriously recorded. Not only can you copy an entire action, but you can copy a single action step as well (although you can't change the name of an action step).

In addition to Insert Menu Item, there are a couple of other menu commands worthy of note. Figure 9-29 shows two important ones.

Figure 9-29

Start Recording menu item

Insert Stop menu

Record Stop dialog box

Start Recording. Often when recording an action, you may want to stop the recording to check some detail or discover where a command may be hidden in Photoshop. You may also wish to test some parameters before deciding what to enter. An easy way to do this is to stop recording the action (click the Stop button) and pick it up later when you've made some decisions. You can select any action step and commence recording again from that step by selecting the Start Recording command. We suggest using this approach when you're working on long and complicated actions. You'll note the Record Again command just under Start Recording; issuing this command is the same as double-clicking on an action step to rerecord the parameters.

Insert Stop. Sometimes, you need the user to make a decision—and that's what this command is designed for. You can record a hard stop (with or without the option Allow Continue). If you are creating an instructional action, you can insert an informational message, or if the user has to select or enter a specific parameter, you can explain that in your message.

If you check Allow Continue, the action will continue running after the specified event takes place. To be honest, we don't do this much since it certainly defeats the purpose of unattended and automated processing. But it's useful to know what it's there for.

Actions calling actions. Rather than recording one long, complex series of steps, you may find it easier to write several individual actions and then record an action that calls those actions. One big caveat (as we mentioned earlier): if you record an action (A) that calls a different action (B), the success of A depends on B being where A expects it to be. Figure 9-30 shows an action that employs previously recorded actions as individual steps.

The names of the called actions appear in quotes, as do the expected locations of the actions. So, the second step after Open is to play the action Save As Archive RGB Tiff, and that action should be found in the set "Workflow Actions." Figure 9-30 shows the action and three example action steps. The action Save As Archive RGB TIFF is a simple save in a specified location with zip compression. The next step calls a recorded action that applies the PhotoKit Sharpener Inkjet 360 Glossy settings. The last example is a multistep action in which we export a JPEG using Photoshop's Save for Web & Devices command (formerly known as Save for Web).

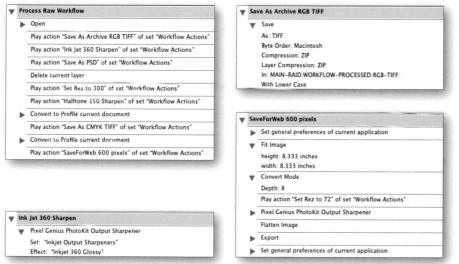

Figure 9-30 Process Raw Workflow action calling multiple additional actions.

When run, the Process Raw Workflow action will automatically save the same file in four different conditions in four different locations. But remember that in order to successfully run an action that calls other actions, all those previously recorded actions must be where they were when you recorded the calling action. The eagle-eyed among you may be thinking, "Well, this action won't work as a batch because there's no Close step."

Very astute! If we ran this action, we would end up with a bunch of images open in Photoshop as well as the four derivatives saved in the various locations. Fixing this is easy—we just add a Close step at the end. So, select the last step, SaveForWeb 600 pixels, and choose Start Recording from the Action palette flyout menu (or you can copy a step from an existing action). Figure 9-31 illustrates the approach we favor.

Figure 9-31 also shows all the recorded actions that are located in the Workflow Actions set. We suggest that when writing actions that call other actions you keep them all together in a single action set. Missing even one action will cause a multistep recursive action to fail. In general, it's also more of a beginner's approach to writing actions. It's better to build an action that does not have dependencies for bulletproof and error-free execution.

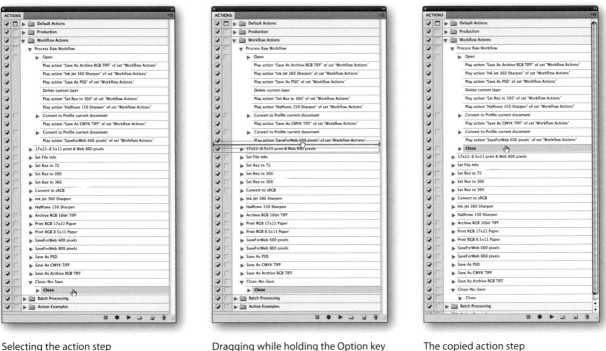

Selecting the action step Dragging while holding the Option key The copied action step
 (Alt key in Windows)

Figure 9-31 Adding an action step by Option-dragging.

To be brutally honest, Photoshop's action writing isn't very intuitive and it's far from an elegant environment in which to edit. But the power of automation cannot be denied. At this point, you might expect we're ready to jump back to the Batch command to learn more about Batch automation. However, we still need to explore a couple of topics related to actions: droplets and the Script Events Manager.

THE POWER OF DROPLETS

Often overlooked when the topic of automation is discussed is the powerful and underutilized droplet. Photoshop lets you save a batch process as a hard-coded droplet application—an actual executable file (which, of course, requires Photoshop to run). This is great if you are constantly doing the same batch operation. The downside is that droplets are not editable, so if you want to alter anything in the droplet, you have to re-create it from scratch.

Create Droplet dialog box. If you think the dialog box in Figure 9-32 looks a lot like the Batch dialog (see Figure 9-1 at the beginning of the chapter), you are correct. A droplet is a saved batch process where all the batch parameters (such as the action you want to play, the designation, as well as the ability to log errors) are saved as a standalone droplet. So, if you often perform the same batch process, constantly setting the same action, destination, and save parameters, why not automate the batch? You'll note that there is no defined "source." That's because a droplet is designed to have an image or an entire folder of images dropped on it to run.

Figure 9-32

Photoshop's Create Droplet command

Create Droplet dialog box

Figure 9-33 shows the Save dialog box where you name the droplet and specify where to save it. You can move the droplet anywhere on your computer or even move it to another computer. The only limitation is that if the droplet has a specific location in which it should save an image, that same directory path must also be available to the second computer.

Figure 9-33 Droplet name and save location.

You should also understand that a droplet, once saved, can't be edited in any way. If you wish to edit any aspect (other than the name) of a droplet, you'll

need to go back and edit the original action and resave the droplet. Simply editing the original action won't do the job since the droplet contains all the action steps internally in the droplet. That's what makes droplets portable.

As Figure 9-34 shows, we dragged and dropped our folder of images onto the Process-Raw-Workflow droplet. We processed a total of 25 raw images and saved them in four iterations in four separate folders in a total of eight minutes. Total processing time was 32 minutes for the final 100 processed images. With time-saving automation like this, it may be possible to actually have a life away from the computer!

Figure 9-34

Droplet

Dragging a folder onto the droplet

Results of the droplet processing

SCRIPT EVENTS MANAGER

We are constantly surprised by the number of people who don't know about a powerful (although really, really scary) functionality in Photoshop called the Script Events Manager. Not only do you run scripts using the Script Events Manager, but you can run actions as well (see Figure 9-35). To launch the tool, choose File > Scripts > Script Events Manager.

Automate	▶
Scripts	▶
File Info...	⌥⇧⌘I
Page Setup...	⇧⌘P
Print...	⌘P
Print One Copy	⌥⇧⌘P

Image Processor...

Flatten All Layer Effects
Flatten All Masks

Layer Comps to Files...
Layer Comps to WPG...

Export Layers to Files...

Script Events Manager...

Choose File > Scripts > Script
Events Manager.

Figure 9-35

The Script Events Manager with no scripts
or events

The Script Events Manager with two actions
specified

Enabling the Script Events Manager. Once you launch the Script Events Manager, the first thing you must do is enable it in the dialog as shown in Figure 9-35 (the Photoshop engineers wisely chose to ship Photoshop with this option off by default). After you use the Script Events Manager to specify the actions or script to be run during events, the manager will run those actions or script repeatedly until you turn it off (uncheck the Enable checkbox), quit Photoshop, and relaunch. Just deselecting the Enable option won't cause the events to stop calling the actions or scripts you specified in the Script Events Manager.

In the example in Figure 9-35, two actions are enabled. At the Start Application event, the action Set Color to RWCR Book (in the Production Actions set) will be run. When the event Open Document occurs, the action Set File Info will be run (that action is in the Workflow Actions set).

What does this mean? Whenever we launch Photoshop CS4, the Color Settings preferences will be already set for us so that we can be sure that all the work we do on this book uses the correct color settings. Also, when we open an image, an action will run that marks the File Info metadata as Copyrighted. Once an event has occurred, you could, for example, go into

NOTE "RWCR Book" was an action we created that set Photoshop CS4's Color Settings to use the ProPhoto RGB color space and set the CMYK color space to the profile we used for separating this book. The action was saved in an Action Set named Production Actions. This is just an example of the type of action that can be used to avoid making color management errors when doing a vast amount of production work.

the Color Settings preferences and change them, but those changes would only last until the next time you launched Photoshop.

You'll find the Script Events Manager to be a useful tool when you want to make sure that Photoshop's preferences are always set a certain way. Figure 9-36 shows some of the options available.

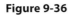

Dropdown menu for default events Adding events Dropdown menu for default scripts

Figure 9-36

By default, there are a variety of events you can select on which to run a specific script or action. Additional events—too many to show in the menu—are available. Just about everything in the current Photoshop CS4 version can have an event scripted. Check the Scripting Reference in the documentation for the full list.

The Script dropdown menu has a few examples, but you can add any JavaScript to this list by browsing. However, take care when enabling the Script Events Manager and selecting an unknown JavaScript. After all, a script has the power to do all sorts of things not only to Photoshop but also to your entire computer. That's where the Script Events Manager has the real potential for destruction.

MOVING ACTIONS TO ANOTHER COMPUTER

Once you record a series of actions on one computer, you may need to move them to another machine, such as from your workstation at home to your laptop. That's possible, and to prove it, we've made the example actions we've written about in this book available for download from the Web site www.realworldcameraraw.com. After logging in, click the Actions link on

the home page, and you'll find the batch processing examples as well as the workflow actions in zip files.

Figure 9-37 shows the downloaded Workflow Actions zip file. To use the actions, you'll need to unzip the file. To load the action in your copy of Photoshop, simply double-click on the action icon. You'll also need to rerecord all the Save steps within the actions and specify folders on your computer (see Figure 9-38).

Workflow Actions.atn.zip

Downloaded zip file

Workflow Actions.atn

Unzipped Workflow Actions icon

Workflow Actions.atn

Double-clicking an action to load

Figure 9-37

Select the Save step and double-click

The newly recorded location on your computer

Choose a new folder location

Figure 9-38 Rerunning the Save step on your computer.

Way back in Figure 9-10 where we showed the Action palette flyout menu, you may have noted a flyout menu called Button Mode. Well, we don't use that. Feel free to click the button mode to see what it does (it turns all your actions into buttons). We're pretty sure that if, like us, you end up with a lot of actions, button mode is next to useless for organizational purposes. Enough said—now on to the finer points of setting up and running a batch.

RUNNING BATCH

Using the actions we've described in this chapter in Batch is very simple—as long as you remember The Rules! (If you need to take another look, refer back to "Batch Processing Rules," earlier in this chapter.) Play by The Rules, and all will go smoothly. Violate them at your peril.

Aside from the settings in the Batch dialog box, there are three common situations that can cause a batch operation to fail:

* There isn't sufficient space on the destination volume to hold the processed files.

* No source files were selected—see "Selecting and Editing" in Chapter 7, *It's All About the Workflow,* if you need a reminder on how to select images in Bridge.

* Files with the same names as the ones you're creating already exist in the destination folder.

If these points seem blindingly obvious, we apologize. We mention them because they've tripped us up more than once. With those caveats in mind, let's look at setting up the Batch dialog box to run the Save for Print action you built in the previous section. The key settings in Batch are the overrides in both the Source and Destination sections of the panel.

Source Settings

Whenever you run a batch operation using an action that includes an Open step, you must check Override Action "Open" Commands in the Source section. To process raw images, you also need to check Suppress File Open Options Dialogs—otherwise, the Camera Raw dialog box will pop up for every image—and whenever you run a batch operation unattended, it's a good idea to check Suppress Color Profile Warnings so that the batch doesn't get stuck on a Profile Mismatch warning.

Destination Settings

Similarly, whenever you run a batch operation using an action that includes a Save As step, you must check Override Action "Save As" Commands in the Destination section; otherwise, the files won't get saved. The Destination section also offers the option to rename the files as part of the batch operation. See Chapter 7, *It's All About the Workflow*, for the major caveats on file-naming conventions. Figure 9-39 shows the Batch dialog box set up to run the Save for Print action you created earlier in this chapter.

TIP Preselecting the Batch Action. Before selecting Batch in the Bridge menu, you can "preselect" the action you wish to run as the batch by selecting that action in the Actions palette in Photoshop. See Figure 9-40.

Figure 9-39
Batch dialog box.

Preselecting the action in Photoshop

Batch dialog box with an action selected

Figure 9-40 Preselecting the batch action.

Batch is the most flexible command on Bridge's Automate menu, but the menu also includes some automation features that are useful for very specific purposes.

IMAGE PROCESSOR

If the preceding sections of this chapter have left you just a bit queasy from *"geekspeak,"* you'll be happy to know there is a simpler method of selecting a bunch of raw images in Bridge and getting processed files out the backside. Image Processor offers a quick way of saving up to three versions of the selected images—a JPEG, a TIFF, and a Photoshop file, with each format in a separate subfolder. You can set different sizes for each format and, optionally, run an action and include a copyright notice. Figure 9-41 shows the Image Processor menu and dialog box.

Let's look at the options:

- **Open First Image to Apply Settings** is primarily useful for processing unedited images that require similar treatment. When you run Image Processor, the first raw opens in Camera Raw. The settings you make there are applied to all the other images. These settings are used only by Image Processor—they aren't written to the image's metadata.

- **Select Location to Save Processed Images** lets you save the images either in the same folder or in one that you designate here. In either case, if you've chosen multiple file formats, a subfolder is created for each file format.

- **File Type** lets you save any combination of JPEG, PSD, and TIFF, with the option to resize the image in any of the chosen formats.

- **Preferences** lets you choose an action that runs on all the processed images, lets you include copyright info if you haven't done so already, and gives you a choice as to whether to include the ICC profile in the images.

The settings shown in Figure 9-41 create a full-resolution TIFF, and a JPEG downsampled to a maximum dimension of 1024 pixels—the image's aspect ratio is always maintained. We applied a resolution action to all the images, and selected the option to include the ICC profiles. We saved the images in JPEG, PSD, and TIFF subfolders in the destination folder.

One nifty feature of Image Processor is that it takes care of flattening and downsampling to 8 bit/channel automatically for the JPEGs while saving the PSDs and TIFFs as layered 16 bit/channel images if an action you choose to run creates layers. So it's by far the quickest and easiest way to save a high-resolution TIFF and low-resolution JPEG version of the same image—something many of us need to do often.

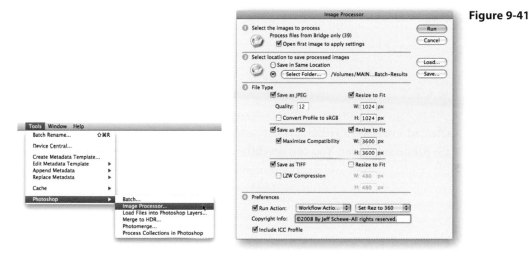

Figure 9-41

Image Processor menu command in Bridge Image Processor dialog box

Advanced Automation

You can accomplish a great deal through the combination of Photoshop actions and the built-in features on Bridge's Tools menu, but actions do have some limitations. You can build amazingly complex actions, but the editing environment is a nightmare once you get beyond a dozen or so action steps, and debugging can be a serious chore.

Some operations can't be recorded in an action, and others must be recorded in very specific ways. Earlier in this chapter, we showed you the problems that can occur when you add an adjustment layer to an image with an open layer set, for example. Usually you can come up with a workaround if you invest enough ingenuity, but sometimes you'll run into a wall. So we'll conclude by pointing out that Bridge is completely scriptable using JavaScript, and Photoshop is quite scriptable using either AppleScript (Mac), Visual Basic (Windows), or JavaScript (cross-platform).

Inside the Photoshop CS4 application folder (see Figure 9-42), you'll find a Scripting Guide folder. It contains comprehensive documentation on AppleScript, JavaScript, and Visual Basic scripting for Photoshop; some sample scripts that you can deconstruct; and a plug-in called ScriptingListener that, when loaded, dumps everything you do in Photoshop to a JavaScript log file. (You only want to load it when you need that data—otherwise, you'll make Photoshop run very slowly and create some very large files!)

Figure 9-42 Scripting Guide folder showing the ScriptingListener plug-in.

For a good example of the power of scripting, just look at Image Processor. It's actually a JavaScript that lives in the Presets > Scripts folder (or just search for Image Processor.jsx). Bridge shows some signs of being a "young" application—it's a great start, but it certainly has some omissions. Expect to see many of the gaps being filled by scripts from enterprising third parties or from Adobe.

If we were to attempt to cover scripting in any depth at all, this book would instantly double in length (and halve in interested readers), so we'll content ourselves with making you aware of the resources that Adobe supplies. Scripting is most certainly not for everyone, but if you've completely digested, implemented, and exhausted all the techniques in this book, and you want more automation, it's the next world to conquer.

If scripting is something you place in the same category as root canal therapy without the benefit of anesthesia, you're far from alone. But Bridge's scriptability presents huge opportunities for those who actually enjoy such things, and we hope to see a plethora of scripted solutions, some free, some commercial, that will extend Bridge's functionality in all sorts of useful ways.

Right now, Bridge is where Photoshop was before the days of third-party plug-ins (yes, we go back that far), but this is not a situation that will last long. So keep an eye out for useful third-party solutions that plug some of the gaps in Bridge—a good place to start is the new Bridge Forum on Adobe's User-to-User Forum. Who knows, the market for Bridge scripts may turn out to be bigger than the Photoshop plug-in market.

The more you automate your workflow, the more time you'll have to practice photography, which presumably is what drew you to this book in the first place, and is certainly what motivated Bruce and Jeff to write it.

Good shooting!

INDEX

Get free online access to this book!

And sign up for a free trial to Safari Books Online to get access to thousands more!

With the purchase of this book you have instant online, searchable access to it on Safari Books Online! And while you're there, be sure to check out the Safari on-demand digital library and its Free Trial Offer (a separate sign-up process)—where you can access thousands of technical and inspirational books, instructional videos, and articles from the world's leading creative professionals with a Safari Books Online subscription.

 Simply visit www.peachpit.com/safarienabled and enter code HMFOSBI to try it today.